Fronte

ex libris

James P. W. Thompson

The Innocent Eye

❖ ROGER SHATTUCK

The Innocent Eye

ON MODERN LITERATURE & THE ARTS

The dispersion and the reconstitution of the *self*. That's the whole story.

Baudelaire, *My Heart Laid Bare*

FARRAR STRAUS GIROUX

NEW YORK

Library of Congress Cataloging in Publication Data
Shattuck, Roger.
 The innocent eye.
 1. Arts, Modern—19th century—Psychological aspects.
 2. Arts, Modern—20th century—Psychological aspects.
 I. Title.
NX454.S42 1984 700′.9′034 84–13737

"Balzac and the Open Novel" appeared as the Afterword in
Eugénie Grandet, by Honoré de Balzac, translation by Henry Reed,
copyright © 1964 by The New American Library of World
Literature, Inc.; reprinted by arrangement with New American
Library. "The Tortoise and the Hare," from *The Origins of
Modern Consciousness*, edited by John Weiss, copyright © 1965
by The Wayne State University Press; reprinted by arrangement
with The Wayne State University Press. "René Magritte"
copyright © 1966 by *Artforum*; reprinted by permission. "The
Alphabet and the Junkyard," from *Fragments: Incompletion
and Discontinuity*, edited by Lawrence Kritzman, copyright ©
1981 by New York Literary Forum; reprinted by arrangement
with New York Literary Forum.

"Vibratory Organism" first appeared in *The Georgia Review*.

Contents

CASES
AND INQUIRIES

Having Congress:
The Shame of the Thirties

1

During the last two weeks of June 1935, the heat in Paris became pitiless. It was precisely the moment when scores of intellectuals from Europe and America and Asia had been summoned to that city to discuss the fate of their world. Inside the sweltering Palais de la Mutualité in the Latin Quarter, a mixed crowd of close to three thousand proletarians and mandarins, watched by muscular ushers, listened to the opening session. They anticipated excitement, portentous statements to match the turn of events. Their newspapers were still discussing a financial panic and a double cabinet crisis earlier in the month. The year had opened with the Saar plebiscite in favor of Germany and with Hitler's reestablishment of compulsory military service, followed closely by Ethiopia's second protest to the League of Nations about Mussolini's intervention in her affairs. In May Laval, now premier, had brought forth the Franco-Soviet Mutual Aid Pact, a

package which confounded the French Communists, for it was accompanied by an unexpected statement from Stalin endorsing the long opposed French rearmament policy. The package also included the summary expulsion of Leon Trotsky after two years of political refuge in France. One wonders how many of the audience, most of them Soviet sympathizers, could acknowledge to themselves the murder of Kirov in Russia six months earlier and of the 105 people shot without trial to foil the "plot." Only a few days later this same auditorium in the Mutualité would house a mass meeting to celebrate the election in the Fifth Arrondissement of Paul Rivet, the first candidate in all Europe put up on a Popular Front ticket. Obviously the assembled intellectuals had multiple occasions to rise to.

It was Friday, June 21, a little after nine in the evening. When the people at the head table finally took their places, the audience could see the startlingly bald and ascetic head of the chairman behind the spider's web of microphones. He opened the session by reading in a beautifully modulated voice:

> Literature has never been more alive. Never has so much been written and printed, in France and in all civilized countries. Why then do we keep hearing that our culture is in danger?

By a mixture of fate, chance, and calculation, the First International Congress of Writers for the Defense of Culture met in the very storm's eye of the thirties. The man who spoke the opening words was André Gide. His slightly Oriental face wore the patina of a half century of literary history. During the 1890s he had belonged to the group that listened to Mallarmé test the secrets and silences of poetry on Tuesday evenings. His novel about gratuitous murder and the rewards of being an imposter, *Lafcadio's Adventures* (1914), had inspired the young devotees of Dada and Surrealism in the twenties; this same novel was now being revived in installments in *L'Humanité*. He had publicly proclaimed and defended his homosexuality in the twenties. For most listeners Gide, now sixty-six, had turned Communist. His bourgeois public considered him a dirty old man all over again.

At the table with Gide sat Barbusse, pacifist and leftist hero since his novel *Under Fire* (1917); Malraux, already a legend at thirty-four with his fourth novel, *Days of Wrath*, just out; and Aragon, convert from Surrealism to militant Communism and editor of the monthly *Commune*. After Gide's short welcome, telegrams of greet-

ing and encouragement were read from Romain Rolland, hero of the pacifist left, and Maxim Gorky, both in Moscow.

The first speaker was a stooped but prickly Englishman, who talked inaudibly for twenty minutes about the close connection in England between traditions and liberties, and the recent danger of censorship. With this speech E. M. Forster entered a kind of half-hearted political period which he later called *Two Cheers for Democracy*. There was more wistfulness than militancy in Forster's statement that he would perhaps be a Communist "if I was [sic] a younger and braver man, for in Communism I can see hope." He was followed by a heavyweight polemicist who brought the proceedings to life again with an impassioned simplification of Western history and by asking in effect for a division of the house. Julien Benda, author of *The Treason of the Intellectuals* (1927), rapped out a stinging speech affirming that, in the West, intellectual activity has traditionally stood apart from material and economic forces and inviting his Communist colleagues to answer the question: "Does Lenin form a continuity with Montaigne, or is there a fracture?" Benda had, in fact, been mousetrapped. Several speakers had their answers ready: Marx belongs to the West; Benda had ignored half the Western tradition in order to make his case; the advances of modern science are based on the very materialism Benda had scorned. They swarmed all over him.

The Congress was off, and it kept running for four more days with sessions at three in the afternoon and nine in the evening, and an extra meeting Tuesday morning, Malraux presiding, on questions of organization. The speeches poured out, ranging from one-minute greetings to a forty-five-minute harangue by Barbusse, who mistook himself for the impresario of all left-wing culture. He emptied the hall. In the heat, more and more suspenders came into sight as jackets were taken off. Speeches in foreign tongues, followed by translation, provided long intervals for beer and conversation. Yet the enthusiasm kept returning. The German poet Regler made a fiery speech about the resistance to Hitler among writers still in Germany, and dramatically handed to Gide and Barbusse token copies of underground pamphlets. "They're being circulated at this very moment." Spontaneously by all accounts, the audience rose at this point and sang the *Internationale*. Regler had in fact departed from his prepared text. Johannes Becher, later to become East German culture commissar, was outraged and hissed at Regler from the wings: "This

Congress can't pretend to be neutral any longer." But Becher had nothing to fear. Efficiently organized, indulgently reported in most of the newspapers, capable of keeping its family squabbles in an inside pocket, the Congress appeared to be a great success.

But could such a congress succeed in being anything more than a mere epiphenomenon clinging to the surface of history? Could it ever constitute a nexus of real forces, a congress of *res gestae?* Of this much I feel sure: the thirties worried their way through a prolonged economic and political crisis that threw intellectuals and artists into a state of increasing tension sometimes verging on panic. The Congress is a surprisingly clear window into that decade.

The year 1935 stands centered in a triple frame of events. In 1930, Europe felt the impact of the American *Krach*, and it was the year that the Nazi Party won six and a half million votes. But the German Communist leader Thaelmann refused any united front against Hitler and proclaimed that the enemy was still capitalism and the Fascism of social democracy. Until 1934 the famous "Third Period" of the Communist International called for the radicalization of the masses and no compromise with the non-Communist left. At the other end of the decade, complementing 1930, stand Munich and all that followed.

Here is the first frame. Hitler's installation as Chancellor in January 1933 and the Reichstag fire should have been enough to alert the astute to the true direction of things. But we know they were not; in May 1933 Gide was still able to write in his journal: "Excellent speech by Hitler to the Reichstag . . . Everything remains to be seen." This date pairs off with the Proclamation of the Axis in November 1936. Here is the second frame.

In the mid-thirties, France had to assume cultural leadership of Europe by default. Writing from Moscow, Victor Serge referred to France as "an oasis . . . facing a crisis." Paris became the arena of events in great part because France was the only country where the Communist Party emerged from the Third Period of Comintern strategy with both numbers and prestige. In Italy and Germany, the Communists had been liquidated or forced underground. But naturally in France a domestic confrontation was needed to produce a sense of urgency. Fascism in Germany and Italy could look remote and even comic until it struck in the streets of Paris. A highly complex and often contradictory sequence of events, including a financial scandal, a cabinet crisis, and a powerful prefect of police, led to what has often

been interpreted as an attempted Fascist coup against the Third Republic and the parliamentary system. That was February 6, 1934. We now know better; the Fascist leagues and the Action Française had planned no such coup. Nevertheless, soldiers had to be brought in to protect the Chamber of Deputies from attackers on the Place de la Concorde. Pushed hard by demonstrators armed with iron bars and knives mounted on poles to disable the horses, the soldiers finally had to fire into the crowd. For all its confusion (there were quite a few Communists among the rioters), this single night of fighting galvanized Paris into a series of frenzied counterdemonstrations, meetings, appeals to honor and to freedom, congresses, maneuvers, and reversals of policy. Out of that activity came the victory of the Popular Front and the Blum government. Politically and intellectually, the three years from the February riots in 1934 to the triumph and decline of the Popular Front in 1936 form the heartland of the decade, the unreal interval during which it seemed still possible to save European culture from totalitarianism without war, and even to assimilate the Soviet revolution into the Western tradition without more bloodshed. Here is the third frame.

In June 1936, huddled over his shortwave radio in Norway, Trotsky wrote his fifth successive pamphlet about the crisis and called it "The French Revolution Has Begun." He was wrong; who knows what it would have taken to make him right. That was the way things felt in Paris also.

Like most crises, this one arose out of the convergence of several strands that were difficult to distinguish at the time. In each instance, there appears to be a general European development with its French counterpart. Recognized late and poorly understood even when most blatant in its methods and ambitions, Italian and German Fascism could still get away with almost anything in the mid-thirties. French Fascism lumped together militant patriots organized in *ligues*, royalist maneuvering, and anti-Semitism inherited from the Dreyfus affair.

The second strand concerns the Third Communist International. Its strategy shifted drastically in May 1934 for reasons that remain cloudy. After six years of bitter attacks on the non-Communist left came the apparent thaw—reconciliation, the Popular Front, "the hand outstretched" to socialists and even willing radicals, and an elaborate machinery of front organizations and cultural activities. In France, the Party seemed to have jumped the gun, primarily through Barbusse's unpredictable yet successful activities. His Amsterdam-

Pleyel movement against Fascism and war in 1932 was the first of its kind. The non-Communist Vigilance Committee of Anti-Fascist Intellectuals sprang up overnight after the February riots in 1934 and set up something like an interlocking directorate with a series of Communist-sponsored groups and meetings. The most important was the Association of Revolutionary Writers and Artists (A.E.A.R.) that Vaillant-Couturier founded in 1932. The following year he assigned to Aragon the joint editorship of its monthly review, *Commune*, as well as responsibility for the Maisons de la Culture. Unlike the bleak years after 1927 when the Surrealists had tried to find nourishment in a suspicious, badly split party, in 1934 the Communists prepared to welcome the entire French left into a huge pasture of anti-Fascism. There, the left's fondness for revolutionary slogans, its ignorance of Marxism, and its admiration for what it thought was happening in Soviet Russia led many individuals into highly irresponsible pronouncements and actions.

Fascism and Communism were the principal ideological strands. But there were more. A genuine, vociferous opposition of militant Marxists and anti-Stalinist Communists had existed since Trotsky's banishment—one might even say since Bertrand Russell's *The Practice and Theory of Bolshevism* (1920), in which he called the Soviet system "moribund" because the Party had taken over. But Trotsky was everybody's devil—too eloquent, too shrill, too intellectual. Russell could not be counted on: by 1932 he was endorsing Soviet policies. (In 1945 he advocated preemptive war against the Soviet Union before it developed the atom bomb.) Other writers like Panait Istrati, who produced evidence to show that the great experiment had gone sour, were quickly labeled Fascists. For those that wanted to look, magazines like *La Révolution Prolétarienne* regularly furnished reliable information about what was happening in L'URSS—a combination of letters that almost reproduces the French word for bear. But few intellectuals ever heard about the case of Victor Serge, who had been imprisoned for months and then banished to Orenburg with no means of supporting his family. The Russians had the equivalent of unlimited political and ideological credit; they alone had achieved a revolution in the twentieth century. For the French left in 1935, "revolution" meant the republican tradition threaded from 1789 through 1848 and the Commune, meant October in Russia, and also meant whatever the "Soviet experiment" had become since then. It made a heady brew. Few took the trouble to examine what

had happened in twenty years, except to see that "Soviet power plus electrification" (as Lenin put it) seemed to have been a stunning success. The Big Bear had even joined the League of Nations in 1934.

The only organized group of self-professed Marxists to withdraw firmly and stridently from the Party, after having signed up, was the Surrealists. They contrived to be *plus royaliste que le roi*. Their constant protests that the Party was compromising the true revolutionary cause looked like a caricature of the Trotskyist opposition (which they later joined) and had the same kind of insistent integrity.

The last strand is pacifism. Everyone but the extreme Fascists opposed war. One of the semi-scandals of the decade was the resolution adopted by the Oxford Union in 1933, by 275 votes against 153, that they would "not take up arms for king or country under any circumstances." Moderates, anti-Fascists, militant Communists—they all considered themselves part pacifists under the skin.

These four strands and many more coincided in the mid-thirties in the sense that they reached peak intensities at approximately the same time. But the tensions they produced in historical events and in individual lives arose because these forces worked not in one direction but in contradiction; anti-Fascism and pacifism were clearly at cross-purposes. The steady movement of intellectuals toward Soviet sympathies and Communism at the very moment when Stalin was clamping his iron control over the Party through the purges compromised the cause of anti-Fascism. A whole generation of honest men tolerated in the Soviet Union the kind of conduct they condemned in Germany and would have opposed with their lives in their own country. The pacifists and the Trotskyist opposition could do little more than call down a plague on everybody's house.

Dissent and disarray characterize any ideological crisis. But the degree of polarization in 1935 almost equaled that caused by the Dreyfus case. In April Maurice Reynal founded an independent monthly newspaper to report on art exhibits and publish little-known writers like Artaud, Queneau, Michel Leiris, and Reverdy. Its name cannot be improved upon: *La Bête Noire*. But in its four numbers the paper found very little "artistic and literary" room to turn around in. The first number devotes the front page to a *"mise au point"* by Léon Pierre-Quint. It is a revealing text. He states that all literary and artistic schools are being deserted wholesale in favor of the Fascist leagues or the Young Socialists. The young are no longer interested in Surrealism, which has now "come into its own in the

university." The public has become so militant in its views that it is no longer possible to make political jokes in the music halls and cabarets. An uncommitted writer, Pierre-Quint reports, is considered either an anarchist or a *petit bourgeois*. The fourth and last number of *La Bête Noire* was almost entirely devoted, not to an exhibit or a writer, but to the proceedings of the Writers' Congress.

Bastille Day in 1935 gives the ultimate illustration to the way things were going. Organized groups had been jockeying for position since May. It turned out to be a perfect summer day. While an estimated six hundred planes flew overhead, the police for once stayed systematically out of sight. Three successive *défilés* or processions ran their course passionately yet peacefully. In the morning, the traditional military parade took care of the Unknown Soldier. In the afternoon, something approaching half a million Communists and socialists, plus a scattering of radicals and every leftist intellectual group with any soul, trooped in a joyful mass from the Place de la Bastille to the Place de la Nation. In front of the statue of Baudin (shot during the brief uprising against Louis Napoleon's *coup d'état* in 1851) they raised their fists and renewed his oath to stand fast on the barricades. Here in the streets, the Popular Front discovered the euphoric spirit that carried it to victory a year later. Red Soviet flags mingled with the *tricouleur*; apparently for the first time in such a mass meeting, both the *Internationale* and the *Marseillaise* could be sung without catcalls. Every surviving participant testifies to the semi-delirium of the occasion. Fascism *must* fall back before this return to revolutionary traditions.

That evening, with torches, between thirty and forty thousand representatives of the right-wing Croix de Feu marched down the Avenue des Champs-Elysées, in step and in uniform. It was the most impressive display of force Colonel de La Rocque's semi-Fascist organization had ever staged, but from here on, its numbers dwindled.

Amid this extreme polarization of opinion that obviously left many citizens gasping, several forms of expression took on a renewed life. Every newspaper and review ran its *enquête* or opinion survey on some variation of the question: *Can we avoid a revolution?* Congresses and meetings and assemblies came so fast that the Mutualité could not handle them and the traffic overflowed to the Salle Bullier and the Cirque d'Hiver and the vélodromes. Later, at the critical juncture of May 1936, while the striking workers waited for their new government to take office, this energy found a new tactic: the sit-in strike.

The only man apparently able to give some direction to these events was neither a fanatic nor a rabble-rouser. Léon Blum began as a first-rate literary and theater critic and became a courageous and honest statesman. But even his integrity failed the test of the Spanish Civil War. It is either appropriate or ironic that at this crucial moment France put itself in the hands of a literary man. Inevitably he attended the Writers' Congress and found himself face to face ("nose to nose," as the newspaper account reads) with Aragon, who had written a wildly anti-bourgeois poem four years earlier with the memorable line: "Shoot Léon Blum." At least one reporter was watching alertly and wrote: "But nobody flapped. The Communist poet-politico cordially shook hands with the socialist politico-poet." There is the decade in a nutshell. The pop front was a handshake in the wilderness. Today it has been romanticized by indulgent memories and documentary films (1936: Le Grand Tournant) into the last utopia.

Everyone I have talked to among the organizers of the Congress produces the same explanation for all that effort: anti-Fascism. Yet the invitation sent out to writers all over the world began in this bland style called "equivocal" by La Bête Noire: "In the face of the dangers which threaten culture in a number of countries, a group of writers are taking the initiative of bringing together a congress in order to examine and discuss means for defending that culture. They propose that the congress clarify the conditions of literary creation and the relations between the writer and his public." Nowhere in the invitation does Fascism or any political term appear.

The vagueness of the invitation was clearly a tactic to appeal to as wide a group of writers as possible. But how did the whole thing start? The explanation seems relatively simple. In August 1934 the First All-Union Congress of Soviet Writers was held in Moscow. Though a few independent voices were raised (soon to be silenced), the huge meeting served primarily as the occasion on which to promulgate the official doctrine of socialist realism—later called Zhdanovism after the Central Committee member who made the principal speech at that Congress. A number of foreign writers were invited to attend, including Aragon, Jean-Richard Bloch, Paul Nizan, and Malraux from France. They returned to Paris with varying degrees of enthusiasm for the new doctrine, yet all apparently eager to stage a similar mass meeting of writers in Paris. The Comintern, having just shifted a few months earlier to a new policy of alliances and popular fronts, gave support. A number of other writers were brought in to

help plan the Congress, including André Chamson and Louis Guilloux. Guilloux, who was one of the secretaries and handled a large part of the correspondence, stated that the man who supplied the funds was Mikhail Kozloff, Comintern agent and commissar of the Soviet delegation. In France, of course, the Party had no official or legal control over writers. But it could now browbeat and shame them with the issue of anti-Fascism, even though the Party itself had been trying to ignore Hitler and Mussolini for five years. In an era of peace conferences and huge international assemblages, a congress could be turned into an instrument of policy.

Of the twenty-four signers of the invitation, four out of the first five in alphabetical order (Abraham, Alain, Aragon, Barbusse, Bloch) were known Communist militants—though Barbusse was allowed a very long tether. Alain, on the other hand, was the very voice of the radical party, a widely respected writer and philosopher who had taken an active part in left-wing groups after the February riots. (His name disappeared from later lists; he refused to participate in the Congress.) Other names that would be immediately recognized were those of André Gide, André Malraux, and Romain Rolland. It would be hard for leftist writers to resist this call, even though its terms were very vague. But quite a few were in fact missing. Neither Thomas Mann nor Bernard Shaw nor H. G. Wells attended, though the first two were subsequently named to the twelve-man presidium. Upton Sinclair, considered the model writer-activist because of his candidacy in California on the Socialist ticket, did not respond. Among the French, Jules Romains and Montherlant stayed away in spite of blandishments. Georges Duhamel is reported to have said, "I cannot take part in a congress along with Gide, and with men who might, one day, be responsible for the death of my three sons." One wonders if the critic Lukacs, at that date in Moscow, was even invited. In addition to the organizers listed above, here are a few names from the 230 delegates from thirty-eight countries who did attend: E. M. Forster and Aldous Huxley from England; Heinrich Mann, Bertolt Brecht, Anna Seghers, Johannes Becher, and Lion Feuchtwanger from Germany—all in exile; Michael Gold and Waldo Frank fresh from the congress in New York which had organized the League of American Writers and abolished the earlier John Reed clubs; Pasternak, Babel, Ehrenburg, Alexsei Tolstoy from the U.S.S.R. Though Valle-Inclán from Spain had been put on the program, he did not appear. French writers were legion. In addition to Gide,

Malraux, and Aragon, the following made speeches of some magnitude or significance: Benda, Guéhenno, Cassou, Chamson, Nizan, Jean-Richard Bloch, Tzara, and Eluard (representing Breton and the Surrealists).

The style of the Congress, judging by newspaper accounts and photographs, was that of a popular assembly prepared to honor its culture heroes, responding generously to the spoken word and impatient with any profound content. The newspapers, naturally, loved the anecdotal and sartorial side. Both Huxley and Mike Gold wore funny hats. Everyone on the platform kept his jacket on in spite of the heat. But the *Dépêche de Toulouse* reported that "Monsieur Vaillant-Couturier walked up to give his speech in a beach costume with a huge scarf tied in a bow around his neck." Delegations of children were brought up in track suits and bare feet to present flowers to foreign writers. Books were sold in the foyer, with authors to autograph them. People sketched the speakers. Photographers prowled. The talks went on and on. Enormous quantities of beer were drunk. The management of the Mutualité had to turn the lights off to drive away the knots of people arguing late into the night. The main headquarters for the celebrities and insiders was the Closerie des Lilas, floating on its fifty-year history of banquets and literary battles. Most reporters enjoyed themselves and shared the excitement. "A scene of high drama to which the modern world, hungry for enchantments, is now treating itself . . . And what a crowd! The young and the not so young, activists, partisans, outlandish types, and girlfriends with their faces craftily painted in ocher and carmine, their fingernails tinted every color in the book."

Aragon and Nizan's monthly *Commune*—which was in a position to be considered the horse's mouth—announced that all the speeches would be collected and published in a book. Many duller and less significant works burden our shelves, but somewhere an editor showed the wisdom not to feel bound by the announcement. The principal speeches can be found scattered through various reviews and the sequence reconstructed. After Benda's rash challenge to materialism almost everyone closed ranks and found continuity and harmony in all directions. Writing in New York about what he called the "Writers' International," Malcolm Cowley had this to say in *The New Republic* after digesting the texts: ". . . nobody spoke in favor of abandoning 'bourgeois culture' in favor of proletarian culture." He was generally right, but he can't have read everything.

Saturday night was the main event. It must have been worth standing in line to pay the three-franc entry fee to hear what the heavyweights would say about "the individual." Gide led off. He had made an address the previous October called "Literature and Revolution" in which he met socialist realism head-on by calling for something more to his liking: "Communist individualism." It must have been hard for him now to raise the ante. Nevertheless, he produced a long, carefully thought-out speech and was followed by Malraux, Ehrenburg, and Max Brod, Kafka's friend and executor, who spoke of the individual as a pure dream in a world defined by society and reason.

The next three days became very confused. The order of speakers had to be changed; squabbles arose about who should be allowed to "intervene" and for how long. On Sunday afternoon, humanism was the announced subject. Brecht got three minutes, whereas he was supposed to have had fifteen Friday night on "Cultural Heritage." Every topic began to sound the same. Sunday night was "Nation and Culture." Chamson gave a solid talk. Barbusse scuttled it with his leaden echoes. Mike Gold shook out his long hair and recited his working-class background. Except for a few tense exchanges, things sank into the doldrums until the closing session Tuesday night. Apparently, the audience never failed to fill the hall. The organizers were very efficient. On the final evening came the most vivid moment of all. Pasternak had been brought to Paris on the last day, under duress and under guard. His name was not in the program. Kozloff had insisted on his presence. His entrance into the Palais de la Mutualité produced a standing ovation. Here is the account carried in Barbusse's *Monde:* its bad faith makes one wince. "In spite of an illness from which he has been suffering for two months, the great Soviet lyric poet insisted on attending the Congress. He recited two poems, beautiful examples of the blossoming of the new socialist realism." No one else had the courage or the imagination to read anything but a prepared speech. Pasternak made his short preliminary remarks in French.

> I wish to speak here of poetry, and not of sickness. Poetry will always exist down in the grass; it will always be necessary to bend down to perceive it; it will always be too simple a thing to discuss in meetings. It will remain the organic function of a happy creature, overflowing with the felicity of language, tensed in the birthright of his heart, forever aware of his mission. The more happy men are, the easier it will be to find artists.

It is difficult to imagine the tone of the last sentence. One of the poems he recited (with Malraux translating) was "So It Begins," about children growing up. It ends, "So poetry sets them on their way." Without that instant of light and life, the Congress might have shriveled up and blown away.

If Pasternak gave literature back to the Congress in the form of poetry, it was the dissidents and the hotheads that gave it life. Obviously the organizers wanted to show a united front, both to the intellectuals they were trying to galvanize into action and to the forces of Fascism that were marching all over Europe. Malcontents who doubted the purposes or the integrity of the Congress were not welcome, and in general they were maneuvered into the background. Since texts of the announced speeches had to be sent to the secretariat of the Congress in advance in order to allow for preparation of press releases, summaries, and in some cases translations, the organizing committee could usually anticipate undesirable speakers. For example, the Czech delegate and poet, Vítězslav Nezval, waited his turn for two days in the wings and suddenly discovered the Congress was over. He had planned to greet the gathering in the name of both the left front and the literary avant-garde of Czechoslovakia, and to go on to condemn both proletarian literature and socialist realism. He was also one of those responsible for inviting the two Surrealists, Breton and Eluard, to Prague two months earlier for a series of literary-political manifestations outside Party sponsorship. This carries us into another story.

2

The political vagaries of Surrealism constitute one of the most fascinating case histories of intellectual gymnastics and conscience-searching in the thirties. The chronicle has now been filled out in considerable detail, but usually in such a way as to detach the political needle-threadings from literary activity, or to treat the politics as an inopportune and marginal pastime that merely distracted from the aesthetic concerns of the movement. Many people are involved, but only Breton remains squarely in the center of the picture. Rudely telescoped, the story runs like this.

Launched ambitiously in 1924–25 with a manifesto and a review called *La Révolution Surréaliste*, the Surrealist movement began as an extraordinary amalgam of generalized poetics and semi-scientific ex-

periments in altered states of consciousness. The Surrealists were also among the first French intellectuals to read Freud attentively. Almost immediately, however, a series of personal and historic circumstances carried the Surrealists toward Marxism and the Communist Party. It mattered little that the Party was in a very dry season, holding out few rewards to artists and intellectuals. Early in 1927 the five principal Surrealists joined the Party and accepted assignment to local cells. After the expulsion of Trotsky and Zinoviev in November of the same year, they had some second thoughts but did not go away. From 1927 to 1933 the Surrealists carried on a steady guerrilla war with the Party while insisting on their right to participate in events and organizations designed to give some shape and direction to artists on the left. Supported in varying ways by Péret, Eluard, and Crevel, Breton acted in a headstrong fashion. He reaffirmed his faith in Freud. He refused to give automatic obedience to directives from Moscow. He defended Trotsky. He would not accept any policies that compromised artistic freedom and the right to experiment in new forms of expression. The Surrealists and their numerous publications represented a challenge to the steady movement of intellectuals toward the Party after 1932. That year, after a lengthy period of despicable, two-faced maneuvers, Aragon abandoned the Surrealists completely for Communism. In 1933 the Surrealists intrepidly attacked Barbusse and Romain Rolland for organizing the Amsterdam-Pleyel movement against war, calling it a betrayal of class warfare. They censured Ehrenburg and the editorial pages of *L'Humanité*. For these accumulated reasons and others, Breton and Eluard were finally expelled from the Communist-controlled Association of Revolutionary Artists and Writers. February 1934 sparked them back to life along with everyone else. Breton was one of the principal sponsors of the first major response to the riots among intellectuals. Dated February 10, "Appel à la lutte" ("Battle Call") calls for unity of action against Fascism and for a general strike. In an important lecture that June in Brussels, he reviewed the whole social evolution of Surrealism and reaffirmed its materialist position by stating: "The liberation of the spirit requires as a prior condition the liberation of man himself." At this point, Surrealism had reached the peak of its activity and its international influence. After the highly successful visit to Prague in April 1935, Breton and Eluard accepted an invitation to the Canary Islands and, in the spring of 1936, to London for a huge Surrealist exhibit with lectures and related events.

When announcements went out for the 1935 Writers' Congress, the Surrealists expressed doubt about the need to defend bourgeois culture and demanded that the agenda include a discussion of "the right to pursue, in literature and in art, new means of expression." They constituted too important a group to be excluded from the Congress. Yet not a single Surrealist appeared in the printed program, even though René Crevel was an active member of the organizing committee for the Congress. Everything was obviously up in the air when, a week before the Congress opened, André Breton recognized Ilya Ehrenburg in the street. An opponent of the Soviets in 1917, Ehrenburg had changed his mind and had spent most of the last twenty years in Paris writing for L'Humanité and representing Soviet literature and culture. In 1934 he published a collection of essays on the French literary scene, praising Gide and Malraux, criticizing Mauriac and Morand, and saving his most concentrated vitriol for the Surrealists.

> I don't know if they are really sick or if they are only faking their craziness . . . These young phosphorescents, wound up in theories of onanism and the philosophy of exhibitionism, playact at being the zealots of revolutionary intransigence and proletarian honesty . . . They have their pastimes. For example, they study pederasty and dreams.

He worked several pages out of it. Now, if there is one prejudice Breton imposed on the group around him, it was the exclusion of homosexuals. (Only Crevel was tolerated.) Fairly early in the game the Surrealists had developed a somewhat violent strain and believed in what they called "correction." Breton, seeing their slanderer there in the street, simply raised his arm and slapped him—twice, according to some accounts. If Breton knew that Ehrenburg was head of the Soviet delegation to the Congress, it did not deter him. Ehrenburg retaliated in the organizing committee: the Surrealists must be excluded. The behind-the-scene maneuvers were long and painful, lasting until after the Congress had opened. Crevel was both absolutely loyal to Breton and a dedicated Party worker. Jean Cassou told how Crevel persuaded him to go to the Closerie des Lilas one night after the evening session in order to convince Ehrenburg that Breton must be allowed to speak. Because the organizing committee wanted to maintain unity at all costs, Ehrenburg had a simple and totally effective answer. If Breton spoke, the Soviet delegation would

walk out. Meanwhile, a kind of compromise had been reached: Eluard would read Breton's speech at the Monday evening session.*

Eluard was finally given the platform after midnight following a long talk on dreams by Tzara that had sent most of the audience home. Breton had written an effective and scandalous speech which trampled resolutely across all the guidelines set up by the context and the program of the Congress. He denounced the Franco-Soviet pact and any cultural rapprochement, the new patriotic face of *L'Humanité*, the Popular Front ideology, and the growing tendency to condemn all German thought. Eluard apparently read the text well, but another incident was already developing which contributed to the neglect of the strong Surrealist attack on the Congress as a sellout to the existing order.

Starting back during Tzara's talk, voices had been raised in the auditorium clamoring for a discussion of Victor Serge. For those that knew the tale, this was a more explosive situation than the Surrealist dispute. Journalists were watching alertly. The protests came from a group of non-Communist Marxists and Trotskyites, two of whom had been scheduled to speak only as the result of desperate personal appeals to Malraux and Gide. It was very late. The burly *service d'ordre* of ushers provided by the Communists left their positions and converged on the troublemakers while Eluard was reading Breton's speech. The Serge advocates had no objection to that text, but they wanted their turn. The most obstreperous of them, Henri Poulaille, finally walked out, taking the bouncers with him and ripping his photograph out of the display case on his way through the foyer. Most of the newspapers picked up these rumblings; not many of them were represented the next afternoon in a smaller hall when Magdeleine Paz was finally given the floor. Gide, Malraux, and Barbusse sat on the platform with knitted brows (as a photograph shows) while she stood to speak. Citing the printed program, she affirmed the need to discuss a specific case involving freedom of expression, direct and indirect censorship, and the dignity of the writer. Serge, French-language writer of Russian parents, Belgian birth, and revolutionary

* This kind of personal-ideological dilemma takes its toll, particularly on the less thick-skinned. Crevel was besieged by a number of personal problems, and he had just learned that he had only a short time to live because of a pulmonary condition. Later, during the night of Cassou's useless appeal to Ehrenburg, Crevel committed suicide. His medical papers were found in his pocket. He had a speech all written out for delivery. There was short tribute at the next day's meeting.

convictions, in 1919 had gone to Russia, where he was admitted to the Party and given important responsibilities in organizing and administering the Third International. His novels and historical works describing the early years of the Revolution in Russia were known to French-speaking intellectuals. In 1927 he was excluded from the Party and imprisoned without trial for several weeks on suspicion of Trotskyite sympathies. Arrested again in 1933, he was deported without trial to Orenburg in the Urals, where he was confined with no resources, material or intellectual, for three years. He could write but not send his manuscripts abroad. He and his wife were both in precarious health.

Magdeleine Paz's speech ran close to an hour, with an impassioned coda: "Right now, he's paying the price. While we sit here at a congress convoked to defend the integrity of thought, out there, on the other side of the Urals, a thinking man is trying to remain calm and hold on to his hope in the revolution." Three Russians, including Ehrenburg, answered her charges by saying Citizen Kibalchich (his family name) had bitten the hand that fed him; they knew nothing about the French writer Victor Serge. The Belgian delegate angrily retorted that they lied, that in fact Serge had translated many Russian texts of the Revolution, including the poetry of one of the Soviet delegates who had just spoken and who would otherwise be unknown in France. Unfortunately, no one made a motion or proposed any specific action. These particular speeches are the hardest of all to find. Anna Seghers provided an escape route by complaining that if the Congress was going to talk about individual cases, why didn't they bring up all the imprisoned German writers? Gide had been immensely nervous throughout the discussion, scribbling draft after draft of a closing statement. What he finally said expressed concern for the security of the Soviet Union and confidence in its actions.

3

It is no easy matter to catch the spirit and specifics of a congress that lasted five days and must have generated upward of a third of a million words, now dispersed. In order to sample those speeches, I shall reduce them to six and quote a key passage from each with a minimum of comment. Each of these six men had wide experience in polemical writing and intellectual maneuvering. In

effect, they form three loose pairs of writers; each pair displays an obvious link and an equally significant contrast. It is the contrasts that I hope will make themselves clear. The first pair is the Soviet delegate Panferov and Aragon, both important and active Party members committed to the doctrine of socialist realism officially adopted a year earlier. Panferov spoke at the opening session and concluded his talk thus:

> Clearly, each one of our artists follows his own path, retains his own style and individuality. But all of us move toward the position of socialist realism, toward creating a literature such as has never existed in the history of humanity . . .
> What then is socialist realism?
> Socialist realism, according to the statutes of our writers [union] is the essential method of Soviet literary art and literary criticism. It requires of the artist that he provide an image that conforms to truth, a concrete historic image of reality in its revolutionary development. This truth and this precision in representing reality must ally themselves with the problem of the ideological reshaping and the education of workers in the spirit of socialism.

Aragon talked on the same subject at the very last session. He was also answering Breton's speech, which had been read the previous day. His tone was fiery, almost gaudy.

> Socialist realism or revolutionary romanticism? Which shall we choose? Realism is the only way to approach the world before us. We must choose the light, and reject the dark. It is a matter of finding our way back, precisely, to the side of the light, and to neglect the shadows . . .

Here he quoted Lautréamont's *Poésies*, stating that the passage applies perfectly to the Surrealists:

> "There are debased writers, dangerous jokers, two-bit fools, solemn mystifiers, veritable lunatics, who deserve to be in an asylum. Their cretin heads, which must have a hole in them somewhere, dream up gigantic monsters which come down to earth instead of drifting away."

At the end:

> Who has shouted loudest for freedom of expression? Marinetti —and look where it has led him: to Fascism. We have nothing to

hide, and that is why we welcome as a joyful expression the new slogan of Soviet literature: Soviet realism. Culture is no longer something for just a handful of people.

Aragon was a very valuable property. As time went on, he seemed to be able to get away with anything.

The next pair of speakers had no use for socialist realism and the Party line. Breton loved to rumble his rhetoric. He was also hopping mad as he wrote. One hopes Eluard read the text as if it were a sermon. "Beware of the perils of too great faith!" Breton said of Comintern directives backing up the Franco-Soviet pact. After an attack on those who took Rimbaud's name in vain as a political rather than a poetic revolutionary, he concludes:

> We maintain that the activity of interpreting the world must go on and remain linked to the activity of transforming the world . . . The movement of authentic contemporary poets toward a poetry of propaganda . . . signifies a negation of the very factors which historically determine the nature of poetry. To defend culture means above all to take in hand the cause of whatever stands up under serious materialist analysis, of what is viable and will continue to bear fruit. Stereotype declarations against Fascism and war will not ever succeed in liberating the spirit from its shackles, old and new . . . "Transform the world," said Marx; "Change life," said Rimbaud. Those two watchwords are one and the same to us.

Allusions to Marx's *Theses on Feuerbach* formed one of the refrains of the Congress; Breton made it clear that there should be no compromise with bourgeois values and that Popular Front politics meant just that.

I pair Breton's intransigence with one of the most straightforward speeches in the whole five days. Gaetano Salvemini was an Italian historian and Socialist deputy whom Mussolini had exiled and stripped of his citizenship. What Salvemini said sounds very elementary. But remember: the atmosphere of the Congress was such that almost every speaker began with the symbolic greeting "Comrades." Salvemini had been fighting Fascism with word and deed probably longer than anyone else attending the Congress.

> If you give the name "Fascism" to all bourgeois societies; if you close your eyes to the fact that Fascism means bourgeois society with something added, that is, a bourgeois society which has suppressed the very possibility of cultural freedom; if you apply

the same treatment to two different forms of society—then you run the risk of allowing in non-Fascist societies the destruction of fragments of intellectual liberty that are not sufficient but that nevertheless have great value. We do not greatly appreciate light and air as long as we have them. To understand their value, we have to lose them. But the day we lose our freedoms, we shall not easily win them back.

Confronted by Fascist-type bourgeois societies, we Italians and Germans have had to take a position of radical negation. In non-Fascist bourgeois societies, radical nihilism is a dangerous thing. Do not scorn your freedoms; rather, defend them stubbornly, while declaring them inadequate and struggling to develop them.

The freedom to create is constrained in non-Fascist bourgeois societies. In Fascist-type bourgeois societies it is totally suppressed. It is partially suppressed in Soviet Russia. Trotsky's *History of the Russian Revolution* cannot be read in Russia. It is in Russia that Victor Serge is held prisoner . . .

The sudden sucking in of breath at those naked words must have been audible for some distance. Anti-Fascism could take many forms, but the Congress did its best to disguise that fact. Salvemini was later appointed lecturer in history at Harvard—over President Lowell's objections.

The last pair is Gide and Malraux. Both spoke Saturday night, on the individual. Picking up a sentence out of the preface of Malraux's novel *Days of Wrath*, Gide developed a history of French literature in which it is Diderot and Rousseau who, after the privileged forms of classicism, brought back the turbulence and the popular feeling missing since Rabelais. Admirable as it has been, the culture handed on by bourgeois society remains artificial, something under glass.

Today in the capitalist society we still inhabit, it seems to me that the only worthwhile literature is a literature of opposition.

For the bourgeois writer, to have a true communion with his class is an impossibility. To have a communion with the people . . . Well, I'll have to say that it is equally impossible as long as the people remain what they are today, as long as they are not what they can and must become, what they will become if we do our part.*

. . . Only the enemies of Communism can see it as a desire for uniformity. What we expect of it, and what the Soviet Union

* At this point the audience apparently rose and applauded for a long interval. The circumstances make it impossible to determine whether the reaction was spontaneous or induced.

is beginning to show us after a difficult period of struggles and temporary constraints in expectation of greater freedom, is a condition of society which would permit the fullest development of each man, the bringing forth and application of all his potentialities. In our sad Western world, as I have said, we still fall far short of the mark. For a time social questions threaten to encroach on all others —not that they strike us as more interesting than the others—but because the condition of the culture depends closely on the state of the society. It is a devotion to culture that leads us to say: As long as our society remains what it is, our first concern will be to change it.

Gide must have been in good form. He would soon regret and virtually eat his words. Deep in politics and polemic, he wrote very little during 1935 in his *Journal*. There is only one page on the Congress, which must have devoured three full weeks of his life. He tells how he greeted one dark and richly robed lady by saying he was happy to see Greece represented. *"Moi,"* she replied with annoyance, *"c'est l'Inde."*

Malraux delivered the only formal speech that did not follow a written text. Afterward the press bureau reproduced a single page of notes from which he had talked for close to an hour. He numbered eleven points, one a quotation from the preface to *Days of Wrath,* each a potential speech by itself. Number 8:

> Fascist and Communist communions. Reply to Gide. There is a communion possible as of now with the people, not in its nature (there can never be a communion in nature) but in its finality, in this case meaning in its will to revolution. Every real communion implies a finality.

The most striking passage comes in point 3. Before him sat a vast assemblage of writers whose literary existence depended on their establishing a name and attracting readers, and who had erected for themselves the elaborate stage of an international congress. Of all of them, Malraux was the writer who most appeared to move through history as if his life were a dramatic extension of his literary work— or vice versa. Here is what he said, according to his notes:

> Individualism arises out of the fact that man finds pleasure in looking upon himself as someone else [*un autre*], in living biographically. The humanism we desire to create, and which displays its earlier stages in the line of thought that connects Voltaire to

Marx, requires above all a true awareness of man, a new stock-taking.
*To be a man means, for each of us, to reduce to a minimum
the actor within him.*
[*Etre un homme, c'est réduire au minimum, pour chacun, sa
part de comédie.*]

The only proper response to that statement by one of the principal
organizers would have been the immediate disbanding of the Con-
gress. One wonders what note of irony—or bad faith—tinges the last
sentence.

4

It is high time (as Aragon snorted, quoting Boileau in support
of socialist realism) "to call a cat a cat." This was one of the most
thoroughly rigged and steamrollered assemblages ever perpetrated
on the face of Western literature in the name of culture and free-
dom. That estimate does not diminish but rather amplifies its sig-
nificance as a historical and intellectual event. Only a few rightist
critics and Fascist rags talked of funds from Moscow and Red writers.
There sat some of Europe's most distinguished men of letters pre-
siding over a meeting that systematically swept into a corner any
dissent from the prevailing opinion that the true revolutionary spirit
belonged to the Soviet government. Did they know better? Could
they have known better? Must we call into question the good faith
of all organizers and participants? These are sore questions. Only
Alain got off the bandwagon. In exchanges I had with them thirty-
five years after the fact, both Aragon and Malraux reaffirmed the genu-
inely anti-Fascist nature of the Congress, accepted their role in it
without regret, and rejected any more ominous interpretation of these
events, described by Malraux as an "impassioned confusion." Yet one
wonders if Salvemini, the writer present who had suffered most for
his opposition to Fascism, would have been allowed to deliver his
speech had he not been a friend of Gide's. The machinery devoured
Nezval, Breton, and Brecht, and kept the Serge affair almost out of
sight. The two Communist publications (*Commune; Monde*) pur-
porting to give a full account of the proceedings and to reproduce the
important speeches gave only a few slanted lines to Benda, Breton,
Salvemini, and Paz. The texts of the last three were too honest and
too defiant of the reigning Stalinist ideology to appear anywhere
except in a small left-opposition monthly called *Les Humbles.* Sev-

eral sponsors in retrospect attributed the success of the Congress to the genius of Willi Münzenberg, a wealthy and powerful member of the Central Committee of the German Communist Party. He lived in France and was skilled in Popular Front tactics. He probably played a role behind the scenes, but the strains and stresses go far deeper. In Gombrowicz's crazily apt theater piece, *Operetta,* the militant revolutionary is carried into battle and on to total power on the shoulders of a willing—and obsessively vomiting—professor.

Outwardly the consequences of the Congress were pedestrian. A final declaration was adopted, an international association formed, and an executive committee with national committees appointed— all by the organizing committee, without vote or discussion. Written or at least carefully edited by Gide himself, the declaration made no waves. It asked for more translations, more travel opportunities for writers, and an international literary prize. It declared that the executive committee was prepared "to fight on its own ground, namely culture, against war, Fascism, and generally against every menace to civilization." A few days after the close of the Congress, Gide wrote the Soviet ambassador about Victor Serge and followed through with a formal visit to the embassy. Serge was finally released in 1936, thanks not to the discussions at the Congress or to Gide's appeal but (Serge writes in his memoirs) to Romain Rolland's personal intervention with Stalin. A second congress was held in Spain in the summer of 1936. Given the situation, not much could come of it. At least it provided the occasion for Malraux to meet Hemingway; they divided up the Spanish War for their private novel-writing contest.

The real effects of the Congress lie elsewhere. It was perfectly timed and designed to consolidate the formation of the intellectual Popular Front, without which the political Popular Front would have had a less euphoric reception in the socialist and radical press. The congress called in New York one month before the French Congress had served the same purpose, apparently responding to the same directives: to politicize the independent, bourgeois *homme des lettres* in terms of anti-Fascism and "defense of culture." Gide's case is almost classic. Benda had written ten years earlier in *The Treason of the Intellectuals:* "Essentially ours will have been the century of the intellectual organization of political hatreds." By 1935 politics was no longer a pistol shot disrupting the literary concert; it seemed to have become the concert itself.

This development could not be traced to any spread of the idea,

dear to Herzen, that the intelligentsia was part of the proletariat because it was exploited, like the working class, by traditional powers. The political drive to rediscover the people had somehow fused with the need to introduce an aesthetic attitude into daily life—a tendency almost universal in Freud, Dada, Surrealism, the Bauhaus, and the personal-journal form of writing to which Gide was dedicated. It was in 1935 that the neglected American writer Joseph Freeman explained and defended proletarian literature with this bald statement, which neatly answers Benda: "The dichotomy between poetry and politics had vanished, and art and life were fused." It begins to sound uncannily like Huysmans or Wilde stood on his head. But now there was a social cause to absorb the deep aesthetic drive toward adventure discernible in the anarchist dalliance of many artists before 1914.

The evolution of the writer can be picked out neatly in the contrast between two almost identical surveys, the one made in 1919 by the editors of the pre-Dada review, *Littérature*, the other made by the editors of the Party-controlled *Commune* in 1934. *Littérature* asked: "Why do you write?" Almost every reply was brief and facetious and implied that there probably was no purpose.

Valéry: Out of weakness.

Paulhan: I am touched that you should want my reasons, but after all, I write very little. Your reproach scarcely concerns me.

Gide: You will be able to classify writers according to whether their answers begin with "In order to," "Out of," or "Because" . . . In my case I write because I have an excellent pen and in order to be read by you . . . But I never contribute to symposia.

Gide declined to contribute to the later survey; yet it was he who had suggested rephrasing the original question to read: "For whom do you write?" Aragon was responsible for both questionnaires. In *Commune* he sifted the responses and added his own editorial comments. This time the answers were serious, long, partisan, far less quotable. Céline rants for a page on the biological impossibility of talking about the status of "writer." Romain Rolland says he writes "for those in the avant-garde of the army on the march." Maublanc wants to call himself a bourgeois revolutionary, but that way, "I run the risk of being suspect to both bourgeois and revolutionaries." No one tries to wisecrack or question the question. Aragon hectored everyone, telling them bluntly to take sides (*"Prenez parti!"*). He

obviously felt he could prick their bad conscience as members of an intellectual elite. His summation divided the hundred-odd replies into three categories: writing for myself, for my class, or for everyone. The true way needs no signs. He particularly denounced those who separated their political or social activity from their literary art. One of the few replies he did not try to rebutt came from Roger Martin du Gard and reverts to the incisive style of the earlier survey: "I see that the world is full of partisans. Too bad: I would like to continue to write for those not yet infected with the contagion of fanaticism." For Aragon, the questionnaire produced less a sampling of attitudes than a device for manipulating or ridiculing them. He was a man of many means.

The tidal movement toward intellectual commitment was evident to the alert minds of that period. In the left-Catholic monthly, *Esprit*, Emmanuel Mounier lamented the stampede toward Communism and compared it to "finding the fountain of youth." What must have been more difficult to detect—and we have by no means freed ourselves from these pitfalls today—is the degree to which the ideological migration of the thirties, and the Writers' Congress in particular, pivoted on a set of heavily exploited confusions or equivocations. Revolution, culture, humanism, fraternity—these giddy terms were all rolled together into the great cause of the middle and late thirties: *anti-Fascism*. Unfortunately, the campaign came late and rarely found tactics more effective than committees, meetings, and tracts. (Gide's and Malraux's trip in January 1934 to Berlin to see Goebbels about the liberation of the Bulgarian Dimitrov appeared to have some effect, even though they had to write a letter because Goebbels would not receive them. Dimitrov, already acquitted by a German court of charges connecting him with the Reichstag fire, was released six weeks later.) However, it is the timing of these events that makes them both ironic and tragic. Comintern policy shifted just in time to swallow the anti-Fascist cause almost whole. The result was a fundamentally bankrupt ideology: it opposed Hitler with a kind of militant pacifism when only resolute force could have stopped him, and it gave unlimited credit to the Soviet government at the moment when the Stalinist freeze had hardened and the massive purges and trials were beginning. Possibly none of us would have shown any better judgment. But in spite of vigorous protests from some of the participants, one cannot interpret these desperate years less harshly.

Events that followed the 1935 Congress make further revelations

about how literary figures recovered, or failed to recover, from the great lurch toward Popular Front politics. A year later, Gide visited Russia for six months at the invitation and expense of the Soviets. He contrived to see more than most official guests in spite of, or because of, the VIP treatment. *Back from the U.S.S.R.*, the book he published immediately after his return in 1936, was a bombshell. He had praise for the schools and for the gaiety of the young. His criticism was devastating: "I doubt that in any country today, even in Hitler's Germany, men's minds are . . . more constrained, more terrorized, more enslaved." And he could not bear the Soviet superiority complex. "It is the haughtiness of your bluff which made my loss of confidence, of admiration, of joy so painful and so complete." Of course, everyone snarled at Gide all over again, either for betrayal or for fickleness. This book must be read in conjunction with a later volume, published just before his death, of letters, speeches, and statements dating from 1932 to 1937. The title is perfect and wags its finger at the fashions of 1950: *Littérature engagée*. Read together, these documents form a coherent and moving record of a man's dedication and disillusionment. It is not the least of Gide's works, even though the accompanying play, *Robert, or the General Interest*, is worse than even his own low opinion of it. Gide's politics did not compromise him. But one must go over the whole course to grasp the scope of the story.

Until 1939, Aragon remained the Grand Inquisitor of the French left, increasingly so when he became co-editor with Paul Nizan of the daily *Ce Soir*. The Moscow trials produced no noticeable turmoil in his mind. His wrigglings to explain the thunderbolt of the Hitler-Stalin pact were despicable. The Occupation forced him to retire to patriotic poetry, underground publishing, and a new literary career after the war. There was no glimmer of de-Stalinization in his politics until the Czech crisis of 1968. But his talents as a novelist died hard. His late novels must be rated among his best. The 1935 Congress came a year after he had published the first of the novel series entitled *The Real World*, dedicated to his Russian wife, Elsa Triolet, "without whom I would have fallen silent." *Residential Quarter* appeared the next year. It reads like Balzac in reverse: proletarian in intent, bourgeois under the skin. His gift kept renewing itself. Communism was both a counterirritant and his private side bet. For this very reason, Aragon will be one of the most difficult of contemporary authors to insert into literary history.

After the disappointing novel, *Days of Wrath*, written in the heat of anti-Fascism that also produced the Congress, Malraux put together a group of volunteers and went off to fight with the Loyalists in Spain. He pulled a magnificent novel out of that experience at record speed in 1937: *Man's Hope* [*L'Espoir*]. The film of *L'Espoir* was made with the government's blessing while the war was still going on. Many of the conversations that fill the novel seem to come directly from the political wrangles and submissions that filled the period from 1934 to 1937, including Malraux's long stays in Russia. Yet politically the book conveys a profound irresoluteness beneath the sturdy anti-Fascism. Subsequently, without any dramatic episodes or major confrontations with old friends, Malraux drifted away from Communism and its outlying areas. After serving De Gaulle he died as one of the last great prophets of high humanistic culture.

Critics have generally neglected or mocked the political record of Surrealism under Breton's leadership. Yet compared to Gide, Aragon, and Malraux, he begins to look like an old walrus of intractable political sagacity. The Congress marks the period in which he was striving to reconcile Marxist materialism with the psychic insights of a whole tradition of visionaries. His best books, *Vases communicants* (*Communicating Vessels*) and *L'Amour fou* (*Crazy Love*), date from 1932 and 1937 respectively. Both display his stern, even haughty resolve to come to terms with some of the problems the Congress listed hopefully in its program and never broached. Just before World War II Breton traveled to Mexico to draft and publish a joint statement on politics and culture with Trotsky. He never gave up hope for a better world. He could resist the immense intellectual suasion of the Communist Party probably because he had organized and headed his own Surrealist party. Under pressure, Breton's political naïveté took the form of an uncompromisingly principled idealism. It served him better than the conciliatory maneuverings of the literary figures who led the Congress.

5

What then was this 1935 Writers' Congress that we should pick it over for so long? Wasn't it purely and simply a flop? It could be painted very easily as a monstrous machine for grinding out worthless copy. It had no effect on history or policy, and the principal side effects worked to the benefit of a militant party subservient to a ter-

roristic foreign state. Couldn't we forget the whole thing? Shouldn't we stick to our habits of examining individual careers and major works of art? I think not.

In the past, writers have organized themselves into different kinds of groups, from official academies to disgruntled café cliques. But unless one goes back to the great ecclesiastical councils, there have been no major attempts like the Paris Congress to mobilize all categories of writers around a political issue, however blurred, and in one convocation, however steamrollered. Even the Soviet writers' congresses which provided the precedent tended to avoid basic political discussion and to deal with the writer as the servant of the state. In their own terms, the Soviet congresses were fairly successful. Since it really had no terms, the Paris Congress neither succeeded nor failed. In a mammoth public ritual it consecrated the formation of an intellectual Popular Front. But that apparent fusion of forces and the euphoria it produced were based on a set of misunderstandings and ambiguities. "Revolution" remained as fuzzy as the "culture" they had met to defend. Since no question ever came to a vote, no terms or issues had to be clarified. The Congress probably tells us as much about the easily hoodwinked idealism, the opportunism, and the vanity of writers as about the political stresses of the era. For those who wanted to know, it was possible to find out about the terror that reigned in Soviet Russia as well as Hitler's Germany. But most people, including writers, turned their backs on at least part of the truth and accepted the dwindling options. Do you choose bourgeois-capitalist Fascism or Soviet Communism? Among the militant writers one rarely heard talk as fundamental and as illuminating as Salvemini's remarks on two kinds of bourgeoisie or Breton's refusal of any kind of political control of literature, even in the name of revolution.

The total event gives a better reading of the intellectual temperature in 1935 than, say, the Manifesto of the Intellectuals in 1898 that helped reopen the Dreyfus case. Yet ultimately the Congress makes one wonder if Valéry, who shunned politics, wasn't right after all. Gide reports something he said back in 1932: "Impossible to put together a united front to oppose the ruinous claims of the nationalists. He convinces me." But Gide was not finally convinced until five years later.

Right or wrong, many writers probably continue to believe that if they only band together, their corporate voice will be heard. The record of protest in the United States during the Vietnam War may

make us feel better. But in that national conflict writers were by no means out ahead of scientists and students. The lessons of the First International Congress of Writers for the Defense of Culture will not soon fade. If the literary heroes of 1935 could not band together effectively against totalitarianism in Germany—to say nothing of Soviet Russia—what can we hope for next time?

NOTE. I wish to thank Pierre Abraham, Louis Aragon, Jean Cassou, Louis Guilloux, and André Malraux for the information they provided in conversation and by letter. Another valuable source of documents is an extensive file of newspaper clippings and press releases concerning the Congress collected by Rose Adler and preserved in the Fonds Doucet in Paris. Most unidentified quotations in my text come from that file. I am grateful to François Chapon, the director of the Fonds Doucet, for having brought the file to my attention at a moment when my investigations had reached an impasse.

The Alphabet
and the Junkyard

First Flaubert:

> Work, meditate, meditate above all, condense your thought, you know that lovely fragments amount to nothing. Unity, unity is everything! A sense of the whole, that's what's missing in all our contemporaries, great and small. A thousand lovely spots, not a unified work. Tighten your style, make it supple as silk, strong as a coat of mail. Excuse the advice, but I would like to give you everything I desire for myself.
>
> [To Louise Colet, October 14, 1846]

> You speak of pearls. But pearls don't make the necklace; it's the string . . . Everything depends on the plan, the outline.
>
> [To the same, February 1, 1852]

When Maxime Du Camp published *Madame Bovary* in *La Revue de Paris*, stripped of certain passages he feared would be offensive, Flaubert angrily disowned the maimed work and called it a "collection of fragments." Over and over again, his letters and his practice

insist on a sense of the whole that excludes any gratuitousness or casualness in assembling the parts.

Yet this is the same author who kept an open file containing the dumbest platitudes he could grab out of the conversational environment; he merely lumped them together alphabetically without system or direction in the *Dictionary of Received Ideas*. The "novel" *Bouvard and Pécuchet* does not even have the alphabet to provide a semblance of structure. It relates the desultory tale of two middle-aged clerks, retired to the country, who bumble through the surrounding culture subject by ponderous subject. Each project ends in frustration or catastrophe, like their scheme to write a biography of the Duc d'Angoulême. They can no more reconcile the conflicting sources on the Duke's life than they can keep themselves informed about what goes on in their own eccentric household. Bouvard and Pécuchet are unable to fit the pieces of the world's puzzle together; they simply keep on picking up the next piece until it, too, falls from their clumsy fingers.

Eighty years later, Flaubert's caricature of unrestrained *libido sciendi* reappears in *Nausea*. Not only did Sartre have Roquentin despair of writing his biography of the Marquis de Rollebon; he also introduced the pastiche figure of the Autodidacte. This plodding inquirer pursues knowledge, not without plan as Bouvard and Pécuchet were willing to do, but rigorously and alphabetically, according to the arrangement of the municipal library of Boueville—the arrangement of the *Dictionary of Received Ideas*. But what kind of order is this on which to string the pearls of a culture?

Next Diderot: he looms large behind Flaubert and Sartre. Examined with any historical and philological acuity, Diderot's *Encyclopedia* reveals a very odd pedigree. Leland Thielemann states it succinctly:

> The fortunes of the encyclopedia may fairly be summed up as the history of semantic improvisations on a word coined by ignorance, dignified by classical authority, and transmitted by Christian theology to a scientific world of the eighteenth century which was already weary of all three.*

* From an unpublished article, "Circles of Perfection: Diderot and the Encyclopedic Theory from the Renaissance to the Enlightenment." I am grateful to Professor Thielemann for having made his article available to me.

What attracted Diderot and his friends to this dubious tradition was their grasp of the way an encyclopedia could embody their deep Leibnitzean faith that, in human knowledge as in nature, everything holds together, everything is linked in a great circle or chain. In the "Prospectus" (1750) Diderot's principal metaphors and phrases invoke the essential continuity of knowledge: "the systematic outline of human knowledge," "the tree of human knowledge," and "our obligation to Bacon." In the "Preliminary Discourse" (1751) D'Alembert writes of their intent in the *Encyclopedia* "to lay out . . . the order and continuity of human thought" and "to classify ideas in the most natural order." Four years later Diderot opens the article "Encyclopedia" by stating: "This term signifies the continuity of knowledge." He goes on to appeal to "the overall system" (*"le système général"*), an equivalent of the widely used seventeenth-century term "universal science." The great *Encyclopedia* would presumably replace the Christian cosmogony with a systematic order appropriate to the new dispensation of science.

Most of us have all too easily forgotten or refused to notice that instead of following any natural or scientific or systematic or even encyclopedic order, these stout eighteenth-century holists were swayed by expediency and a sense of the reader's convenience to adopt a perfectly arbitrary scheme. Their non-system was based on the alphabet and words in the French language. At the juncture we have come to call the Enlightenment, when one might expect to find a search for a new unity and coherence of the world and our knowledge of it to replace the waning structures of feudalism and Christianity, Diderot & Co. produced a thoroughgoing fragmentation of knowledge into unrelated entries arranged according to the spelling of presumably key terms. They did so in the name of ease of reference and retrieval. In the "Preliminary Discourse" D'Alembert had the embarrassing task of explaining how the editors could claim "to reconcile encyclopedic order with alphabetical order." He makes much of the systematic table of the branches of learning printed at the head of the first volume, of the scheme of generic classifications employed to place articles in that table, and of the numerous cross-references. But these secondary devices do not redeem the *Encyclopedia* from its capitulation to the arbitrariness and illogicality of one language's alphabet.

It is distressing to listen to Diderot justify his betrayal of his own principles.

We believe we had good reasons to follow alphabetical order in this work. It seemed to us more convenient and easy for our readers, who, if they wish to inform themselves on the meaning of a word, will find it more readily in an alphabetical dictionary than in any other . . . If we had dealt with each science separately in an extended treatment, following the order of ideas and not that of words, the form of this work would have been even less convenient for most of our readers, who would have had trouble finding anything in it. The encyclopedic order of the sciences and the arts would have benefited, and the encyclopedic order of words, or rather of the objects by which the sciences overlap and relate to one another, would have suffered infinitely.*

The reader's convenience carries all before it; order and articulation be damned. The bad faith of the last clause is appalling. There is no such thing as an "encyclopedic order of words." The expression seeks to legitimize a blatant contradiction in terms and to palm off the pure convention of the alphabet as a system of nature.

France's major eighteenth-century undertaking to survey and correlate human knowledge according to new principles of unity and order ironically and surprisingly turns out to be a great intellectual diaspora, a scattering of knowledge into fragmentary entries under the then current "denominations." Hugh Davidson's observation strikes home: "Scientific order is logical, natural, and *forbidding*; while alphabetical order is illogical, conventional, and *inviting*."† Convenience and speed of retrieval may represent a powerful principle of cultural entropy that we have not yet recognized and that continues to play a dominant role in our universe of computers.

A hundred and fifty years after Diderot we come upon another example of how the alphabet can invade and lay waste to a systematic and logical order. P. M. Roget had published his *Thesaurus* in 1852 by describing the overall topography of meanings projected by the language itself. This aerial map of English is one of the most revealing documents we have to tell us about the intellectual countryside we inhabit; it virtually diagrams the relationships of our words to our ideas, habits, and shared perceptions. Then, in the first two

* *Oeuvres Complètes*, ed. John Lough and Jacques Proust (Paris: Hermann, 1976), Vol. V, p. 93.

† "The Problem of Scientific Order Versus Alphabetic Order in the *Encyclopédie*," in Harold E. Pagliaro, ed., *Irrationalism in the Eighteenth Century* (Cleveland: Case Western Reserve University Press, 1972).

decades of this century, an American lexicographer, C. O. S. Mawson, recast Roget into an alphabetical format. Like Diderot he did so in the name of convenience for the reader, "above all if he is in a hurry." Nothing could be more inappropriate. Roget's great spectrum of words and meanings was hacked up into another list, and Mawson's "handy" version has now virtually driven out the original.

Once again a paradoxical and heavily ironic effect hovers over this event. Mawson was revising Roget's *Thesaurus* into a semblance of Flaubert's *Dictionary of Received Ideas* at the very moment when Sausurre was lecturing in Geneva how the amorphous domain of ideas comes into relation to the equally amorphous domain of human sounds. Language itself serves as intermediary, Saussure affirms, and illustrates his exposition with a figure that looks like two facing wave

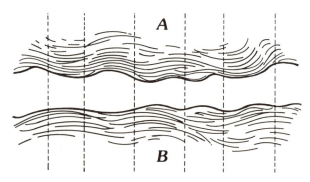

Ferdinand Saussure, diagram of "Linguistic Value." From *Cours de Linguistique* (1915)

patterns. A word or sign is an arbitrary form connecting A to B, and whose meaning arises primarily from its "value" (*"valeur"*)—that is, from its relative position in the double continuum of ideas and of sounds, represented horizontally in the diagram. Words carve conventional chunks of meaning and corresponding sound out of the two proximate series; the "value" or meaning of our words can be best measured by situating them within these series, by their difference from their immediate neighbors, and not by listing them as isolated items according to some other system. Roget's original *Thesaurus* is the closest we have come to a photograph of our language as a dual system, of the dynamic and arbitrary relation between our thinking and our phonic representation of it. Yet this scheme, too, has succumbed to the fragmenting power of the alphabet.

What is going on here? Is there a general force at work impelling the literary imagination to break up any system that might hold things together around a center? Do we seek out the fragment as more vivid and exciting than a unifying principle? Think for a moment of the significance Proust builds up around the tiny word *"pan"* (patch, panel) as an isolated, fleeting item of perception caught and magnetized by the artistic sensibility. Proust's "patch" bears a startling resemblance to Joyce's cry in the street—the brief awareness of a fleck of naked reality imprinting itself on our consciousness. The "patch" and the cry in the street finally lead, I believe, to the opening pages of Sartre's *Nausea*, where they congeal into a fascinating-repulsive object—the pebble. Roquentin's pebble has become so intensely and isolatedly itself, removed from any accommodating environment to give it a context, that it seems to assert a revolting existence of its own, to come alive in his hands.

Sartre's extreme case inspires me to advance a vest-pocket theory of the fragment and its hugely ambivalent status in modern literature and art.

Roquentin's sickening pebble is a rare case of the *absolute fragment*. It remains isolated and cannot find its way into any larger order of things. Its collapse into itself expresses Roquentin's sense of decay, formlessness, disorder, entropy. Its self-containment does not lead back to the circles of nature and knowledge. This appalling thing becomes a kind of fissure or vortex in the real through which the whole universe will leak out. Such absolute fragments occur very rarely, because they challenge everything, contaminate everything. Beckett is probably the only author who has probed further in this direction, laughing derisively all the while. The sixteen "sucking stones" that Molloy carries allude directly to Roquentin's pebble. Molloy seems to stave off his nausea through the elaborate and obsessive games he plays in transferring the stones from pocket to pocket. In both cases the smooth pieces of mineral imply a complete disintegration of the Great Chain of Being. There is no order to redeem them from their isolation.

The *implicate fragment* leads a totally different life. The archaeologist's potsherd illustrates this category most satisfactorily. From one odd piece of ancient pottery the astute investigator can restore not only the original vessel but also, with other sources of knowledge, a whole culture. In this perspective nothing stands alone, and the tiniest fragment of the universe breathes forth its secret connections to everything else. No item is so small or insignificant that it cannot

be a relic, a clue, a piece of the true cross. This is the universe of Swedenborg and Blake and Novalis, of Schelling and Baudelaire. The net of correspondences and implications weaves its way down into Mallarmé and Yeats and Stevens, even as it loses a steady metaphysical or transcendent basis. Yet the cultural yearning for universal analogy holds firm. Very early, Coleridge referred to this sense of things in his description of why the conversation of a superior mind impresses us, even on a trivial subject.

> It is the unpremeditated and evidently habitual arrangement of his words, grounded on the habit of foreseeing, in each integral part, or (more plainly) in every sentence, the whole that he then intends to communicate. However irregular and desultory his talk, there is method in the fragments.
>
> ["On Method," *The Friend*, Essay IV]

However, the real appeal of the fragment in the two centuries since Diderot's anti-encyclopedia lies in its ambiguity. This double orientation emerges most immediately in the ethos of Cubism. A detached ear or a floating mustache, one table leg or a few disembodied guitar frets, the lopped letters JOU—these scraps of everyday life drift about and withdraw into themselves as if they had lost their bearings and *raison d'être*. Yet at the same time each familiar detail shouts its incipient relation to everything else in the composition and in the world at large. The lines and planes of Cubist design both isolate and connect the everyday motifs they manipulate. The *ambiguous fragment* contrives to be both absolute and implicate. The most extended instance is probably Marcel's scrutiny of Albertine's behavior in the later volumes of *Remembrance of Things Past*. Her impulsive, or calculated, or casual, or perhaps meaningless actions will not fit together into a pattern that Marcel can recognize and categorize. Albertine is an uncrackable enigma, perhaps a cipher. Since he yearns for an order that refuses to declare itself in Albertine's acts, Marcel wears himself out in hypotheses and investigations that express his faith in the coherence and continuity of human character. There must be an explanation, yet he cannot find it.

The intellectual activity Diderot refers to as *libertinage* (freethinking, debauchery) in the opening sentences of *Rameau's Nephew* rests squarely on this response to the fragment as ambiguous—both isolated and implicated. Baudelaire developed Diderot's attitude into the endemic activity of the dandy: *flâner* (to stroll about, to saunter).

The Surrealists in their prose narratives of city promenades refined *flânerie* into fine art, whose concrete aesthetic reward took the form of an *objet trouvé* (see Breton's *L'Amour fou*). Walter Benjamin gathers up many of these strands in his essays on Baudelaire, and in his very special use of quotations both as disconcerting scraps obstructing his own discourse and as the elements of a montage. The great master of the ambiguous fragment is of course the other Marcel: Marcel Duchamp, whose "works" or "jokes" flutter on the frontier between meaninglessness and deep metaphysical significance.

More than any other art, film has exploited the fragment. Kuleshov and Pudovkin demonstrated that they could assemble empty isolated shots into sequences that have unity and meaning. Eisenstein referred to cinema as "fragments standing in a row," and all his writings about montage insist on a dialectic of fragmentary shots played against one another. The sense of the fragment has bestowed a new openness of form on the arts which combines a refusal of traditional orders, deliberate ambivalence of meaning, acceptance of obscurity, comic playfulness, and deep self-irony.

Thus the fragment, which would first appear to be a mode of anti-structure, itself shapes the way we perceive the world and recast it into works of art. The most striking demonstration of that statement may be simply to quote the three principal modernist poets in English. Because things won't fit together, all three poets reach a point at which they allude affirmatively, even affectionately, to an ethos of the junkyard. They appear satisfied to accumulate objects and words and ideas simply tossed together without rhyme or reason. In "The Circus Animals' Desertion," Yeats, trying to find a central self beyond successive personae, makes his ultimate appeal to "the foul rag-and-bone shop of the heart." In an early draft of *Canto II*, Pound twits the "art-form" of his Sordello: "The modern world/ Needs such a rag-bag to stuff all its thoughts in." And Eliot closes *The Waste Land* with a terse description of its genre and form: "These fragments I have shored against my ruins."

Perhaps we have come to fear an overarching unity more than we yearn for one. That might explain why many modern artists turn readily to the alphabet, the junkyard, *l'objet trouvé*, and montage as acceptable and even comforting orders.*

* Roland Barthes has some pertinent remarks about Michel Butor's *Mobile*, alphabetical order, and *"le degré zéro des classements"* in "Literature and Discontinuity," in *Critical Essays* (New York, 1972).

The D-S Expedition

1

Let's call it the D-S expedition. Between 1915 and about 1947 an unruly group of writers and painters made a collective attempt to reach a new territory of mind. They said that they wanted a revolution and that they were ready to leave literature and art behind. They were far from indifferent to adventure and glory. History tells the story of other great fiascoes—the Crusades, the utopian settlements of the last century. The D-S expedition overturned no governments and never reached the people. Since it never really got under way, it could not leave anything far behind. Nevertheless, the events are very real and they are ours.

Or call it Dada and Surrealism. In any case, the cultural police have now herded those rowdy crowds back onto the sidewalks of literature and art. It's all firmly under control. Today, in the top class of French *lycées*, the works of André Breton are listed as rec-

ommended reading. American universities offer courses on the literature of Dada and Surrealism. A new book on some aspect of the D-S expedition seems to appear every few months. Was the expedition, after all, a success?

Purists insist on a careful discrimination between Dada and Surrealism as different or even opposed movements. I have been taking sightings and soundings on them for many years and cannot find a more satisfactory distinction between the two than straight chronology. The first six years or so, from 1915 to about 1921, belong to Dada. Duchamp and Picabia rocked New York during World War I. In Zurich, Hugo Ball and his friend Richard Huelsenbeck stumbled on the unbeatable nonsense name that made a dozen reputations, especially Tristan Tzara's. The biggest and socially most significant eruption of Dada took place in Berlin at the end of the war; it has been sadly neglected. The two big Paris seasons of 1920 and 1921 replayed —with a few adaptations—the two Zurich seasons of 1916 and 1917. Then, for twenty years, Surrealism held its own.

The textbook version of the D-S expedition says that the Cartesian cast of the French mind organized the anarchistic and nihilistic spirit of Dada into a constructive movement. Thus Surrealism is depicted as having a coherent doctrine, working poets and artists, and a firm place in history. Such a tidied-up account violates both the letter and the spirit of what happened. Dada was child's play, literally and figuratively, and for a time it had wide appeal. Its spirit drew on a deep simplicity of purpose. "Drop everything. Drop Dada." Breton's goodbye to Dada expresses its logical essence. There is an incontrovertible order in being opposed to everything, including one's own survival. In comparison, it is Surrealism that seems wayward and contradictory. Don't let anyone tell you that Surrealism took all these high spirits and subdued them, fitted them into a rational synthesis. The situation was very different.

Until recently all physics textbooks contained an illustration of a historic experiment called the Magdeburg hemispheres. In some engravings the sphere is no bigger than a man's skull, with a pair of horses pulling on each half. In others, performing for groups of burghers and nobles making astonished gestures in the carefully drawn landscape, eighteen to twenty horses strain at a globe as big as a hogshead. The ideas and individuals lumped together as Surrealism had no more cohesive force of their own than the two metal

shells joined in Magdeburg. But after the interior chamber had been emptied by endless discussions and declarations, the surrounding pressure of Western art and bourgeois morality held the parts together with remarkable strength. In the case of Surrealism, however, we would have to revise the engraving to show a sphere divided into *three* parts and another team of horses tugging off in a third direction. For it was a triad of forces that wracked Surrealism: politics, science, and the spiritual.

Although the Surrealists, led by Breton, made some ridiculous mistakes, in the long run their political record is uncompromised. They did not allow themselves to be herded for long into the Communist Party corral. They defended Trotsky, refused to swallow Communist fronts and the pap printed in *L'Humanité*, and were among the first to circulate statements condemning the Moscow trials. It makes a fascinating story in which Breton's stiff-necked disposition lost him many friends yet served him well.*

In one of his sturdiest political statements Breton tries to sort out the several stresses exerted on the Surrealist activities:

> . . . all of us hope that power will pass from the hands of the bourgeoisie into the hands of the proletariat. Meanwhile, it is no less necessary, in our opinion, that experiments [*expériences*] with the inner life continue, and without any external control, even Marxist. [*Légitime Défense*, 1926]

The French word *"expérience"* means both scientific experiment and experience in the general sense. The emphasis here is scientific. Breton and Aragon were former medical students. Their review, *La Révolution Surréaliste*, was designed to look like a medical journal, the better to set off the humor and scandal in its pages. The group established a Bureau of Surrealist Research and conducted surveys on suicide, dreams, and sexuality. They published Freud on lay analysis and honored Charcot on "the Fiftieth Anniversary of Hysteria." These scientific ambitions, though fumbling, were genuine and served as an antidote to what they were already calling "the literary alibi."

The ground on which Surrealism established its foundations is

* See Henri Lefebvre, "1925," *Nouvelle Revue Française* (April 1967); Robert S. Short, "The Politics of Surrealism, 1920–1936," *The Journal of Contemporary History*, No. 2 (1966), and my essay "Having Congress," which opens this collection.

described by the first manifesto as "pure psychic automatism," presumed to reveal "the real functioning of thought." Like Gertrude Stein under William James and Hugo Münsterberg, they sought something other than literary results. A great cloud of uncertainty still hangs over the authenticity and the significance of automatic writing.* The confusion is increased by the fact that Surrealists turned to the unconscious not primarily for therapeutic purposes but for what they often called "revelation." And here we have already slid a long way into the third domain of the spiritual.

The eighth number of La Révolution Surréaliste contains an apparently unposed photograph, Benjamin Péret Insulting a Priest. It almost looks as if Péret, in an undershirt, is spitting at the startled figure in a cassock. However, attacks on church and clergy were obviously a matter of trustbusting. The most perceptive French critics (especially Monnerot, Carrouges, and Audoin) have insisted on the commitment of Surrealism to the spiritual and the sacred. Some of

* In an age of extended professional training and widespread skepticism toward received values, it constantly confounds me that not only the young but also many certified intellectuals accept uncritically the superiority of spontaneous or unconscious products of mind over those subjected to conscious, rational control. In many situations it is difficult to tell whether this attitude is due to laziness, conviction, or bad faith. The practice and study of automatic writing (the label is highly unsatisfactory) could lead to a better understanding of the relations among nonverbal thought, interior speech (endophasia), and articulation. The psychologist Jean Cazaux wrote a short book on Surrealism in 1938; the severe essays of Herbert J. Muller and Kenneth Burke in New Directions 1940 are still very pertinent. But the most probing questions about autowriting (and painting) remain unanswered, rarely asked.

1. Is the autowriter perched on a privileged frontier between sleep and waking (cf. Proust), or does he speak from the heart of the unconscious—trance, deep sleep, "inspiration"?

2. Does the autowriter reach the seat of individual identity? or a repository of collective experiences and attitudes? or Huxley's "Mind at Large," Schrödinger's "singular consciousness"?

3. What does he dredge up: profound, suppressed thoughts closely connected to childhood and primitive knowledge? or a store of clichés, trivia, and drivel mostly of cultural origin?

4. Are talent, sensitivity, and training irrelevant to the operation of automatic processes? ("The essential nature of Surrealism is to have proclaimed the complete equality of all normal human beings before the subliminal message . . . a shared patrimony of which each one of us has only to claim his portion" [Breton, Le Message automatique].)

5. Are the published automatic texts (most of which are punctuated in sentences, retain basic syntax and logic, and have a literary tone) genuine examples of the form? If so, do they have primarily scientific or literary significance?

the early documents circulated within the group speak both of revolution and of "Surrealist illumination." The language does not lie: the Surrealist revolution "seeks above all to create a new kind of mysticism." The members functioned very much like a sect of initiates, and the second manifesto brings all its weight to bear on discovering "a certain point of the mind" which would reconcile all contradictions —a modern version of the Holy Grail.

Occultism, objective chance, the revival of the chivalric and Arthurian traditions of erotic love, magic, and alchemy, the cult of the supernatural in woman—all these unstable items fed a faith that had unmistakable elements of transcendence. It comes out with intensity in much Surrealist poetry, in prose narratives full of quests and epiphanies, and in visionary paintings. Even Paul Eluard, the most "classic" of the poets, shows his hand in *Donner à voir* (*Making Manifest*).

> No mere play on words. Everything is comparable to everything else. Everything finds its echo everywhere, its justification, its resemblance, its opposition, its becoming. And this becoming is infinite.

The word with which the Surrealists tried to conjure so often, *"le merveilleux,"* belongs to a sustained attempt to find spiritual values in everyday life.

These, then, were the great attractive forces pulling Surrealism, and the whole D-S expedition, in three different directions: politics, science, and the spiritual. Though the Paris group held together for nearly two decades, it never achieved any complete synthesis or reconciliation of these forces. The dynamics shifted steadily both with the times and with the composition of the group. Such stresses help explain why it is difficult to discern the shape of the D-S expedition —its effort and its accomplishments. As I see it, substantial effort produced limited accomplishments in two respects. From Hugo Ball to Max Ernst to André Breton, the D-S expedition sought a redefinition and a reunification of mind in order to incorporate large segments of mental activity increasingly excluded by materialism (including Marxism). Secondly, they often tried to work collectively, in pairs or as a group, ready to believe that mind and imagination do not occur exclusively in the singular.

A revised version of mind, a surpassing of individuality—in spite of the energy expended both attempts must be counted as failures.

Nevertheless, the D-S expedition remains one of the great modern case histories, because of and in spite of its failures. It has much to tell us about inducing and simulating mental processes and about the dynamics of artistic collaboration. It may even have dropped off a few works of art as it went past.

During these events, two men attained recognizable greatness, though they were by no means free from flaws and crotchets: Breton and Duchamp. For fifty years these contrasting figures, leader and loner, were resourceful and intractable in their opposition to an acquisitive society and to political and artistic compromise. Their methods were totally antithetic. Breton founded a counterinstitution —cell without party, brotherhood for research, nonresidential phalanstery. It was an attempt to fight fire with fire. Without the institutionalization of Breton's moral conscience in manifestoes, public meetings, and private game sessions, it is hard to imagine the shape the avant-garde would have taken in France during the twenties and thirties.

Meanwhile, Duchamp enacted a lengthy and elaborate pantomime of shaking out of his garments and off the soles of his feet every particle of the dust of Western art. Refusing all institutions except the ancient freemasonry of chess, he performed a solitary rite of divestiture. It has had an effect as lasting as Breton's negative institution. Though Breton sometimes acted like a toy Pope, and though Duchamp began to look like W. C. Fields trying to get rid of the flypaper, they were neither charlatans nor fools.*

In the United States we have been kept reasonably well informed about these goings-on. The fund of translations has gradually grown. The best general treatments have been written by artists—Robert Motherwell's *The Dada Painters and Poets* (1950) and Hans Richter's *Dada: Art and Anti-Art* (1965). Books about the whole D-S expedition rarely attempt any significant revision of the picture sketched in fifty years ago by Marcel Raymond in his useful survey,

* One of the most penetrating and poetic descriptions of Surrealism hides away in Sartre's vehement attack on it (*What Is Literature? IV*). Unerringly he pins down Duchamp and Breton as the principal agents of destruction. Duchamp, he insists, is a metaphysical and semantic prankster, making holes in conventional meanings so that subjectivity itself begins to dribble out. Breton achieves destruction of the objective world by overloading it with signs, images, and unresolved ambiguities. The eloquence of Sartre's writing hints at a kind of outraged sympathy with these two villains who tried (but failed) to destroy the "bourgeois ego."

From Baudelaire to Surrealism. But Raymond leaves out vast and essential areas. And why isn't Berlin Dada, with its close interplay between politics, literary and plastic arts, and psychoanalysis, far more revealing than the domestic squabbles of the Paris crowd? Is it possible that the shape of time we should be scrutinizing begins somewhere back before the turn of the century with, say, *Ubu Roi* (1896) and its shocking fusion of Symbolism and anarchism, and ends soon after 1930, when modernism ran out of steam and capitulated to socialist realism? Roger Caillois, the writer and critic best equipped to reassess the role of dreams, games, psychic experiments, and the occult in Surrealism, died in 1978 before he had collected and revised his early writings on the subject. The only important attempt to reconceive the full enterprise of the movement can be found in the articles collected in the French review *Change*, No. 7 (1971).

Short of a book-length study, an examination of four major books on the subject will reveal the varied ways in which we are still trying to come to terms with the D-S expedition. I shall look with some care at a critical history of D-S art, a major volume of poetry in translation, a biography of the leading literary figure, and a monograph on the most influential and elusive artist of all.

2

In March 1968, the Museum of Modern Art in New York held a black-tie opening for a large exhibition entitled "Dada, Surrealism and Their Heritage." Inside, Marcel Duchamp and Salvador Dali made benevolent remarks about three hundred "gentle hippies" who were demonstrating in the street outside. According to the *Times*, one of their placards read, "Surrealism means revolution, not spectator-sports." The museum's chief curator, William S. Rubin, had prepared both the show and the 250-page catalogue. A year later he published an immense, semi-exhaustive critical history, *Dada and Surrealist Art*. Rubin obviously had at his disposition a competent museum staff along with excellent collections and libraries. And he is clearly master of the enterprise. From the three reproductions on the jacket (Duchamp, Miró, Magritte) to the final paragraph, a single intelligence and recognizable taste govern the machinery. In a brief preface Rubin states that he will engage in two activities essentially alien to the iconographic interests of the Surrealist poet-critics: stylistic analysis and judgments of quality.

The lengthy opening chapter on Dada is in many ways the most satisfying in the book as art history and as analysis. Fortunately, Rubin has mastered the German background as well as the French. He detects the dandyism behind the Dada gestures and is not ruffled by raucous noises. The second chapter on "background" runs into a few problems of selection and chronology and includes several fine pages on de Chirico. "The Heroic Period" treats five painters: Miró, Masson, Ernst, Tanguy, and Magritte. The chapter on the thirties brings in Dali, comes back to Arp and sculpture, and includes a careful examination of Picasso's relation to Surrealism. Rubin concludes that Picasso's work is "ultimately antagonistic" to Surrealism because his inspiration remains figurative. His demonstration of this, an analysis of the crucifixion theme in *Guernica*, displays the power of a discriminating eye supported by scholarship.

The final chapter, "Surrealism in Exile," deals with what happened after the fall of France, primarily in New York. Rubin ends by summarizing the art-history disputes over the transitional role of Arshile Gorky, the major American painter, who committed suicide in 1947. There is no coda.

The organization of this volume does not differ widely from that of an earlier book by Marcel Jean. The prose is readable even though it rarely falls back on anecdote. Rubin sets out to insert Dada and Surrealist art into history and does so by marshaling his facts, collecting superb illustrations, and taking account of different opinions. He has the critical coolness to give Dali his due, and no more, as a miniaturist with an immediate hallucinating power that declined after 1929. Rubin is not afraid to take a stand. "Miró is unquestionably the finest painter to have participated in Surrealism." Everywhere Rubin's documentation is magnificent.

The critical scaffolding on which Rubin erects his work remains in the background. In a scattering of brief passages one begins to glimpse it as a sequence of binary distinctions. Rubin repeatedly emphasizes Surrealist *peinture-poésie*, with its renewed attention to content, as against *pure painting*, powerfully embodied for the twenties in the "Cubist grid." Within Surrealism he sees two basic styles: biomorphism, primarily in Arp, and spatial illusionism, principally in Magritte and Dali. Others like Miró and Tanguy blend the two. At some points Rubin speaks of "abstract" versus "illusionism." But he never gives us "a comprehensive *intrinsic* definition of Surrealist painting" as he promises. These organizing categories remain tenta-

tive and somewhat blurred. For that very reason they yield to a strange undertow and make one wonder about the author's attitude toward his subject.

> The plastic arts played only an ancillary role in Dada and Surrealism; they were held useful as means of communicating ideas, but not worthy of delectation in themselves. [p. 14]
>
> . . . it is now evident that the *programs* of Dada and Surrealism constituted a major interlude (about 1913–47) of reaction against the main premise of modern art, which was in the direction of the *increasing autonomy of art* as such. [p. 15]
>
> Surrealism itself was less a cause than a symptom of the concerns that animated the cultural scene during the *entreguerre*. [p. 281]
>
> It was with the Dada and Surrealist generations of the interwar period (and *not* recently in America, as some believe) that the situation changed. For the first time, originality—which was to become indistinguishable from novelty—was itself a goal . . . Precisely at that moment, the quality of avant-garde painting fell off. [p. 396]*

Out of this very elegant bag, some kind of a cat is creeping. As curator of MOMA, and in command of formidable knowledge of twentieth-century developments, Rubin is duty-bound to reckon with so major a force as Dada-Surrealism in modern art. But as an admirer of the critical ideas of Meyer Schapiro and Clement Greenberg, frequently acknowledged in the text, and with a sensibility trained in post-Renaissance aesthetic traditions, he finds himself in something of a quandary over the anti-art and automatic content of the D-S expedition.

I suspect that Rubin's reservations about the whole shebang run very deep. He tries to curb them in the interest of objective history; furthermore, some of the individual works produced in close association with these heretical principles move him very much. But I am disturbed by the catches and cracks in his voice, not only because they mar the unity of the book, but also because they imply the possibility of a book Rubin might have written, with greater honesty toward himself and his reservations. Somewhere inside Rubin lurks a half-suppressed classicist yearning to criticize the entire superstructure of D-S ideology and to salvage from it a limited number of works

* Precisely here Rubin has strayed off course. See "The Demon of Originality," pp. 62–81 in this volume.

and individual talents assimilable within the "main premise of modern art."

But Rubin is not happy with the "Cubist grid" either. So we are left with a mammoth scholarly and critical work that glistens with a kind of intellectual iridescence. Its sympathies keep shifting. He is content with a downbeat ending about the trailing off of Surrealism after World War II. Yet the sheer mass of the book, cultural, commercial, and physical, suggests some kind of triumph for the Dada and Surrealist art it memorializes and faintly deplores. Rubin goes to great lengths to bury his ambivalence about his subject. I suppose he speaks for many of us. Yet one looks to such a work to cut through uneasiness, not to sustain it.

3

Of all the artists and writers who lived through Dada, only two went on without ever changing. For instead of rejecting art, they threw the whole house open. "Everything the artist spits is art," growled Schwitters. Arp, all smiles, went further. "The whole world is art." Of the two, Arp is the greater artist and a multiple threat: artist and poet; artist in both sculpture and painting; poet in both German and French. Over the years, first in his reliefs and then in his whimsical writings, he developed what he called "concrete art" (as opposed to abstract art)—material and verbal shapes that grow naturally without imitating natural objects. Concrete art arises from spontaneous processes of dream, chance, play, and humor.

In spite of financial worries and frequent travels, Arp had an astonishingly sustained fifty-year career of work. He participated in almost every art movement in Europe without belonging to any. He reached fame slowly without scheming or scandal and avoided personal and political squabbles. Sophie Taeuber, a remarkably talented artist in her own right, afforded him both a lasting and happy marriage and a valuable artistic collaboration. The pervasive wholeness of his work tends to obscure the slow evolution it went through. He moved from flat collages and paintings to sculpture in the round, and from tightly constructed poems in German toward more open works, including prose and prose poems in French.

I still remember vividly my first stereotyped reactions to Arp's work: he's just making playthings. I could do better myself if I tried.

But of course we usually don't try, not for a lifetime. When we do, we can't. Arp's plastic works and his writings remain childlike, often impish, but fraud does not enter here. Unlike the Surrealists who rarely abandoned a strong sense of decorum (partially in order to be able to violate it), Arp never differentiated between literary genres. Verses, prose poems, fairy tales, reminiscences, declarations of faith— they all fit side by side because of a pervasive whimsy that never detracts from deep communion with nature and life.

> The stars write at an infinitely slow pace and never read what they have written. It was in dreams that I learned how to write and it was only much later that I laboriously learned how to read. As if such knowledge were innate to them, the night birds read what is written by perishable men, a wrinkly scrawl in the opaque night. The vagabond flowers offered me a charming surprise when they forged my signature in living groups on cliffs.

Poetic prose like this, as well as wonderful fables like "The Great Unrestrained Sadist" (who threw everything out the window, including himself, and it all turned into marmalade) and "The White Man with Negro Feet" (who walked on water) draw deeply on the unconscious without being "automatic." Arp is forever looking for, or rather finding, verbal patterns in which sound and sense have approximately equal weight. It often comes off as humor.

> *humor*
> *is the water of afterlife*
> *mixed with the wine of this life*

But in the French it's even whackier, more wobbly, for he is not only rhyming but also playing with his o's.

> *l'humour*
> *c'est l'eau de l'au-delà*
> *mêlée au vin d'ici-bas*

After reading a great deal of Arp in both German and French, I have the impression that it is not the unconscious, not any literary tradition, not an assertive talent, but *the language* itself that Arp encouraged to write his poems.

> *Two little Arabs adult and arabesque*
> *who were playing on two small Nero's fiddles*

were strolling legibly
through the wrinkles of two runic curtains
when suddenly a pipe loomed up
before the two little adult and arabesque Arabs
a papa pipe on puppet feet

One does best to relax and enjoy it, and possibly to keep a finger on the French. The nervous exegete, worried about having missed a buried meaning, might fail to hear the sound surfing and syllable sledding. Once or twice the Beatles and Bob Dylan strolled by this way.

Arp's reputation has been growing steadily in Germany and France, and his complete works have been published in both languages—a unique case. A French sociologist, Alfred Willener, went so far a few years ago as to attribute to Arp a significant role in the formation of the aesthetic attitudes behind the May 1968 riots in Paris. His literary work stands in a special relation to his art in a reciprocal exchange of motifs and moods. Arp's poetry in German is, if not superior to, at least more varied than his French work. Born and raised in Strasbourg, Arp was genuinely bilingual (plus the local dialect). But he wrote differently in the two languages, more from the inside in German, I should say, less rhythmically and with a little less assurance in French. In both he uses the same techniques of permutating syllables and joining items not by their center (denotative meaning) but by their edges (sound and connotation).

In English Arp has had a lopsided fate. Years ago *On My Way* provided a fine short sampling. Recently everything available in his big French collection, *Jours effeuilés*, including reruns and faint asides, has been competently translated by Joachim Neugroschel in *Arp on Arp* in the Viking Documents of 20th-Century Art series. But five hundred pages at once is too much. Arp's fragile lines come through best in small collections with reproductions of his own graphic work, not so much to illustrate them as to frame and punctuate them. *Auch Das Ist Nur Ein Wolke* (Basel, 1951) is one of the most satisfying poetic objects I have ever laid eyes on, held in my hand, and read aloud. Equally appropriate to Arp's miniaturizing genius is the fifty-page selection of his German poetry in Harriet Watts's *Three Painter-Poets* (Penguin). So presented, his work displays a child's lyric wisdom dancing across meadows of laughter. Without Arp's lightness and mirth the D-S expedition would be a pretty doctrinaire affair.

4

> Unlike most literary men of the twentieth century, Breton was
> loath to reminisce . . . He rejected the memoir as a literary genre
> . . . *Entretiens* is the story of a mind rather than of a life; and none
> of Breton's commentators has complained of the lack of intimate
> details and introspection because the substance of the mentally and
> sensually active life is the work itself, candidly laid before us, avail-
> able but often undecipherable as a cryptogram.

Thus Professor Anna Balakian lays out the lines of her study,
André Breton: Magus of Surrealism. Later she quotes Breton himself
on the "infinitesimal interest" of an author's life as compared to "the
message." Balakian has gone on to write an honest, healthily partisan,
well-informed book that sometimes stays too close to its subject but
at least tries to come to terms with a powerful mind. (The subtitle
seems inappropriate; she treats Breton essentially as an intellectual
hero.)

The book moves in chronological order and mixes basic biographi-
cal information and interpretation with discussion of the writings.
The brief remarks on Breton's solitary upbringing in Brittany, be-
tween a dark northern countryside and the sea, have real pertinence.
Balakian never pauses to ponder whether Breton (like Anatole
France and Charles de Gaulle) may have found his initial vocation
in his name. Breton threaded the needle of his life through the magic
year 1913, when he was a medical student in Paris. A little later he
wrote to and began seeing the two major poets of the era: Apollinaire
and Valéry. After the war, which he spent working in hospitals and
psychiatric centers, came five years of tentative, intermittent activity
in Paris as a young poet and editor of the review *Littérature*.

His "Surrealist" experiments with automatic writing never really
meshed with the Dada campaign of general decontamination. After
two very difficult years Breton wrote a manifesto, launched a move-
ment, and began publishing again. He had in fact made his reputa-
tion well before he was thirty. Although Balakian considers Breton
primarily a poet, she gives long attention to his four Surrealist narra-
tives (only *Nadja* has been translated) and briefly explains the po-
litical squabbles of the thirties. A chapter toward the end of the book
describes Breton's unflagging work as a literary critic—both his astute-
ness as an interpreter and his influence in establishing a new canon
of literary classics. Balakian's summation proposes that Breton's con-

tribution was "a new humanism." His reconciliation of conscious and unconscious is seen as an effort to "remake human intelligence," and his position as having finally a "moral basis."

Balakian compresses a great deal, too much really, into 250 pages. For several reasons we should be grateful to her. For instance, in the third chapter, "Medicine, Magic, and Mathematics," she documents the genuinely scientific orientation that Breton, more than anyone else, brought to Surrealism. The psychologist Pierre Janet appears as the principal formative influence on Breton's thinking about unconscious processes. But Balakian has stayed too close to home. One generation further back lies an even more fascinating source that Balakian does not mention: Taine. In a book that still makes magnificent reading, De l'intelligence, Taine comes to the conclusion that "exterior perception is truthful hallucination," thus linking all forms of dream and unconscious to what we finally call "reality." De l'intelligence is the first book Breton mentions in the manifesto, and he comes back to it in a later work, Surrealism and Painting. Taine solicited many of his firsthand reports on an artist's capacity to hallucinate from Flaubert; the revealing letters are all published. In a world where everything connects, Flaubert becomes the first Surrealist.

It is also useful to find Breton taken seriously as a poet. Balakian concentrates almost all her attention on his imagery, which is obviously the most striking aspect of his work. But Breton had a finely tuned ear for free verse that leaned toward the orotund. I cannot concur that "his words are harsh, unpoetic, because many of them have never been pronounced orally." He observed that great poets are auditory and was so himself. His own diction fares best in short poems, which is good reason to doubt that "Breton also developed a new genre, the modern epic." His long poems become bombastic; the modern epic, such as it is, took shape elsewhere.

I have two further reservations about Balakian's critical position. She wraps six of Breton's prose works together and calls them a new genre: "analogical prose." But two of the six are early automatic texts. The last four do hang loosely together, not as a new genre, but as an outgrowth of the autobiographical, reflective, semi-journal form called in French the récit. Breton drew heavily on both Nerval and psychoanalytic case histories.

My other reservation is more serious. At the beginning of her discussion of automatic writing, Balakian severely reduces her critical

maneuverability by accepting as true two of Breton's main premises. "The absence of critical intervention in writing, which is Breton's definition of automatism, precludes mechanical coupling of words by the deterministic function of the mind." Yet, as I have implied earlier, without self-criticism the mind may well be victimized by all kinds of external determinism and built-in trivialities.

She also writes: "Breton's notion of language is closely akin to that of present-day structuralists. If, as he believes, 'The speed of thought is not greater than that of speech,' then language is the concrete realization of thought." Now we may have discovered the speed of light, but the speed of thought remains one of the great unknowns. The real interest of automatic writing lies in its exploration of the limitations of speech, not in its demonstration of the omniscience and omnipotence of that faculty. The possibility that the Structuralists share some of Breton's views on language does not prove anyone right or wrong. Because she accepts these two ideas, Balakian fails to get a purchase on Breton's shortcomings as a thinker.

There are at least nine full-length books on Breton in French and English. The best of them are intellectual and literary studies; a few are fragmentary memoirs. Almost every writer of and on Surrealism speaks of it as a state of mind, a way of life, a liberation of the total sensibility. "Take the trouble to *practice* poetry," exhorts the first manifesto—meaning both to write it and to live it. "Dada and Surrealism stand for a total, absolute disavowal of anything literary," writes Jacques Baron, one of the early participants. One writes, Breton says, to find other men. And Balakian, modifying some of her earlier statements about message and mind, chimes in: "Even in his most active years [Breton] had considered writing second to the creation of human contacts and to the search for the comprehension of the symbols of the human labyrinth." Where, then, is one to look for a record of this wonderful Surrealist life?

In spite of the first paragraph I quoted, we have circled back to a very old and very powerful belief: human greatness achieves its fullest meaning when it belongs not to a set of detachable works but to the sustained quality of a man's life. For this reason, a searching, comprehensive life of Breton is something we very much need. He exerted remarkable powers of leadership on an impossible crowd of artist types. He had the almost magical power to be "*un flâneur, qui travaille toujours*"—an idler, who is always working. His willfulness carried him to extremes of thuggery and violence, yet gave him a

strong sense of self-preservation. As I know from having heard one of his talks, his voice and sheer physical presence made up a large part of his secret. His dignity allowed him an astonishing projection. Charles Duits describes Breton reading poetry.

> He had no shame. He didn't even know that one could be ashamed. He was the way he was, and put himself on display. There was something great about it, as well as something pathetic. He was naked. Naked among all those distressed people, who lowered their eyes, fiddled with their ties, coughed. [*André Breton a-t-il dit passe*]

It is this sense of Breton the man that I fail to find in Balakian's "semi-biographical book." She makes his life congruent with his writings and seeks out little that he does not report himself. Even from a semi-biography we could hope for an account of how a man spent his time—not only in public but also alone, or in private. Or does the Surrealist life stop there? The question is crucial. It may not be necessary to document, for example, the details of Breton's lovemaking. But, as it happens, we do have an earnest, occasionally comic discussion of sexuality published in *La Révolution Surréaliste* in 1925. In it a number of Surrealists, including Breton, supply a few facts about their sex habits and beliefs without yielding to exhibitionism or embarrassment. Kept in perspective, such details have a place in the account of a man's life, along with his habits of work and sleep, eating and relaxing. If we are concerned with *practicing* poetry, these items are no more beside the point than a man's philosophy or imagery. In fact, Breton's prose narratives record a large number of such details.

Or take the depression that afflicted Breton between 1921 and 1924—an interlude of doubt and hesitation about his own future and his role on the Paris literary scene. Balakian passes over it, unexamined and unexplained, in eight lines. She does not even mention a significant interview in the *Journal du Peuple* in which Breton stated he was preparing one last statement, after which he would abandon writing completely.

What changed his mind? Duits reports an astonishing conversation, one summer night in 1943, in which Breton questioned the wisdom of his attempts to turn the "pure revolt" of Dada in the direction of Surrealism, toward transforming the conditions of existence. "Since Dada . . . basically, we haven't done a thing." Apocryphal? I should like to know, for there lies a personal and intellectual dilemma. Balakian also unfortunately omits the intense, secret,

young-man's oath sworn by Breton and Aragon in March 1919 to avoid all forms of conventional fame and success, above all literary. They had convinced themselves that art was an excuse for not doing better things—like transforming life itself. They were twenty-three and did not realize yet how hungry the culture was to coopt their talent, and how hungry they could become for what they now despised. Documented fully, but not therefore indiscreetly, Breton's biography would provide a remarkable instance of a man setting out resolutely to live his life and discovering how his life lives him.

5

The Complete Works of Marcel Duchamp is a book of another color. It examines the second of the two great figures of the D-S expedition—and is dedicated, to boot, to Breton. Arturo Schwarz's book belongs to the same massive format as William Rubin's *Dada and Surrealist Art*. Though a sustained effort has been made to list, illustrate (seventy-five in color), and exhaustively annotate every (anti-) art object touched by Duchamp's hands, this large volume does not contain Duchamp's written texts. Therefore, the title is misleading. For after 1912 (the year he "stopped" painting), Duchamp's work became increasingly verbal.

Schwarz divides his 200-page analytical text into two parts. The first describes Duchamp's upbringing in a family of many painters, his trying out of contemporary styles up to the age of twenty-five, and his decision to "get away from the physical aspect of painting" in order to put it at the service of the mind. Several of Duchamp's interviews and Calvin Tomkins's *The Bride and the Bachelors* cover the same story. But the deepest motives of Duchamp's conversion remain obscure. The stimulating presence of Apollinaire and Picabia obviously played a role, as did the strange, self-generating literary work of Raymond Roussel. And possibly something unreported happened in Munich that summer of 1912—when Arp also was visiting the city where Kandinsky and Hugo Ball were living. Duchamp soon discovered puns, chance, ready-mades, and "playful physics." In 1913, he achieved overnight celebrity because of his *Nude Descending the Staircase* in the New York Armory show. He went around for the rest of his life resolutely and masterfully *not* being an artist. One way was to "choose" a urinal to sign and exhibit as a piece of sculpture. There were others.

Part Two opens with a detailed analysis of a 1911 painting, A

Man and Girl in the Spring. Schwarz considers it the key that unlocks everything. Its symbolism of the hermaphrodite, sun and moon, brother and sister, convinces Schwarz that its theme is incest.

> Duchamp punishes himself for desiring his sister and chooses for himself the same form of execution (hanging) that he chose for her. His solidarity with his partner continues until the moment of his death. This identification of the artist with his creation is as old as art itself. It helps us to understand another striking fact: many of Duchamp's readymades are to be hung (hanged). [p. 99]

From here we move on through voyeurism, onanism, and disguised exhibitionism into the Large Glass, or *The Bride Stripped Bare by Her Bachelors, Even.* Schwarz gives an exhaustive examination of this famous work, which was begun in 1915 and abandoned uncompleted in 1923, was later cracked in transit and repaired, and is accompanied by a detailed set of sketches and notes. In the elaborate pseudo-circuit of mechanical parts, with one floating cloud form at the top, Schwarz sees the delayed or failed union of bachelor and bride, the triumph of self-love over love. He is dead serious about the symbolic content of these panes of glass now mounted (not hung) in the Philadelphia Museum.

> Humanity's first mirror was water; it was in water that Narcissus first admired his own reflection. Narcissus and Water are as closely linked as an object and its mirrored image. It may, therefore, not seem too farfetched if we suggest that the driving force of the Water Mill is not water, but what water can be identified with—Narcissus. Water is also a female symbol, and we have associated it before with the Bride. Thus, the ambivalence of the situation could not be expressed by the choice of a more appropriate element, since the outcome of the narcissistic trend is both desire for the Bride and onanism . . .
> Identifying water with Narcissus unveils the hidden connections between the three common points of the Water Mill. Onanism and the incest-intention generate the guilt complex which is extinguished by castration. [p. 186]

Sic. (For the moment I shall withhold comment on this polluted prose.) In the ambivalence of the symbolism, Schwarz sees the therapeutic virtue of myth negotiating between reality principle and pleasure principle.

For a man who ostensibly abandoned art for chess, Duchamp managed to produce a fairly sizable oeuvre before he died in 1968.

Apart from his own unbelievable text, Schwarz deals with it through excellent reproductions, a "critical catalogue raisonné" of over 200 pages, and *two* full bibliographies. If you cannot visit Philadelphia, you will find all Duchamp's plastic work here in compact, though far from portable, form. And you can read a six-page description of his last major work, *Etant donnés (Being Given)*, an alcove-sized, mixed-media "sculpture-construction" made public in the Philadelphia Museum only after his death. Schwarz argues that this obviously shocking peep show reproduces in *trompe-l'oeil* the solitary sexual moment which the Large Glass elaborately camouflages. Perhaps. But there is more. I am convinced that *Etant donnés* is Duchamp's ultimate and most daring art-history hoax, perpetrated (with their connivance) upon museums, critics, art historians, book reviewers, stunned public, and himself.

Schwarz has mobilized everything in sight in order to perform the definitive psychoanalysis of the great Sphinx of modern art. Every exegetical sentence, as well as the twice-repeated epigraph (*"Eros C'est la vie. Rrose Sélavy"*), says the same thing: the secret is sex. Specifically: incest. Thus the bride-bachelor is laid bare. What I complained of as lacking in the Breton biography is here granted, transformed beyond recognition, in Schwarz's insistence on personal erotic motifs in Duchamp's works.

Schwarz has command of a wide general culture, an almost miraculous knowledge of Duchamp's life and work, and the mind of a cryptographer. The first seventy pages of his text are better than adequate. They make a comprehensive and comprehensible guide to the game of hide-and-seek that Duchamp played with art and language. But after that, Schwarz loses his footing and slips deeper and deeper into the trap set by Duchamp himself. He was one of the greatest practical jokers of all time. I have already quoted two of Schwarz's commentaries. Here is another, on the witty, impeccably constructed semi-ready-made, *Fresh Widow*. That work consists of a miniature French window with panes of black leather and bearing its title in English. Schwarz properly recognizes a "three-dimensional pun." But *he* is the man obsessed, not Duchamp.

> The castration symbolism of this item is clear if we recall that the French colloquial term for the guillotine is "widow." Thus this "French widow" may be a metaphor for the *vagina dentata*, which has already been recognized in a detail of the Bride of the Large Glass. Windows are, of course, ambivalent sexual symbols. Freud

has noted that they stand for the openings of the body . . . The
adjective fresh, then, perfectly defines a male sexual organ which
does not stop short of incest . . . [p. 480]

A note on page 179 informs us that Duchamp read Schwarz's
manuscript and presumably raised no major objection to its publi-
cation. It takes a little while to grasp just what could have happened.
Is this book real? Another artist reading such mishmash about him-
self would die of laughter or burn the book. Not Duchamp, the eter-
nal feline. He must have licked his lips and whiskers for days, for
he had devoured Schwarz. He had annexed Schwarz's lucubrations
to his work as a kind of bizarre outbuilding, its official chamber of
horrors. Without that sly takeover, the book's jargon and wrong-
headedness would never have passed Duchamp. At least so I surmise.
I cannot let it pass me.

Fresh Widow, to come back to cases, presents a constellation of
plastic and verbal puns, two of which Schwarz does not even men-
tion: "fresh paint" and saying "French window" with a cold in the
nose. All the meanings Schwarz does detect may well have occurred
to Duchamp; at least he would have been amused to watch Schwarz
examining the entrails. But Schwarz never comes to terms with the
fundamental dynamics of this work and of many others: Duchamp
bears joyful witness to the possibility and the process of punning
among verbal signs, visual signs, and the interpretations of both. By
leading all meanings tediously back to sublimated incest, Schwarz
collapses a multidimensional structure into one rut. He also snuffs
out the joy. In another passage, Schwarz follows one of his Freudian
analyses of onanism, incest, and the castration complex with this
statement:

It should be clear, of course, that these patterns were entirely un-
conscious. The extraordinary poetic quality of the Large Glass
resides precisely in the fact that its creator was led by forces and
drives of which he was ignorant. [p. 167]

In view of the quotes Schwarz finds in Duchamp's own notes, the
artist was singularly lucid about the sexual overtones of his work—
along with all the others. Not art, not sex, not just Rube Goldberg
mechanics, but *permutation itself, metamorphosis, rules everything.*
That process is both the water and the mill, what Duchamp finds and
what he makes. Everything is something else, this huge book included.

Schwarz thought he was writing the definitive study of Duchamp. It looks to me as if Duchamp used Schwarz as his unwitting fall guy and straw man. For *The Complete Works of Marcel Duchamp* is the old wizard's last ready-made—on the face of it solemn scholarship, uproariously funny to a reader with his wits about him, a stink bomb in the motor of art history, a literally posthumous work. And for a few more years Schwarz himself will be on exhibit in his own Milan gallery.

6

At the close of World War I, an unexpected power vacuum had developed in the artistic avant-garde of the West. Symbolism had long since been melted down. By 1918 both Futurism and Cubism had seen their best days. The artistic and literary activity in Germany covered by the term "Expressionism" was lively but very diffuse. The New York Armory show had revealed vast but still unexploited possibilities in the United States. More than most people realized at the time, Apollinaire's death in 1918 removed the incumbent hero and ringmaster of the postwar avant-garde. The succession was open.

Then, to their great amazement, several groups of artists and writers in different parts of the world discovered that they could lay their hands directly on the controls. No one would stop them. They were welcome. In New York Picabia and Duchamp, along with Walter Arensberg, Man Ray, and Marius de Zayas, exploited the liberating scandal of the Armory show and raised Cain. In Zurich, Hugo Ball was aghast, and Tzara delighted, at the speed with which news of Dada circled the world and was converted into journalistic copy and commercial value. The Russian Futurists answered Lunacharsky's call to artists to join the revolutionary bureaucracy. For a short time the Berlin Dadas hoped to have an opportunity to play the same role.

In Paris, Breton, Aragon, and Soupault suddenly found themselves famous and sought after in 1918 because of their new literary review, *Littérature*. All of these men developed a keen sense of the public's taste for scandal and of the nihilism working at the roots of the modern sensibility. (Many of them were also pack rats and saved every document for posterity and the collector's market.) By a combination of presumptuousness and talent, they took command. Within two to three years the power vacuum had been filled.

In France, where the cross-currents tended to converge, the situation was peculiar. Duchamp, ten years older than the young generation, neither disappeared like Picabia after 1924 nor let himself be appropriated by any movement. He chose to become the cat that walked alone. His works and statements face in many directions, from mechanical engineering to joke art, from audience participation to art as a thing of the mind. But it turns out that all along this light-fingered operator was really engaged in a direct surgical incision into the cerebrum of culture, a painless aesthetic lobotomy. After Duchamp it is no longer possible to be an artist in the way it was before. Because of his style and his coolness, Duchamp has grown into a widely admired and imitated shadow-hero of the century. He is very hard to put down, or put aside.

Meanwhile, having rounded the corner of Dada, Breton and company pulled themselves together and founded Surrealism. Even though we may now want to tuck the whole D-S expedition away into history, we have not yet assimilated or dismissed its attack on the autonomy of art and its sustained attempt to reconcile Marx and Freud. Since World War II, France has also exported Existentialism, the New Novel, and a theory of theories called Structuralism with its wrangling aftermath. If called upon to say which of these movements is the most compelling, the most enlightening, I would unhesitatingly say the D-S expedition, the whole thirty-year trip. It alone explored the possibilities of collective endeavor in psychic experiments, in political action, and in artistic creation. In a culture based primarily on individual achievement and freedom, it was a perilous and sometimes misguided venture. Inevitably, certain individuals like Breton, Arp, and Duchamp loom larger than the others.

And, secondly, the D-S expedition tried to reincorporate the activity of art into everyday life after its long extrusion into a separate sphere. In my opinion we will finally be happy neither with the collectivization of art nor with the obliteration of the aesthetic as a distinct category of behavior. Nevertheless, what Dada had Surrealism tell us on those counts in a capitalist-bourgeois context has an equal and complementary value to what we can learn from the Soviet experience as it yielded to totalitarianism. Furthermore, the D-S writers and artists produced a large amount of significant art-in-spite-of-itself. Some of those works will survive as major fetishes of our time. They deserve their fate.

The Demon of Originality

1

Between 1973 and 1976 a forty-year-old Bulgarian-born artist and entrepreneur named Christo raised money and carried out negotiations to construct what he called a "Running Fence" across twenty-four miles of open ranch country in Northern California. He had attracted wide attention in the media and in the art journals a few years earlier by hanging a mammoth orange curtain across a mountain pass in the town of Rifle, Colorado. There have been later schemes for New York City's Central Park and for an island off Florida. This time Christo proposed to raise two thousand 18-foot-high nylon panels on steel cable along a zigzag line through the coastal zone fifty miles north of San Francisco. It took three years to win over the landowners and the local and state authorities to accept the projected path of the fence. Christo and his dynamic French wife carried out a grueling personal, social, and political campaign

in the face of several unfriendly injunctions from environmentalists. Finally, in September 1976, the completed artifact, or stunt, stood in place as promised for exactly two weeks, tugging at its lashings, bellying out in the wind like a sail for the Planet Earth itself. The fence lifted itself (illegally) out of the Pacific and ran along the crests and slopes of the brown hills, looking sometimes like a living monster, sometimes like an alluring natural feature in the already uncanny landscape.

Residents and tourists and people from the international art world came to look and, in general, to acknowledge that this gentle yet fanatic foreigner had accomplished something—just what, few seemed able to say. Was it the ultimate attempt to subordinate technology to natural beauty? Or just the opposite? A sympathetic housewife, during one of the eighteen public hearings, defended the project by comparing its ephemeral rewards to the satisfactions of a well-prepared meal enjoyed among friends. That aesthetic insight from the untutored public will not be soon forgotten.

Realizing that his extended happening would disappear into the sands without even Ozymandias-like ruins to bear witness, Christo arranged to have the Maysles brothers film the whole three-year episode. The resulting film, *Running Fence*, has been shown in art cinemas and universities without the commercial success that welcomed their earlier work, *Gimme Shelter*. The Maysles' neo-documentary style, using natural sound, abrupt cutting, and a minimum of commentary, gives the film the texture of authenticity.

Like some recent works in "land art" or "earth art," the ambitious dimensions of Christo's *Fence* place it in a special category. It belongs less to the collective endeavor that built Roman aqueducts and Gothic cathedrals than to the megalomanic imagination of pharaohs and emperors who transformed an entire countryside into an extended work of art as a monument to themselves. We would do well to remember the passage in which Plato compares the philosopher-king to a painter working on the blank tablet of human character (*Republic* VI). Burckhardt, following Hegel, speaks of "the state" as a work of art. Trotsky refers to "directing events" and shaping society as "the highest poetry of the revolution" (*Literature and Revolution*). Some art aspires to the condition of high-handed autocracy known in our time as totalitarianism.

Christo's *Fence* did not reach that order of magnitude, yet in order to achieve his aesthetic effects he had to invade a community

and an environment. As shown in the film footage, the completed structure provided views of genuine beauty without any attempt, as at Thebes and Versailles, to line up grandiose vistas of stonework reaching to the horizon. Some participants and onlookers experienced moments of euphoria, almost as if they had never before contemplated an expanse of countryside, or felt the wind as a fluid flowing across the land, or listened to a sunset. The fence became a kind of temporary frame defamiliarizing the natural landscape. The best moments of the film are remarkably lyric, without a shred of background music to cover the bird sounds and the wind.

During the lengthy undertaking out of which *Running Fence* emerged, the constant presence of cameras and crews operating complicated equipment created a context of newsworthiness and theatricality. That atmosphere transformed the events as they took place into a phenomenon hovering somewhere between history and art. The film viewer soon becomes aware of the intruding yet certifying stare of the camera lens aimed at the ordinary citizens and scenes that he also is watching through that very lens. Every aspect of the project becomes as self-conscious as a rehearsed performance.

The financing of this piece of conspicuous expenditure is even more revealing than the cameras. From private collectors, friendly corporations, enterprising galleries, and museums everywhere, Christo finally raised three million dollars for his fly-by-night fence with no paid admissions. Drawings, engineering plans, and other records and byproducts would gradually pay it back. His and his wife's business acumen as their own corporate managers and promoters has been widely admired—and criticized. Clearly the nineteenth-century alienation of the artist from established wealth and power played no part in this venture. The Christo company plunged with gusto into an activity resembling the research-and-development operation of a government department or a corporation. We are not dealing here with the avant-garde and its associated features of poverty, bohemia, and protest. We have entered the realm of large-scale, officially sponsored, artistic *experiment*.

2

In the past three hundred years the term "experiment" has cropped up at crucial points in the development of literature and art. Swift honors his own *Tale of a Tub* in its closing pages by calling it an "experiment to write upon nothing." Flaubert's letters tell us he had

a similar dream. The opening of Wordsworth's preface to the *Lyrical Ballads* refers to them as an "experiment." In some notes for a lecture, Whitman speaks of *Leaves of Grass* as "only a language experiment." At the close of Part I of *Notes from Underground*, where he discusses the narrative to come in Part II, Dostoevsky's narrator echoes Poe and Rousseau on the subject of total candor. "I want to try the experiment whether one can, even with oneself, be perfectly open and not take fright at the whole truth." Deeply attentive to the work on scientific method by his close friend Claude Bernard, Zola proclaimed the theory and, presumably, the practice of "the experimental novel." "In the early days of Cubism," Picasso has stated, "we made experiments . . . To make pictures was less important than to discover things all the time." Even T. S. Eliot associated poetry with experiment when he referred to the poet's mind as a "catalytic agent." In 1924 a storefront in Paris opened for business with the official title: Bureau of Surrealist Research. All these declarations and contexts lead us to the frontiers of a country called science. Do art and science share the quality of being "experimental"?

A number of authors (among them Max Weber) have made the point that the concept of scientific experiment has important sources in Renaissance music and painting and passed from art into what we now know as experimental science. We are concerned here with what looks like the reverse movement of scientific experiment back into the arts. In recent years a great deal of intellectual energy has been expended on exploring the relations between creativity in science and creativity in literature and the arts.* In any such discussion one must distinguish between at least two meanings of the word "experiment." On the one hand, there is limited and controlled experiment—scientific inquiry directed toward answering specific questions about the world according to a reigning system of interpretation.† This activity seeks to eliminate contradictions and anom-

* Valéry and Poincaré and Max Weber, Popper and Blachelard and Polyani, and of late Arthur Koestler and Thomas Kuhn have speculated about this hazardous subject.

† *In Science and Hypothesis* (1902) Poincaré speaks clearly: "It is often said that one should perform experiments without preconceptions. That is not possible. Not only would it render all experiments useless, but one could not do it even if one wanted to." Thomas S. Kuhn is equally categorical in Chapter 3 of *The Structure of Scientific Revolutions*. "No part of the aim of normal science is to call forth new sorts of phenomena; indeed those that will not fit the box are often not seen at all."

alies in our understanding of the world either by perfecting the system or, at long and dramatic intervals, by finding a better one.

On the other hand, we also let ourselves use the word "experiment" to refer to a very different process of open, even playful exploration for which no specific question has been formulated in advance.* In this case, instead of eliminating, the experimenter provokes and sustains any elements of surprise, anomaly, and disorder he can discover. Following his whim he asks: "What will happen if . . . ?" making no predictions about the outcome, seeking above all the unexpected.

The classic description of this kind of experiment can be found in Baudelaire's prose poem "The Useless Glazier." In a semi-hysterical mood, Baudelaire's first-person protagonist summons up to his room from the street an ambulant glazier with his pack of windowpanes on his back. When the poor man admits that he has no rose-colored glass, the protagonist, in a fit of inspired hatred, kicks him downstairs and then drops a flower pot on him as he emerges into the street, thus smashing the glazier's entire fortune. This startling anecdote of gratuitous and perverse cruelty is preceded by a concise theory of why such impulsive acts take possession of certain individuals.

> Another of my friends will light his cigar next to a powder keg, *pour voir*, just to see, to know, to tempt fate, to force himself to prove his energy, to play the prankster, to feel the pleasures of anxiety, for no reason at all, by pure caprice, out of idleness. It is a kind of energy that springs from boredom and revery.

This extreme case, which closely parallels Dostoevsky's use of caprice in *Notes from Underground*, developed into Gide's "gratuitous act" and provides a reference point for understanding "experiment" in the arts. It points to a form of playing with reality and personal identity, with experience and morality, in order to assert a freedom perceived as jeopardized by the constraints of culture—or even nature. We play this game not by following but by breaking the rules.

The two forms of experiment, scientific and artistic, share an attitude of detached yet intense observation toward the events precipitated. Yet the two activities are fundamentally opposed. *Scientific experiment*, relying on empirical rigor in refining its methods and verifying its results, seeks to extend and consolidate our grasp of

* The semi-fortuitous discovery of X-rays and of penicillin falls between my two categories.

order in the universe. *Artistic experiment* sets out to breed disorder, thwart determinism, and open up a space for individual freedom and consciousness. The results of this latter process—on rare occasions it may be a work of art—are subject to no conventional process of verification and may well gain value insofar as they depart strikingly from previous canons of genre, style, and taste.*

When Swift, Wordsworth, and Whitman used the word "experiment," they were feeling their way from the scientific to the artistic sense. Most histories take for granted that an experimental attitude in the arts began in the nineteenth century and organized itself into a counterinstitution called the avant-garde, expressing itself in movements and schools and culminating in twentieth-century modernism. In both narrative fiction and the plastic arts, however, the experimental principle has been at work far longer. Several early prose narratives take evident pleasure in their own novelty and naughtiness in overturning conventions. Some of them figure among the major founding works of the modern novel. Consider *In Praise of Folly, Gargantua and Pantagruel, Don Quixote, Tristram Shandy,* and *Rameau's Nephew.* Cervantes indeed refers to himself in *Viaje del Parnaso* (*Journey from Parnassus*) as "raro inventor." Diderot's intellectual *libertinage* in his opening lines—"I let my mind rove wantonly . . . my ideas are my trollops"—gives a metaphorical description of the very activity he knows he is engaged in: artistic experiment. In all those works the basic mode of experiment is *satire*—of character, of current ideals, of narrative forms, of the literary project itself. High seriousness does not appear to favor innovation to the same degree. We need not be surprised that the most successful scenes and themes in Flaubert and Proust, as in Joyce and Kafka, are superbly comic.

Now the Old Masters, from Leonardo to Rembrandt to Chardin, that correspond historically to the literary classics I have just mentioned, do not work primarily in a satiric style or with a comic vision. Their prolonged and partly collective enterprise was to master the representation in two dimensions of three-dimensional reality. However, many artists engaged in a private studio diversion from high seriousness. *Caricare* in Italian and *charger* in French yielded *caricature,* a genre which earned an honored place through the work of Hogarth in the eighteenth century and Daumier in the nineteenth.

* Morse Peckham's *Man's Rage for Chaos* (1965) develops a somewhat shrill version of this thesis.

As E. H. Gombrich fleetingly suggests in *Art and Illusion,* a persuasive case can be made for identifying caricature as the principal practice and vision that released Western art from imitation and turned it toward experiment and expression. Without the subversive strain of caricature, it would be hard to place and grasp painters like Goya, Courbet, Monet (who began as a caricaturist), Klee, and Picasso.

What I have just said about caricature and satire was briskly stated in 1742 by Fielding in his preface to *Joseph Andrews.* "Now what Caricatura is in painting, Burlesque is in writing." Both modes exploit exaggeration, the ludicrous, and license; Fielding mentions his friend Hogarth as an example. In the eighteenth and nineteenth centuries, literature and the arts found an enlarged domain of freedom and imagination less through a new rationalism than through forms of the comic. The person who brought together plastic caricature and literary burlesque was the wonderfully inventive yet neglected Swiss artist-writer, Rodolf Töpffer. His little treatise on physiognomy (1845) explains how an artist can play with human features in order to discover new expressions, new appearances—the principle of experiment in art. When he applied his own double talent in works like *Monsieur Vieuxbois,* the dynamic, nearly cinematic hybrid of text and drawings produced the first true comic strip.

After a century and a half of caricature, political cartoons, moving pictures, animated cartoons, funny papers, and comic books, Töpffer's spirit has reincarnated itself recently in a work by the best known of the French "new" novelists. Since this book illustrates many of the characteristics of experiment in the arts, I shall take a few moments to consider it.

In over a dozen books Alain Robbe-Grillet has mounted a powerful campaign against *naturalité* in the novel. He directs the dizzying or paralyzing force of his fictions against any natural or mimetic relation between the world we live in and the stories he puts together out of his mock-human materials. The Kantian categories of space, time, and causality—plus the presumably bourgeois category of autonomous individual *self*—appear in his novels primarily as objects of unrestricted manipulation and derision. Robbe-Grillet's opposition to these modes of experience in literature appears to spring from both political and aesthetic causes. He made his strongest statement at the 1973 Cerisy symposium on the New Novel. "The myth of naturalness has served a whole social, political, and moral order in order to

establish and prolong it . . . Today we are resolved to assume fully the artificiality of our work."

One of Robbe-Grillet's recent books, entitled *La Belle captive* (*The Fair Captive*), wears its method on its sleeve. It contains seventy-eight reproductions of paintings by the Surrealist painter René Magritte, filling more than half of the 150 pages. The cover copy tells the simple truth without flourishes.

> Walking through a retrospective exhibition of a painter he espe-
> cially likes, the writer is impelled to borrow from the paintings cer-
> tain objects, certain stories. The figures come to life, the repetition
> of a theme turns into a diachronic development, the title of a pic-
> ture turns into a password . . .

In other words, Robbe-Grillet has assembled out of or "after" Magritte a loosely interlocking universe of European hotels, prison cells, cafés, classy crime, beautiful young girls, and sinister old men. He passes from one sequence to another as easily as Alice in her Wonderland—by floating through a keyhole, by dissolving the action into memory images, or by simply quoting another piece of writing encountered along the way. Robbe-Grillet "generates" (as he says) a fiction, the way old music-hall singers would throw together a medley out of tunes suggested at random by members of the audience.

> But I come back to my story: in the next room . . . the murdered
> mannequin now lies on a long lacquered table—already described.
> On the floor, in the foreground, sits an old-fashioned phonograph
> with a large horn, of about the same vintage as the sewing machine
> mentioned earlier. Next to this last, and almost touching the blond
> head of the young girl, a slightly older man leans with a distraught
> hand on the back of the lacquered chair. He may be the murderer,
> even though he looks exactly like the two plainclothes police officers
> waiting behind the door in the hallway . . . Since his back is to the
> window, he has not yet caught sight of the female figure that has
> just appeared in the window opening, behind the balcony. Smiling,
> clad only in a filmy beach robe . . . it is she who holds knee-high
> by the end of its thorny stem a red rose whose open corolla hangs
> downward.

> Immediately the idea presents itself that the new arrival could be
> Lady H-G in person, and that the two adolescents in the room are
> her own children, the famous twins, David and Vanessa.

It goes on and on like a disjointed yet inexplicably seamless mosaic. Robbe-Grillet's meticulous deadpan style seems to bond directly

with the ominous mood and empty clues of Magritte's phantasms. The visual-verbal match here is as sophisticated as Töpffer's comic strips are childlike.

Robbe-Grillet's *La Belle captive* (with attached paintings) and Christo's *Running Fence* (with attached film) are extreme yet representative examples of the artistic form of experiment. Like Baudelaire's *Glazier* they depart from traditional norms of unity, scale, and verisimilitude "in order to see what will happen." There is a tendency in contemporary criticism with its linguistic models and mythological leanings to seek deep meanings in such works. Signs lurk everywhere. Incoherence must be kept on a short leash. Yet I believe we need not look too far afield for explanations.

In 1865 the Goncourt brothers published *Manette Salomon*, a fictionally weak but historically informative novel about the life of artists in the mid-nineteenth century. Near the opening, they devote three lyric pages to characterizing the principal mood that bursts out of the teeming studios of Paris and inspires Anatole, their ill-fated hero.

> *La Blague*—the great Joke, that new form of French wit, born in artists' studios . . . raised amid the downfall of religion and society . . . the modern version of universal doubt . . . the nineteenth-century Blague, the great sapper and revolutionary, poisoner of faith and murderer of respect . . .

Despite its effusiveness, the passage brilliantly identifies a strong current of feeling that flowed close to the surface of nineteenth-century art and literature. Courbet and Cézanne and Baudelaire also spoke of *la blague*, often when they were talking most intensely about their own work. The cabaret spirit of mystification and hoax hovered in the wings of Impressionism and Symbolism and Cubism. In his letter of October 8, 1852, to Louise Colet, Flaubert catches the highest and purest form of this spirit. "When will we begin to write from the point of view of a *superior joke* [*une blague supérieure*], that is, as God sees everything from on high?" The Goncourts recorded the circumstances through which three successive revolutions in France produced *la blague* as a major self-protective response among artists, a form of cultural desperation masquerading as cynicism. When asked by some German students to describe his own character, Courbet in 1858 whipped off a self-caricature as a clay pipe hanging on a nail with the inscription "*Courbet, sans idéal et sans*

religion." The crucial scene in Huysman's "decadent" novel, *A rebours (Against Nature)* describes Des Esseintes's "pepsin enema" to save him from self-inflicted starvation. In Jarry's 'Pataphysics and Duchamp's ready-mades, in the whole Dada caper, mystification assumes the status of high seriousness.

Here is the line that will help us place the two contemporary works I have described. Christo's *Running Fence* is in part a mammoth lark, a spoof-wager that both defied and exploited a divided art establishment, hesitant capitalist backers, and the skepticism of property owners in Marin and Sonoma Counties, California. The best response to its sheer entrepreneurial brio and evanescent beauty is a great barbaric yawp like Whitman's. On a much smaller scale Robbe-Grillet is also a crypto-comic writer seeking the guffaw. "The writer is impelled to borrow . . ." he explains vaguely on the cover of *La Belle captive.* To a large degree it is the experimental spirit of *la blague* that impels him to adopt the permutative structure of that narrative and others like it. However, Christo and Robbe-Grillet are not unknown studio bums on the fringes of society, like Anatole in *Manette Salomon.* They are well-established figures with reputations, playing to a substantial audience of intellectuals, students, and professionals. Clearly there are some pieces missing in my story.

3

In order to explore why in the modern era established and presumably "serious" artists have worked so close to the edge of laughter and *la blague,* I think we must turn to a more fundamental term than "experiment." In *The Art of Poetry* Horace wrote briefly on the charms of novelty, by which he meant departing from Greek models. In a later classic era Corneille justified his unconventional poems in *Don Sanche* by murmuring in the dedication that we all know "how the French . . . love novelty." When Milton proclaimed at the start of *Paradise Lost* that he was launching himself into an epic style on a Christian subject, "things unattempted yet in Prose or Rhime," he was echoing Ariosto's identical claim at the beginning of *Orlando Furioso* and also passing on the same phrase to Fielding for use in the first paragraph of the preface to *Joseph Andrews.* Both Montaigne in "On Repentance" and Rousseau in his *Confessions* claim to be the first in the field with an utterly faithful self-portrait;

neither refers to St. Augustine. In *The Philosophy of Composition* Poe speaks of "keeping originality *always* in view." Cézanne's biographers record that as a young provincial ill at ease in Paris cafés he would declare belligerently, "The day will come when one original carrot will be enough to start a revolution."

The ideal that emerges with growing urgency in Western art and literature is *originality*.* We still have no comprehensive account of this master idea, related to yet different from progress. Without attempting such a history I believe I can suggest the complexity of originality as a concept. As we have come to use it, the word contrasts with three opposing notions that deserve distinction: imitation of a model, banal or routine behavior, and correctness. Imitation and innovation were long thought of as complementary human faculties, a combination that has given human beings dominance over other species. Imitation, however, probably has some kind of priority in both individual and social development. In *Social Change and History* Robert A. Nisbet puts it very bluntly: ". . . it is not change but persistence that is the 'natural' or 'normal' condition of any given form of social behavior."

When, at an advanced stage of culture, we reverse the balance and attach positive value to originality, the new attitude encourages departures from routine patterns of behavior and thought and provokes the response of surprise. Dr. Johnson's oddly ambivalent remarks on *Paradise Lost* display a shrewd awareness of this shift: "These truths are too important to be new . . . Being therefore not new, they raise no unaccustomed emotion in the mind; what we knew before, we cannot learn; what is not unexpected cannot surprise." The value of a surprise or shock was fully acknowledged in Montesquieu's aesthetics. "Surprise is the genuine principle of

* It may be that the earliest recognitions of originality as a cultural value came during the stylistic revolution under Akhenaton in Egypt in the XVIII Dynasty and in the deliberate innovations of the Alexandrian coterie poets of the third century B.C., particularly Lycophron and Callimachus. Then there is the very word "original." In the Middle Ages, as many scholars have pointed out, it meant "having existed from the origin of things." By the eighteenth century it had reversed itself to mean "without earlier origin, independent, novel"—and when applied to a person, "bizarre, extravagant." (In French the existence of two spellings makes the contrast even more emphatic.)

As if to underscore this change, the word "art" underwent a parallel shift—from "mastery of a traditional skill or craft" to "created as a work characterized primarily by originality and individuality."

beauty," he wrote in *An Essay on Taste*. This recognition of the need to break the traces of habit and the commonplace can be followed through the Romantics to Bergson, the Russian Formalists, Apollinaire, Gestalt psychology, and late Freud. *Beyond the Pleasure Principle* sounds like Montesquieu reworded: "Novelty is always the condition of enjoyment." Modern information theory aspires to measure originality in equations, where it varies inversely with both intelligibility and banality.

In literature and the arts, these first two meanings of originality take the further shape of resistance to conventions, forms, and genres, the rejection of anything formulaic or stereotyped, of good taste and rhetoric. In the twentieth century we have lost any firm sense of what Pope and Dryden worked hard to define and practice: the principle of *correctness*. Our spiritual restlessness and psychological mobility lead us to draw back in scorn from anything considered to be correct or conventional. We think we wish to be free of constraints.

Originality aspires to the new, the unprecedented; even Dr. Johnson hoped to be taken by surprise. Just what does that mean for an artist watching the field around him? Let me quote an interview with a widely respected contemporary artist. This sentence from George Balanchine might have been said by hundreds of contemporary artists: "Only the *new* concerns me; I'm not interested in the past." We must ponder such words. Behind the bad faith and professional irresponsibility of the statement lies an unwillingness to acknowledge the dependence of the new on the old. For how can any artist recognize or create what is new unless he knows the old, the occupied ground he avoids, the competition he must outstrip? In an essay called "The Aporias of the Avant-Garde," Hans Magnus Enzensberger included a masterful polemic about the reliance of every "advanced artistic movement on the arts of the past." Since the mid-nineteenth century, he writes, "the arts are cognizant of their own historicity as stimulant and threat." Balanchine's case is exemplary. In his youth he received superb conservatory training in music, the arts, literature, history, and languages. The past he appeared to scorn surrounded him in the form of scores, books, and paintings. His originality as a choreographer derived not from ignorance but from knowledge and from close familiarity with the dance performances he had seen throughout his long career. Without that heritage, dance itself would have no status as an art form nor any means of nurturing in its own bosom the dynamic principle of originality. The most

daring innovators rely constantly on critics, scholars, and less experimental artists who, it is assumed, will tend the store and keep the traditions and conventions in place. For something must provide the ground against which original works can be picked out in dramatic contrast. An avant-garde gains its special status from its adversary relation to the main body of the culture to which it is reacting. Behind his lofty tone in *The Revolt of the Masses* Ortega y Gasset found the nub of this relation. "The cynic, a parasite of civilisation, lives by denying it, for the very reason that he is convinced that it will not fail."

The fact that modern art, free as it is, remains dependent on a persistent culture for its status exasperates many individuals dedicated to original creation. That exasperation has contributed to what I call the Demon of Originality. The Demon possesses a wide range of intellectuals, including the humble graduate student from whom we have the temerity to expect "original research" and the gifted young painter or sculptor looking for an entry into the overcrowded world of art. To understand the Demon of Originality we will do best to stay with historical cases.

There is a famous (and probably authentic) letter by Mozart in which he describes how he composed entirely in his head and could hear the parts *gleich alles zusammen*. Afterward he had merely the mechanical task of copying it all down. But why, then, was his music so characteristically "Mozartish"? He concludes the letter: "I really do not study or aim at any originality." He uses the word only to insist that novelty for novelty's sake, the refusal to imitate existing forms, played little part in his work. A wonderful aesthetic tranquillity presides over Mozart's irrepressible inventiveness.

A hundred years later, a young French artist provides a revealing statement of the opposite attitude: the obsessive pursuit of the new before all else. Seurat was convinced that he had created, singlehanded through his scientific investigations, the technique of "optical painting." What Seurat wrote in August 1888 to his friend Signac on the subject has none of Mozart's serenity.

> The more of us there are, the less original we will be, and when the day comes that everybody begins using this technique, it will have no further value and people will look for something new—which is already happening. It is my right to think this and say it, since I painted this way in order to find something new, a kind of painting that would be my own.

The only way to carry originality any further would be to keep everything secret, to publish nothing—or to eliminate everyone else.*

But why the *Demon* of Originality? Is any dangerous or sinister element at work? Shouldn't we be satisfied with Harold Rosenberg's deft, paradoxical title "The Tradition of the New"? A longer historical perspective than his, I believe, will afford some insight into the paradox that surrounds originality and will bring out the demonic element I wish to emphasize.

Aware of its experimental and even revolutionary character, Diderot did not publish *Rameau's Nephew* during his lifetime. Modern writers since that time have read it attentively, including philosophers from Hegel to Freud. The dialogue revolves around the character of a small-time musician and salon-mimic who chafes under his borrowed identity as the nephew of a great genius. In his non-stop performances and posturings the imitative faculty that normally serves social stability and continuity overreaches itself and becomes self-destructive. The nephew lacks his uncle's genius; he is only an *original*, an eccentric. Diderot's radical anatomy of social behavior, which could appropriately be called "the Paradox of Originality," creates not a character but a full-fledged caricature. The nephew personifies a man driven by his limited gifts and insecure social status to practice originality for originality's sake. His hyperactive energy bursts through his cynicism and his *ennui* to give him demonic force.

In 1805 Goethe discovered and enthusiastically translated Diderot's manuscript. Its matched themes of boredom and compulsive originality pervade *Faust*, in which the central action has been transposed from jealous nephew (Mephistopheles) to uncle of genius (Faust). We are all implicated. The demonic goads Faust to forms of secular striving and greatness that Rameau's nephew only babbled about. Neither story offers any repose, any possibility of lasting achievement or satisfaction. For there is no final goal or salvation. Temporal transcendence devours its adepts, whether fools like Rameau's nephew or geniuses like Faust.

* This dog-in-the-manger attitude, this tight metaphysical jealousy, crops up in revealing places. In *Philosophy in the Boudoir* Sade has Dolmancé express the sentiment that he would "like to be the only one in the world able to feel what he is feeling." Nietzsche gives the thought a slightly different twist in *Beyond Good and Evil*: "One loses love for one's knowledge as soon as one has communicated it."

We already know how Baudelaire took these themes of *ennui* and compulsive originality and reduced them to the tragicomic dimensions of prose poem with flower pot. The "delicate monster" of boredom provokes us to a form of transgression known as originality, which dares us to tamper with the givens of life. From this perspective we begin to grasp the crux of Coleridge's lengthy meditation in *Aids to Reflection* on original sin and free will.

> . . . it is evident that the phrase, original sin, is a pleonasm . . . For if it be sin, it must be original; and a state or act, that has not its origin in the will, may be calamity, deformity, disease, or mischief; but a sin it cannot be.

Coleridge seems to be punning, testing the wobble in the term "original" at the very moment it was going through its shift. In effect, he is reinforcing the association of originality as free choice with the demonic, with sinful transgression.

The case of Roland Barthes demonstrates how close the Demon lurks in our day to the fundamental operations of perception and judgment. In the preface to *Critical Essays* Barthes defines "literariness" as the writer's need to vary an otherwise banal message in order to communicate effectively. "Originality is the price one must pay for the hope of being taken to heart (and not just understood) by the person who reads you." Ten years later in *The Pleasure of the Text* he declares his position even more strongly in a context not of communication theory but of personal confession. Barthes admits to deriving pleasure from many kinds of reading. "But I reach full gratification [*jouissance*] only in response to absolute newness, for only the new displaces (weakens) consciousness." This is no joke; it is a declaration of faith.

4

The Barthes case takes us a step further toward understanding another aspect of our present juncture. A few pages after the above quotations Barthes seems to turn against the source of his most lasting enjoyment. "Art appears compromised, historically and socially. Whence the attempt of the artist himself to destroy it." Why, as time goes on, has originality seemed to carry the arts and literature and even criticism in a self-destructive direction? How and why did

we reach anti-art as a major category of art? What I have said so far about *la blague*, parasitism, and the demonic gives us only a preliminary perspective.

It's hard to pick a starting point. In 1883 at the Arts Incohérents exhibit, the humorist Alphonse Allais framed and hung a perfectly blank piece of white cardboard (*Bristol*) and gave it the title *First Communion of the Chlorinated Young Ladies during a Snowfall*. It should have been outrageous. Yet at the time people paid no more attention to this small-scale in-house art witticism than they had to Courbet's self-caricature as a clay pipe. The later chapters of anti-art are better known—Jarry's *Ubu Roi* (1896), Duchamp's *Bicycle Wheel* (1912), and Futurist and Dada antics all over Europe and in New York (1908–22). After a breather for more urgent activities in the thirties and forties, the strain reappeared in Pop art, the New Novel, and Happenings. Profiting from the work of many predecessors, Christo's *Running Fence* and Robbe-Grillet's *La Belle captive* pick their methods and effects with great care. They are not twitting some marginal aspect of art, as Allais was doing. The butt of their elaborate *blague* is the very cultural category that gives their work a habitation and a name: high or fine art. How else is one to receive such artistic constructs as a temporary fence built across other people's land or a "story" as deliberately incoherent as a game of jackstraws about characters with no manifest humanity? The expense of effort and money behind these works is directed toward dismantling our conventional idea of art as something endowed with form, coherence, significance, and permanence. The German writer Peter Handke sings it right out.

> The progress of literature seems to me to consist in the gradual removal of unnecessary fictions . . . the story becomes superfluous, what matters more is the communication of experiences, linguistic and non-linguistic ones.

We are apparently reconciled to a permissive aesthetic of erasure and cancellation, of which Duchamp was the master.

However, there is another approach to the anti-art aesthetic that requires us to entertain a disturbing and uncertain hypothesis about contemporary Western culture. Let's call it the *cul-de-sac* or deadend hypothesis. The prevailing view today, rooted in concepts of evolution and progress, envisions an infinity of discoveries still lying

ahead of us in art as in science, in personality and politics as in technology. For presumably we have barely grazed the surface of our neural and mental potentialities and of the real world in which we live. Experiment and originality in all domains explore only the immediate frontiers around the tiny point we occupy in the infinity of evolutionary time-space. We think and dream in terms of an expanding mental and physical universe forever outrunning our most extravagant imaginings.

But do we know this is the case? Have we examined the evidence? What is the evidence? What would be the consequences for our thought and activity if we felt a limit could be reached, that the universe is finite after all, and that we might already be approaching a *cul-de-sac*, a flattening of the curve of invention? Before the Quarrel of the Ancients and the Moderns was won three centuries ago by the Moderns, men and women were brought up to believe that the heroic achievements in all domains lie in the past. Listen to Swift again digressing on digressions in *The Tale of a Tub*. He is talking about precisely that quarrel, the seventeenth-century version of our present debate over originality and experiment. Swift even sounds a little like an ancestor of Seurat's dog-in-the-manger attitude.

> Now, the method of growing wise, learned, and sublime, having become so regular an affair, and so established in all its forms, the number of writers must needs have increased accordingly, and to a pitch that has made it of absolute necessity for them to interfere continually with each other. Besides, it is reckoned that there is not at this present a sufficient quantity of new matter left in nature to furnish and adorn any one particular subject to the extent of a volume. This I am told by a very skilful computer, who has given a full demonstration of it from the rules of arithmetic.

In the great century of freedom and discovery, Swift could write a dry mock about the overpopulation of scribblers and the exhaustion of subject matter. He sounds anything but worried.

It is possible, however, that we can no longer laugh with the same confidence. In *Paradoxes of Progress* (1978) the molecular biologist Gunter Stent writes earnestly and courageously on this neglected subject. Stent assembles evidence from the arts and sciences to suggest the diminishing returns of the search for the new in both domains. For example, what is created in post-tonal music or dis-

covered in subatomic physics appears to draw increasingly on chance phenomena and indeterminism rather than on causality and order. The resulting products—art works and scientific theories—do not appeal to common sense and therefore have diminished human appeal or significance for most people. According to Stent, Gödel's theorem may have made mathematics infinitely open-ended, but only in terms of undecidable propositions increasingly remote from any kind of reality principle. The social sciences are least likely to offer us significant laws because statistics about human behavior produce more noise than signal. Stent is neither philistine nor reactionary. He asks unfashionable questions. His book implies that the ideal of originality in all our enterprises may have reached the limit of its usefulness. He does not propose a response to the changed situation.

The only other contemporary author who, to my knowledge, confronts this hypothetical limit on discovery in the arts and sciences calls his book poetically and ominously *The Shape of Time* (1962). A historian of art and architecture, George Kubler includes in his last chapter a section on "Finite Invention."

> Radical artistic innovations may perhaps not continue to appear with the frequency we have come to expect in the past century. It is possibly true that the potentialities of form and meaning in human society have all been sketched out at one time and place or another, in more or less complete projections . . .
>
> Should the ratio between discovered positions and undiscovered ones in human affairs greatly favor the former, then the relation of the future to the past would alter radically. Instead of regarding the past as a microscopic annex to a future of astronomical magnitudes, we would have to envisage a future with limited room for changes, and these of types to which the past already yields the key. The history of things would then assume an importance now assigned only to the strategy of profitable inventions.

The revolutionary prospect Kubler asks us to contemplate implies a shift by which invention and experiment would be largely replaced by history and archaeology. Are we now approaching this change? Behind its romantic pretensions, Michel Foucault's work on the archaeology of knowledge is probably symptomatic. Are artists subliminally aware of the predicted flattening of the curve of invention? Even without an answer, such questions are well worth considering. We do not know, furthermore, how far our own

actions and attitudes affect the kind of tidal movement in cultural history that is being proposed here.

I will venture two comments on the *cul-de-sac* hypothesis as presented by Stent and Kubler. First, the sobering possibility that nearly everything has been done, that "there is nothing new under the sun," helps explain the kind of artistic behavior that, for lack of other avenues of achievement and originality, turns against its own medium, undermines painting and literature as privileged activities, and seeks to destroy the category of art itself. It looks like an act of desperation provoked by an impasse. To destroy the ground we stand on, the atolls of art slowly accumulated over the centuries, would be the ultimate experiment—a risk not yet calculated that could direct us back toward the zero point, a gratuitous act expanded to the dimensions of the culture itself. We have already tolerated body artists who practice this operation on a small scale by maiming themselves. Self-consuming art objects are no longer a joke when they aim at discrediting art itself as an activity. Have we put ourselves unthinkingly on a self-destruct course? Extending this perspective, can we detect strains of demonic self-destruction in the staggering and competitive research programs we support in weaponry, medicine, genetics, space travel, subatomic physics, and astronomy? We act as if beneficial and limitless new discoveries await us in all these areas, but do we believe it? It could be argued that we are undertaking in the name of original research and technological progress enterprises whose success will wipe out many of the human values we seek to defend. It is presumably by our originality and inventiveness that we will outstrip the Soviets. But at what cost? The Demon of Originality drives our research budgets as fanatically as it inspires Christo, or Robert Wilson, who creates ever more grandiose, extended, multimedia spectaculars as if to defy Aristotle's precept that art should be of a certain magnitude, namely human.

My second comment complements the first. The *cul-de-sac* hypothesis may exasperate the Demon of Originality to provoke acts of desperation and destructiveness, as I have suggested above. The same hypothesis, however, may partly extirpate the Demon. The idea that a cycle of Faustian discovery is coming to an end can serve as a corrective to our romantic notions of progress and soul error—the constant search for a utopian elsewhere. Without postulating a Golden Age in the heroic past, we can at least consolidate

our idea of ourselves as continuous with a partially knowable history from which we learn much about our condition. The change in outlook required by such a reorientation is not easy for us to assimilate. Anthropologists inform us that among the Bolivian Quechua a person is conceived as moving through time backward—that is, with the past visible in front of him, the future invisible behind him. No one can deny the logic of this picture. Modern man speaks of the past as behind him—gone, obsolete, soon out of sight, dead—and of the future as "the prospect before us." A responsible education will dramatize the strengths and weaknesses of both perspectives.

We shall not soon know whether the *cul-de-sac* hypothesis will hold up. But merely to formulate it and meditate on its implications will help us tame the powerful and overindulged Demon of Originality.

The Tortoise and the Hare: Valéry, Freud, and Leonardo da Vinci

1

In the last chapter of Bertrand Russell's *Wisdom of the West* (1959), one comes upon two superbly chosen illustrations on facing pages. On the left Marie Curie stands pensive in her austere laboratory waiting to get back to work with her electrical equipment. On the right Sarah Bernhardt, with an expression of infinite longing and infinite boredom, leans her handsome head on her arm amid the bric-à-brac of her histrionic sensibility. We chuckle over the neatness of the juxtaposition and comprehend the opposition it stands for of two sensibilities, two ways of reckoning with life and reality. (Accepting the convention, encyclopedias and biographical dictionaries make much of the actress's amours and conveniently omit mention of the turbulence and public scandal of the scientist's private life precisely at the moment she received her second Nobel Prize in 1911.)

A comprehensive account of how Western thinkers have divided the mind into different components or faculties or dispositions would make absorbing and revealing reading. The limited corner of that history I propose to discuss goes back to the seventeenth century at least. After Descartes had done his best to separate the thinking mind from the vagaries of the body, Locke attempted to fuse bodily sensations with mental ideas in order to affirm a near-mechanical continuum. Between Descartes and Locke there appeared the scientific child prodigy and Christian mystic, Blaise Pascal, a few of whose *pensées* opened a fissure in the midst of thought itself without reference to the body. Pascal's distinction between *l'esprit de géométrie* and *l'esprit de finesse* remains difficult to translate or define and undergoes disconcerting shifts in his own writings. Yet his celebrated pairing, which implies a division of the mind into a rational, analytical faculty and an instinctive sensibility has left its mark on Western thought. Pascal seems to have named a phantom separation of powers within the mind.

After the seventeenth century it is possible to trace a deepening split in the higher levels of culture. A scientific cast of thought bent on reducing all phenomena including man to material causes, mathematical principles, and (after Darwin) chance operating within a vast expanse of geologic time, stood opposite a widespread faith in feeling, instinct, the spirit, and the irreducibility of life and humanity to material causes. Some of the greatest modern thinkers, like Diderot, Goethe, and Coleridge, contain both strains. A sentence from Madame de Staël's *On Germany* (1800) marks the extreme to which the Romantics carried the latter tendency. "In effect, when we abandon ourselves completely to reflections, images, and desires that surpass the limits of our experience, only then do we begin to believe freely." The traditional conflict between faith and reason gave way to a modified conflict about the very faculty with which we should encounter experience: reason or feeling, intelligence or sensibility.

The portraits of Marie Curie in her laboratory and Sarah Bernhardt in her studio stand not only for two types of woman but also for Pascal's division in the mind as it can be discerned at the end of the nineteenth century. The contrast leads one to wonder what rearrangements of the furniture of ideas accompanied this conventional dualism. Instead of examining the work of Nietzsche or William James or Bergson, all of whom were deeply concerned with

the question, I shall proceed in a different direction. Which great thinkers or artists of the past were receiving particular attention at the turn of the century? Aristotle? Jesus? Dante? Montaigne? Goethe? All of them, of course; we know no reliable method of measurement to ascertain the intellectual heroes of an era. Yet one means of discovering what people were thinking, writing, and reading about is to inventory the titles of books published. My investigations have yielded this unexpected result: between 1869 and 1919 an average of one full-length book per year was published in Europe on the subject of Leonardo da Vinci. (The number excludes the numerous editions of Leonardo's own writings, and also excludes translations and the flood of articles in reviews.) The list of some fifty items includes the following authors: Bernard Berenson, Jakob Burckhardt, Pierre Duhem, Sigmund Freud, Arsène Houssaye, Edward Mac-Curdy, Dmitri Merezkovski, Walter Pater, Péladan, Smiraglia-Scognamiglio, Gabriel Séailles, Edmondo Solmi, Paul Valéry, and Lionello Venturi. If we set aside the institutionalized figure of Jesus, no other human being, historical or imaginary, appears to have received so much systematic and widely disseminated attention from Western culture during the fifty years under scrutiny.

Now here is a raw piece of information to fit into place. But the job is not easy. In most of these writings, and in the books that have continued to appear about him in slightly diminished numbers, Leoardo emerges as the great ambiguous figure of all time. The impression one comes away with is something like a cross between Benvenuto Cellini and St. Francis of Assisi. What was Leonardo's sex life? Was his real preoccupation magic, or science as we know it? Was he the mere creature of his patrons or a great independent mind? Do his notebooks give us the fragments of a supremely organized consciousness or the best efforts of a distraught talent? Does his art serve his science or his science his art? In his restless career and spottily preserved work, should we read triumph or tragedy? I shall not attempt to answer these questions. In the face of so great a bulk of publication on Leonardo, my attention gravitates irresistibly to two books that are the shortest on scholarship yet the most revealing of a particular strain of thinking—in Leonardo's mind, in their authors' minds, and in the climate of an era. The names Paul Valéry and Sigmund Freud stand for two of the most independent, courageous, and productive intelligences of recent times. What they wrote about the great Italian, apparently unaware of each other's work,

carries us off on two fruitful expeditions that reach adjoining countries by different routes.

2

Paul Valéry wrote and published his earliest poems before he was twenty, while still a law student in Montpellier. His mind had been attracted very early to the study of architecture, painting, mathematics, and physics, and to works of Poe, Huysmans, and Mallarmé. Through the writer Pierre Louÿs, he came to know Mallarmé, then entering his fifties, and Gide, just Valéry's own age. In 1892, at the age of twenty-three, he underwent a kind of conversion in reverse, a period of profound self-doubt leading to a night of turmoil in Genoa. Subsequently he turned away from poetry toward further study in the sciences and history. It was twenty years before he returned to literature with a succession of poems, essays, notes, translations, introductions, and plays that made him the leading poet of France in the thirties and forties. He bore the major responsibility for keeping the French Academy free of taint during the German Occupation. His elaborate state funeral in 1945 symbolized the country's resolve, following the Liberation, to reaffirm its great intellectual and artistic tradition. Valéry wrote six different texts on Leonardo at approximately even intervals throughout his career. The first two are the most important, *Introduction à la méthode de Léonard de Vinci*, begun in 1894 soon after his detachment from poetry, and *Note et digression*, added to the previous work when it was republished in 1919. In 1929–30 he wrote extensive marginal notes to these two early texts and to a third written in 1928, so that today they appear as a palimpsest, the apt representation of a mind that could endlessly develop and transform any subject by bringing attention to bear on it.

Valéry opens the *Introduction* by stating flatly that neither the biography nor the personality of Leonardo concerns him. Rather, he will examine a method of thinking or a "creature of thought" to whom, because it appears the most appropriate, he assigns the name Leonardo. In prose so dense that one can feel the sustained cerebration that formed it, Valéry describes an elevated, universal, and perpetually self-correcting Mind. Its secret is to grasp "relations . . . between things whose principle of continuity escapes the rest of us." Thus, for both Leonardo and Napoleon, "at the crucial moment

they had only to act." This hypersensitive ability to see connections is rendered bearable by a compensatory mechanism of "foresight" that carries every train of thought instantaneously to its limit, a heightened capacity for compression and comparison. Valéry is somewhat hard put to explain the operation of this form of consciousness. What he says about how thought organizes undifferentiated impressions resembles Taine's theory of *hallucination vraie*. He seems to be on firmer ground in considering the two complementary faculties of universal thought: to identify with individual things—a strong sense of particularity in the world—and to recognize regularities in the world: continuity, similarity, periodicity. The truly great mind exercises these faculties at a speed so high as to appear instantaneous, yet remains at least partially conscious of the mental operation taking place within it.

Valéry's undulating reflections on the nature of thought and subjectivity make difficult reading. In a curious way, though Valéry's theory of mind is diametrically opposed to that of biologically oriented behaviorists and sociologists, what he writes often sounds like an elaborate restatement of the dictum: "Mind is minding." But the crosshatch and chain stitch of his style convey Valéry's perpetual refinement of such an equivocation. The pure activity, the mere free play of mind is as exciting and as productive as any externally imposed purpose or special discipline. This in fact is the point with which he begins the later essay *Note et digression*. He swoops back down on Leonardo as the "leading actor in the intellectual comedy which never to this day has found its poet." In a less clotted, more transparent prose, Valéry reaffirms this judgment of the "integrity" of Leonardo as a mind, never torn between a naturalistic and a spiritualistic sense of man. But another, more subtle division lurks within, for which Valéry offers the expression "presence of mind." He illustrates the delicate circular equilibrium of this self-awareness with two metaphors: first, the swirling drafts that form a smoke ring, and second, the stage of a theater surrounded by a hidden but distinctly real audience. Finally, these two easily grasped figures are plunged together to a deeper level of discourse and of mind:

> The character of man is consciousness; and the character of consciousness is a perpetual emptying, an unremitting unsparing detachment from everything that appears, no matter how it appears. An inexhaustible act independent of the quality or number of things that present themselves, and by which the *man in the mind*

[*l'homme de l'esprit*] must knowingly restrict himself to being an indefinite refusal to be anything at all.

Before this endless self-repulsion of mind, all things are equal. What survives, the pure impersonal self of consciousness, sounds to Valéry like the very bass note of our existence. Leonardo represents this intensified and complex presence of mind; he is as much the result, Valéry concludes, as the cause of his works.*

In these two texts and the later ones, Valéry has composed variations on a single theme: the miraculous variety of Leonardo's work springs from a highly developed singleness of mind or unity of thought. Examined in itself, apart from the works it strewed along its path, this astonishing mind reveals the nature of the self, not personality or biography but pure consciousness beholding an infinity of relations in what it sees and perpetually backing away from what it sees in the very act of beholding.†

At the end of the first essay on Leonardo, Valéry quotes (inaccurately) a sentence in which, he submits, Leonardo has expressed a purely modern concept:

L'aria è piena d'infinite linie rette e radiose insieme intersegate e intessute senza ocupazione l'una dell'altra; rapresentano a qualunche obbietto la vera forma della lor cagione. [*I Manoscritti di Leonardo Da Vinci*. Il Codice A, 2172; Man A, fol 2. Roma, 1923]

The air is full of infinite, straight, radiant lines crossing and interweaving without one ever entering the path of another, and they represent for each object the true FORM of its cause.

Valéry relates this sentence to the undulatory theory of light, to the old absurdity of "action at a distance" in gravitational theory, and then successively to the work of Faraday, Maxwell, and Lord Kelvin. Remember, this is a disaffected poet aged twenty-three writing in

* Anyone who has read *Being and Nothingness* will perceive the extent to which Valéry's idea and vocabulary in this passage anticipate Sartre's description of the *pour-soi*. Jean Hippolyte was the first to notice the unexpected resemblance. ("Note sur Paul Valéry et la crise de la conscience," *La Vie Intellectuelle*, March 1946)

† An earlier treatment of this theme appears in *An Evening with Monsieur Teste*, Of this work about another "master of his own thought," Valéry later wrote: "I think there is also in it a kind of transposition out of art and a unification of Leonardo da Vinci and Mallarmé." The figure of Descartes also lurks behind both figures. The best treatment of the literary and philosophical value of these two works by Valéry is in Francis Scarfe's book.

1894, when the results of the Michelson-Morley experiment six years earlier had not yet gained universal acceptance. He was discovering in Leonardo da Vinci an early formulation of field theory, something that had not yet taken clear shape out of Maxwell's electromagnetic theory published twenty years before. Edmund Wilson has pointed out in *Axel's Castle* the evident vanity in Valéry's parading of scientific materials in much of his writing. But here Valéry sums up in one all-encompassing idea the various aspects of consciousness that he has brought out earlier: rigor, continuity, compression, contrast, symmetry, regularity. Himself of course an outstanding example of the mentality he was exploring, Valéry saw the relation between the infinity of visible connections among all things apparent to a supremely attuned imagination like Leonardo's, and the infinity of physical connections among all things soon to be established by field theory. This essay on a Renaissance subject is less historical than prophetic.

The word that chants the refrain in Valéry's series of texts on Leonardo is "continuity." And in the quoted passage expressing a vast unity of creation, Valéry is expanding and refining into scientific terms the now commonplace doctrine of *correspondences*. Its recent history goes back to Swedenborg, Fourier, Novalis, Blake, Baudelaire, and Yeats. But Valéry made bold to transpose the idea of discontinuous and analogical correspondences, parallels among different things, into the idea of a continuum, a single medium or field displaying modifications that we call "things" yet not separable into different entities. In these pages the mind is one as, some ten years later, space and time would be affirmed as one in the special theory of relativity. And Valéry concludes the 1919 text with a reference to the problem of the existence of intelligences outside our own as being "comparable to the physical problem of relativity."

3

Until 1910 Freud's theory of mind had stressed the division between primary or instinctual thought processes operating according to the pleasure principle and secondary or inhibitory thought processes observing the reality principle. The last chapter of *The Interpretation of Dreams* gives the best systematic account of the two processes, and one still hears in this work, finished in 1900, the professional neurologist both urging on and cautioning the vigorous young analyst. The chapter in question, once it has established the

two thought processes and the areas of consciousness and uncon-
sciousness they rule, pays lengthy attention to the principle that
guards the frontier: repression or censorship. Gradually, however,
Freud shifted his attention from separation to communication be-
tween these areas. The last of the Clark lectures, delivered in 1909,
contains at its close a fine paragraph that recognizes the previously
little-mentioned process of sublimation as psychically and socially
valuable. "It is probable that we owe our highest cultural successes
to the contributions of energy made in this way to our mental
processes." Within a few months Freud began to work on Leonardo.

Freud was over fifty when he wrote his first and only psycho-
analytic biography. The subject was not new to him. "Perhaps the
most famous left-handed individual was Leonardo," he had written
in a letter in 1898, "who is not known to have had any love affairs."
A questionnaire in 1907 revealed that Merezkovski's novel *The Gods
Reborn: Leonardo da Vinci* was one of Freud's favorite books. Then
in 1909, right after the Clark lectures, he was consulted by a patient
whose temperament strongly resembled that of Leonardo, though
without the Italian's genius. Impelled from so many sides toward
Leonardo, Freud bought several works on him and began extensive
reading. It was only at this point that he discovered the text of Leo-
nardo's remarkable childhood recollection. That brief passage pro-
vided the framework for the study entitled *Leonardo da Vinci and
a Memory of His Childhood*.

The disclaimer with which Freud begins differs from Valéry's.
The fact that he is studying Leonardo, Freud tells us, does not sug-
gest that the great Italian genius was a pathological case or even
represent any desire to detract from his fame. Freud affirms he is
concerned with "laws which govern normal and pathological activity
with equal cogency." The problem Freud first poses is the apparent
interference that occurred between Leonardo's investigative activities
and his painting, between scientist and artist. The first and longest
of the six sections advances the thesis that Leonardo's truly excep-
tional capacities as an experimental investigator, unimpeded by the
authority of either church or antiquity, can be traced in great part
to his childhood, through the theory of sublimation. "After his
curiosity had been aroused in infancy, he succeeded in sublimating
the greater part of his libido into an urge for research." His notes and
his behavior show that he felt compelled "to love in such a way as
to hold back the affect, subject it to the process of reflection." This
instinct for knowledge, though it channeled his genius, in the end

affected the free play of his artistic expression. What was left of his childhood sexuality, Freud supposes, expressed itself as sublimated homosexuality.

The remaining pages flesh out this hypothesis with a brilliant, though often factually unsupported, demonstration. Freud quotes from a German translation the famous sentence from the *Codex Atlanticus* given by Scognamiglio:

> It seems I was always destined to be so deeply concerned with vultures; for I recall as one of my very earliest memories that while I was in my cradle a vulture came down to me, and opened my mouth with its tail, and struck me many times with its tail against my lips.

Freud interprets it as a passive homosexual fantasy of fellatio transferred to infantile suckling. Unfortunately, "vulture" is a mistranslation of *nibio*, which means kite; part of Freud's more elaborate bird and mother symbolism collapses as a result. He reconstructs a plausible but unprovable portrait of the illegitimate infant Leonardo alone with his doting mother and then adopted by his father, married but as yet without legitimate children. In his father's prosperous household Leonardo was further indulged. These pages give one of the earliest discussions of the origins of homosexuality in narcissism: desiring to reinforce his mother's love for him and to identify with it as an extension of his self-love, the son indulges his love for her to the point of substituting himself for her, looking for a male partner, and thus remaining faithful to his mother. Freud attributes the mysterious blend of reserve and seductiveness we call "Leonardesque" to the painter's having been reminded of his mother by the model for the *Mona Lisa*. Thenceforward that ambivalent expression characterizes all his female figures, including the two in *Virgin and Child and St. Anne*. In that composition Freud detects a recollection of Leonardo's two young mothers, the real and the adopted. After associating Leonardo's great preoccupation with flight—bird flight and human flight—with a throwback to his childhood sexual researches when he was alone with his mother, Freud concludes with a reaffirmation that Leonardo's extreme case of inhibition was not pathological or neurotic but obsessional and healthy. Freud concedes the insufficiency of the material evidence on which to construct a case, the need "to recognize here a degree of freedom" in Leonardo's choice of actions, and the "limits which are set to what psychoanalysis can achieve in the field of biography." Yet he believes that

the key to Leonardo's great and mysterious genius lay in his capacity to direct and transmute the deep feelings aroused in him during childhood.

The reservations that have to be made about hanging so much mass of interpretation on a single sentence can be found elsewhere.* The passage on which Freud's argument pivots occurs about ten pages after the opening. He states in effect that what might be seen as two separate problems in Leonardo must be interpreted as one: "There is only one way in which the peculiarity of this emotional and sexual life can be understood in connection with Leonardo's double nature as an artist and as a scientific investigator." The "one way" means, of course, sublimation, in this case accompanied by narcissism and homosexuality. But the last two items are far less important than the central hypothesis that in Leonardo we witness a mind that succeeds in defending its integrity and defeats the censor, even if at some final cost in dispersion of talent.

4

This would seem a long way to come if these two highly individual books have no more in common than their subject and their total inadequacy as systematic biographies. But the reason for the com-

* The most thoroughgoing criticism is Meyer Schapiro's "Leonardo and Freud: An Art-Historical Study," in *Journal of the History of Ideas*, April 1956.

So far as I know, no one has undertaken to correct Professor Schapiro's extreme position in two matters. Freud did not accept Pfister's "discovery" of a vulture hidden in the *St. Anne* painting as confirmation of his theories. The 1919 note says the discovery "is of remarkable interest, even if one may not feel inclined to accept it without reserve." And the one new document Professor Schapiro cites about Leonardo's ten godparents supports his own thesis of a hostile mother no more strongly than Freud's. Both those matters arise at the start of the article; the remainder of it and the conclusion seem to me very judicious, and his documentation invaluable.

[In an amiable letter of rejoinder to my essay, Mr. Schapiro insists that he nowhere committed himself to the theory of the hostile mother, but rather wished to suggest a possibility Freud ignored. On this point I readily yield. However, I cannot agree with Mr. Schapiro that the pronoun "one" in the 1919 footnote refers only to the "skeptical reader" and does not include Freud's own mixed feelings. The question has not been allowed to rest there. Several important commentaries on Leonardo's life and Freud's version of it have appeared since this essay was written: a lengthy monograph by K. R. Eissler in 1962; Brian Farrell's tendentious introduction to the Penguin edition of Alan Tyson's translation of Freud's text; and a remarkable review article by E. H. Gombrich (*New York Review of Books*, February 11, 1965), which brings out Freud's debt to Merezkovski's novel based on Leonardo.]

parison should begin to assert itself. Valéry, whom we think of as an artist, gives most of his attention to Leonardo's notebooks and to his methodology as a thinker. Freud, whom we think of as a scientist, at least by training, refers briefly to the notebooks and then elaborates the greater part of his argument on the basis of the painting and the life. Valéry cites no historical persons, dates, or places, and attempts only to illustrate a theory of self-consciousness; Freud obviously believed he could contribute to Leonardo's biography and to biographical method by bringing to bear on an enigmatic and eminent life the new science of analysis. Yet by the time we reach the end of Freud's study, Leonardo's personality interests us less than the process that permitted him to come to terms with himself and the world. Not the individuality but the generality of his case emerges from these pages. His personality has melted away into a set of carefully described responses.

Why, then, if neither author wrote a biography but was really concerned with something quite apart from Leonardo's individual life, did they compose these two books nominally aimed in his direction? The first answer is quite easy. They both identified with Leonardo—admired him, understood something of him, and could understand something of themselves in examining him. Though Valéry's first article was commissioned, the subject was far from new to him. He makes little effort to hide the fact that what he writes of Leonardo is in effect the fruit of introspection. And he wrote at far greater length on Leonardo than on any other person, including his master, Mallarmé. Freud's interest in Leonardo went back at least a dozen years and probably more, and the work remained one of his favorites. Ernest Jones tells us that Freud particularly admired two historical figures: Moses, the wise leader who guided his people to a new land and a full life, and Leonardo, who combined the talents of an artist and the knowledge of a scientist in creating some of the greatest artifacts of Western culture. There is nothing very rash in saying that both Valéry and Freud felt in themselves the double temperament, the twin genius that tradition attributes to Leonardo. Furthermore, Leonardo's apparent irresolution and perpetual shift of focus in his work probably struck a responsive chord in each of them. Valéry had just gone through a personal crisis that was to divert the channel of his writing for many years: he came to value a completed work less than the state of mind that permits creation. Freud, though well established in his central field of in-

quiry when he wrote on Leonardo, had been very much at loose ends for a time about what calling to follow. After deciding against law, a slow and somewhat erratic progress had carried him through physiology, medicine, teaching, neurology, and psychopathology to psychoanalysis. He was always profoundly attracted to literature and the arts, and wrote to the novelist Schnitzler that he felt their temperaments were very similar.

But more important than any personal reasons for writing of Leonardo, the conclusions of their studies show more similarity than we might have expected. I have suggested earlier that the books contribute to a discernible pattern that reveals Leonardo as a culture hero for the era. Yet these two works, weak as they are biographically, help us understand why so many other authors were studying Leonardo without shedding much new light. From their very different cultural vantage points, Valéry and Freud glimpsed something behind Leonardo they could approach through him. For both of them, Leonardo stood for a form of consciousness they admired—a new equilibrium of faculties that could be fully recognized and appreciated only four hundred years after the fact, and on slender evidence. Their essays describe a case that has particular relevance to our modern situation, like Eliot writing of Donne, or Baudelaire writing of Poe. I feel that in the end, for Freud as much as for Valéry, the name Leonardo is reduced to an exemplary case, a convention, a pure symbol, a term like "Socrates" as traditionally used in the syllogisms that start "Socrates is a man." Someone has to represent humanity, if possible at its best. But subtracted from his life, what does Leonardo stand for? Does anything remain beyond Vasari's appealing myth of a restless genius releasing birds, blowing up bladders, and painting an occasional picture?

Three semi-parenthetical remarks will clear the ground a little around these questions. To begin with, Valéry's *Note et digression* carries one of the most merciless and concise attacks on Pascal (his name is not mentioned in the text) that has ever been composed. It is too good to miss:

> [Leonardo] had not the least knowledge of that gross and ill-defined opposition which, a century and a half later, was declared between *l'esprit de finesse* and *l'esprit de géométrie* by a man entirely insensible to the arts, who could not conceive of that natural but delicate blending of talents. It was he who lured us into a wager that gobbled up all finesse and all geometry, and who, having changed his

new lamp for an old one, wasted his time sewing little notes into his pockets, when the moment had come to bring to France the glory of having discovered infinitesimal calculus . . .

No, Leonardo was not wasting his time on dividing the mind against itself and setting odds on immortality. The passage is significant. Secondly, nothing in Freud's analysis of Leonardo's tendency to abandon his painting for elaborate, fragmentary, and often mysterious scientific studies inclines in the slightest toward the concept of schizophrenia. On the contrary, this double man, distracted as he may have appeared on the outside, incapable of finishing much of what he started, and careless of the fate of what he did finish, exemplified a high level of inner integration. "Our aim remains that of demonstrating the connection along the path of instinctual activity between a person's external experiences and his reactions." Here at the end of the essay Freud affirms for the second time that Leonardo made these connections very well indeed.

The last remark concerns the French mathematician Poincaré, who began publishing in the 1890s a series of articles on the intuitive, unconscious nature of mathematical imagination, on the distinction between fact and hypothesis, and on the significance of the new physics. Though these writings found a large audience only when they were published in book form (1902–9), Valéry read the articles as they appeared, consulted Poincaré personally on a mathematical point, and cited him for support in the first text on Leonardo. A year later Valéry wrote André Gide that he was thinking of composing a literary portrait of the mathematician. "Poincaré is hard to deal with without knowing the man. He interests me very much, for he hardly does anything now but psychological articles on mathematics. That's exactly to my taste." And he regrets not knowing Poincaré well. Evidently the "novel" about an imaginary personage, *Monsieur Teste*, the *Introduction* to the hypothetical mind of Leonardo, and the unwritten study of the contemporary mathematician turned psychologist all represent one preoccupation, in effect, one work. We discover also that Freud received from Marie Bonaparte a copy of Poincaré's *La Valeur de la science* (1905), a book which he read with interest and sympathy because it corroborated his conviction that science could never replace religion. Science teaches not to have faith but to doubt the things about which we feel most certain. Freud's letter to Marie Bonaparte makes it evident that psychoanalysis had particular reasons to keep its doubts about itself.

Valéry's attack on Pascal's irresponsible dividing of the mind into two parts, Freud's reluctance to see Leonardo as a man at odds with his own most precious talents, and their common interest in Poincaré's psychology of scientific and creative thinking—these circumstances reinforce what should already be clear about the coincidence that Valéry and Freud both wrote about an Italian painter and thinker who lived four hundred years before their time. They did not see in him a universal genius who represents the variety of human faculties vying with each other in a great divergence of roles and activities. His versatility led them in another direction. Their two highly contrasting books relentlessly trace the multiplicity and contradiction of Leonardo's activities back to a mind. And above all, that mind is one, an integrity of scientist and artist, of sensibility and intelligence. All Valéry's terms (method, invention, central attitude, presence of mind) grant to that master mind a tremendous freedom to see from a single vantage point the continuity of all things around it.* Freud's elaborate apparatus for describing two cities in the mind (or three, if one counts the preconscious along with the conscious and unconscious) gradually vanishes as he approaches Leonardo. And the lesson of the book is that a single, all-encompassing power, an incredible integrity of mind, can result from a mingling of previously separated energies. One can distinguish different directions for investigation (sex, science, art), but the "case" of Leonardo displays not different drives or instincts but a single common activity of mind that gives rise to all these.

And thus, along with Pascal, a whole tradition of dualism in the mind comes a cropper if we draw the full conclusion. Valéry did; his precocious certainty about the indivisibility of the mind probably explains the coyness with which he indulges in interdisciplinary byplay in some of his writings. But his vision was steady.

* A passage often quoted from *Note et digression* runs thus: "I sensed that this past master of all disciplines, this adept at drawing, at illustration, at mathematics, had found the central attitude from which the undertakings of knowledge and the operations of art are equally possible; the exchange between analysis and action, singularly probable: a marvelously exhilarating mind."

In the years to follow, Valéry did not remain alone. In the *Second Surrealist Manifesto* André Breton writes as follows in 1929: "Everything leads us to believe that there exists a certain vantage point of the mind, from which life and death, the real and the imaginary, past and future, the communicable and the incommunicable, high and low, cease to be perceived as contradictory. Now, it would be useless to look for any other motive in Surrealist activity than the determination of this point."

Freud unfortunately never tested his theories against another mind equal to Leonardo's and turned increasingly to culture and society as his subject. His dualistic terminology has remained, but I maintain that his essay on Leonardo lets us see how strongly Freud felt drawn toward an interpretation of mental activity as one, only artificially divisible. At the very moment when, we are usually told, Western consciousness was hardening into a division between reason and feeling, two of the greatest contemporary minds were saying precisely the opposite in terms that recapitulate the history of modern European thought. They assert, in effect, that the experience of four hundred years tells us urgently and insistently not to divide up the mind. For to oppose one faculty to another implies that the drift toward specialization has its source in our thinking, and favors a racism of the mind inclined toward segregation. Furthermore, they avoid the error of Vico and Comte and finally Lévy-Bruhl, who affirmed the existence of "primitive" thought as an essentially different functioning of mind from our "civilized" thought. No one has ever satisfactorily demonstrated that the "savage" makes associations and forms conclusions about his animistic or god-ridden world in a way different from ours. Nor—to take an extreme example—need the "logic" of Rimbaud's *Les Illuminations,* or of *Alice in Wonderland,* or of a nightmare, be any different from the "logic" that should be connecting one proposition to another on this page. T. S. Eliot's "logic of the imagination" is a misnomer and a red herring.

Valéry and Freud do not indulge in any suggestion that the superiority of Leonardo's mental organization, his power to perceive relations and find pleasure in experiment, removed him from humanity. On the contrary, an image they both use displays their awareness of the risks run by so powerful a mind if aware of its own power. Valéry's exposition never withdraws from the dilemma of self-consciousness, so that every metaphor for thought or attention ("the dreams of the waking sleeper," "detachment," "repulsion") signifies a perpetual spiraling out of the self in order to see the self—which is no longer there to be seen. Throughout his poetic production, Valéry reverted to the figure of Narcissus to express this problem of the fugitive self: and narcissism is precisely the psychoanalytic concept to which Freud gave one of its earliest elaborations in the Leonardo text. The metaphor does not serve the same purpose for the two of them; but in both cases its meaning reaches far into the ambiguous area where the mind, trying to catch sight of itself in

action, discovers that nothing is there but a perpetual movement of recoil or afterthought. Narcissus attests not to a division but to a contortion of mind. Freud points out very shrewdly that nothing seemed to escape the notice of Leonardo's investigations. "Yet his urge for knowledge was always directed to the external world; something kept him far away from the investigation of the human mind. . . . There was little room for psychology."

In other words, Leonardo would never have written either Valéry's or Freud's book.

5

So limited a demonstration as this could never "prove" that all thought is one. Nor could it hope to flatten the barriers that have grown up between a long series of artificial opposites, not the least of which is the inseparable pair: theory-fact. And even if the theory-fact of the unity of thought is accepted as demonstrated in the specific instances of Valéry and Freud looking at Leonardo, the problem remains of why we cling to different words for such versions as patient observation, discursive logic, intuition, a flash of inspiration, reverie, and the like. Or more specifically, how is it Freud associates wit-work, dream-work, and artistic creation and treats that cluster of activities as distinguishable from the thought patterns that direct our ordinary living? And then there is the even more troubling question of why certain forms of presumably rational thought, such as the implications of quantum and relativity theory, or theories about time and entropy, bear a close resemblance to their decreed opposites, dream and fantasy. The answer, I believe, lies close at hand in the pacing of mental events. Both Freud and Valéry speak of rapidity and compression.

Our thinking, in a manner no one has yet described satisfactorily to my knowledge, has a widely variable speed. The basic operations of association and dissociation take place slowly in activities we refer to as "reasoning it out" or "systematic analysis," and with infinitely greater speed in dream and hunch and wit. However, it is ridiculous to assume—as we usually do—that our minds work at a nearly uniform rate in any given interval. The eureka effect of inspiration or intuition may occur in the midst of the dullest analysis. The dross that surrounds the vividness of a remembered dream probably just goes unrecorded. In the superb essay "Mathematical Invention,"

Henri Poincaré describes how he discovered Fuchsian functions not during the long hours spent sitting at his worktable but one morning as he was stepping into a bus. It sounds like a page out of Proust. Nevertheless, those seemingly fruitless hours were necessary, for the solutions they eliminated and for the inner expectancy they built up. Valéry describes the composition of his poem "The Graveyard by the Sea" in the same fashion. Scientists or poets, we do not know the very timing of our minds.

Reasoning by analogy is a very dangerous procedure. Yet the experimenter as much as the artist proceeds on faith—the faith that his mind can truly come to terms with reality and that there is always a higher order of things for him to discover. (That faith is often called doubt.) I wish to argue from one of the most ambitious theories of orderliness in nature back into the jungle of the mind. Einstein's special theory of relativity was given graphic expression almost immediately by Minkowski, whose four-dimensional geometry does an enormously helpful job of representing physical reality. In the figure below, the x axis represents the three dimensions of space and the t axis represents time measured by a free (i.e., unaccelerated) observer at o. In this geometry a diagonal oc separates time-like curves (more vertical than horizontal) from space-like curves (more horizontal than vertical), and this diagonal represents energy moving at the speed of light, c.

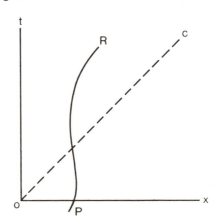

The world line of a single particle, say PR, must be time-like, and as it approaches the limiting speed of light it contracts so enormously as to cease to have the properties of matter. To "jump" into the diagonal it would have to change from matter into energy, ac-

cording to Einstein's formula, $E = mc^2$. A space-like curve is really a map of points in space which cannot be reached by any one particle's world line. In the xt plane, called space-time or Minkowski space, the velocity of light c is of crucial importance and is assigned some very special characteristics. For example, the world line of energy traveling with this velocity has zero length and is perpendicular to itself. But the significant point is that all this represents a single space, a *continuum*, both connected and articulated by the mysterious diagonal $x = t$ or c. The "light" that travels with unalterable speed is the most commonplace and miraculous element in our environment. What "travels" in time or "stays put" in space is one, energy or mass, according to how you look at it, or, more revealingly, according to its velocity.

So it is, I submit, with thought: one entity, one faculty, one process. But of various velocities. What Minkowski space suggests by analogy is the possibility of a critical velocity. In this idea of a frontier not between two things but between two speeds or two states, I suggest we have a working definition of consciousness itself. Below a certain speed, thought seems observable and its coherence verifiable; its trajectory lends itself to expression in discursive forms of language. Above a certain speed, thought outruns any continuous observation, appears incoherent, and finds expression in extremely elliptical or disjointed forms.* When he dealt with dream and psychosis and

* The villain of the preceding parts of this essay, Pascal, was not the fool Valéry painted him to be. In the principal *pensée* devoted to distinguishing between *l'esprit de géométrie* (analytic thought consisting in a patient working back to a few fundamental notions) and *l'esprit de finesse* (a rapid grasp of the evidence or a feel for it, thanks to a keen eye), Pascal includes a sentence that appears to link the two opposed faculties along the lines I am presenting. He describes the almost ridiculous process of step-by-step reasoning implied by *l'esprit de géométrie*. Then he adds:

> Ce n'est pas que l'esprit ne le fasse; mais il le fait tacitement, naturellement et sans art, car l'expression en passe tous les hommes, et le sentiment n'en appartient qu'à peu d'hommes.

> It is not that l'esprit [*de finesse*] doesn't go through the same process, but it does so tacitly, naturally, and without system; for no one can express the process, and few have a feel for it.

I suspect that Pascal had some hidden (strategic? religious?) motive for dividing thought at its seat. Otherwise it is difficult to understand why he left so neat a loophole in his argument. Many, from Bergson to Polanyi, have walked through it with huge success.

wit, Freud described this high-velocity activity in terms of compression and displacement. They are probably as good working terms as we shall have in some time.*

I do not wish to imply a fixed constant of consciousness for all individuals at all times, in the fashion that the constant velocity of light has turned out to be the Rock of Ages in physics. All of us have direct experience of the fluctuations in our own consciousness according to physical and psychical states. Inevitably I am speaking out of my own experience, remembering those exalted yet awkward moments of stumbling onto a mountaintop in the mind from which one beholds the majesty of everything properly in place. In particular, one evening while reading an article on physics after an exhausting day, I suddenly felt an almost physical release within me. Two images flashed vividly into my mind: an early Cubist painting by Braque I had seen several months earlier and the haunting mystery of Poe's stories read many years earlier. And it all came clear. The necessity of anti-matter, the necessity of mirror symmetry, the necessity of the psycholiterary myth of the double, and above all, the necessity of myself seeing it thus—all that literally struck me, at once and as one. I found no words to record the blow then; it seemed

* In the best-known chapter of *Psychology* (1892) William James insists on the importance of mental velocities: "When we take a general view of the wonderful stream of our consciousness, what strikes us first is the different pace of its parts." The ensuing discussion of "substantive parts" (resting points stable enough to have names) and "transitive parts" (fleeting relations that cannot be named) brushes close to the hypothesis I am putting forward.

It was an attentive reader of James, the French Surrealist André Breton, who addressed himself most directly to the question in his many affirmations of automatic writing as the key to the whole Surrealist enterprise. The crucial text appears in the center section of the first manifesto (1924): "I resolved to produce from myself . . . a monologue delivered at the highest possible speed . . . which would be the closest possible approximation of *spoken thought*. It seemed to me and still seems to me today . . . that the speed of thought is not greater than the speed of speech, and that it does not necessarily outrun the tongue or the pen." Six years later, commenting on his first published automatic texts, Breton reaffirmed the crucial role of speed "to influence the character of what is said" (see "Le Groupe: la rupture, *Change* no. 7, 1971, p. 10). And he proceeds to classify his various automatic texts according to a table of five speeds.

The hypothesis about different rates of thought placed by Breton and Soupault at the center of the Surrealist experiment should not be linked to the Dada spirit of humbug and mystification. Breton was in dead earnest. His greatest error was to believe for some reason that either writing or speech could keep up with thought at all its velocities. At its fastest and freest, thought leaves far behind not only speech and writing but the conventions and confines of language itself.

miraculous yet very familiar, as if I had known it for a long time. Still, the ceiling of consciousness had to lift in order for me to glimpse it. What lures mankind into experimentation with drugs is probably not a direct sensual pleasure but the fact that they can raise (or lower) the critical velocity below which our mental processes reveal themselves. Slow-motion effects, geometric music, massive coilings and uncoilings—these drug experiences show the mind, rather than the cosmos, laid bare. Censorship and repression, the processes so roundly criticized by Sartre, could be described anew as measurements of distance and the velocity of thought rather than as a separate faculty. Of course just as Minkowski geometry, like any representation of space-time, must include a location for the hypothetical observer, so a representation of consciousness leaves us in the quandary of showing an observer, an "I" beholding the trajectory of my own thought. This incipient duality in human identity is vastly more real and significant than the false one we started with between intellect and sensibility.

For one very elementary lesson, then, we may look back a medium range of sixty-odd years to the turn of the century. Amid the surprisingly large number of writers in Europe devoting their attention to Leonardo da Vinci, two thinkers discovered the opportunity to approach the most universal subject of all: the nature of the human mind. A little distance beyond the place where their explicit commentary stopped, one can discern a significant agreement. The division we have begun to lament publicly between two climates of thinking, scientific and humanistic, between opposed methods of inquiry, cannot be traced to any corresponding division between regions or faculties in the mind. At the origin is unity; we have imposed the separation upon ourselves, possibly to lighten our burden. For it is an onerous responsibility to live both inside and alongside the thoughts that we are—almost.

There is more than we ever knew in the story of the tortoise and the hare. Just look again. You will see not two animals but one, traveling at different speeds.

What Is 'Pataphysics?

'Pataphysics, the Science of Sciences, has always existed—ever since a man first scratched his head not to squash a flea but to release the itch of reflective thought; ever since Socrates demonstrated to Meno that his slave boy had known the Pythagorean theorem all along; ever since Lucretius versified about *clinamen*, the tiny swerve of falling atoms that opens a space inside determinism for the play of free will; ever since Rabelais and Lewis Carroll agreed on the equivalence of cabbages and kings. Not until the end of the nineteenth century, however, at a time when science and art were soon to burst out in renewed activity, did 'Pataphysics drop its disguises and disclose its intentions. Its chosen vessel was Alfred Jarry, who achieved notoriety by assuming paternity of a raucous schoolboy farce, *Ubu Roi*, performed in Paris in 1896. Jarry appropriated from *le père* Ubu his "science of 'Pataphysics" and attributed it to a new personage, Dr. Faustroll. In a book which remained unpublished until after his death (*Exploits and Opinions of Dr. Faustroll, Pataphysician,*

1911) and in a variety of novels, poems, and speculative texts, Jarry elaborated and applied the Science of Sciences. Jarry and 'Pataphysics were kept very much alive by Dada and Surrealism and, after World War II, drew themselves up to their full height in le Collège de 'Pataphysique. That lighter-than-air institution, complete with statutes, hierarchy, commissions and subcommissions, quarrels and settlements, irregular review, publishing house, worldwide representation, and occasional public manifestations, is one of the great symptomatic creations of our time. In all its internal and external activities, the College has cultivated the pataphysical sense of life and demonstrated the perspicacity of *le père* Ubu when he said: " 'Pataphysics is a science we have invented, the need of which was universally felt." Faustroll clipped his words even closer: "*La 'Pataphysique est la science . . .*"*

But what, once again, is 'Pataphysics? Relying principally on Jarry, I shall attempt the self-contradictory task of defining 'Pataphysics in non-pataphysical terms.

1. *'Pataphysics is the science of the realm beyond metaphysics; or, 'Pataphysics is to metaphysics what metaphysics is to physics.*

Metaphysics is a word which can mean exactly what one wants it to mean, whence its continuing popularity. To Aristotle it meant merely the field of speculation he took up after physics. The pataphysician beholds the entire created universe, and all others with it, and sees that they are neither good nor bad but pataphysical. René Daumal, one of the great practitioners, stated that in *Mount Analogue* he proposed to do for metaphysics what Jules Verne had done for physics. 'Pataphysics, then, proposes a great voyage of discovery and adventure into what Jarry called "ethernity." That, in case anyone didn't know, is where we all live.

2. *'Pataphysics is the science of the particular, of laws governing exceptions.*

The realm beyond metaphysics will not be reached by vaster and vaster generalities; this has been the error of contemporary thought. A return to the particular shows that every event determines a law, a particular law. 'Pataphysics relates each thing and each event not to any generality (a mere plastering over of exceptions) but to the

* English-speaking members of the college delight in producing alternative translations of this sentence. " 'Pataphysics is *the* science." " 'Pataphysics is the one science." " 'Pataphysics is all science." " 'Pataphysics is the only science." " 'Pataphysics is science." " 'Pataphysics is the science of . . ."

singularity that makes it an exception. Thus the science of 'Pataphysics attempts no cures, envisages no progress, abhors any "improvement" in the state of things, and remains innocent of any message. Indeterminacy and complementarity, black holes and antimatter are merely recent entries in its file. 'Pataphysics is *pure* science, lawless and therefore impossible to outlaw.

3. *'Pataphysics is the science of imaginary solutions.*

In the realm of the particular, every event arises from an infinite number of causes. All solutions, therefore, to particular problems, all attributions of cause and effect, are based on reduction by arbitrary choice. Gravity as curvature of space or as electromagnetic attraction —does it make any difference which solution we accept? Understanding either of them entails a large exercise of poetic imagination. Science must elect the solution that fits the facts—travel of light or fall of an apple. 'Pataphysics welcomes all scientific theories (they are getting better and better) and treats each one not as a generality but as an attempt, sometimes heroic and sometimes pathetic, to pin down one point of view as "real." Students of philosophy may remember the German Hans Vaihinger with his philosophy of *als ob.* Ponderously yet persistently he declared that we construct our own system of thought and value, and then live "as if" reality conformed to it. Truth is an imaginary solution, or rather all of them.

4. *For 'Pataphysics, all things are equal.*

The pataphysician not only accepts no final scientific explanation of the universe, he also suspends all values, moral, aesthetic, and otherwise. The principle of universal equivalence and the conversion of opposites reduces the world in its pataphysical reality to particular cases only. Yet there is no reason why the pataphysician should not work for a living and sleep with his own wife, why he should not behave with considerateness toward his neighbor and fill a responsible role in society, why he should not enjoy particular situations and particular works of art. 'Pataphysics preaches no rebellion and no new morality, no political reform and no promise of happiness. What would be the use, all things being equal?

5. *'Pataphysics is, in aspect, imperturbable.*

Jarry was regarded by most of his contemporaries as a joker or a lunatic. Here lie the first errors of incomprehension. 'Pataphysics has

nothing to do with humor or with the kind of housebroken insanity psychoanalysis has drummed into fashion. Life is, of course, absurd, and it is ludicrous to take it seriously. The pataphysician, therefore, remains serious in appearance, attentive, imperturbable. He does not burst out laughing when asked to fill out in quadruplicate a questionnaire on his sex life, any more than he raves at the police officer who gives him a ticket for not crossing at the intersection. His imperturbability affords him a secure anonymity in which he can savor the marvelous contradictions of life. Jarry's musical contemporary and survivor, Erik Satie, perfected the etiquette of 'Pataphysics: *ironic conformity*.

6. *All things are pataphysical; yet few people practice 'Pataphysics consciously.*

No difference in value, only in state, exists between ordinary people and those who are consciously aware of the pataphysical nature of the world, including themselves. The College of 'Pataphysics is no better and no worse than the French Academy or the Hilldale Garden Club Men's Auxiliary Committee on Poison Ivy Extermination. The College, however, being aware of its own nature, can enjoy the spectacle of its own pataphysical behavior. And what science but 'Pataphysics can cope with consciousness? No science or philosophy, clearly, has ever been able to look long into a mirror, to catch its own tail. Père Ubu's monstrous *gidouille*, or belly, is represented by a spiral, which Dr. Faustroll's 'Pataphysics transposes into a symbol of consciousness circling forever around itself. Symbol? By now all words are pataphysical, being equal.

7. *Beyond 'Pataphysics lies nothing; 'Pataphysic is the ultimate weapon.*

Like the sorcerer's apprentice, we have become victims of our own knowledge—principally of our scientific and technological knowledge. In 'Pataphysics resides our only weapon, our only defense against ourselves. Not that 'Pataphysics will change history; it has no such pretensions. But it allows a few individuals, beneath their imperturbability, to live up to their particular selves, Ubu or Faustroll, you or I. Outwardly one may conform meticulously to the rituals and conventions of civilized life, but inwardly one watches this conformity with the care and enjoyment of a painter choosing his colors—or perhaps of a chameleon. 'Pataphysics, then, is an inner attitude, a dis-

cipline, a science, and an art. It allows each person to live his life as an exception, proving no law but his own, remaining loyal to the precarious condition of his species. Dr. Faustroll's attendant ape, Bosse-de-Nage, celebrates that condition with his all-purpose, tautological, and monosyllabic ejaculation: "Ha! Ha!"

The Prince, the Actor, and I:
The Histrionic Sensibility

1

In the second part of Stendhal's *Charterhouse of Parma,* Prince Ranuce–Ernest V succeeds his father as absolute ruler of Parma. He is twenty-two, self-conscious, timid, brave, romantic, stubborn, and still single. You almost forget that he is also rich and powerful. The Duchess of Sanseverina, finding herself in danger for political reasons, wishes to make herself valuable to the young prince. She decides to arrange a series of theatrical entertainments for the court, of which she is herself the principal ornament. The prince is so delighted that he insists on taking part in the improvised scenes; that way he can act opposite the beautiful and vivacious duchess. The inevitable happens. Stendhal describes it in his usual terse prose.

[The prince] played the role of the duchess's lover. Far from having to feed him his lines, she soon had to induce him to shorten his

scenes. He talked of love with an enthusiasm that often embarrassed the actress; his speeches lasted five minutes.

Twenty pages later, at the critical moment when the duchess's nephew, Fabrice, is about to be poisoned in prison, the prince has taken his acting so much to heart that he is a changed person. The duchess, you will remember, is passionately yet chastely in love with Fabrice and close to collapse at the thought of his death. Stendhal's plots seem to thicken by themselves.

> Now the prince, being very timid, yet taking anything that had to do with love very seriously, met the duchess in one of the palace corridors . . . He was so surprised and astonished by the duchess's beauty charged with feeling that, for the first time in his life, he showed some character. With an imperious gesture he dismissed the marquis and launched into a full-blown declaration of love. The prince must have worked it all out well in advance, for he said some fairly reasonable things.

The duchess replies by asking him to save Fabrice. The prince sees his opportunity: yes, at the price of her favors. The pact is breathlessly made. Stendhal tells us twice more that this is the first time the prince has shown real "character." Thanks to the duchess's acting lessons, he can now play opposite her on the daily stage of the court.

Only a member of the "happy few" will know that Stendhal is here signing The Charterhouse of Parma with his own youth. The prince is a barely veiled reincarnation of the biographical Henri Beyle, who, at age twenty-two, as the typical provincial in Paris, became absorbed in three simultaneous activities. Beyle was taking daily three-hour acting lessons from the famous Comédie Française actor Dugazon. Second, he decided that he had fallen in love with Mélanie, an actress in the same class, and he was planning an elaborate theatrical strategy to capture her. Third, he was recording everything, the hour-by-hour beat of his actor-lover's existence, in his journal, where he constantly exhorted himself to be a shameless cabotin, a ham. After a few months he feels he can cast a spell over Mélanie in their scenes together, both played and real, and outact all his rivals. Here is the close of the fifteen-page entry (with drawings) about his performance with Mélanie after class on February 25, 1805.

> This has probably been the best day of my life. I may have greater successes, but I'll never display so much talent. My perception just

at the right setting to guide my feeling. It wouldn't have taken
much for my feelings to carry me away. But I had an almost po-
litical sense of what I should do and knew exactly when to recite
a bit of poetry. Then, as soon as the first word was out, I felt what
I was saying. I couldn't have acted passion any better for the sim-
ple reason that I really felt it . . .

 To describe the perfection I attained today, I could say I acted
. . . the kind of role Molière would have written, being both author
and actor.

In that exalted season Beyle almost gave up writing plays to become
an actor. It would take him twenty years to realize he was a novelist
with a flair for histrionic heroes. But he lost no time in transposing
into his own life the psychological and moral lessons he had learned
in Dugazon's classes. Just a week before he persuaded Mélanie to
go off to Marseille with him (where for a time he earned his living
as a wholesale grocer), Beyle summarized those lessons in his journal.

 In short, I must form my character. Character consists in doing
 what I have resolved to do (whether or not with passion) with verve
 and gaiety . . . I must devote myself to this plan of the true ideal
 for my conduct, which grows straight out of the principles of acting.

Everything Beyle–Stendhal wrote between the journal, when he was
twenty-two, and *The Charterhouse of Parma*, when he was fifty-five,
explores the subtle paradox by which *le joué* or playacting can enhance
and extend *le naturel*—true feeling, spontaneity, naturalness. He be-
lieved he had found a *method*, a method of becoming himself.

 Twenty-five years after the *Charterhouse*, Baudelaire published one
of his miniaturized novels—usually referred to awkwardly as a prose
poem—about a prince, a *bouffon* or actor-clown, and an evasive first-
person narrator. Baudelaire borrowed the plot in part from Poe and
in part from a sociophilosophical tract entitled *On Boredom* by
Brierre de Boismont. To the best of our knowledge Baudelaire never
took acting lessons, but his self-discipline in the elected role of a
dandy and his intense interest in costume, makeup, how women walk,
clowns, and charlatans certifies his histrionic sensibility. "A Heroic
Death" ("Une Mort héroïque") runs to five pages in *Le Spleen de
Paris*, his collection of prose poems. I have had the brashness to re-
duce it to one page, using Baudelaire's own words as much as possible.

 Fancioulle was a superb actor and almost a friend of the prince,
who was grieved and angered to learn of Fancioulle's part in a court

conspiracy against him. Sensitive, cruel, and voluptuous, the prince was virtually an artist whose principal enemy was boredom. His great misfortune was that he did not have at his disposal a theater big enough to match his genius. The announcement of a special performance by Fancioulle of one of his greatest roles started the rumor that the unfortunate actor would be pardoned for his crime. But I suspected that the prince had in mind a psychological experiment concerning the acting abilities of a condemned man.

The whole court turned out for the performance. Now, "good acting" usually means that behind the role one can glimpse the actor, that is the technique, the work, the will. But that night Fancioulle gave a perfect realization, an impersonation so convincing that I saw a halo of Art and of Martyrdom shining over his head. The audience and the prince were swept away in their admiration for this incomparable performance, which I knew was taking place on the brink of death.

As I watched the prince, an intense expression of bitterness and jealousy came into his face, as if he felt challenged at the seat of his power. He whispered a few instructions to a page. A few moments later a long, ear-splitting whistle interrupted Fancioulle in one of his most inspired moments and seemed to wake him from his dream. He staggered slightly, opened his mouth, and fell over dead.

One would like to think that the prince did not foresee the mortal effectiveness of his trick and that afterward he missed his dear and talented Fancioulle.

Ostensibly Fancioulle dies for political reasons. But the eyewitness narrator tells us insistently that Fancioulle has made the prince jealous by acting too well, by displaying a competing source of power. Under a despot, no one must shine too bright. This tiny fiction carries so much latent significance that it reads like the allegory of a shift in the culture. But what shift?

Character and acting are again at stake in a well-known passage by a modern writer who, unlike Stendhal and Baudelaire, became a successful playwright. When Jean-Paul Sartre discriminates his concept of bad faith from its neighbors known as hypocrisy and sincerity, he describes a flirtation-seduction gleefully and shamelessly lifted from two all-time classic scenes of the French novel: Julien courting Madame de Rênal in *The Red and the Black* and Rodolphe courting Emma in *Madame Bovary*. After a page devoted to the innuendo-filled conversation of the two parties, we come to this:

> But suppose he takes her hand. This act of her companion risks changing the situation by calling for an immediate decision. To

leave the hand there is to consent in herself to flirt, to engage herself. To withdraw it is to break the troubled and unstable harmony which gives the hour its charm. The aim is to postpone the moment of decision as long as possible. We know what happens next; the young woman leaves her hand there, but she does not notice that she is leaving it.

(What a pity that Sartre was apparently never interested in cultivating the talent for comedy apparent in this scene.) Such behavior, Sartre tells us, is bad faith. The woman is duping no one but herself. This devastating passage prepares us for the famous sequence three pages later that is even more deeply concerned with acting and being. Here Sartre is illustrating not bad faith but what he calls the "obligation . . . to be what we are not." At this stage in his career he usually wrote in a café in order to find warmth. Notice how the narrator stands up, brushes aside the third person, and enters the action in his own first person.

Let us consider this café waiter. His movements are quick and definite, a little too precise, too rapid . . . There he comes, trying to imitate in his walk the inflexible stiffness of some kind of automaton while carrying his tray with the recklessness of an acrobat by putting it in a perpetually unstable, perpetually broken equilibrium, which he perpetually reestablishes by a light movement of arm and hand. All his behavior seems to us a *game* . . . He is playing, he is amusing himself. But what is he playing? It doesn't take long to see: he is playing at being a café waiter. There is nothing here to surprise us. The game is a kind of blocking out, an investigation. The child plays with his body in order to explore it and take inventory of it. The waiter plays with his condition in order to attain it.

Conversely, from within, this waiter in the café cannot immediately be a café waiter in the sense that this inkwell *is* an inkwell . . . He knows his condition means getting up at five o'clock, the right to tips, etc. But all that is a matter of abstract possibilities, of rights and duties conferred on a "person possessing rights." And it is precisely this person that I *have to be* and that I am not.

. . . there is no common measure between his being and mine. It is a "performance" for others and for myself, which means that I can be he only in performance, by impersonation. But if I impersonate him I am not he; I am separated from him as object from subject . . . I can not be he, I can only play at being he, that is, imagine to myself that I am he . . . Yet there is no doubt that I *am* in a sense a café waiter—otherwise could I not just as well call myself a diplomat or a reporter? I am a waiter in the mode of being what I am not.

All Sartre's writings circle perpetually around this discrepancy at the center of human existence and of human consciousness, a nothingness that requires us to perform a role in order to bridge the gap over into the being we call ourselves, our self. This is the mode of *being what I am not, or pour-soi*. To be sad, Sartre argues in the following paragraph, consists in finding my sadness by acting sad. In *Acting: the First Six Lessons* Boleslavski says much the same thing about the doorman at his theater: "He is not just a watchman—he is a splendid impersonation."

Of the many things one notices about these three passages, I shall mention only two. The first is the most obvious. The two princes and their proletarian counterpart, the waiter, are all presented as actors, almost by definition or by condition, each within his little theater— principality or café. Prince Ranuce–Ernest V achieves a new freedom and strength of character through his acting lessons with the duchess. Baudelaire's principle, on the other hand, is threatened by Fancioulle —not politically, as we are led at first to believe, but metaphysically in his authority. In Baudelaire's words this prince fears being "conquered in his power as despot" by Fancioulle's prowess as an actor. Sartre's waiter, like Stendhal's fledgling prince in his improvisations, performs an elaborate conventionalized dance with his tray for his audience of customers. Both characters succeed reasonably well in reaching their status by enacting it. Baudelaire, however, emphasizes the limits or taboos of acting by having Fancioulle killed for appearing to be a menace to the prince's privileged station.

Second, all three passages move covertly or overtly toward a first-person narrative and achieve a certain directness and even intimacy of tone. Standhal's twenty-two-year-old prince, we now know, speaks in part for the biographical author fondly recalling his early days as an aspiring actor in Paris. Baudelaire watches and comments on his prince through a first-person narrator, the only spectator in the theater alert to the full significance of the situation. We are either fooled or jolted by the stylistic feint by which Sartre slips into the role of the waiter and begins saying *I*—something he does not do for the flirting woman behaving in bad faith. We have reason to lend particular importance to these passages; their authors have underlined them for us in order to suggest that we ponder them with care.

Through the "play within a play" device, acting has long served literature as a metaphor for contrasting appearance and reality, the feigned and the genuine. Hamlet uses the players as much to explore

his own irresolute character (his first major speech concerns the word "seem") as to test the king's and his mother's deceit. Earlier works like Rotrou's *Saint Genest* and even *Le Jongleur de Notre Dame* assign to acting a powerful role in religious conversion—a theme close to that of Loyola's *Spiritual Exercises*. The three passages I have quoted from the nineteenth and twentieth centuries seem to me to lend increasing scope to the acting motif, both to bring it close to ordinary behavior and to give it a marked significance for non-actors. Has something happened since the end of the eighteenth century to give new weight to the histrionic mode? Can we associate such a putative shift with any other cultural forces at work in the modern era? I find these questions suggestive enough to provoke a fairly wide-ranging investigation.

2

A series of ancient metaphors informs us that, prior to a profound shift of attitude during the seventeeth and eighteenth centuries, most people grew up believing they had been born to a station, to an allotted place in the universe and in human society. In the fourth book of the Old Testament the Lord commands Moses to assign a number and an order to all the tribes of Israel in their tents, and to their children and their possessions, and to a considerable part of their daily lives. In the New Testament the apostle Paul replaces the order of Numbers with the more living and organic metaphor of the Body of Christ, or the Church (II Corinthians 12). All believers, however feeble and uncomely, have their assigned and essential place as members of that body, that whole. In later centuries when the power and order of the Church began to wane, another metaphor held out considerably longer: the Great Chain of Being. It exercised a wonderful fascination on writers like Leibnitz, Voltaire, and Pope. But no such metaphor could last long under the attack of new knowledge. Lamarck may have been the first major figure in science to invert the chain or ladder and consider only forces working up from the bottom of the natural order. Well before Lamarck's work, it was whispered about that there is no Mind above us to hold up the end of the chain, to stand at the head of the Body. By the middle of the eighteenth century, Figaro knew it was time to tell the count where things stood: "Nobility, wealth, rank, great employments—all these things make you so proud! But what have you done to earn all these

good things? You have been born, nothing more." When station comes to be seen not as divine but as something handed out in the arbitrary and precarious lottery of birth, what is left? The one major new institution forged by the Revolution, the modern nation-state, conferred on the individual no station, only undifferentiated citizenship. How then were citizens to find their place in the world? their role in life?

To so sweeping a question I can offer only a tentative answer. Citizens of the modern world have sought not so much a station as a *self*, a personal identity or individuality, a self which also gradually displaced the earlier term, *soul*.* I discern at least four directions in which the search has turned its efforts during the past two centuries. None is new; each has acquired a new urgency and promise. One can forge a self by obtaining property—ownership and direction of the material things of this world, including money. One can affirm a self by engaging in adventures—usually the conquest of power, love, knowledge (including science), and fame. One can also turn inward and discover a self at the focal point of subjective processes. Rousseau's reveries and confessions seem to illustrate Kant's and Fichte's speculations leading to the philosophic category of *das Ich*, or individual consciousness. The introspective or cœnesthetic strain comes down through Wordsworth and Dickinson to Ruskin and Proust.

These three paths of self-discovery are familiar and widely practiced. The fourth remains less recognized, yet significant and influential. It is the approach of which Stendhal, Baudelaire, and Sartre reveal a keen awareness in the passages quoted earlier. This fourth path emerges around 1800 in revolutionary France through the convergence of two previously unconnected strands: the fledgling science of mental medicine and the ancient profession of acting. Each requires a little background.

It took a revolution to bring to an end the indiscriminate imprisonment of the insane in Paris and their virtual disbarment from human-

* There is an important philological study to be made of the shift in philosophic and literary usage from soul (*l'âme*) to self (*le moi*). In Book IV of *Discourse on Method*, Descartes writes explicitly of "the self, that is to say the soul." A hundred years later Hume was already on the attack in *A Treatise of Human Nature* (Part IV, Section VI) in the chapter "Of Personal Identity": "There are some philosophers who imagine we are every moment intimately conscious of what we call our SELF." And he rejects the proposition by insisting that "the mind is a kind of theater." In the next century Baudelaire is still producing a complex set of variations on *l'âme* and *le moi*.

kind. (Until the end of the eighteenth century, asylums were open to the public like monkey cages.) But the reasons why the physicians Pinel and Esquirol continue to be seen as the founders of psychiatry is not so much their reforms of the Paris insane asylums as the convincing way their theory and their practice approached a new *sentiment du moi*, a sense of self that persists even in the insane. The responsive and responsible therapist, in their view, can negotiate with this conscious self in order to lead a patient back toward some form of identity and sanity. Their key term, *traitement moral*, clumsily translated as psychotherapy, affirms that many madmen are still human and still sane enough to be treated through their "moral" faculties—the intelligence and the emotions. Early French psychiatry based its halting reforms on a strong belief in a sense of self and identity that survives the rudest mental traumas. Pinel and Esquirol acknowledged that madness remains in part a matter of choice, of free will. (We still are far from understanding these mysteries— witness our debates in the United States over the insanity plea in criminal law.)

It also took a revolution to restore full human and legal status to the actor, who had been seen in previous centuries as a kind of useful and tolerated lunatic. The actor gives up his true identity to impersonate another; he sells his self, theologically a sin against the Creator. Hence his systematic excommunication.

But between the seventeenth and nineteenth centuries the actor underwent a marked transformation from an anonymous social outcast excluded from all Christian sacraments into an honored citizen expressing the highest ideals of nation and culture. The stages of that evolution are commonplaces of theater history. Louis XIV had to intervene in order to obtain churchyard burial for his protégé, Molière. Bossuet's celebrated letter of 1694 to the Bishop of Meaux argued powerfully that theatrical representations excite rather than purify "concupiscence of the flesh," and he condemned Corneille, Racine, and Molière along with all actors. Rousseau's antitheatrical letter to D'Alembert in 1757 accused actors of exploiting an art based on inauthentic and vicarious emotions. Public discussion of actors and acting increased through the eighteenth century, and their social status gradually improved. In 1786 a Royal School of Declamation was founded (with Stendhal's Dugazon among the teachers) to feed the flourishing Comédie Française. Ironically, however, it required an anti-clerical revolution and a vote by the National Assembly to

restore to actors in 1790 the legal right to holy matrimony and Christian burial. The famous competition for eminence between the two eighteenth-century stars of tragedy, Mlle Dumesnil and Mlle Clairon, culminated in the almost simultaneous publication of their memoirs in 1798 and 1799. The memoirs of actresses! That should have been the very definition of scandal. But no longer. In spite of their busy love lives, these ladies could establish a claim to a high calling and an honored station.

The actor who rode these events and his own magnificent talent to the peak of fame was Talma, Dugazon's student at the Royal School of Declamation, creator of a restrained and coherent style on stage, and author of an important essay on acting. His disciplined and energetic sensibility won him the patronage and friendship both of Napoleon and of Napoleon's banished archenemy, Mme de Staël. Talma stands at the end of the development that changed the actor from pariah figure, scorned for abdicating his birthright in order to simulate identities not properly his, into official hero glorified as the ideal figure of post-revolutionary France. Portraits of him celebrate a new nobility of demeanor. Even Flaubert succumbed: "I would have wanted to be Talma more than Mirabeau, because he lived in a sphere of purer beauty" (Letter to Louise Colet, August 8, 1846). Talma also bore, in the opinion of many, a helpful physical resemblance to his prince, against whom he never conspired, whom he may well have coached.

Thus around 1800 the conscious individual self asserted its presence in places that represented the opposite extremes of emptiness in human nature and lack of social status: madness and playacting. That sense of self, based not on property or adventure or inwardness but on acting and projecting, spread into fertile terrain. In the post-revolutionary limbo of the Directory, anyone could play any role—at least for a while. Many extravagant citizens did just that in the streets of Paris for a delighted public. The figure who outlived all the other flamboyant types was the dandy, new aristocrat of calm superiority, elegant dress, and no known origins of station. There were many other roles, recorded with genius by Daumier. Demeanor was all.*

* Writing in 1850, Hawthorne clearly understood the social evolution from station by birthright to assumed appearance or persona. That historical insight guided his description of the Massachusetts Bay colony in 1650. Hawthorne is describing the procession of dignitaries preceding the election sermon in *The Scarlet*

Without king and court, all Paris became a stage, or an insane asylum. Actor and madman have rejoined the human race and walk together into the nineteenth century. It is more appropriate than surprising that during the Terror the inmates of Charenton asylum were performing plays directed by the Marquis de Sade, an inmate acting the therapist.* The link was probably strengthened by physiognomy, a widespread belief that an individual's external traits correspond in systematic ways to his innermost character. Both actor and patient reveal themselves by appearances. By the end of the cen-

Letter. In a new world of equality and freedom, what gives these persons their respected status?

> . . . the men of civil eminence, who came immediately behind the military escort, were better worth a thoughtful observer's eyes. Even in outward demeanor they showed a stamp of majesty that made the warrior's haughty stride look vulgar, if not absurd . . . In that old day, the English settler on these rude shores—having left king, nobles, and all degrees of awful rank behind, while still the faculty and necessity of reverence were strong in him—bestowed it on the white hair and venerable brow of age; on long-tried integrity; on solid wisdom and sad-colored experience; on endowments of that grave and weighty order which gives the idea of permanence and comes under the general definition of respectability . . . So far as a demeanor of natural authority was concerned, the mother country need not have been ashamed to see these foremost men of an actual democracy adopted into the House of Peers, or made the Privy Council of the sovereign.

In the "New World," demeanor, semblance, and the deportment of rank and majesty had to take the place of "natural authority." The dignitaries are described as actors playing the roles of nobles.

* The heated official disputes over Sade's situation pertain directly to my argument. The chief doctor at Charenton, Royer-Collard, wrote a powerful and informative letter in August 1808 to the Napoleonic Minister of Police. He urged that Sade, "that abominable man," be transferred to a fortress-prison. "This man is not insane. His only delirium is that of vice . . . Unwisely a theater has been established within these walls on the pretext of having the inmates perform plays, and without taking into account the deadly effect that such unbridled activities must have on their imaginations. Monsieur de Sade is the director of this theater."

Coulmier, director of the Charenton establishment, successfully defended Sade's presence in an asylum rather than in a prison on grounds that could never have been considered a few years earlier and that demonstrate the spreading influence of "moral treatment." A police report says of Coulmier: ". . . because he considers acting as a method of curing mental alienation, he is happy to have in his asylum a person capable of giving theatrical training to madmen, whom he hopes to cure by this remedy." Coulmier, his friends, and other outsiders attended these famous, therapeutic performances. (See Gilbert Lély, "Le Vieillard de Charenton" in *La Vie du Marquis de Sade*.)

tury the connection between acting and therapy was unmistakable. In the eighties Charcot was presenting his hysteria patients in demonstrations produced and directed like theatrical performances. Soon after, behind very different styles and philosophies, Stanislavsky and Meyerhold and Copeau implied that the demanding discipline of acting can form and expand the character of the actor and elevate the community within which he works. Psychic health and therapy concerned them deeply. By the time we reach Artaud and Brecht, Grotowski and Brook, the actor has become either a skillful pedagogue or a figure of martyred sainthood sacrificing his common humanity to a lofty calling as therapeute. In the absence of station and self assigned by mere birth, it is as if playacting offered a means of forging a self and constituting a community. "A session of psychodrama in an asylum," writes Brook in *The Empty Space*, "represents, to my eyes, the image of a necessary theater."

Meanwhile, a complementary shift has carried important segments of analysis and psychotherapy in the direction of the theater, of histrionics. The writings of Kierkegaard, Huizinga, Sartre, Kenneth Burke, and Roger Caillois have prepared the way for various schools, among them existential psychoanalysis, psychodrama, and transactional analysis. These schools share a tendency to construe the self or character as something virtual and problematic, as an entity capable of coming into being only in performance. In recent social thought Clifford Geertz speaks in measured tones of "the theater state," and Victor Turner and Richard Sennett of "social drama." In the preface to *Progress and Disillusion*, Raymond Aron goes the full distance: "Society is a sort of *commedia dell'arte* in which the actors have the right to improvise along prescribed lines. It is a strange theater, like Leibnitz's universe, which admits of no distinction between the stage and the pit, and in which everyone belongs at once to the cast and to the audience." In these circumstances the actor, instead of being the symbol of heretical self-abdication and betrayal, has become a source of truth, community, and potential therapy for those who learn the elements of his art. Acting appears to many to offer a grammar of self.

An alluring paradox arises here, best discerned in the combination of theater and therapy developed as psychodrama by Freud's dissident student, J. L. Moreno. In psychodrama sessions mental patients are encouraged to free themselves from their traumatizing fantasies and obsessions by acting them out completely (or by reacting spontaneously as members of the audience). In effect, these theatricals serve

not to dramatize but to dedramatize, to defuse events and emotions that are interfering with the rest of a person's life. One patient's response tells all: "It is only in psychodrama that you don't have to act." In other words, for that patient—and perhaps for many other people—we have reached the point where all the world is indeed a stage; and only on a stage within a stage, while officially acting, can one turn back to the authenticity of self.

Here also our vocabulary fails us. For in considering the reciprocating relations between daily life and theatrical traditions, the simple word "acting" loses all shape and edge. It is like having only the symbol H_2O to designate all the different states of that element when talking about the weather or the operation of a steam engine. Though Huizinga, Caillois, and Bateson differentiate several categories of play, few authors have commented intelligently on modes and intensities of acting.* Take a public lecturer. As he stands in front of his audience in ritual suit and tie, trying to embody in his voice and movements the lineaments of a fine sensitivity and an awesome intelligence, he is projecting himself into the role of public lecturer. Yet this heightened and conventionalized performance of himself still under his own name and in his own person—we assume he is not the same at home—must not be confused with "acting" at its opposite extreme. For the word also refers to the nearly total inner and outer transformation sought by some professional actors into the very being of, say, Othello, appropriately costumed and made up, in a stage set representing another time and place. An actor may aspire to "lose" himself and to "live" that role on stage at the moment of playing it. Appearing as oneself for a formal lecture lies far removed from total impersonation eliciting empathy from the audience for that role. Yet we can use the word "acting" for both, and for all the vast terrain between. Sartre, in his discussion of sincerity, hypocrisy, bad faith, and *being what I am not*, makes some essential discriminations at the end of the spectrum closest to ordinary living. I believe that Molière, in the matched pair of plays *Tartuffe* and *The Misanthrope*, is dramatizing the same material. Tartuffe's blatant and greedy hypocrisy contrasts beautifully with Alceste's righteous self-delusion and insensitivity to the feelings of others, the seventeenth-century version of bad faith.

This is not the place for me to propose an elaborate new classi-

* An exception is Michael Kirby's "On Acting and Not-Acting" in *The Drama Review*, March 1972.

fication and nomenclature for modes of acting. Yet it should be possible to establish gradations along a spectrum running from a hypothetical (and for adults probably inaccessible) zero point of complete "naturalness" or unself-consciousness as oneself, through varying degrees of playacting to the extremes of total impersonation. (Pathological delusion—i.e., believing calmly that one is Napoleon —may carry the process full circle back to zero.) Our behavior often varies fairly actively back and forth across this range, as Brecht makes clear with his street-scene model. The behavior of a professional actor can be seen as the special case of a person who, at least in his working hours, tries to find and hold a position far over on the high side of the dial, a long way beyond platform lecturing or singing, yet short of the self-alienation that blends into psychosis and insanity.

What I have said so far about providential station yielding to a constructed self, and about the relation between psychotherapy and acting leads me to the conclusion that we have added a second paradox of acting to the first one that Diderot proposed two hundred years ago.* In its most condensed form the original paradox goes like this: To move the audience successfully, the actor must remain unmoved, fully in control of his movements and feelings. He does not, in other words, entirely lay aside his own self or identity in order to enter the self of the character he is playing. The paradox is inverted in Leigh Hunt's comparison of John Kemble's acting ("a personation—all external and artificial") with Edmund Kean's ("the real thing which is the height of passion . . . the truth of sensation"). And the opposition comes down to our century in the loose taking of sides by Stanislavsky and Artaud for living a role on stage against Meyerhold and Brecht for stylization, control, and various forms of histrionic irony.

My remarks on acting and insanity, on self and therapy, all point to the slippage of that paradox. One can no longer speak about self or identity or character as something one is given and can only provisionally set aside for another. Diderot himself opens up the view for us.

> It has been said that actors have no character because by playing all characters they lose the one nature gave them and become false,

* We cannot tell to what extent Diderot wrote the dialogue *The Paradox of Acting* ironically, tongue-in-cheek. Internal evidence and Diderot's other writings on the subject convince me that he is being far more ironic than is usually believed.

the way a doctor or surgeon or butcher becomes cold-blooded. I believe that this is mistaking the cause for the effect, and that actors can play all characters because they have none in the first place.

The state of characterlessness that Diderot attributes (perhaps playfully) to actors is what we have come to suspect of ourselves, of all of us. If the mere circumstance of birth gives us no divinely ordained role in the social and psychic order, we are free then to carve out for ourselves as much social and psychic space as we can adequately fill. Indeed, it would appear to be our moral duty—perhaps our civic and democratic duty.

The second paradox of acting enters here and applies not just to actors but to all of us. "To be[come] oneself, one must act that role successfully enough to convince oneself and all spectators worth considering." It sounds commonplace, almost trivial to our ears. But note again that in this innocent statement the sinful practice of acting, of feigning, has changed into a psychic achievement and recommended therapy. Some startling sentences in Darwin's *The Expression of Emotions in Man and Animals* seem to found the whole argument: "He who gives way to violent gestures will increase his rage; he who does not control the signs of his fear will experience fear in a greater degree . . . Even the simulation of emotion tends to arouse it in our minds." Thus simulation brings stimulation; acting is becoming.

Diderot's remarks suggest that actors may have special testimony to give on this second paradox. At the time of Peter Sellers's death in 1980, many newspapers reported his repeated statements that he had no sense of himself as a person, as a character, except when he was acting. Kean and Talma had recurrent trouble keeping track of their offstage and onstage personalities. In a little-known and important correspondence with Freud, the French cabaret singer Yvette Guilbert implies that she could always maintain a safe distance between her own person and the sleazy characters she represented on stage. Freud would not allow her to get off so easily and proposed his own tentative theory of acting and personality.

Not that the actor's own person is eliminated but rather that elements of it—for instance, undeveloped dispositions and suppressed wishes—are used for the representations of intended characters and thus are allowed expression . . . But so little is known. [March 8, 1931]

Louis Jouvet, in *Le Comédien désincarné (The Disembodied Actor)*, made the most revealing statement: "One practices theater because one feels that one has never been oneself, that one is incapable of being oneself, and that, at long last, one will be able to become oneself." From so strong an offstage presence as Jouvet, the sentence sounds perverse. But is it? The feeling spreads very wide. Byron revealed himself to Lady Blessington: "Now if I know myself, I should say that I have no character at all. I am so changeable, being everything by turns and nothing long." Isn't this condition something that most of us confront, not from birth perhaps, but following the phase of intellectual puberty at which we first sense that the circumstances and roles in which we have grown up are not given but tentative, open, subject to change instituted by us? The injunction "be yourself" is less a restriction than an invitation.*

Here, then, is "the histrionic sensibility" of my title, a term I borrow from Francis Fergusson's *The Idea of the Theater.* The history of mental medicine and of the theater reveals the ways in which playacting and character formation have mingled in the modern post-revolutionary world. What is no longer given—station or self— must be created. It may take a lifetime. To that end most of us own a little property, have some adventures high or low, and revert at intervals to the mutterings of our innermost feelings. It all helps. At the same time I wonder how far the histrionic sensibility, the fourth path to a place in the world, has also made actors, and perhaps lunatics, of us all.

3

We should now be ready to have another look at the three passages quoted at the start. Stendhal's jubilant tone suggests that act-

* These last remarks entail a serious criticism and realignment of "the looking-glass phase" that Jacques Lacan proposed in *Ecrits* as the earliest step toward a unified sense of self and character formation. We may first recognize and assume our body image in a mirror between six and eighteen months of age, as Lacan argued—though direct, tactile exploration of the body is probably equally important. But that looking-glass process continues, subject to challenges, shock, and rupture, for as long as we continue to reflect on the image of our self. And following what I have called intellectual puberty, the obverse side of the essentially passive looking-glass phase comes to the fore as a willingness to try out new forms of behavior and feeling toward the world around us and to screen the results into a temperament, a self. The footlight phase of character formation overlays anything done with mirrors.

ing gave the young prince the very means he needed to assume his new station. What he learned from the duchess still resembles the kind of training Castiglione describes in *The Book of the Courtier*, training in roles fully appropriate to a noble's condition and to the status quo. In Baudelaire and Sartre, however, the situation has become distinctly uneasy. The reasons of state that require Fancioulle's death are more metaphysical and psychological than political. The actor practices a magic so effective that it seems to threaten the prince's authority and the status quo that it rests on. In Sartre the status quo has simply vanished. Having no given being (*en soi*), the man employed by the café must be what he is not, in order to do his best to become a waiter. He plays a role. There is something terribly wistful about Sartre's semi-comic description. He presents the waiter so that we see him as "alone—with onlookers," as Valéry says of Stendhal's characters. It is the very condition Stanislavsky finds exalting for the actor: "solitude in public" (*An Actor Prepares*). These two quotations reveal not so much a passive narcissism in the human psyche as our profound reliance on self-performance. The footlight phase sets the terms of our freedom.

In his *Autobiography* Henry James refers to "the histrionic character." Borges speaks in *Borges and I* of his personal preferences for walking, maps, coffee, hourglasses, and the prose of R. L. Stevenson, and then of how the public Borges "shares these preferences, but in a vain way that turns them into the attributes of an actor." The histrionic character surrounds us more than ever, permeates the words we use and the moral atmosphere we breathe. Fiction and film never tire of exploring the new paradox of acting. In John Barth's *The End of the Road* the antihero Jacob Horner is under treatment by a nameless psychotherapist who found Jacob in a semi-catatonic state on a bench in a railway station. The principal scene on "mythotherapy" measures out a troubling mixture of ridicule and respect. The doctor speaks: "This indicates to me that you're ready for Mythotherapy . . . But it's best you be aware of what you're doing, so that you won't break down through ignorance. Some time ago I told you to become an existentialist. Did you read Sartre?" Jacob says he hasn't read much lately; the psychotherapist explains that he must learn to play a part.

> "It's extremely important that you learn to assume these masks wholeheartedly. Don't think there's anything behind them: *ego*

means *I*, and *I* means *ego*, and the ego by definition is a mask. Where there's no ego . . . this is you on the bench—there's no *I*. If you sometimes have the feeling that your mask is *insincere*— impossible word—it's only because one of your masks is incompatible with another. You mustn't put on two at a time. There's a source of conflict, and conflict between masks, like absence of masks, is a source of immobility. The more sharply you can dramatize your situation, and define your own role and everybody else's role, the safer you'll be. It doesn't matter in Mythotherapy for paralytics whether your role is major or minor, as long as it's clearly conceived, but in the nature of things it'll normally always be major. Now say something."

I couldn't.

"Say something!" the Doctor ordered. "Move! Take a role!"

I tried hard to think of one, but I could not.

"Damn you!" the Doctor cried. He kicked back his chair and leaped upon me, throwing me to the floor and pounding me roughly.

The ensuing fight does knock a little sense into Jacob.

Barth, like many of us, feels both skepticism and fascination toward this notion that we have to fake a character in order to find one. Stendhal's high spirits about the whole prospect are very rare and belong to a sanguine temperament. Baudelaire and Sartre speak with tragicomic directness to our deep uneasiness. Have we lost touch with, lost control of ourselves *as selves?*

One or two walk-on figures in Walker Percy's *The Moviegoer* attain the lofty condition of being "certified" as real, authentic, not because of any role they play in the story, but because they are historical, flesh-and-blood movie stars with famous names whose acting has transformed them out of mere humanity into the mythological realm. They carry the magic aura of what they have been seen to do on the screen. There lies our ideal of acting as a means of achieving character. It fascinates us as method and as madness. It can quickly lead us astray. "Oh, dear," says one of the peaceful, grotesquely costumed lunatics in the film *King of Hearts*, when the Scottish and the German soldiers start slaughtering one another on the village square. "Oh, dear, they're overacting."

NOTE. In addition to those already mentioned, works by a number of authors have contributed to this investigation: Aristippe, William Archer, Jonas Barish, E. K. Chambers, Toby Cole and Helen Krich Chinoy, Edwin Duerr, Jean Duvignaud, Michel Foucauld, Marcel Gauchet and Gladys Swain, Erving Goffman, G. H. Lewes, C. B. Macpherson, Marcel Mauss, Richard Sennett, and Joseph S. Tunison.

WRITERS

Balzac and the Open Novel

How does one go about reading Balzac? The things we learn first about him can be discouraging. We are told that he wrote close to a hundred novels and novellas; that a quarter of the way through his twenty-year period of peak production he discovered the inner unity of his works and gave them a single title and a master plan; that he had more than fifty novels named and mapped out when he died, at fifty-one; and that the volumes of his massive creation vary enormously in quality, theme, and treatment. What baffles us most is that Balzac established no starting point, no front door opening into the interlocking apartments of his universe. Might he not have built better and less ramblingly? Proust shows us exactly where to begin his three thousand pages, as do Zola and Roger Martin du Gard and Jules Romains for their *romans-fleuve*. But Balzac did not write a "river novel," flowing along in discernible banks to the sea. He wrote a flood novel, which gradually swallows the countryside

by moving in all directions at once. It is itself a sea—of fiction and of life.

Tradition has served us well in settling on *Père Goriot* as a work to represent Balzac. The longer and more mature *Lost Illusions* and *Cousin Bette* offer equally good access to his central Parisian stage of intrigue and social turmoil. One of those three might come first. Afterward, the stranger to Balzac's world would do well to choose *Eugénie Grandet*. Its provincial setting and compact narrative line balance the frenetic pace of the Paris novels. Yet the calm of Saumur cannot conceal for long the tidal forces that drive some men, wherever they are.

Aware of these forces gushing from within him as from his characters, Balzac set himself beside the greatest public figure of his age. "What he began with the sword I shall finish with the pen." "He" means Napoleon. When Balzac died, the critics grudgingly acknowledged that the comparison had stuck. But does the boast carry any true meaning? There have been greater novelists than Balzac, and more prolific writers. But none has delegated his life so completely to his writing as a means of self-aggrandizement. I do not say *sacrificed* his life: that would suggest he gave up something dear to him. Neither Napoleon nor Balzac sacrificed anything to achieve fame. Rather, they acquired through fame the only sense of themselves that could satisfy them. All biographers' efforts to build the private lives of these two into something that surpasses their public achievement fail ridiculously. Napoleon's sleepless nights of planning and his painstaking codification of law, Balzac's week-long writing bouts alone at his desk and inspired by huge amounts of coffee—their labors show us how intense was their resolve to be more than general or writer. These were means to immortality. They were willing when necessary to grub for it.

Fortunately, none of the grubbing shows in the leisurely, old-fashioned opening of *Eugénie Grandet*. Instead of dropping us *in medias res*, Balzac begins with forty pages of description, which he calls "*Physionomies Bourgeoises.*" No matter what pitch of passion they will reach, most of his novels start with a careful arrangement of the setting—interiors, exteriors, costumes, and the *mœurs* (customs) that bind the whole together. Here Balzac addresses himself directly to the reader as to a visitor and invites him to "go in." Gradually everything comes into focus around Grandet's house. The way Balzac devotes twenty pages to developing the significance of the

expression "Grandet's place" recalls the amusing device near the opening of *Remembrance of Things Past*. Proust lovingly embroiders fifty pages of provincial life around Aunt Léonie's urgent question as to whether or not Mme Goupil arrived at Mass in time for the Elevation. In the descriptive passages of both authors, architecture assumes a presence like the solidification of life itself. This masterful opening of *Eugénie Grandet* carries us not only to the scene of action but also far inside the existence of the characters. There is only a handful of them, most of them treated with a sly combination of sympathy, mockery, and enjoyment. The great comic bits—the Cruchoteer-Grassinist rivalry over Eugénie's hand, Grandet's crafty stammering, and Eugénie's mock court of flatterers at the end—belong in the broad tradition of Rabelais and Molière. It is strange how frequently Balzac bungled that tradition in *Droll Stories*, which he was writing the same year.

The plot of *Eugénie Grandet* is double in every respect. To begin with, it is propelled by a series of obvious but powerful contrasts, between Paris and the provinces, between father and daughter, between passion and monotony, and between the "good servant" Nanon (who prefigures Dickens's Peggotty, Flaubert's Félicité, and Proust's Françoise) and the civilized corruption of everyone else. The first narrative line grows out of Grandet's love of wealth. Everything and everyone, including his family, is related to him by finance, in gold *louis* or in paper *livres*. The second and opposing line relates the fortunes of love. Eugénie's muted sensibility awakens to "subtle excitement" (*fine volupté*) and the reward of a single kiss, which occurs more than halfway through the novel. Significantly, the event is witnessed and blessed by Nanon. When Eugénie's persevering love comes to nothing because of Charles's callousness, the two lines fuse into one. And here lies the elemental strength of the story: Eugénie inherits not only Grandet's enormous fortune but also, along with it, his parsimonious habits, his favorite expression—"We will see about it . . ."—and his indifference to all spontaneous feelings of sympathy. As Grandet's financial maneuvers outsmart the Paris market riggers, Eugénie's calculated marriage represents a triumph over the Cruchoteers. By that unconsummated union she secures good legal advice and, in the end, her husband's money. She triumphs as well over Charles, who cuts a sorry figure. She dispatches him with one of the most mordant lines in Balzac: "Be happy, in accordance with the social conventions to which you are sacrificing our early love." This

accumulation of powers and positions earns for Eugénie the right to the title role.

Compared to the opening, it is a curious ending. All through the last chapter the pace of the action has picked up markedly, with breathless transitions and jumps indicated by no break in the original text. It should satisfy no one to be told that Balzac was being hounded by debts and deadlines. And then the thirty-three-year-old widow with her millions and her faded beauty returns to Grandet's place and the same routine of life described in the first chapter. Finance has overcome feeling; the circle has closed. Or has it? Rumors of a second marriage for Eugénie are quietly narrated with a shift into the present tense, thereby lifting the whole story out of the past to a level that hovers between the universal and the immediate. The novel closes on a half cadence.

The reason for this ending brings us back to the larger perspective of *The Human Comedy*. The carpentry that holds that five-foot shelf together is Balzac's *ex post facto* discovery and subsequent exploitation of the device of recurring characters. The best-known figures, each of whom leaves his mark on a succession of novels, are the archcriminal and fugitive from justice, Vautrin (under a score of aliases), and the master plotter, Rastignac, Vautrin's pupil. The action of *Eugénie Grandet*, however, takes place away from their natural habitat of Paris, where barely masked vice provides the driving sense of movement that constantly supplants the sense of order in Balzac. True, the cosmopolitan and aristocratic world of Paris stands in the wings of this provincial story; Balzac sees to that. Charles Grandet and Adolphe des Grassins, for example, have met earlier at a ball given by the fabulously wealthy banker Baron de Nucingen. And Monsieur des Grassins, the Saumur banker, is happy to become Grandet's regular agent in Paris because he has thrown over family and fortune for the actress Florine. Both Nucingen and Florine appear in a dozen other novels in important roles. But the real link to the outer world comes through the open ending. Although it was completed in 1833, before Balzac had consciously adopted the scheme of using reappearing characters, the last page of *Eugénie Grandet* cries out for a sequel. That sequel, as it turns out, was never written. Nevertheless, at that early stage in his development Balzac already had the instinct for shifting things around unexpectedly at the end of his story. It is as if some faculty in him knew enough to leave one or two characters ready for further development so that he might

come back to them. No wonder his endings often sound like beginnings—beginnings not of the same story all over again in cyclical repetition but of new events, reversals, and further varieties of action. The terrain stretches on as far as the eye can see on every side. Balzac's proposal to survey it all is truly gigantic. In this novel one is free to conjecture what he might have done later with Eugénie had he come back to her. At least he had not buried her, and had left her with all those millions to amplify the effect of every move she made.

Though no sequel exists, there is a novella written three years earlier that forms a counterpart or companion story to *Eugénie Grandet. Gobseck* traces the decline of one of Père Goriot's beautiful and vicious daughters. But our interest centers on the powerful, megalomaniac, yet finally honest intelligence of Gobseck, a Paris usurer and miser. His wealth comes closer than Grandet's to bringing him happiness. "My gaze is like God's, I see into people's hearts. Nothing is hidden from me." So much money appears to endow its possessor with a kind of second sight. Gobseck dies stoically in a house overflowing with accumulated treasure and junk.

The action and characters of *Eugénie Grandet* display a potential rather than an actual link with the other events of Balzac's large-as-life narrative. Yet the simple machinery of the novel sets in motion a surprisingly large number of themes central to *The Human Comedy*. The explanation is not Eugénie's pure heart: that delicate organ will soon wither. The explanation lies in the inflexible and despicable character of Grandet, the miser, whose calm at the news of his brother's suicide makes even the lawyer Cruchot shiver. But Balzac tells us in the earliest pages that Grandet is by no means without feeling. Quite the contrary:

> The gaze of any man accustomed to drawing immense interest from his wealth inevitably acquires—like the eyes of the libertine, the gambler, or the courtier—certain indefinable habits, a greedy, furtive, mysterious flicker; and this is not lost upon his fellow worshippers. It is a secret language constituting in some respects a freemasonry of the passions.

The single-mindedness of Grandet's passion places him next to Balzac's other great egoists, all as fascinating as they are execrable: Balthazar Claes, Rastignac, Cousin Bette. But the figure of the miser, in Balzac's money-ridden society, takes on far greater significance than that of the semi-comic characters we are accustomed to: Shy-

lock, Molière's *avare*, and Dickens's Scrooge. As Balzac paints him, this worm in the fruit has devoured so much of its substance that he threatens the very balance of nature. The subject is well worth pursuing further.

In his article on Balzac, Hugo von Hofmannsthal writes of an "imperceptible system of coordinates" that allows us to orient ourselves among the wealth of personages and motifs. The fascination of *The Human Comedy*, the whole and the parts, arises more from this network of themes than from the frequently overdrawn or jejune characters. Grandet takes on particular importance because the miser occupies a point of convergence of several such coordinates. I shall mention four, whose roles are evident in the majority of Balzac's novels. There is the theme of money and commerce, evolving into its "abstract" and semi-magical form of speculation. There is the theme of paternal devotion and heredity, clearly close to the idea of authorship, both of which suggest a strong desire for immortality. There is the theme of high adventure and fantasy, the willingness to risk everything including one's own soul to obtain what one passionately desires. Otherwise life lapses into unbearable tedium. And there is the theme of patient hoarding, of knowledge or of goods, against the action of time. The inspired greed of the true miser clutches these four strands tightly together, and they lead him to the visible and ponderable substance of gold. Language itself gives us clues to this lust for power. The miser goes beyond mere penny-pinching to live by *interest*—the marketplace transcription of *self-interest*, the premium our selfishness levies on everyone around us in return for the claims they make on us. Even more revealing is the French word for usury: *usure*. Along with the meaning of excessive interest rates, it also signifies a wearing down or using up, the erosion of any substance by a natural process. It is as though the miser were supremely and compulsively aware of the terrible attrition of mortality. He sees all around him the high cost of mere living, the cost in energy and feelings and goods. He combats this *usure* with the other *usure* and strives to control and dominate one commodity: money. His avarice does not prevent Grandet from taking considerable risks, venturing forth in the dead of night with his precious gold to exchange it for paper when the price has risen. He does not hesitate to buy up choice property. Balzac's misers have a strong streak of the speculator in them; their capital grows at a dizzy pace. And above all, Grandet pulls off his great scheme of saving his

brother's honor through legal astuteness, stalling, and flourishing his own wealth without parting with a penny of it. Gobseck speaks of money with a greater gift of expression, but Grandet has a purpose that must not be overlooked. He is resolved to deliver his colossal fortune intact into his daughter's well-prepared hands. Surely he was a harder man than Père Goriot, but I would venture to say that he was no worse a father. Both men, of course, came close to destroying their daughters. And it belongs to Balzac's "comedy" that the fortune of neither man should survive him long.

There is another linguistic coincidence to which I cannot help attaching at least symbolic significance. One of the great discoveries Grandet makes in the course of "saving" his brother's honor is the lucrative rates paid on government bonds. He relinquishes his gold for a huge entry in the *Grand Livre*—the Great Book—which Joseph Cambon established in 1793 to consolidate and keep account of the public debt. In justifying to his family and friends the size of Grandet's fortune, Balzac cites the case of a peddler who had swelled his hoard of thirteen million francs to twenty million by "entering them in the Great Book." This beneficent volume is alluded to in several novels to explain the generation of wealth. The miser "makes" money by lending it against an entry in a ledger. In the postface to *Eugénie Grandet*, Balzac cannot have completely forgotten high finance when he falls back on a stock metaphor: "This story is an imperfect translation of a few pages overlooked by copyists in the great book of the world." It may have been an unconscious association. Balzac himself seems to step into the role of investor. He inscribes his savings in a "great book," the one he has devoted his life to writing, so that they may grow to a fortune. And in effect they did. Authorship here displays how close it lies not only to paternity but also to usury —usury in the complex and exalted form that obsessed Grandet and Gobseck.

Against this background it is foolish to make resounding statements about Balzac as a practitioner of realism in the novel. True, he called himself "a modest copyist" and the "secretary" of French society, compared his methods to those of the naturalist Cuvier and the physicist Réaumur, and identified his subject as "the pathology of social life." But Baudelaire, in a fine short article full of insights, declared him "a passionate visionary." The monk's robe he wrote in could not chasten the incorrigible romantic, ready to believe in all systems and all myths. Obviously Balzac's aspirations to order worked

at right angles to his promiscuous performance. (He referred to his desperate measures to keep on producing after his health began to fail as "masturbation of the brain.") This conflict, skillfully directed, produced the intensity and flexible pace of his style at its best. The aggravation of the conflict or its absence explains the origin of several celebrated clinkers: *The Fatal Skin, The Lily in the Valley,* and *Splendors and Miseries of Courtesans.*

Several writers have admired *Eugénie Grandet.* As might have been expected from certain resemblances in setting and theme, Flaubert speaks glowingly of the book in his correspondence. A translation of the novel into Russian was the first published book of a young writer, Fyodor Dostoevsky, who owed a great literary debt to the French author. Inevitably, Balzac, the most controversial and prolific novelist of his day, encountered Victor Hugo. Hugo was an ardent democrat, an elected representative of the people, and a member of the Academy. Balzac, royalist and pseudo-aristocrat (*de* Balzac), had failed in his candidacies both to the Constituent Assembly in 1848 and to the Academy in 1849. One of their meetings took place in the ludicrous barracks of a country house Balzac had bought as a speculation in real estate. The last one came when Balzac, recently married to his Polish countess and installed at last in the fine house he had bought for her in Paris, lay on his deathbed. Each time, they spoke of the people and of democracy. Balzac profoundly distrusted both and said so. They seemed irreconcilable, yet their flamboyant temperaments show similar markings. The old fox, Hugo, who had given his friend detailed and wasted advice on how to increase his earnings by writing for the theater, pronounced a stunningly appropriate funeral oration over Balzac's grave. After stating that all contemporary civilization is recorded in *The Human Comedy,* Hugo rolled out over the strong wind that swept the cemetery a sentence worthy of them both: "Without knowing it, whether he wished it or not, the author of this immense work belongs to the sturdy race of revolutionary writers." In his heart Balzac could not have protested. He had himself written a rival sentence, which now appears as the inscription in a widely circulated compilation of his writings: "I belong to the opposition party, which is called life."

Vibratory Organism:
Baudelaire's First Prose Poem

1

We rarely read a text "cold." The author's name, or even a century number, is enough to prepare our reactions. Such information sets the work in context and fits it into a system of interlocking classifications that direct, or prejudice, the reading. The scholar virtually encases himself in such tendentious data before venturing out onto the frontiers of knowledge. Yet it is those of us who live with and by literature who most need to come back to the written word "cold turkey," without props and habits and protective garments.

I say all this in order to adjure my readers to peruse the following quotation "naïvely and sincerely," as its author would have said. For this purpose the best method is to read aloud. A few readers may recognize the words immediately; they might try feigning ignorance. I shall ask the others not to worry over the question of

attribution. For heuristic purposes we can hold off the recognition
scene as long as possible.

*Supposons un bel espace de nature où tout verdoie, rougeoie, pou-
droie et chatoie en pleine liberté, où toutes choses, diversement
colorées suivant leur constitution moléculaire, changées de seconde
en seconde par le déplacement de l'ombre et de la lumière, et agitées
par le travail intérieur du calorique, se trouvent en perpétuelle
vibration, laquelle fait trembler les lignes et complète la loi du
mouvement éternel et universel. —Une immensité, bleue quelque-
fois et verte souvent, s'étend jusqu'aux confins du ciel: c'est la mer.
Les arbres sont verts, les gazons verts, les mousses vertes; le vert
serpente dans les troncs, les tiges non mûres sont vertes; le vert est
le fond de la nature, parce que le vert se marie facilement à tous
les autres tons.* Ce qui me frappe d'abord, c'est que partout,—
coquelicots dans les gazons, pavots, perroquets, etc., —le rouge chante
la gloire du vert; le noir, —quand il y en a, —zéro solitaire et in-
signifiant, intercède le secours du bleu ou du rouge. Le bleu, c'est-à-
dire le ciel, est coupé de légers flocons blancs ou de masses grises
qui trempent heureusement sa morne crudité, —et, comme la vapeur
de la saison, —hiver ou été, —baigne, adoucit, ou engloutit les con-
tours, la nature ressemble à un toton qui, mû par une vitesse ac-
célérée, nous apparaît gris, bien qu'il résume en lui toutes les
couleurs.*

*La sève monte et, mélange de principes, elle s'épanouit en tons
mélangés; les arbres, les rochers, les granits se mirent dans les eaux
et y déposent leurs reflets; tous les objets transparents accrochent
au passage lumières et couleurs voisines et lointaines. A mesure
que l'astre du jour se dérange, les tons changent de valeur, mais,
respectant toujours leurs sympathies et leurs haines naturelles, con-
tinuent à vivre en harmonie par des concessions réciproques. Les
ombres se déplacent lentement, et font fuir devant ellts ou éteignent
les tons à mesure que la lumière, déplacée elle-même, en veut
faire résonner de nouveau. Ceux-ci se renvoient leurs reflets, et,
modifiant leurs qualités en les glaçant de qualités transparentes et
empruntées, multiplient à l'infini leurs mariages mélodieux et les
rendent plus faciles. Quand le grand foyer descend dans les eaux,
de rouges fanfares s'élancent de tous côtés; une sanglante harmonie
éclate à l'horizon, et le vert s'empourpre richement. Mais bientôt
de vastes ombres bleues chassent en cadence devant elles la foule
des tons orangés et rose tendre qui sont comme l'écho lointain et
affaibli de la lumière. Cette grande symphonie du jour, qui est*

** Excepté à ses générateurs, le jaune et le bleu; cependant je ne parle ici que
des tons purs. Car cette règle n'est pas applicable aux coloristes transcendants
qui connaissent à fond la science du contrepoint.*

l'éternelle variation de la symphonie d'hier, cette succession de mélodies, où la variété sort toujours de l'infini, cet hymne compliqué s'appelle la couleur.

Let us imagine a beautiful expanse of nature where the prevailing greens and reds shimmer and modulate in complete freedom, where all objects, variously colored according to their molecular structure, changing from second to second by the interplay of heat, exhibit a perpetual vibration that makes their outlines tremble and fulfills the universal law of external movement. —An immense area, sometimes blue and more often green, extends to the furthest limits of the sky: it is the ocean. The trees are green, the grass is green, the moss is green; green weaves along the tree trunks; the unripe shoots are green; green is nature's basic color, combining easily with all other tones.* What strikes me first is that everywhere—dandelions in the lawn, poppies, parrots, etc.—red sings the praises of green; black—where there is any—an insignificant solitary vacancy, borrows heavily from the blue or the red. The blue, that is the sky, is broken by light white puffs or gray masses that relieve its raw uniformity; and, since a seasonal mist, winter and summer, bathes, softens, and blurs all contours, nature comes to resemble a great spinning top which, turning very fast, looks gray to us even though it contains in itself all colors.

The sap rises, and its blend of elements spreads out everywhere in mixed tones; trees, rocks, granite formations are mirrored in the water that receives their image; anything transparent absorbs flecks of light and color as they pass through, from close by or far off. As the daystar moves overhead, the tones change in value but, always observing their natural sympathies and repulsions, continue to live in harmony through reciprocal concessions. The shadows shift slowly and chase certain colors out ahead or extinguish them, while the lighting itself changes and starts other tones quivering again. These tones reflect one another and, modifying their textures with borrowed transparent glazes, endlessly multiply their melodious and fluid marriages. When the great ember descends into the water, scarlet fanfares burst forth on every side; a blood-red harmony fills the horizon, and the green deepens to a rich purple. But soon huge shadows begin rhythmically chasing away the scattering of orange and rose tones that act like the remote muted echoes of the lost light. This great symphony of daylight, which is the eternal variation of yesterday's symphony, this succession of varied melodies welling forth directly from the infinite, this commodious hymn is called color.

* Except with its two generating colors, yellow and blue; however, I'm speaking only of pure shades. For this rule does not trouble transcendental colorists, who have mastered the science of contrast and counterpoint.

If we found this passage as an anonymous fragment in an ob-
scure provincial collection, would we pause to examine it closely?
Does this unitive vision seem excessive, or does it project a powerful
sensibility in command of its medium? Does it immediately reveal
its provenance? I shall assume that an inner voice, literary conscience
or unconscious, has prompted us to look again.

The passage opens with the phrasing of a mathematical demon-
stration. After the first clause, the style veers sharply toward sensuous-
scientific description of a strange landscape. The four rhyming
verbs carry a curious echo of a sentence in Perrault's *Bluebeard*.*
The scene appears both abstract and visionary, like a painting that
combines full-blown Impressionism with Magritte's petrified space.
The only objects in the picture are either conventional (sea, sky,
trees) or seemingly emblematic (poppies, parrots, rising sap). The
first sentence focuses on an intense Brownian movement that ani-
mates everything within the encompassing stillness. The expanded
scale of events forces us to confront molecules and seconds. This
palpitating closeness gives way to a composition of vivid colors
which, by an accelerating momentum carried over from the open-
ing, fuses into the gray blur of a spinning top. Meanwhile, we learn
that a correspondingly fleeting consciousness (*me; nous*) is behold-
ing the scene. In the second paragraph solar time enters the pic-
ture and shifts the pattern of tones inexorably toward the histrionics
of sunset. Twilight restores the hush, and the closing sentence re-
inserts the composition into a vast cyclical pattern of time and
change.

A few words project out of this carefully developed passage:
vibration, movement universel, toton, reflets (twice), *harmonie*
(twice), *réciproque, mariage* (twice), *variation*. They all depict some
form of self-contained or reciprocating motion. Several verbs are
made reflexive at key points. Even the personal pronouns fluctuate.
After the initial first person plural of *supposons*, the syntax shifts
through *je* and *me* back to *nous*. The second paragraph mentions no
persons; it has simply dispensed with them. Yet its excited descrip-

* Bluebeard's wife, having opened the forbidden door and seen the horror of the
slain wives, cannot hide her deed from her husband. During the interval he grants
her to pray before her own death, she calls out desperately to her sister to see
if their brothers are coming. "*Et sa soeur Anne lui répondit: 'Je ne vois rien que
le soleil qui poudroie, et l'herbe qui verdoie.'*" The unexpectedly poetic verbs
create a vivid feeling of suspense.

tion radiates the presence of a strong subject beholding the trembling scene. That consciousness does not stand back; it joins the dance with a minimum of syntactic separation. Because of these devices the entire composition develops as self-reflexive, self-beholding, and gradually takes on an all-inclusive wheeling motion. The initial "vibration" becomes the rotation of an enormous top. As readers we are drawn into the elemental turning of the scene, of the earth itself as the sun "goes down," of the whole natural cosmos, and of the tiny human consciousness here appended to it, creating and observing it. The vocabulary and subtly circular style of the passage carry us to the edge of vertigo, the great gray blur of natural process.

Everything contributes to this effect. The relatively long sentences of the first paragraph, broken by a great number of dashes, become short and accelerate their pace in the second paragraph. Each paragraph opens with a marked auditory repetition (*oie; m*). Then the sonorities become muted and leave the stage to the opulent vocabulary of color, synthesis, and science. Yet how does one assemble the whole and place it in context? Does it add up to a work of any literary significance? Is this a page out of a journal by Van Gogh? or Kandinsky? Is it some third-rate romantic foisting off on us an overwritten account of a howling drug experience? Why so much semi-scientific color theory? Is this a fragment out of a larger work? In any case, the last line is startling. The crescendo of visual display and intense feeling balances precariously on the head of the word *couleur*. By the end the color theme has been almost overworked. Yet these confident effusions cannot be the work of a third-rater. The author displays a singular and convincing sensibility.

No, not a third-rater. Baudelaire *fecit*—as many readers may have divined. The passage represents not typical but quintessential Baudelaire. This self-contained text appears at the opening of the third chapter, "On Color," of the *Salon de 1846.** Read beside the other 130 pages of his first important published work, it appears very much like a separate piece of writing half embedded in the assemblage of notes Baudelaire must have pulled out of his drawers in order to meet his deadline. He claimed he composed the *Salon* in a week. It appeared as a printed book eight weeks after the vernissage. He was in top form.

* Baudelaire, *Oeuvres complètes*, ed. Marcel A. Ruff (Paris: Seuil [l'Intégrale], 1968), pp. 230–31. References to Baudelaire's work will be indicated by numbers in parentheses giving the pages in this edition.

Yet 1846 was a desperate year for Baudelaire, who at twenty-five was better known as a bohemian and dandy than as a poet. Two years earlier his family had put his inheritance into a trust, from which he received an allowance. Financial need had driven him to write the *Salon de 1845*, an ineffective pamphlet that earned him practically nothing. A month later he melodramatically and feebly attempted suicide. Meanwhile, he seems to have been reading widely, particularly in the works of Swedenborg, Hoffmann, and probably Fourier. The historical significance of the text I have quoted can be succinctly conveyed by listing the various ways in which it represents a "first."

1. These opening paragraphs from "On Color" represent Baudelaire's first *poème en prose*.* He ends the previous chapter by saying, "I wish to write about color a series of reflections which will not be unusable for the full understanding of this little book" (p. 230). After the two initial paragraphs, the rest of the chapter on color breaks down into short paragraphs mostly of one sentence and of a discursive nature. The passage quoted resembles a shaped fragment of heightened experience, and its style generally conforms to Baudelaire's major statement in the 1862 dedication of *Petits poèmes en prose* to Arèsne Houssaye.

> Which of us has not, on his ambitious days, dreamed up the miracle of a poetic prose, musical without rhythm or rhyme, both supple and rough enough to adapt itself to the lyric movements of the soul, to the undulations of reverie, to the jolts of consciousness.

Baudelaire had made a first, unsuccessful attempt to write a prose poem in the opening pages of the *Salon de 1845*. Delacroix's painting *The Last Words of Marcus Aurelius* is seen as a "harmony of green and red," and the whole composition gives "the effect of a monochrome object which *turns*" (p. 205). The following year Baudelaire dispensed with Delacroix and composed his own visionary

* A few critics have implied as much in passing, but without pausing to examine the merit of the idea. See André Ferran, *L'esthétique de Baudelaire* (Paris: Nizet, 1933), p. 140; and Enid Starkie, *Baudelaire* (New York: New Directions, 1958), p. 159. Two other books have contributed substantially to my interpretations: F. W. Leakey, *Baudelaire and Nature* (New York: Barnes and Noble, 1969); and Baudelaire, *Salon de 1846*, texte établi et présenté par David Kelley (London: Oxford University Press, 1975). Kelley states (p. 110) that, as portrayed at the extreme right of Courbet's *The Artist's Studio* (1855), Baudelaire is reading the published text of *Salon de 1846*.

landscape saturated with shrill colors. The visionary prose texts by Aloysius Bertrand that suggested the new style to Baudelaire, *Gaspard de la nuit,* had appeared four years earlier.

Even though in 1846 he may not yet have defined and named the genre *poème en prose,* the circumstances suggest that the color passage is a nearly conscious attempt to write and publish such a work. Two comparisons reinforce the association. The second of the prose poems actually published as such, "Le *Confiteor* de l'artiste," describes a setting and a state of mind so similar to that of the color poem that it echoes the same vibratory response to a scene: "The huge delight of drowning one's gaze in the immensity of sea and sky! . . . (for in the vastness of reverie the self quickly loses itself!) . . ." (p. 149). *Confiteor* expresses a more self-affirming and combative attitude toward nature, and also replaces most of the color imagery with the concentrated point of a sail contrasting with the vastness of the seascape. Yet it is recognizably the same imagination propelling both.

The other work of Baudelaire's that comes to mind in reading the 1846 color passage is a poem whose date of composition is uncertain and which might be contemporary. "Harmonie du soir" ("Harmony of Evening") embodies in its repetitive pantoum form a powerful turning movement that subsumes all the elements of the poem—rhyme, rhythm, setting, sunset, and the poet's state of mind:

> *Voici venir les temps où vibrant sur sa tige*
> *Chaque fleur s'évapore ainsi qu'un encensoir;*
> *Les sons et les parfums tournent dans l'air du soir;*
> *Valse mélancolique et langoureux vertige!*
>
> *Chaque fleur s'évapore ainsi qu'un encensoir;*
> *Le violon frémit comme un coeur qu'on afflige;*
> *Valse mélancolique et langoureux vertige!*
> *Le ciel est triste et beau comme un grand reposoir.* [p. 69]

Now comes the time when trembling on its stem
Each blossom breathes its incense to the sky;
All sounds and odors wheel in the evening air;
Languorous waltz, enchanted vertigo.

Each blossom breathes its incense to the sky;
The violin sighs like a mournful heart;
Languorous waltz, enchanted vertigo;
The sky spreads out its glorious altar cloth.

The circular movement of the lines matches the vertiginous per-
ception—strongest at sunrise or sunset—that the earth is turning
under our very feet. Though the last line of the poem introduces
the figure of a loved one, "Harmonie du soir" and the color passage
deserve the kind of joint reading we accord to other associated
poems and prose poems.

For all these reasons I propose that the color text is not merely
"like" a prose poem half hidden in a critical essay. It actually is
Baudelaire's first attempt at the genre, partially set off as a separate
whole, and reaffirming the early onset of his desire to develop a form
of writing distinct from both formal verse and expository prose.

2. The intensity of Baudelaire's writing in the color poem, as
well as repeated terms like *harmonie* and *loi du mouvement éternel
et universel* suggest that it may be his first treatment of the theme
of *correspondances*. Though the word itself does not appear, the
rest of the chapter concerns nothing else and leads into the famous
passage quoted from Hoffmann's *Kreisleriana:* "I find an analogy, an
intimate union, among colors, sounds, and perfumes" (p. 232).
Several details suggest that Baudelaire intended in this chapter to
make his contribution to the reigning dispute over the relative im-
portance of *ligne* (Ingres) and *couleur* (Delacroix). What came from
his pen instead was a manifesto on universal analogy. There should
be no need to belabor this point. In 1846 Baudelaire had already
advanced a long way into his *"forêts de symboles."*

3. Because of the way he transposed his personal experience of
seascape and color—either as he had seen them in the tropics, or in
Delacroix's paintings, or in hashish-induced hallucinations—Baude-
laire created in the *Salon de 1846* a word tableau which we could
call the first Impressionist painting. Everything is there to describe
a Monet or a Renoir. On the next page Baudelaire sets down a
whole series of statements that open the way for Impressionist
theory.

> Color is thus the harmony [*accord*] of two tones . . . they exist only
> relatively. [p. 231]

> The atmosphere [*l'air*] plays so great a role in color theory that if
> a landscape artist painted leaves as he sees them, he would obtain a
> false tone. [p. 231]

He imagines himself a painter, and it is in this role that he makes
the final affirmation of the chapter: "Colorists are epic poets"

(p. 232). Like the most extreme of the Impressionists at the height of their scientific experiments, Baudelaire yearns to obliterate the contours of objects in order to convey the pervasive vibration of molecules and light.

It is possible that Baudelaire derived some of his color theory and vocabulary from Chevreul, the director of the Gobelins tapestry workshop and a meticulous experimental scientist with an artist's eye. His magisterial illustrated work, *De la loi du contraste simultané des couleurs*, had appeared in 1839. From the book, or indirectly through accounts in *L'Artiste* and elsewhere, Baudelaire probably became familiar with Chevreul's ideas. The expression *"coloristes transcendants"* in the footnote probably refers not only to painters like Delacroix but also to Hoffmann and Chevreul.* To a degree not yet fully explored, the Impressionists (particularly Seurat, who had a strong scientific and optical bent) found verification and support for their practice in Chevreul's theories. He was concerned with juxtaposing colored threads in a tapestry in order to form a harmony of tones, and his major experiments deal with the optical mixing of colors in the observer's eye.

4. I shall propose lastly that the quoted passage by Baudelaire contributed to a line of thinking and looking in Western art that would eventually lead to non-figurative or abstract painting. On the following page he states that "since art is only an abstraction and a sacrifice of detail to the whole, one must pay attention above all to the forms" (p. 231). Of course he is using the word "abstraction" analytically more than aesthetically or historically, yet one

* Chevreul deserves a footnote as long as I dare make it. In his effort to systematize the subjective process of color vision and interpretation, Chevreul has to develop a psychology of perception, virtually a science of sensibility. He distinguishes carefully between simultaneous, successive, and mixed color contrasts, the last being an after-image combined with a new color. In a long section on color and music, successive contrast comes out as melody, simultaneous contrast as harmony. The dynamics of color contrasts is compared in the final section to mental processes in general. Chevreul lays it down as law that comparison exaggerates differences and needs correction. This law applies particularly in solitary thought, in a two-way conversation, and in teaching. "Absolute" judgment is not possible for us because of "relative" circumstances affecting all observation. Because analysis proceeds by dividing wholes into parts, it necessarily distorts. (See M. E. Chevreul, *De la loi du contraste simultané des couleurs* [Paris: Imprimerie national (Edition du centenaire), 1889], pp. 545–58.)

Chevreul wrote a remarkably modern text, in which one keeps hearing anticipations of Saussure on language, of Eisenstein on montage, and of the Surrealists on the nature of an image.

cannot ignore the drift of his thought. A little later, in the same chapter on color, he makes himself clearer: "The sure way of knowing whether a painting is harmonious is to look at it from far enough away to grasp neither its subject nor its lines" (p. 232). He is asking us to consider the pure play of color. Veronese and Delacroix are both in his mind. He returned to the same idea seven years later in a famous passage about Delacroix in the *Exposition Universelle de 1855.* "You could say that this painting projects its thought from afar . . . This use of color seems to think on its own, independently of the objects it clothes" (p. 369). What Baudelaire later begins to call *l'art pur* in the unfinished essay "L'Art philosophique" is probably a further exploration of the non-representational possibilities of painting. In a phrase reminiscent of Coleridge and anticipating Mallarmé, he defines pure art as "a suggestive magic containing both object and subject, the world outside the artist and the artist himself" (p. 424). Faint echoes of pure art survive in the *Salon de 1859* in the discussions of photography and the imagination. After that, in the last essays on Delacroix and Guys, this strand of critical thought gives way before the doctrines of modernity and spontaneity. Nevertheless, the evolution of the idea of "abstraction" can be followed as late as 1858 after its beginnings in the 1846 prose poem on color. Baudelaire's references to it are very tentative, yet we learn from them what he actually saw.

These last two "firsts"—that is, a prose poem straining to transform itself into an Impressionist painting, and the same prose poem projecting out of its swirling movement the possibility of an "abstract" color composition without identifiable objects—lead to the not unexpected conclusion that in the 1846 color passage Baudelaire was practicing a kind of imaginary ekphrasis. In highly rhetorical language he described a work of art that can be attributed only to his own hand and that looked prophetically forward toward two major developments in European painting of the next hundred years.

2

With a little perseverance, therefore, one can place Baudelaire's early prose poem on color in a rich historical context that arrays his career as a writer beside the development of painting and art criticism in the nineteenth century. The two intensely written paragraphs begin to look like a remarkable anticipation of things to come.

But once again I find myself impelled to ask the question with which I began. Without the historical and literary context, does one receive a direct impression of the literary significance and merit of this text?

When I try to put aside the rich associations evoked in the preceding pages and come back to it "cold," the color passage from the *Salon de 1846* leaves me with two principal impressions. The first is of the hortatory tone propelling the entire exposition, even the most personal responses. The text exceeds the bounds both of description and of meditation. The second impression is of the author's sustained effort to affirm a single principle that will embrace all the elements of his experience—physical and spiritual, moral and aesthetic.

Read aloud, the two paragraphs take on the sonorities of a sermon. Bossuet's periods move like a ground swell beneath the surface rhythms. In this light I believe we can begin to understand better the oddly addressed opening chapter, "*Aux Bourgeois.*" You have taken over the government and the city, Baudelaire writes boldly; now, in order to reach "*cette harmonie suprême*" of property and knowledge, you must learn to appreciate beauty. One sentence leads me to doubt the possibility that irony undercuts the words here: "Pleasure is a science, and the exercise of the five senses requires a special initiation, which is reached only through inclination and need" (p. 227). This helps us. For it suggests that the two paragraphs we have been discussing belong to a "special initiation." In his mid-twenties, Baudelaire still wanted to believe that he could convert the middle class to some aesthetic sympathies. The initiation he proposed, encountered in concentrated form in the color text, consists in a direct presentation of what Baudelaire perceived under certain circumstances. The natural bent of his sensibility included a strong urge toward insight, clairvoyance, hallucination, distortion, abstraction. He was conscious of it and cultivated it deliberately and far longer than Rimbaud. The words *étrange, bizarre, dédoublement,* and the like stud his prose even when he is not concerned with drugs. Indeed, wine and hashish can be seen as one aspect of a self-imposed discipline intended to heighten his powers of vision. We can hear his resolutely visionary intent, and the same hortatory tone, in the fragment on realism he wrote in 1855: "Poetry is what is most real, it is what is completely true only *in another world*" (p. 448). When, in 1862, Baudelaire states, "I have cultivated my

hysteria with pleasure and terror" (p. 540), he feels the approach of madness; the process has gone on for fifteen years—since 1846 at least.

Because of the special nature of his sensibility, Baudelaire was not content to cast his initiatory message in ordinary words. He painted a word picture; he directly depicted what he saw and what he believed we too can see. "A permanent taste since childhood for all plastic representations" (p. 612), he states in a biographical note. His fundamentally didactic purpose in writing about the arts is probably best expressed in the late essay on Guys: "Few men are endowed with the faculty of seeing; fewer possess the faculty of expression" (p. 553). He began in 1846 with the idealistic goal of converting the bourgeois; gradually he restricted himself to writing for fellow artists and poets. But until the very end the evangelistic manner continues.

One of the most apt terms to identify what Baudelaire saw and what he wanted others to see is the word he introduced forcefully at the very end of the *Salon de 1846*: "The marvelous envelops and nourishes us like an atmosphere; but we don't notice it" (p. 261). He uses the word also in the essay on laughter (p. 377), written at about the same period. It conveys Baudelaire's sense of wonder that so many parts of the world emit a quality we call beauty, connect mysteriously with one another, and speak softly to us. I believe it is a strong sense of the marvelous that radiates from his early undeclared prose poem—even if we know nothing about its provenance and circumstances. Eighty years later the Surrealists elected *le merveilleux* as their ideal. But by then the word had come to mean not so much *relation* as *rupture*—a sharp break with conventional modes of living and feeling. *Le merveilleux* traces a gradual shift in sensibility across a century.

The title of the chapter and the vocabulary of Baudelaire's initiatory prose poem appear to present color as the key to his vision. He probably thought so himself, in great part because of Delacroix's influence. Samuel Cramer, the highly autobiographical hero of *La Fanfarlo*, written the same year, consoles himself by composing a book on color symbolism (p. 287). Yet closer inspection shows that the key is not so much the distribution and relation of tones as a deep-seated movement, what Baudelaire refers to in the first sentence as a "vibration, which makes the lines tremble and completes the eternal and universal law of movement." In the *Salon de 1845* he had tried out a weaker expression, "this equilibrium of green and red" (p. 205). In the final version, *vibration* pervades the entire

scene beginning with the molecules themselves, an insight fully in accord with the theories of modern physics. An eternal and universal law carries the principle of vibration to its extreme limit and places it also at the seat of consciousness. The spinning top represents not only the ceaseless agitation of nature but also, enfolded into one rhythm, the operation of thought itself.

Approaching the subject from a different direction and citing a few of the same passages, Georges Poulet has come to comparable conclusions in his chapter on Baudelaire in *Les Métamorphoses du cercle*. However, he finds limited value in the principle of vibration, which he analyzes as a kind of dispersion on the one hand and paralysis on the other. According to Poulet, the symbol of this compromise is the thyrse—a curved line grafted onto a straight line —which Baudelaire borrowed from antiquity via De Quincey. I wish to suggest that vibration represents not a compromise, not a restriction on the poet's sensibility, but the full display of his powers. Furthermore, vibration as a deep-seated poetic principle continues to work powerfully in modern poetry down to the present.

Here is the innermost burden of Baudelaire's prose poem. In the vibration of color he sees a supreme *correspondance*, linking external reality and the mind. This alternating rhythm also becomes the subject of "Le *Confiteor* de l'artiste," which begins to throb between *immensité* and *petitesse*, between *les choses* and *moi* (p. 149). Baudelaire returns to the universal law of alternation at a few other crucial moments of his writing. In "Advice to Young Writers," he speaks of *"la loi des contrastes, qui gouverne l'ordre moral et l'ordre physique"* (p. 268). Chevreul is audible again in this further attempt to find the unifying principle for all domains. Later, after assimilating Barbey d'Aurevilly and Poe, Baudelaire seemed to find a personification of the oscillating consciousness in the idealized figure of the dandy. But in 1846 he used vibration to express a dynamic combination of materialism and transcendence, in nature and in man. Therefore, the strong hortatory tone of the prose poem finds its justification in the vastness of the principle of correspondence Baudelaire is affirming in it. The whole universe vibrates as one—if you can only see deeply enough into the world. In this context *le vertige*, vertigo, specifically evoked as one of the rhymes in "Harmonie du soir" quoted earlier, represents not loss of consciousness but an intensification of consciousness. Gods speak out of whirlwinds; in order to reach true knowledge man must brave the maelstrom.

Approximately ten years later in one of the journal entries col-

lected as *My Heart Laid Bare,* Baudelaire caught the principle of vibration in two lapidary sentences that could stand as the inscription for his entire work. *"De la vaporisation et de la centralisation du Moi. Tout est là"* (p. 630). "The dispersion and the reconstitution of the *Self.* That's the whole story." The systole and diastole of the universe itself is reproduced in the contraction and expansion of the mind, alternately concentrating its attention and then opening itself to all impressions. The passage we have been examining implies, even more powerfully than a painting of the same subject, that the fascination of sunrise and sunset lies in the fact that these particular moments make sensible for us the earth's harmonious rotation, the generalized vibration of everything.

These are not simply the vagaries of an overwrought poet. A modern philosopher of science centered his boldest work around a concept that sounds like the product of Baudelaire's imagination. In the second chapter of *Science and the Modern World* Alfred North Whitehead sums up his description of the energy and periodicity of the very stuff of the universe in the term "vibratory organism." Sixty pages later, arguing on scientific grounds against the possibility of simple location for any event, he firmly states: "In a certain sense, everything is everywhere at all times." Baudelaire and Whitehead provoke us to contemplate a universe of dizzying proportions and relations.

Paul Valéry:
Sportsman and Barbarian

1

When a man becomes a public institution, he has either abdicated his personality and privacy or arranged his "back shop" so securely that no one can disturb him. In the case of Paul Valéry it all happened swiftly just as he was entering his fifties. He appears to have thrived on prominence.

The death in February 1922 of Edouard Lebey, the cultivated businessman for whom he had worked as "private secretary" for twenty years, coincided with the events that established Valéry's literary fame. A few months earlier, over three thousand readers of the literary review *Connaissance* had named him the greatest contemporary French poet on the basis of two slender volumes in limited editions. In May 1922, *Le Divan* published a special number honoring Valéry, with contributions by André Gide, Henri de Régnier, François Mauriac, Charles Du Bos, and Anna de Noailles. A major

collection of new poems, *Charmes,* appeared the following month. That same autumn, responding both to his need for a new source of income and to the call of literary celebrity, he began a series of speaking engagements. For the next twenty years until his death, he spent a substantial portion of his time aboard trains and on lecture platforms across the entire continent of Europe. By 1924 he had assembled a collection of essays and lectures for publication under the title V*ariété.* That was also the year in which Anatole France died. The Dada-Surrealist group, toward whom Valéry had been cordial a few years earlier, welcomed France's death as a release of the present from the burden of the past; their public demonstrations of delight outraged the official guardians of French culture. But Valéry was not among the demonstrators. For it was he who succeeded France in the two positions he left vacant as a member of the French Academy and president of the French P.E.N. club. Thus Valéry stepped symbolically into the role of poet laureate of the Third Republic. Its life span was to coincide with his. From that time on, every official honor and duty fell to him automatically. He complained in 1932 of being "a kind of state poet." He had thirteen more years of it.

Fortunately, Valéry was safe. He had prepared his retreat. Between 5:00 a.m., when he rose, and midmorning, his time was his own. The matutinal man belonged to no one else. The wonder of it will long remain. No adequate biography, official or unofficial, has yet appeared to tell the tale. More than a hundred books have been written about Valéry—about his mind, his poetics, his work, his painting. But no life. It is ironically appropriate that the best source of information on him is the compressed chronology that opens the first volume of the Pléiade edition of his works. (I, 11–72. Later references will be to this edition.) Even in those pages the emphasis falls on his intellectual career, the story of his mind. One has to look far afield to discover anything about his physical activities: his sensitive pencil drawings, his lifelong love of swimming, the bicycling he enjoyed as a young man, his love life (he had one), and the fact that he composed much of his published prose directly on a typewriter. Valéry himself tells us why all these things are relevant. In the "Note and Digression" on Leonardo da Vinci, he taxes literary criticism and criminology with the same fundamental error: treating a man as the *cause* of what he does. An author, like a criminal, is rather the *effect* of his works.

It is difficult to tell just how seriously this literary institution came to take himself. A good number of people have retailed the story about his reluctance to be satisfied with the customary hand-me-down uniform when he was elected to the French Academy; he had one made to order, of elegant cut. Yet the creature of ceremony was clearly not the whole man. François Valéry relates how his father at the family dinner table liked to refer to himself as a "government anarchist" and had blunt words for the mighty men of state he began to see more and more often. "They don't know any more than anyone else. They're all buffoons." It is hard to gauge the streak of imposture and flippancy that runs through all his writings, particularly *Mon Faust*.

The real question may not lie in the direction of Valéry's "seriousness." Laughter he referred to as "a kind of intellectual vomiting"; yet it is textually evident that he approached most public performances with his tongue well in cheek and a strong sense of self-parody. He would have dismissed all these matters as beside the point; they belong to literary history, the "external politics" of a writer. Nevertheless, even though his back room was secure and steadily occupied, the externals make their own special revelation. His career, in fact, resembles a compounding of Montaigne's, who quit "the dance" of public life at least twice in order to write, with Rimbaud's, who quit literature for keeps in his early twenties and found his way into gunrunning. Valéry's poetic production was confined to two brief periods: once very early before he turned twenty-one (1887–92), and again in his forties (1912–22).* After each period came twenty years of highly active "silence" in prose. His daily life evidently followed a comparable alternation between solitary work and a full social calendar. In a letter to Gide in 1929 Valéry identified the geological or ecological formation that allowed him to survive when he was inundated by the great ocean of public life. "The bottom layers, the foundation hasn't changed. You know that part is simple and straightforward. But between Me and me, one thing and another has raised a ring of coral. I'm an Atoll."

In my own experience I have found that the process of reading and absorbing Valéry observes an alternating rhythm comparable

* Scholars now working on Valéry's personal papers and unpublished manuscripts have discovered evidence of new poetic output toward the end of his life. The circumstances and the quality of these works will probably raise a few eyebrows, without modifying the basic shape of his career.

to that of his life. Usually one begins with the poetry and responds to the sensuous flesh and fiber of his best poems. Later, an inevitable reaction leaves one cool to the narcissistic repetitiousness of his inferior verse and to the mock dignity of certain speeches. Then, after an interval of absence, one returns to find in his work a surprisingly harmonious and unified monument of the mind. Contrary to much that has been said and written, Valéry's long dialogue with mathematics and science does not represent a flirtation or a useless humbug. To ridicule his serious application to these studies and his friendship with Einstein and Bergson, with Poincaré and Vallery-Radot and Jean Perrin and other contemporary men of science, is to miss the value of his exceptional sensibility. From his youthful investigations of Poe and Leonardo down to his last lecture on Voltaire, Valéry emphasized the simple truth that specialization belongs to our technological civilization and not to the mind itself. In 1925 he wrote to the physicist Charles Henry:

> Because you feel the prick of relativity, you have undertaken to discover the reciprocal relations between all phenomena, not only physical but also sensory and psychic, to the very limit of possibility. Nothing could appeal to me more, for the ruling thought of my entire life has been to try to represent such a general relation of symmetry and to discover consequences applicable to culture and even to art.

The proof lies in the notebooks that cover fifty years. In page after page of prose paragraphs that lead to equations, he put into practice what he declared from the start: that he wanted "to amuse myself by translating everything into mathematics" (*Cahiers* [*Notebooks*] I, 116). But it was no mere matter of amusement. His early and enduring conviction that such relations as relativity, simultaneity, reciprocity, symmetry, interference, and periodicity belong to the mind as much as to any other part of nature expresses his genius better than his clever pronouncements on politics or the rules of versification. I should judge that, poetically as well as philosophically, Valéry's early reading of William Thomson (Lord Kelvin) on the composition of the ether and of Clerk Maxwell on the sorting demon was as important as his study of Poe and Huysmans and Mallarmé.

But Valéry was never inclined to sacrifice humanism to mere scientism. In the academic set speech on "Prizes for Virtue," he introduces a fictional character who comes from the Companion of

Sirius and represents the "point of view" of that distant star. (Valéry is borrowing from Ernest Renan.) But far from exposing the relativism of all virtues and ideals, this imaginary inquirer from outer space discovers the true nature and value of Christian charity and carries that startling news back to where he came from. The best of what men have slowly created through history is worth defending against the encroachment of mindless relativism. Close behind Valéry's apparent detachment lie both conviction and courage.

2

A myth Valéry fostered in the 1924 preface to the first volume of *Variété* has it that he wrote his poetry entirely for himself with no plans for publication, and that all his prose was written by invitation on assigned subjects. This contrast of private poetry and public prose corresponds exactly to the Symbolist doctrine stemming from Baudelaire and Mallarmé that there are two languages: vernacular journalism and poetry. As one might expect, the distinction breaks down in practice, and it is just as well. Valéry's most important prose works, *Monsieur Teste* and *Mon Faust*, were in no respect "occasional." On the other hand, it was the persistent solicitation and encouragement of Gide, who wanted to publish Valéry's early poetry, that drove him back to writing verse and led to the completely new poem, "La Jeune parque" ("The Young Fate"). The whole magnificent volume *Charmes* grew out of that complex occasion. Later, of course, the official Valéry became a victim of circumstance in every sense and was highly aware of it. In February 1927, four months before his formal reception into the French Academy, he was at work on the speech "praising" his predecessor, Anatole France. He wrote as follows to Gide:

> I'm writing five things at once and everyone thinks the France speech is finished before it's even begun. And then we have to help settle Claude's family, plan Agatha's wedding, go out to dinner, go out to lunch—be toastmaster at the Perrin banquet, participate in the Spinoza ceremonies (!) and type, type forever on the Oliver, type a Stendhal, type a Mallarmé, type a Europe, type a La Fontaine, type a Paris, type an Alphabet, type, type, type . . . I realize now that I pay for everything with ideas—and those imbeciles are forever asking me for something high-flown or lengthy, the kind of thing that runs me ragged.

Still, much as they may have harassed him, these command per-
formances and set pieces for official functions provided Valéry with
more than a needed source of income. Each commission made cer-
tain formal demands on him, sometimes with good results. For ex-
ample, the strict terms governing the text asked of him in 1921 on
architecture (115,800 characters to fit a special format) led him to
adopt the dialogue form (*Eupalinos or the Architect*), which he
went on to use to good advantage. An increasing portion of his read-
ing and thinking was undertaken "on order"—and we need not
regret the fact. For I believe that the occasional nature of Valéry's
production saved him from his two most serious intellectual vices:
silence and monomania. Without the insistence of friends and lucra-
tive commissions, Valéry might well have left us only his note-
books, unclassifiable either as literary works or as the systematic
study of a subject. And even the notebooks would have been the
poorer. A constant succession of new contexts, however, forced him
to modify the arrangement and the lighting of his ideas; he was
perpetually coming upon a new approach or a fresh metaphor out
of empathy with his audience. Monsieur Teste, Valéry's fond carica-
ture of a solitary genius or prince of all intellectual charlatans, never
produced anything except his own exasperating "plasticity" of
thought, a counterfeit letter from his wife, a ten-page Log Book,
and hours on end of concentrated sleep. No one asked any more of
him. But much more was asked of Valéry. Though he did not have
to be locked in a room with sheets of blank paper (as was the case
with Anatole France), the deadline was his negative inspiration. It
provided his extensive prose work with the equivalent of rhyme in
poetry: "a law independent of the subject and comparable to an
external timepiece." From verse to verse, from platform to platform,
the writer rises to the occasion.

Both the most prominent and the most neglected example of
Valéry's piecework is the set of inscriptions (see p. 157) he produced
in 1937 for the new Palais du Trocadéro, known today as the Palais
de Chaillot. Remembering his fruitful experience with *Eupalinos*, he
insisted that the commission be given precise terms. The architect
asked for four texts of five lines each, not exceeding thirty-seven
characters to a line. These seven hundred–odd letters were to be
carved in stone for all Paris to see during no one knows how many
years to come on a public building housing a museum and two
theaters. Literature by the meter; yet we have no living tradition of

lapidary style. Valéry's performance astonishes in its mastery of the genre until one looks through collections of his fragmentary texts like *Mélange* ("Mixture") and *Tel Quel* ("As Is"). He might have been writing inscriptions for public buildings and private retreats all his life at the foot of his notebook pages.

> *Action is a fleeting madness.*
> *The most precious thing a man has is a brief epilepsy.*
> *Genius lasts only an instant.*
> *Love is born of a look; and one look is enough to beget eternal hatred.*
> [II, 612]

This jotting takes on the permanence of granite; the words could have been graven on an opera house—or a "mental institution."

The Palais de Chaillot inscriptions come tantalizingly close to poetry; their disposition and style oblige one to read the lines as individual verses. All but one have an even number of syllables. (In fact, an earlier version of the second line published in the *Nouvelles Littéraires* has ten syllables: *Que je sois une tombe ou un trésor.*) The fourth inscription comes out as a perfectly regular unrhymed five-line stanza. The syntax, which grows into something deliberately complex and crabbed in much of Valéry's writing, both prose and poetry, here displays an utter clarity even without benefit of punctuation. The final work stands up under the immense weight of attention focused on it; every word counts, literally.

A building, he says softly, offers itself directly to the individual passerby, with a promise of riches to him who holds the secret of observation: that secret is desire. This building houses the handiwork of men we call artists because they, more than anyone else, are aware of what they do. Their very awareness makes their acts more entire and confers on them a lucidity that is both painful and consoling. The works housed in these walls all flow from the human hand, most marvelous of organs, the direct extension, instrument, and agent of thought. Ears, eyes, mouth—these organs behold and confront the world. Only the hand *makes*. And the rare or beautiful things the hand makes teach us to see everything else in the world afresh.

These limpid commonplaces convey the very essence of Valéry. He is attitudinizing and perorating less on the face of this public building than he sometimes does in his informal essays. The little miracle of these lines is to have expressed it all—all Valéry's thought on the attentiveness of the individual spectator, on the artist as con-

scious of his making, on the symbiotic link between hand and thought, on art *not* as embodying eternal and autonomous aesthetic value but as producing an effect.* A work of art calls attention to itself in order to reveal *the world*. These twenty lines declare what it is not always easy to discern in reading his beautifully chiseled verse: that Valéry cannot be classified as the last great devotee of art for art's sake. This most institutional of occasions permitted Valéry to stand completely at ease on the unmapped frontier that connects journalism to poetry, elevated sentiments to intimacies, the creative spirit to the public act, the body to the mind.

If one compares these four inscriptions to Valéry's two principal formal speeches, made in the full pomp of the French Academy, the public man comes off poorly. I partly concur in Edmund Wilson's petulant criticisms of Valéry's reception speech. The formalities have no polish. The coyness with which he avoids mentioning Anatole France by name, and the smirk with which he calls his predecessor a "classical writer," make the speech more evasive than incisive. The two promising ideas it broaches (the book as an "instrument of pleasure" offering a perfect instant; the suggestion that *le doute mène à la forme*, "doubt begets form") never take full shape. Valéry misjudged the occasion and his own talents.

From all accounts the speech welcoming Pétain to the Academy in 1931 was more impressive in performance. The work stands up well as a piece of writing appropriate to the occasion and surpassing it. Hindsight shows us that Pétain's legendary sagacity had already failed him when he was elected to the Academy. For, quite apart from his political role in coming to terms with the Germans between 1939 and 1944, one has to reckon with the catastrophically wrongheaded influence he had in lulling the country to sleep behind the Maginot Line and in refusing to recognize the revolutionary implications of mechanized warfare. But in 1931 the great general's glory was still unclouded. Valéry narrates the events of his career effectively and eloquently; the audience must have followed his periods with

* The works housed in the Musée de l'Homme (the north wing of the Palais de Chaillot) are ethnographic and anthropological in nature: masks, idols, clothing, ornaments, utensils, weapons, etc. Such objects are produced in the daily life of human beings in society, and all such objects "express" and refer to a set of acts or gestures, like hunting and worship, of which they are a part. It is precisely these "primitive" works in the Musée de l'Homme that Apollinaire and Picasso discovered together in 1905–6 and incorporated into their new aesthetic of deformation and juxtaposition. Cubism was about to appear.

INSCRIPTIONS AU PALAIS DE CHAILLOT

IL DEPEND DE CELUI QUI PASSE
QUE JE SOIS TOMBE OU TRESOR
QUE JE PARLE OU ME TAISE
CECI NE TIENT QU'A TOI
AMI N'ENTRE PAS SANS DESIR

TOUT HOMME CREE SANS LE SAVOIR
COMME IL RESPIRE
MAIS L'ARTISTE SE SENT CREER
SON ACTE ENGAGE TOUT SON ETRE
SA PEINE BIEN-AIMEE LE FORTIFIE

DANS CES MURS VOUES AUX MERVEILLES
J'ACCUEILLE ET GARDE LES OUVRAGES
DE LA MAIN PRODIGIEUSE DE L'ARTISTE
EGALE ET RIVALE DE SA PENSEE
L'UNE N'EST RIEN SANS L'AUTRE

CHOSES RARES OU CHOSES BELLES
ICI SAVAMMENT ASSEMBLEES
INSTRUISENT L'OEIL A REGARDER
COMME JAMAIS ENCORE VUES
TOUTES CHOSES QUI SONT AU MONDE

PALAIS DE CHAILLOT INSCRIPTIONS

THE PASSERBY MUST DECIDE
IF I AM TOMB OR TREASURE HOUSE
ELOQUENT OR MUTE
THE CHOICE IS YOURS MY FRIEND
DO NOT ENTER WITHOUT DESIRE

EVERY MAN CREATES UNWITTINGLY
AS HE BREATHES
BUT THE ARTIST FEELS HIMSELF CREATE
THE DOING ABSORBS HIS WHOLE BEING
HIS CHOSEN SUFFERING GIVES HIM STRENGTH

WITHIN THESE CONSECRATED WALLS
I WELCOME AND PROTECT THE WORK
OF THE ARTIST'S MIRACULOUS HAND
EQUAL AND RIVAL OF HIS THOUGHT
THE ONE IS NOTHING WITHOUT THE OTHER

RARE THINGS BEAUTIFUL THINGS
HERE SKILLFULLY DISPLAYED
TEACH THE EYE TO BEHOLD
AS IF NEVER SEEN TILL NOW
ALL THINGS IN THIS WORLD

rapt attention. And he hangs the tale around the supreme common-place of military science: *le feu tue*—bullets kill. Pétain's secret was to have discovered the obvious. Though it is annoying to read of how Pétain and Valéry compared notes and read their speeches aloud to each other in advance of the event, Valéry produced a subtle essay that has two effects. First, it directs our attention toward the phenom-enon of the military mind which had long interested him. It was really Foch's mind, with its swift grasp of essentials and its impatience to act, that impressed Valéry. (The irony of this occasion arose from the fact that Pétain had been elected to succeed his archenemy, Foch, and had to eulogize him for two hours. Pétain did not attempt any of Valéry's subtleties in praising Anatole France.) The second effect of the speech about two generals must have been very carefully cal-culated. Valéry's passionate patriotism in describing his country's behavior in the First World War turns out to be the intellectual stronghold from which to denounce the horror, the fascination, and the unthinkability of war. His rhetorical address in the second person to Pétain sitting next to him "under the Cupola" earns him the right to speak out against man's greatest self-deception. Pétain was a cold, authoritarian figure with an orderly but lackluster mind; Valéry's portrait inflates him to exaggerated greatness. But on the larger in-ternational issues, Valéry's political instinct was sound and eloquent at a time when once again Europe was beginning to drift toward war.

Two examples of his success in occasional writing are the speech given before the congress of surgeons, "Personal Views on Science," and the short reply to the Surrealists' questionnaire on suicide. In addressing the surgeons, Valéry made a few preliminary flourishes and then advanced unhesitatingly toward the underground aspects of surgery: the liturgical atmosphere of an operation, fainting at the sight of blood or of an incision in the body, the interference between knowledge and the functioning of natural processes, and, as in the Palais de Chaillot inscriptions, the magic that resides in the human hand. "Personal Views on Science" consists for the most part of a lucid exposition of what has happened to technique and theory in modern science, plus some comparisons that are entirely Valéry's. Confronted by the assigned subject of suicide, he turns into a scenario writer. What he produces is the outline for a short story by Poe: suicide by self-fascination. In these two cases, the occasion served everyone's purpose including Valéry's. The results convey a sense of ease and enjoyment in the writing.

3

What best characterizes Valéry's prose is the variety, in kind and quality, of the styles he can muster. All the formal speeches are larded with asides, brief skirmishes with the audience that play for a laugh. In these passages, Valéry's "I" hovers between the mocking academician, the serious "man in the mind," and the straightforward human being. Only in the Pétain speech is his rhetoric effective; he was being didactic. In contrast, the short reply on suicide and the somewhat more developed article on "The Future of Literature" waste no time on preliminaries or lengthy transitions. Valéry divides suicides into three classes and examines them one after another as if before a class. Then, instead of imagining himself in the situation of delivering a speech and padding it out with dramatic asides, he imagines himself convincingly in the very act of committing suicide. As a result his two columns are more arresting than the surrounding texts by Surrealist activists in the pages of *La Révolution Surréaliste*. When he bends his attention to the social evolution of literature there is a kind of comic grace in the ease with which he reaches his conclusion: "I sometimes catch myself thinking that in the future the role of literature will be close to that of a *sport*."

Before long one notices that Valéry rarely fails to plant such a key sentence at intervals in every sustained prose piece. Many of them have become famous. The opening sentence of the opening essay in his first collection, *Variété*, stirred controversy for years: "We self-styled civilizations now know that we too are mortal." The two lapidary sentences italicized in the speech to the surgeons (*Il est possible de donner la mort*. It is possible to kill. *Tantôt je pense et tantôt je suis*. Now I think, now I am) pick up the emphatic rhythm of the two I have already mentioned: *Le feu tue. Le doute mène à la forme*. Valéry tells us that his poem "La Jeune parque" took shape around a wordless rhythm sounding in his head; he speaks elsewhere of the *vers donné*, or "given line," which becomes the armature of an entire poem. I believe these italicized sentences work in a similar fashion in his prose. In the dizzy spaces of thought a distant light shines forth toward which one can sight and slowly make one's way. A single thought, a profound platitude, or a verbal formula is enough. Then the rest of the essay comes together around that spark. One could, of course, take the contrary position and argue that these startling simplicities are not what he started with as isolated markers in the wilderness, but are rather the final results of the pressure of

thinking patiently applied to anything whatsoever. But in either case we are led to a related question that particularly concerns the "occasional" writer.

Did Valéry have something like a method, a sequence of mental steps to which he could submit any raw material and produce a presentable written result? Frequently he leaves precisely that impression. Gide asserted that nothing Valéry wrote could be neglected. I remember hearing one of my teachers long ago state—apropos of what author I cannot recall—that "his mind was incapable of producing anything second-rate." It could be said of Valéry except at his most dutifully formal. He never ceased searching out the central command post of all thought. By 1924—give or take a year or two—he had organized his ideas, found a method of work, and discovered that he could turn his mind to any subject without wasting his time. Of course, the external circumstances of his career thrust this responsibility upon him in great part. His most seminal essays—"Introduction to the Method of Leonardo da Vinci," "Conquest by Method"—were twenty years behind him; their titles are not without significance. His debut as a public figure required that he be prepared to speak on all topics. It turned out to be possible, even rewarding. He already had a profound intellectual faith in the act of attention, and from the very earliest of his writings on Leonardo he had expressed a belief in the relationship between all things and all events. Given that attitude, he did have a kind of method or process. I am reminded of a remarkable machine a friend of mine bought which can be used for any ordinary woodworking job. A few simple attachments adapt the same sturdy motor to a score of different operations, and the whole set can be carried about in a small case. Valéry has a limited number of attachments. Take things literally; examine the obvious; recast the question; let the words themselves do it. Other attachments have tags borrowed from science or mathematics, notions equally applicable to his "poïetics."*
All the terms I mentioned earlier belong here: relativity, simultaneity, reciprocity, symmetry, interference, periodicity. Valéry's vision of an irregularly ordered world in fluctuating equilibrium was adaptable enough to make the most of such unlikely topics as virtue

* The seminal discussion of this aspect of Valéry's thought can be found in Jackson Mathews's article "The Poïetics of Paul Valéry," *The Romanic Review*, October 1955.

and photography. Virtue survives both language shift and moral relativity. Photography yields the analogy between light and thought.

Valéry's "method" had the effect of reducing the infinite variety of his subject matter to three themes: the mind, language, and everything else. His earliest metaphors for mind (a theater; a smoke ring) depict its turbulent equilibrium as circular and self-beholding. As time goes on, he rejects with increasing vehemence any theory of separable mental faculties and portrays consciousness as a rhythm. His conjectures about a man hypnotized by the mere possibility of suicide relate directly to his description of Marshal Foch's dispatch in "acting on" an idea and find their full working out in the speech to the surgeons. Valéry must have startled them with his example. If I know or think too much about what I am doing, I cannot do it. And in a beautifully turned page he asks the learned doctors: How, since you know so much about the organic functioning of the reproductive organs, can you bring yourselves to make love? He suggests that the answer lies in the existence of an alternating rhythm of being. "Now I think, now I am." We cannot be everything at once.* This functional rhythm of vibration had already been described in a pithy little essay called "The Aesthetic Infinite."

To justify the word "infinite" and give it a precise meaning, we need only to recall that in the aesthetic order satisfaction revives need, response renews demand, presence generates absence, and possession gives rise to desire (II, 1343). In these most critical pronouncements about mind, Valéry falls back on the sexual metaphor, or rather on the erotic ritual with which man, more than any other animal, has sanctified the act of mere coupling. No one could miss the atmosphere saturated with erotic feelings in poems of the mind like "Les Pas" ("The Steps"), "L'Abeille" ("The Bee"), and, above all, "La Jeune parque." In his theoretical statements, Valéry contrasts the aesthetic realm of infinitely renewable pleasure with the practical realm, where satisfaction obeys the entropy principle and returns everything to zero.

But most important of all to Valéry and to us are two intermedi-

* I believe that Proust is describing the same profound instability or vibratory character of the psyche when he speaks of "les intermittences du coeur." It is revealing that Jacques Rivière used Proust's expression in referring to borderline mental states in his correspondence with Antonin Artaud. The clinical label "schizophrenia" clearly is inappropriate to describe such a state of being known to us all.

ate realms where pleasure and delight arise under circumstances of restraint and reticence, two realms where we come to the threshold both of ourselves and of another person. Those realms are love and language. They lead us to the most precious and fragile acts of mind and body that we can know.

4

Valéry wrote a vast amount of prose about poetry and the terrain that lies on all sides of it. He was also concerned with performance. When he told an interviewer of the need not to ham up the dramatic effect when reciting a line of poetry, he was repeating a conviction he had expressed many times. He recommended that his grandchildren be taught single lines of poetry in order to know them properly as sound. He said so much about his own and other people's poetic practice that it is easy to assume that he is all intellect in his verse. But not so. His fellow poet Jules Supervielle has recalled us to reality by pointing out that Valéry was a "poet of enthusiasm," and by reminding us to count the number of exclamation marks in his poetry. In the interview "Some Reflections on Poetry," Valéry deplores the fact that, in 1930, poets think they can substitute intelligence for inspiration. But whatever the proportions of technique and inspiration, Valéry persisted in distinguishing between the clumsy prose of everyday discourse and the privileged language of poetry.

This theory of *poésie pure* versus ordinary prose led him into deep water and drowned a small army of critics behind him. Possibly because they are detached and ambivalent in their feelings toward Valéry, two American critics have come very close to the heart of the problem. First came Edmund Wilson, who, back in 1930, bore down on the contradiction between Valéry's ideas on the magical, nondiscursive, and musical qualities of poetry and his ideas on the "basic similarity between the various forms of intellectual activity" that implies "the kinship between poetry and mathematics. And if the function and methods of poetry are similar to those of mathematics, they must surely be similar to those of prose." Now of course Wilson is wrong. In their economy (compression), generality (breadth of reference), and attention to relations and analogies, poetry and mathematics can be seen as more closely akin than poetry and prose. What mathematics lacks is the sensuous or audi-

tory side that Valéry believes allows language to become a work of art. In *Eupalinos or the Architect,* Valéry did in fact treat mathematics as a third form of language, characterized by rigor. But Wilson, at least at the time when he wrote this pioneering essay, had the right to indicate an incomplete admixture of science and aesthetics in Valéry's published writings.

Fifteen years later, T. S. Eliot, without referring to Wilson's strictures, with which he must have been familiar, shifted the site of the contradiction in Valéry's philosophy of composition. In the essay "From Poe to Valéry," Eliot concludes that Valéry adopted and adapted from Poe not only the doctrine of the autonomy of art (Baudelaire writes of Poe's belief that "a poem should have nothing in view but itself") but also "the notion that the composition of a poem should be as conscious and deliberate as possible." The latter borrowing Eliot finds troublesome, for "this, in a mind as sceptical as Valéry's, leads to the conclusion, so paradoxically inconsistent with the other, that the act of composition is more interesting than the poem which results from it."

Though Eliot is closer to the mark than Wilson, even this inconsistency is more illusory than real, and more attributable to Poe than to Valéry in his mature years. Valéry's notorious and much disputed concept of "pure poetry" rests on musicality and suggestiveness and tends to enthrone the work of art as the final, all-justifying goal for its own sake. But in the essay where he first uses the expression ("Avant-Propos à la Connaissance de la Déesse" [Foreword to Knowledge of the Goddess]) and in the passages where he refers to it again in hopes of repairing some of the damage it has done ("Calepin d'un Poète" [Poet's Notebook] and "Discours sur Henri Brémond"), he leaves no shred of doubt that he once espoused yet *now rejects* this "spiritual illusion."* Valéry's reluctance to surrender his poems for publication reveals how he acted on his conviction that a work of art is a kind of necessary and revealing byproduct. The mental

* It is worth noting the comparisons he makes in order to pass judgment on "pure" or "absolute" poetry: "But, like a perfect vacuum or absolute zero, which cannot be attained and can be approached only by progressively more difficult operations, the final purity of our art demands of those who seek it such stern and prolonged constraints that it absorbs all the natural joy of being a poet and leaves only the pride of never being satisfied" (I, 1276). The personal notes that form *Propos Me Concernant* (*Remarks about Myself*) (II, 1505–36) make the same point in totally different style.

process that produced it is the true locus of being and value. Nothing is ever finished. The work of art constitutes both a distillate and an excretion, the part which is purged in order to allow the process to continue without poisoning itself. To my knowledge Valéry never used that figure; I insist on its aptness nevertheless. We examine feces in order to determine the health of the organism that produced them. But the byproduct may take on a value of its own. The entire Western tradition that erects the work of art into an eternal object surpassing contingencies of time, place, and personal creation, defined by intrinsic aesthetic principles and providing a substitute immortality, is now brought into question. Valéry is frequently seen as the last great representative of that classic tradition which began with the Greeks, reappeared forcefully in the Renaissance, and reached its extreme and fetishistic stage at the end of the nineteenth century in France. But in spite of his youthful associations with the decadent school and the extreme cult of art, Valéry never finally yielded to that form of civilized coprophilia. His works show a preoccupation with the role of the poet as universal thinker and a steady emphasis on life itself as the theater of art. The last classic poet had a clear idea of the perils of formalism. "Civilization sustains itself only by a certain barbarity" (*Cahiers* II, 738).

Only now can we broach the great paradox that defines Valéry. He seems to have lived an upright, quiet life, secure in the bosom of his family and the solitude of his study. He did not perform his poetry in public; he appeared before audiences as a poet writing prose, as a member of the French Academy, or as a professor at the Collège de France. The erotic escapades of his later years provoked no particular scandal. The portrait left us is of a supreme antiromantic. Yet this muted figure came to believe more strongly than the Surrealists that art invades life. He even conducted himself in a fashion that deserves the epithet "action poet." Richard Howard pointed out in a book review how Valéry's comparison of the act of painting to a dance anticipated recent theories of action painting. But the comparison also belongs to Valéry's total aesthetic and places him further than we ever knew from art for art's sake. His personal notes for 1928 contain the following observations:

> The doing means more to me than its object. It is the doing and the making in themselves which represent the achievement, as I

see it, the object. Major point. For the thing, once made, immediately becomes someone else's act. It's the perfect case of Narcissus . . . And I come out with this paradox: Nothing is more sterile than to produce. The tree does not grow while it forms its fruit.
[I, 52]

Valéry's poetics, as he sketches its outlines in the inaugural lecture for the Collège de France, rests its foundations on the execution of acts. It is not surprising that the controlling metaphors of that magnificent piece of thinking are economics and politics: not the creation of eternal objects but an art (and science) of action. The rest follows. A poem worthy of the name is the compressed and fragmentary record of a segment of life lived through with energy and attention. An essay pursues possibilities of thought and breaks off short of conclusions. In both style and sense the last sentence of "Some Personal Views on Science" displays Valéry's stance: "Man is an adventure . . ." In this context one understands full well Valéry's long fascination with dance—a doing and a growing of form that does not produce anything other than what it is in the process of becoming.

Now if there is any truth in what I have been saying, one further thing becomes clear. We systematically read Valéry in improper fashion. First we probably read his poems; they are, willy-nilly, works of art belonging to special systems of language and of the fiduciary values of culture. Then we read his essays and speeches in areas that concern us. The volumes of his work in English are entitled "The Art of Poetry"; "Aesthetics"; "History and Politics." Having in good faith agreed to contribute to the translation and presentation of his works in precisely that format in English, I discover that I am obliged to question its final appropriateness to the forceful and complex movements of his thought. These standard works are admirable achievements, significant in ways I hope I have pointed out. But as *acts* they finally mean less than his letters and journals and notebooks. In English, who knows when we shall be able to read these authentic moments of his mind; in the French Pléiade edition, they are scattered so unpredictably through those three thousand pages that after months of steady reading one may still not have discovered the most revealing sampling of all in the notes of the second volume (II, 1430–538). The table of contents breathes not a word of this section.

In order to watch Valéry's self in action must we necessarily go

to the twenty-nine monumental volumes of his notebooks* and the various collections of letters? I see no alternative. On one of the pages we are likely to read last, if at all, a letter written in 1917 to Pierre Louÿs, Valéry struggles with the problem of how to make proper use of those notebooks, how to publish them without systematizing, classifying, separating, uprooting, and thus killing their contents. The only answer he found was negative: "avoid discursive order" (*ne pas écrire À LA SUITE*). But he found a definition. "Literature growing wild. If you pick it, it will die" (II, 1483). This impeccable stylist and former devotee of "pure poetry" attached increasing and probably final value to the inchoate states of his writing—the fragment, the sketch, the detached observation that has not found and may never find its place in a finished "work." This was his barbarity.

5

Is there any significance in the fact that Valéry's closest personal friends and intellectual confidants for the crucial early decades of his career were André Gide and Pierre Louÿs, an avowed and aggressive homosexual and a proud philanderer?

We neutralize such facts by separating the artist from the man, by dividing the work from the life. Thus Proust spoke of the *autre moi* who wrote his novels and was not to be mistaken for the social self that showed up at chic receptions and gatherings of less repute. It is a form of this separation that Eliot criticizes—and trenchantly— when he takes Valéry's poetics to task in his introduction to the Bollingen volume *The Art of Poetry*. Eliot states that Valéry "pro-

* In 1922, just as he was entering "public life," Valéry wrote Gide from London: "Anyway, I always have to come back to the question of my famous notes. I may end up deliberately believing I did nothing till I was forty-five. Still, the real me is there in the notes" (II, 1490). From 1894 on, Valéry wrote daily in his *Cahiers*. We may owe both their existence and their unsystematic form to his long study of Leonardo da Vinci, which began the same year. A sampling of the 28,000 pages indicates that they contain little poetry, very few first drafts of published prose texts, and only indirect, uncircumstantial accounts of his daily life or of encounters and conversations with people, etc. Mathematical symbols occur frequently in carefully worked problems. There are occasional ink drawings. In the twentieth century Whitehead's and Wittgenstein's writings best bear comparison with Valéry's for range and depth. Those three minds moved along intersecting lines of tension that connect language and mathematics. The similarities in form and style between Valéry and Wittgenstein are particularly striking. The Centre National de la Recherche Scientifique published the *Cahiers* in 1958 in facsimile, apparently with some materials omitted.

vides us with no criterion of seriousness. He is deeply concerned with the problem of process, of how the poem is made, but not with the question of how it is related to the rest of life in such a way as to give the reader the shock of feeling that the poem has been to him, not merely an experience, but a serious experience." It's a superb point, but it misses Valéry. For him the work of art was not, as it was for Horace and Petrarch and Mallarmé, the supreme value. What was?

Another tradition in literary criticism, with which we have been familiar and uneasy since long before Sainte-Beuve, sets up the life and the work of an artist as if they necessarily reflect one another. They form a kind of echo chamber or mirror device in which we cannot deal with one without the other. In various degrees and with shifting emphasis, the Dandy, the Decadent, and the Surrealist proclaim this reciprocal relationship between art and life. Their life aspires to the privileged state of a work of art. Correspondingly, their art absorbs their life. Huysmans's *Against the Grain* tells precisely such a story in what has always struck me as a more "experimental" novel than anything Zola wrote. Where does this grafting process leave Valéry and his two friends? The question does not apply. Valéry himself supplies the reason.

Following a limited number of leads in literature and philosophy, devoting himself instead to science and language steadily enough to make most of his critics resentful, Valéry introduced a third term mediating between life and art. He sees conventional social behavior and works of art as the outermost aspects of our individual existence. Adjoining them, however, and also adjoining our innermost life, lies a neglected domain of *acts of the mind*—private writings, decisions about one's acts, preparatory stages of "creation," reflections on one's self—a domain that forms a third term and modifies the linear relationship between the original two. Valéry refers frequently to his jottings as a form of geometry, and also used the expression "algebra of acts" to refer to a painter's mode of sensibility as contrasted with both his life and his finished work. If life and art are two semi-independent variables, and not two easily related elements of biography, then Valéry's intermediate "acts of mind" suggest a form of infinitesimal calculus that seeks and reveals their relation. To that perpetually renewed relation he devotes more time and attention and attaches more human value than to either of the variables it links. Valéry's truest work, which appears on every page he

wrote but more directly in his "wild" texts, is his exercise of this calculus of acts, a psycho-poetic reckoning of "changes of mental states." He liked to call it a "Geometry of Time" at the beginning of his career and (in an essay inspired by H. G. Wells's novel) developed his theory of the symbol as a "time machine" that fuses and embodies different states. Later it took the form of a fine discrimination between unconscious, subconscious, and subliminal—accompanied by a sturdy preference for the conscious mind.

Valéry is a myth, of whom and of which we remain incredibly ignorant. He did not want it thus, but the format of his writings has produced that effect. We tend to dismiss as irrelevant the two most important facts about him. He renounced the composition of poetry not once but twice, even though the first time he was highly esteemed by fellow poets and the second time he had earned a worldwide reputation as a poet; and secondly, he spent the greatest part of his time meditating over a morality and ontology of thought based not on art but on scientific and mathematical models. He believed profoundly in the unity of mental process in an individual; with equal vehemence he rejected any external unity—any system of events or knowledge of them that could lay claim to the term "universe." To dismiss the scientific pretensions of his thought and to admit one hundred pages of verse (out of a total production of over thirty thousand pages) as his true contribution to culture is to capitulate to our prejudices. The heir of the Symbolists was heretical to the point of sacrificing permanence to the immediate and the transitory. The reader confronts not an eternal object but the scenario of an organic event. Though smiling, Valéry has weighed his words when he suggests that literature will increasingly take on the function of a sport. Not art as the supreme spiritual value or a new priesthood, nor as something purely decorative and purposeless. It is rather that art, competing with the real strengths and promise of science, will become a valuable exercise of mental acts, a process whose products are beside the point except as they improve, extend, and record the game. We can all play, and it brings great joy. Naturally, the real pros like Valéry are very rare. When they play it is worth watching, for to watch so powerful a performance is to participate. The truly active spectator will already know that, like artist and criminal, he is as much the effect as the cause of his works.

Artaud Possessed

You are in Paris, a city still gray from the Occupation and unsure of peace. The tiny theater overflows with people, all looking important or intense. Someone behind you is identifying them: André Gide in a wool cap, Albert Camus, André Breton recently returned from New York, Henri Michaux, Jean Paulhan, and a crowd of prominent actors and directors. They have all come to hear a one-man lecture-performance by Artaud.

Artaud comes on stage alone. Dressed like a *clochard*, he looks emaciated and a little startled. When he starts reading from the pile of papers, his voice sounds emasculated, yet undeniably powerful. There is some heckling, then a tight silence. Artaud declaims, whispers, roars, and comes to an awkward pause. He seems to have lost his place or his nerve, shuffles his papers, takes his head in his hands as if he were giving up. Yet he starts again. Now he is not reading

but haranguing the audience. "Saliva." "Syphilis." "Piss." "Electroshock." He stops to catch his breath, then reads again:

It is not a mind that has created things
but a body, which got along by wallowing in debauchery with its
 prick crammed up its nose

> *Klaver striva*
> *Cavour Tavina*
> *Scaver Kavina*
> *Okar Triva*

The denunciation of language, of sex, of himself goes on and on. Artaud appears a man possessed, lunatic beyond recall. Yet he remains an actor, a painful ham, clowning, mocking himself, spouting his outrage and conscious of his excess, forcing it. With the audience at bay in front of him, he is watching the combustion of his own mind. He wants to drop not words but bombs. There is no end to it, no stopping him, until Gide climbs on stage and throws his arms around the exhausted performer.

From this dream you cannot awake. For it is history, Artaud's performance, *Tête-à-tête*, at the Vieux-Colombier theater in January 1947.* He died fourteen months later.

In the sixties Artaud became an even more powerful presence than he had been in 1947, and far beyond the cafés and theaters of Paris. His cultural eclecticism had been astute and prophetic. He had concocted a magic amalgam of theatrical style, occult and esoteric knowledge (from Zen to acupuncture), anti-literary pronouncements, drug cultism, and revolutionary rhetoric without politics. Naturally, the theater felt his impact first.

In his collection of essays and manifestoes, *The Theater and Its Double* (1938; English translation, 1958), Artaud proclaimed that the theater, mobilized into total spectacle by the director's commanding imagination and subservient to no literary text, should become as powerful an agent of cultural and emotional change as a plague, or cruelty, or hunger. During the fifties and sixties, these (far from

* For this mosaic version I have borrowed phrases from published accounts by Jean Follain, Maurice Saillet, Alain Jouffroy, André Gide, and Artaud himself.

new) ideas traveled fast. They played a key role in the articulation of the anti-aesthetic mode ultimately named the "happening." For it was John Cage's reading of Artaud (in French, suggested to him by Pierre Boulez before the translation appeared) that provided the impetus for the original multimedia show at Black Mountain College in 1952. Cage persuaded Charles Olson, Robert Rauschenberg, and Merce Cunningham to participate in that remarkable performance.

A few years later, underground newspapers began pirating Artaud's writings. City Lights published an unfortunate anthology of his works. During its exciting formative period, the Living Theater company treated Artaud's book as semi-gospel, as did the directors behind La Mama, Cino, and Dionysus 69. Peter Brook launched the Theater of Cruelty in London in 1964, and his production of Peter Weiss's *Marat/Sade* derived from his absorption of certain of Artaud's ideas. Jerzy Grotowski, founder of the Polish Laboratory Theater, wrote a fine article ("Les Temps Modernes," April 1967) denying that Artaud had formulated any method but calling him a "prophet." By the early seventies, however, people working in directing and production were turning away from total theater and beginning to forget Artaud.

Even though they make strange bedfellows, Artaud's admirers in the literary world have been more faithful, particularly in France. The established Gallimard publishing house has been bringing out his complete works since 1956—thirteen volumes to date and probably two to go. Marxist and Maoist critics, directing influential reviews like *Tel Quel* and *Change*, claimed Artaud as their intellectual property. The unconstituted group known as the Structuralists chose two totem figures (after Mallarmé) to flaunt in front of the philistines: Georges Bataille, pornographer-economist, and Artaud, the whirling dervish of literature as self-performance. Foucault, Deleuze, Guattari, and particularly Derrida have accorded Artaud a significant place in their works of cultural psychoanalysis. They have good grounds. For the primary meaning of Artaud's work reaches beyond theater fashions and literary theory to pose tense questions about the relation of civilized living to madness and acting.

In 1976 Helen Weaver published an extensive collection of translations. Susan Sontag's long introductory essay in that volume argues that Artaud produced not a literary oeuvre but a *moi*, a fanatical self. I shall come back to this thesis.

1

When Artaud arrived in Paris in 1920, aged twenty-three, his family and his doctors had sent him there as part of the treatment for lingering nervous disorders. He had a history of early meningitis, neuralgia, facial spasms, and stuttering. In Marseilles his mother cared for him attentively. During the war the army discharged him after nine months, and he spent several years in rest homes in France and Switzerland. Literature and painting had interested him from an early age. In Paris, he remained under loose medical surveillance.

Ambitious and talented, Artaud threw himself into multiple activities. He wrote intensely poetic texts about inner states of consciousness. Charles Dullin trained him as an actor; later roles came from the Pitoëffs and films. In 1922 he fell in love with the Rumanian actress Génica Athanasiou. After two seasons of excitement and happiness, they discovered their incompatibility and gradually separated. Génica was the only great love of his life. Through the painter André Masson, Artaud joined the Surrealists and in 1925 took charge of their Bureau of Surrealist Research concerned with everybody's unconscious, the neuroses of culture, and what we would call today the quality of life.

Practically single-handed he wrote and edited the third number of the review *La Révolution Surréaliste*. For six months his personal insurrection outstripped that of the rest of the group. But by the end of 1926 the Surrealists sacked him after a violent exchange of letters, because, among other things, he refused to follow them into the Communist Party. Meanwhile, he had published two thin volumes of poetry. Dissatisfied with his film roles, he founded the Alfred Jarry Theater, whose experimental productions usually provoked some form of scandal. Between 1923 and 1928 Artaud was able to develop his talents and keep all his projects moving. He was already on opium and laudanum.

But by 1929 his theater faltered and he was left with a pile of aborted plans. His thinking about the theater was directed into new channels by a trip to Berlin to act in Pabst's film of *The Threepenny Opera*, by a performance of Balinese dancers, and by a new interest in Mexican culture. In 1935 he staged and acted in a memorable but (even by his standards) unsatisfactory performance of his own play, *The Cenci*. The following year he spent nine months in Mexico in pursuit of the rites of a truly primitive culture. The principal

product of this second period was neither *The Cenci* nor the Mexican texts but the lectures and manifestoes collected in *The Theater and Its Double*.

In 1937, unable to break his long-standing drug habit and behaving in a highly unstable manner, Artaud left for Ireland. He claimed he was returning St. Patrick's cane, an object he carried around with him in the streets and cafés of Paris. A few months later he came back to France—in a straitjacket. The first five years of his confinement were spent in the most degrading and debilitating of mental hospitals. Then his mother and some friends intervened during the war to have him transferred to a private institution in Rodez in south-central France. Dr. Ferdière, a widely cultured and sympathetic young psychiatrist, gave Artaud electroshock treatments, allowed him considerable freedom, and encouraged him to write and paint again. As Artaud gradually improved, his Paris friends clamored for his release and finally obtained it. He survived nearly two years of postwar Paris.

Partly inspired by the controversy and cultism that swirled around him, Artaud was writing actively again during the last months. *Van Gogh, the Man Driven to Suicide by Society*, is a frenzied autobiographical document. At the Vieux-Colombier reading in 1947 he unlimbered the savage poetic texts he was producing at the time. His last major work was a program commissioned by the government radio. In a matter of weeks he wrote, rehearsed, and recorded *An End to God's Judgment*, an anti-American, scatological, blasphemous scenario of incoherent power. At the last moment the director of the French radio refused permission for its broadcast. Artaud died a month later, in March 1948—of cancer, according to one diagnosis; according to another, from the intestinal effects of laudanum and other drugs.

This steeplechase career calls for several observations. Artaud was a *poète maudit*, a pariah, only in a limited sense. His nervous condition caused him genuine physical suffering during much of his life and led him to drugs. But socially and artistically he was not only well treated but given special protection. Despite his metaphysical refusal to acknowledge natural birth as his origin, he remained attached to and attentive to his mother. Elegant patronesses supported his theatrical projects. Established publishers accepted and even sought out his most idiosyncratic works. Through an uncle, he had a special entry into theater and film circles in Paris. Friends raised

money to send him to Mexico, and the Mexican government itself
sponsored his trip to the Tarahumara region. The years of confine-
ment from 1937 to 1943 must have been frightful. Then he was trans-
ferred to Rodez by special dispensation and finally freed. Artaud's
myth of himself, mediated through Van Gogh, as "driven to suicide
by society" will not pass muster. He was a favorite son from the
start.

Secondly, madness, the real possibility of losing his grip on him-
self, was never far off. He was not at home in his own being. He
could not stomach himself, body or mind. Yet for fear of losing any
part of himself (images of defecation and parturition run through
his writings), he had to live inside the ulcer of consciousness, the
mind devouring itself. In such circumstances it becomes very diffi-
cult to distinguish lucidity from lunacy. His first important publica-
tion was an exchange of letters with the prominent editor Jacques
Rivière, who rejected Artaud's poems and published their correspon-
dence instead. In those letters Artaud describes how "my thought
abandons me . . . a sickness that affects the essence of my being . . .
a genuine paralysis." He began his literary career with a histrionic
plea that he couldn't write anything worthwhile. There is no evi-
dent reason not to believe him when he says that he risks losing his
mind the way the rest of us might get a headache or a chill. Twenty
years later he was still writing elaborately staged letters, this time
from the mental hospital in Rodez, proclaiming not his sickness but
his higher sanity.

For considerable periods in the twenties and early thirties Artaud
seems to have kept a grip on himself. At other times, in spite of
friends' claims to the contrary, he simply went mad. St. Patrick's
cane, the "magic" stiletto given him as he stepped off the boat in
Cuba, the spell cast on him by masturbating Indians in Mexico, the
obsession with feces, the conspiracy of angels that led to his confine-
ment—these were neither jokes nor metaphors. There is little reason
to contest the judicious opinion of one of Artaud's oldest and most
loyal friends, André Breton.

> In a down-to-earth way, a man is connected to the society in which
> he lives by a contract which forbids him certain kinds of external
> behavior at the risk of seeing himself locked up in an asylum (or
> prison). There can be no doubt that Artaud's behavior on the boat
> coming back from Ireland in 1937 belonged to that category. What
> I would call "stepping over the line" consists in losing sight of these

prohibitions and of the sanctions one risks in transgressing them, while yielding to an irresistible impulse.

My third observation on Artaud's career partly redeems the first two. In spite of the precariousness of Artaud's material and mental life, he could be an indefatigable worker. He read voraciously and compensated for a spotty education by building up a large though erratic knowledge of literature, esoterica, mythology, and history. For nearly ten years he earned his keep as an actor. He carried on an extensive and significant correspondence with many people, especially with Jean Paulhan, the editor who had replaced Jacques Rivière at the *Nouvelle Revue Française*. Paule Thévenin, the person closest to him in the last months and the editor of his complete works, describes how he was constantly writing in a notebook he carried with him—in the Métro, in cafés. He never ceased disciplining himself physically through exercises and experiments in body and voice control. This broken man of many failures left a long record of accomplishments, published and performed. There is no sluggard here. The notoriety he achieved in his last months may even have corresponded fairly closely to his deepest ambitions. Though his writings were more frenzied than ever then, he apparently achieved periods of tranquillity.

The question that inevitably arises here is whether Artaud's undeniable talent as an artist developed because of or in spite of his pathological condition. He was not oblivious to the dilemma. "In every madman there is an unknown genius," he affirms in his little book on Van Gogh. Yet the question is inept and simplistic, whereas the evaluation of his case demands great subtlety. Soon after arriving in Paris, Artaud responded to what he repeatedly called *mon mal*—both illness and evil—by becoming hugely attentive to it. He affirmed it as the center of his being and condemned it as the flaw in his talent. He put his sickness squarely center stage. His correspondence with Jacques Rivière does this so successfully that Rivière was impressed and moved by the theatricality of Artaud's self-awareness. When Rivière tried to confine his comments to the poems, Artaud snarled, "I offered myself to you as a mental case, a genuine psychic anomaly, and you answered with a literary opinion on poems I didn't care about." By publishing the letters, Rivière reinforced the pattern. Artaud became an egomaniac of his own cleft condition.

In this light, the choice of the theater as a career was consistent, even if devastating. For Artaud never wanted to play anyone but Artaud. In person he was always impressive. Photographs show deeply sculpted features devoid of relaxation. Handsome and dandified as a young man, he became increasingly negligent of his dress and defiant in bearing. "He carried around with him the landscape of a Gothic novel, rent by flashes of lightning." Breton caught the effectiveness of Artaud's persona. But there is far less agreement about his success as a stage actor. Neither Dullin nor the Pitoëffs could keep him in a company for very long. Louis Jouvet hesitated over hiring him in any capacity. Janet Flanner refers to his "unmodulated" voice and "nonexistent" stage presence.

There is nothing finally puzzling about this uncertainty concerning his acting abilities. Artaud dwelt in and on the unsteadiness of his identity. Called upon to play another person, he could not reach beyond the part he was already playing. An actor who took Artaud's ideas very seriously, Jean-Louis Barrault had no illusions about what was going on: "Dissatisfied with the artificial rewards of the theater, Artaud transposed his theatrical gifts into his life. He authentically lived his own role and used himself up in it. He became a walking theater [homme théâtre]." Plagued by sheer emptiness at the center of his being, increasingly unwilling to identify himself with family or society or traditional culture, Artaud had no other way to grasp his identity than to enact it. He may even have borrowed it. I am inclined to look carefully at a statement by Mme Toulouse, widow of the doctor who first lodged and cared for Artaud in Paris:

> In 1924 he made a trip to Germany and came back with a passionate admiration for what he had seen in the theater and the film, for Max Reinhardt's conceptions which pointed in the same direction as his own, and for the actor, Conrad Veidt, hero of The Cabinet of Dr. Caligari and The Student from Prague. Veidt was very tall and thin, and at the same time supple and angular. There was something unsettling in his personality that fascinated Artaud.

Jean Hort, a fellow actor, confirms Artaud's fascination with Veidt's role in The Cabinet of Dr. Caligari. I believe that, to a degree we shall never determine precisely, Artaud grafted onto himself the tense fantastic character projected by Veidt-Caligari and made it his own. Illusion provided his reality, or at least reinforced it. When Artaud heard that Abel Gance was going to make a film of Poe's Fall of the House of Usher, he sent off a near ultimatum: "I'm not offering

myself for this part; I'm asking for it . . . My life is that of Usher and his sinister hovel."

Artaud turned to the theater not as vocation but as potential salvation. He seems to have known early and clearly that he would need some form of therapy all his life. The psychiatrist who came closest to curing him, Dr. Ferdière, admits readily enough that electroshock may have been a questionable treatment, and that what really brought Artaud back across the line to precarious stability was "art therapy." Any form of writing and painting seemed to help him in Rodez. In the twenties Artaud had chosen an art form even better suited to his needs. Listen to the psychologist J. L. Moreno defining the advantages of psychodrama as therapy for a patient: "On the stage he may find his equilibrium again, due to its methodology of freedom . . . The stage is an extension of life beyond the reality test of life itself. Reality and fantasy are not in conflict." Philip Rieff identifies the two most important institutions for "the triumph of the therapeutic" as the theater and the hospital. Artaud served most of his life in one place or the other. However, I would not say that Artaud represents anything like a successful case of "therapeutic man." He did what he could.

Artaud perpetually reconnoitered the one space he was sure of: the cleft in his thought, his absence of self. He had a very aggravated case of nausea, without any capacity to transform it into the stuff of philosophy. He was left face to face with unsteadiness, with the aching physical sense that being itself fluctuates. "A man possesses himself in flashes, and even when he possesses himself, he doesn't fully attain himself," he wrote to Rivière. As Proust's editor, Rivière quickly connected this metaphor with the "intermittences of heart" that Proust describes and accepts as the human condition. But Artaud could never detach himself from or resign himself to the endless flickering of everything. The word that provides a refrain in *The Theater and Its Double* is "exaltation." His early writings show little attempt to master his own suffering—physical and metaphysical; instead, he exacerbated it to the point of frenzy. Correspondingly, the Theater of Cruelty aims at provoking collective delirium. Once again Breton puts his finger on the right word. "Finally I distrusted a certain paroxysm that Artaud was clearly aiming for." But the point is that what Artaud sought was *sustained* paroxysm, a form of permanent intensity that would leave behind the fluctuations of consciousness.

Artaud's short pilgrimage in 1936 to the Tarahumara region in

Mexico and his participation in the peyote rite represent his furthest foray toward a steady state of exhilaration. He began writing on the spot about those divinely possessed Indians, their magic mountain full of signs, and their cruel gestural ritual. Ten years later, after Ireland and the mental asylums, he was still writing accounts of "the three happiest days of my existence." He had found his living theater.

> Boredom disappeared, I ceased looking for a reason to live, and I no longer had to carry my body. I grasped that I was inventing my life, that this was my function and my raison d'être, and that I got bored when I had no more imagination and peyote was giving it to me.

Artaud's recollection of his best trip is pitiful in its honesty; like the rest of us, he is still engaged in mouth-to-mouth combat with the old *Doppelgänger, ennui*. In one of the Rodez letters he uses a metaphor that justifies our perceiving his aspiration as a kind of metaphysical satyriasis: "When I write or read, I want to feel my soul in an erection, as in Baudelaire's 'La Charogne' ["The Carcass"], 'La Martyre,' or 'Le Voyage à Cythère.'" Scornful of physical sex, he wished to eroticize the mind itself. There is something pornographic, not about his subjects, but about the way he uses language to provoke and excite, rarely to reflect.

In Artaud one finds none of the attitudes that could keep him firmly within the domain of the human. He lacks any sense of scale or limit to contain time short of eternity, to contain individual consciousness short of megalomania. He lacks the capacity to doubt the authority of his own immediate sensations. He lacks the third ear of humor, which can detect one's own voice becoming obsessed or grandiloquent. Sustained exaltation, the permanent high, is not humanly possible; to seek it is to aspire to the divine. We exist in fluctuations of mind and body, and Artaud's written works and his whole approach to the theater as liquidation, as orgy, declares his intolerance of being simply a man. The rest is perfectly logical and consistent. In our society, wary of shamans unless they are successful gurus, we classify "divine frenzy" with insanity. Therefore, Artaud's confinement in mental institutions confirmed his ambitions at the same time as it removed him from society.

Permanent exaltation was too much even for Artaud. The image

that emerges paradoxically from his last and most violent poems is that of "a tree without organs or functions." The revulsion from ecstasy comes with such force that it carries him to the opposite extreme. The dream of being a tree does not restore humanity; it suggests sessile continuity with inorganic nature. Artaud's attempt to surpass intermittence as the condition of life threw him back to the frontier of non-being. He remained unaware of the fateful logic by which paroxysm recoils into quietism.

2

We will understand Artaud better if we consider two contrasting and important sections of his work, the writings on the theater and the declamatory poetry written during his last years. His thinking about the theater attempts with only partial success to lay down a fundamental opposition between *life*, the realm of signs, acts, and exaltation, and *culture*, the realm of forms, things, and contemplation. The vivid metaphors in *The Theater and Its Double* depict the means whereby the theater will goad us back to life. Cruelty, plague, and alchemy stand for a coercive missionary intent to rescue us from culture.

The essay "No More Masterpieces" will serve as a case in point. After a rousing opening that condemns all past literary works as dead, Artaud approaches the perennial problem of theater as therapy.* At first he describes the effect of performance as a direct release of action by sympathetic magic, like snake-charming. "I propose to treat spectators like snakes." Then he reverses his field and speaks of the spectator as having experienced "a superior action . . . I defy him once outside the theater to yield to ideas of war, uprising, and casual murder." By the end of the essay the theater has become "disinterested" and "produces sublimation."

Artaud thus tries to have it both ways, to affirm together two ancient and antithetical approaches to theatrical experience: Plato's

* Artaud's ideas about devaluing the literary text in favor of total production and bodily gesture did not originate with him. Dullin, Copeau, Baty, and the Pitoëffs had already made such an approach the dominant trend in the Paris theater of the thirties; Piscator, Reinhardt, and Brecht were working along parallel lines in Germany, as was Meyerhold in Russia. Gordon Craig and Adolph Appia had similar convictions and even shared Artaud's dilemma of being forced to write about schemes they were given small opportunity to produce.

infection and Aristotle's catharsis. However, having rejected literary form and psychology, he has deprived himself of any element to reconcile or mediate between the two doctrines. Furthermore, Artaud is content to imply that actor and spectator have the same response, almost the same role, in a performance. As that crucial distinction dissolves, his argument becomes increasingly fuzzy in these writings on the theater. But their aggressive style helps to convey the doctrine of theatrical performance as direct intervention in people's lives. Artaud himself grants that "there is a risk."

The last poems pose even more problems than the theater works. In 1946, just out of confinement in Rodez and approached by Gallimard publishers about editing his complete works, Artaud wrote a preamble for the edition. He begins by rejecting his early poems in regular verse as *"farces."** Then, in a rumbling stylistic shift from prose to free verse, he turns to his later work. "For me the question was to find out what could insinuate itself not into the set pieces of language, / but into the weave of my living soul." The whole palpitating manifesto proclaims poetry not as something written in words but as the flesh and blood of his life. Yet the preamble also displays his enormous dependence on rhyme (in the above quotation: *écrit / âme en vie*) and on verbal sound effects to generate and propel his thoughts. Compared to the self-pity and wavering diction in the early poems, the free verse/prose compositions of the 1940s resound with pronouncements of a stentorian ego seeking untrammeled self-performance. One begins to hear echoes of Victor Hugo. These declamatory works rely increasingly on two elements: a scatological vision of the universe and invented words apparently used for sonorous effect as if they were physical entities, not mental signs.

passakenouti loki esti
loki esti tenudi

koni kropt ta kerni poula
kerni poula ternupti

ton ana diroula
ton ana douri

* They are not that. Alone in his work they have a lightness of touch that shows his study of Laforgue and Rimbaud. For example, "La Trappe" ("Trapdoor") in *Tric trac du ciel* (*Celestial Backgammon*) (1923) modulates the theme of spirituality and excrement without the obsessiveness that characterizes it in his later work.

Most critics interpret such texts by discovering in them the dregs and drippings of everyday French. But in the letters from Rodez, Artaud speaks several times with conviction of writing "in a language which is not French, but which everyone could read, whatever his nationality." If that is the case, how are we to hear, or pronounce, these universal symbols? Is this a new phonetic alphabet? Artaud never steps over the line for very long into sustained ecumenical discourse; he comes back after a dozen lines of goulash to the safety of standard French.

Now Artaud undoubtedly knew about the Futurists' "liberated words," about the Dadaists' experiments with phonic poetry, and possibly about Khlebnikov's claims, dating from 1913, for *Zaum* as a universal language. Furthermore, Dr. Allendy, whose influence on Artaud during his early Paris years was extensive, had a special interest as a psychiatrist in religious glossolalia. Nothing suggests that Artaud took these sound formations lightly or in any way faked them. In fact, they are as far from being gratuitous as the scatological motifs that accompany them. Both elements belong to a single bond, grounded in the magic nature of Artaud's imagination. In these final poems it is as if an auditory spell had been cast on him, often invoking the Egyptian spirit principle *ka* or *kah*. In a letter to Henri Parisot he describes a vision of excrement flowing from coffins.

> The name of that material is caca, and caca is the material of the soul . . . The breath of bones has a center and that center is the abyss of Kah-Kah, Kah the bodily breath of shit, which is the opium of eternal survival.

For two pages Artaud fixes on the sound *kaka*. For him language does not remain an arbitrary, socially established set of signals; it unmasks universal correspondences that link everything to everything. A powerful and darkly equivocal sound like *ka* can capture the universe in its coils. Artaud's oracular fragments in these last poems seem to be saying that if we suddenly heard the superabundance of interlocking meanings in language, we could not bear it. That was his cancer of the spirit.

We now face several complications. Having rejected the literary text as the basis of theatrical performance, Artaud went on to try out the possibilities of magical, non-linguistic, incantatory sounds in

poetry. I think we can keep track of his movements only if we have in mind some rough definition of the nature of verbal expression. Let me reduce the jungle of theory to two basic approaches.

The first says *expression kills*. Genuine feelings and thoughts lie below the level of verbal discourse. When brought to the surface by the gross processes of language, they shrivel and die. Expression betrays the integrity of thought in its natural habitat. "Language," writes Nietzsche, "remains incapable of objectifying the great human myths."

The second approach says *expression creates*. Until we try to express them, we hardly know what feelings and thoughts we have. Words are not frozen scraps of experience but malleable tokens for it. A writer both uses words to guide his thought and reshapes words as his thought outstrips their ordinary meanings. "I noted down the inexpressible," brags Rimbaud, half ironic, half incredulous. Laforgue composed a terse manifesto for this basic attitude: "It cannot be too strongly stated that a poem is not the expression of a feeling the poet had before he began to write."*

Of these two positions, the second is the more truly poetic. Pity the poet who fears or distrusts language, for he has lost his true love. Mock the poet who whines about the inadequacy of language to convey his subtle states of mind. It is his own fault; he has not mastered his art. Artaud was as confused about language and expression as he was about the effects of theatrical performance. Over and over again he preached the first theory and deplored the bankruptcy of verbal and literary expression. The tone becomes increasingly shrill.

> The words we use were passed on to me and I use them but not to make myself understood, not to say everything once and for all
> *why then?*
> *but I don't use them*
> *all I do is shut up and hit things*
> anyway if I talk it's a kind of fucking [*ça baise*], the universal fornication of words makes us forget that there's no thinking going on

But Artaud never stopped writing. He kept beating on the wall of words. He was not just a writer in spite of himself; he mastered an

* If I have understood the drift of recent French critical theory, Laforgue here provides the clearest description to date of the strenuously overused term "*écriture*."

explosive polemical style that often moves out ahead of his thought. The hypnosis of words led him on and on, until in the last works it is the very sound of declaimed speech that provides the continuity from sentence to sentence. Thus, while preaching the first theory of expression he was practicing the second with a kind of *terribilità* that is now his mark. To read his French critics, particularly Derrida, you would take Artaud for a basically anal writer, hoarding all thought formations. In reality, he had a serious case of logorrhea. At no time did Artaud approach the problem of language and expression with the uncluttered insight of Emily Dickinson.

> *A word is dead*
> *When it is said*
> *Some say;*
> *I say it just*
> *Begins to live*
> *That day.*

3

What shall we do, then, with this whirling dervish of self-performance, with this poet anathematizing poetry and proclaiming contradictions at the top of his voice? We cannot dismiss him as merely mad. He had too much talent and perverse intelligence. Must we grant him a secure place in the canon for the fierceness of his jeremiads and the intensity of his suffering?

Addressing herself to these questions in the introduction to her collection of Artaud's writings, Susan Sontag has written a fine exposition of Artaud's thought. Her long essay has greater reach than the three other books on him in English, and she remains more clear-sighted than most of the French critics who have now taken him up.* Her evaluation of Artaud's important encounter with Surrealism is balanced and illuminating, and she perceives the essen-

* One of the most disturbing critical enterprises in recent years took place at Cerisy-la-Salle in 1972. A group of writers and critics associated with the review *Tel Quel* organized a major colloquy on Artaud, and the full proceedings appeared a year later in the widely distributed paperback series, 10/18. The seven prepared talks plus a hundred-odd pages of discussion constitute a systematic attempt to wrap a web of Maoist ideology around Artaud. In their desire to link schizophrenic process to cultural revolution via the avant-garde, a few of the critics are not above quoting out of context and doctoring Artaud's lines to suit their purposes. Beware of ideologues.

tially gnostic nature of his thought. It is Sontag's examination of Artaud's dream of uniting mind and body ("the mind as carnal") that carries her the greatest distance into his universe. Her discussion of his "aesthetics of shock" stops short of pointing out that he was advocating in the theater a form of collective shock treatment that he railed against when it was administered to him individually in a clinic. According to Sontag, he bequeathed to us "a singular presence, a theology of culture, a phenomenology of suffering," even though he was a failure as a writer. (Somewhat confusingly, she also tells us that Artaud was "the greatest prose poet in the French language since Rimbaud.") His failure as a writer was due to his alienation from language and to the agony he experienced in writing.

I must disagree with both reasons. Artaud reveled in language: the evidence indicates that he found writing one of his few available links with reality and with the joy of accomplishment. Furthermore, Artaud was deluding himself and his readers when he claimed that the only form he could write in was the personal letter. His chosen format was the public lecture, a one-man theater, solo performance for an audience—even in writing to one person. When he acknowledged as much in a letter to Paulhan, he also revealed a deep distrust of his own vocation. The lecture format, he wrote, "permits me direct expression without the interposition of actors who might betray me." Thus he commandeered and suppressed true theater. Artaud was not an intimate letter writer but an incorrigible public preacher, more histrionic finally than gnostic.

Sontag's opening discussion of the modern artist at odds with his culture, and her final somewhat tormented verdict on Artaud as "indigestible" and "unassimilable," impel me to make a few final remarks. At the beginning of the nineteenth century a fairly successful attempt was made to divide medicine into allopathic (cure by producing the symptoms of health) and homeopathic (cure or prevention by producing mild symptoms of the disease in question). The distinction is helpful in describing the contrasting ways in which a culture treats its own various strains and disorders. Sade, Hölderlin, Nerval, Nietzsche, and Artaud were all at some point certified by the culture as criminal or pathological; yet their lives and their work have not been cast out of the Republic of Letters. Quite the contrary; we carefully preserve their biographical and literary remains in the usually unstated belief that their strain may yield a valuable inoculation against dangerous ideas, including some of their own. This homeo-

pathic faith justifying liberalism of mind and opposing Plato's banishment of poets probably represents the most exciting risk Western culture has taken.

But how can we tell if we are preserving a strain too virulent to serve as vaccination? Before we certify Artaud either as the mapmaker of a liberated society or as the best vaccine against cultural anarchy, we had better examine the serum very closely for potency, side effects, and delayed reactions. There is a recurring theme in Artaud's thinking that we would do well to single out.

> The theater must bring itself up to the level of life, not individual life or its individual aspect in which CHARACTERS dominate, but a kind of liberated life which gets rid of human individuality and in which man becomes a mere reflection. The true object of the theater is to create Myths . . . [*The Theater and Its Double*]

> Destruction of individual consciousness [*conscience*], however, represents a lofty idea of culture, it is a deep idea of culture from which will come a completely new form of civilization. [*First Contact with the Mexican Revolution*]

> Bombs need to be thrown, but they need to be thrown at the root of the majority of present-day habits of thought, whether European or not. [*Manifesto for a Theater That Failed*]

> Like men, epochs have an unconscious . . . Now nothing reached by reason or intelligence is spiritual . . . What was the spiritual value of the artists shot by the Russian Revolution? Today more than ever artists are responsible for the disorder of the period, and the Russian Revolution would not have shot them if they had had a real sense of their period . . . André Chénier, wandering across useless and reactionary terrain, was easily spared without loss to poetry or the period . . .* Art must take hold of individual occupations and raise them to the level of an emotion capable of dominating the era . . . All eras are not capable of appreciating the artist and the protective function he exercises for the benefit of the collectivity. [*The Social Anarchy of Art*]

> I suddenly realized that the time was past for bringing people together in a theater, even to say true things to them, and that there is no longer any language that society and its audiences will understand except bombs, machine guns, barricades, and everything that follows. [Letter to André Breton after the Vieux-Colombier reading]

* Chénier, the one gifted poet of the French Revolution, was guillotined in 1794, two days before the fall of Robespierre.

How much commentary is needed? Artaud was prepared to renounce the social transactions of language, to renounce reason itself. He did not fear violence, bombs if necessary, against poets who did not submit to their true mission. All this in the name of "myth," "being," "collectivity." Let us be very careful about this extreme case. When he was protesting the Surrealists' blind march toward Communism in 1927, Artaud could take a very different stand: "But what does all the Revolution in the world mean to me if I know I remain eternally afflicted and miserable in the midst of my own charnel house." But over the long haul and in his most crucial writings, Artraud is prepared to surrender individual consciousness and even individual life to a higher collectivity. Some might call it a prophetic mind. I call it a totalitarian mind—or at least one deeply pulled in that direction. The second quotation above continues as follows:

> Not to feel oneself living as an individual amounts to escape from the fearful capitalism that I call capitalism of consciousness, for *l'âme* [soul or mind] belongs to everyone in common.

Artaud was making bombs and said he wanted to drop them on culture. But half-metaphorical bombs can end up killing real people.

Once Artaud caught himself just right. "I'm not mad," he wrote to Jacqueline Breton, "I'm a fanatic." We should by now have learned what it means to canonize fanatics. The strain is too potent to yield safe vaccine. Even Aragon, whose political history is contemptible, saw things clearly at the outset of Artaud's career. In 1925 Aragon spoke to an audience at the University of Madrid about the recent launching of the Surrealist movement.

> I announce the coming of a dictator. Antonin Artaud is the man who has taken the plunge. Today he is assuming the immense task of leading forty willing men toward an unknown abyss.

Artaud was not the leader for long, but he has now assumed the fascination of an almost official pariah. Having "taught" his works to college classes, I believe firmly (just short of fanatically) that we must ascertain the ingredients of the books we read, be they allopathic or homeopathic, evangelical or indigestible. Artaud contains a significant quantity of nostalgia for violence along with a tendency to capitulate to undefined collective forces that speak in an unknown tongue. Very strong medicine.

"What books are worth writing, except Memoirs?"
—*The Conquerors*, 1928

Malraux, the Conqueror

1

In 1965 President De Gaulle sent his Minister for Cultural Affairs to visit the Chinese leaders in their heartland. André Malraux had staked his spiritual claim on the Orient more than thirty years earlier with four books, and no one had challenged it. The move was an obvious one for De Gaulle, and a mission not without excitement for Malraux. Probably in order to find rest and resume his writing, interrupted since 1957, he traveled by water. The name of the liner, *Cambodia*, recalled his earlier trips to the Far East. That corruptly administered French colony was the scene of his arrest and trial in 1924, actions which provoked strong protests from many Paris writers. Moreover, the opening sequences of his first two novels take place at sea.

Malraux carried on board with him in 1965 a small library, including his most recent novel, *Wrestling with the Angel* (*La Lutte*

avec l'ange). The first part had been published in 1943 as *The Walnut Trees of Altenburg:* the second part, of which an unfinished manuscript had been destroyed or lost by the Gestapo, was announced as still "in progress" in 1965. He had almost a month to work on it in the privileged calm of shipboard life. But instead of returning to the novel, he found himself writing an extended, self-revealing, magnificently eloquent log of the trip, a reweaving of his life back into his work. He chose a countertitle, implying a new genre: *Anti-Memoirs*. It is as if, beneath the keel of that slow boat to China and inside this substantial volume, Malraux's past began slowly surfacing, like an unknown creature from the deep. When it did, as in the China sequence recounting his conversation with Mao Tse-tung over the fate of the hemispheres, the pace of things slowed and deepened in order to encompass that past. Malraux completed his circumnavigation by air over the Pole and returned to Paris a changed man, not so much because of the trip as because of the unexpected book the trip had spawned.

This much information, at least, can be deduced readily from internal evidence. This much, and possibly more—barely discernible, bringing a note of private lyricism that is unexpected in Malraux. Granted the mood is half shrouded in rhetoric. I quote from the second page of the French version in my own translation:

> Why do I remember these things?
> Because, having lived in that uncertain country of thought and fiction that artists inhabit, as well as in the world of combat and history, having discovered in Asia when I was twenty a continent whose turmoil still illuminated the meaning of the Occident, I have encountered at intervals those humble or exalted moments in which the fundamental enigma of life appears to each of us as it appears to most women on looking into an infant's face, as it appears to most men on looking into the face of a corpse. In all forms of whatever draws us on through life, in every struggle I have seen against humiliation, and even in you, sweetness so pure that one marvels how you can walk upon the earth, life seems to spring forth as from the gods of vanishing religions, like the libretto for an unknown music.

Unaccountably, the only words that seem to have been dropped from 400 pages of the American edition are the two personal pronouns, *toi* and *tu*. But the American edition does contain something not in the French edition: a prominent dedication "For Mrs. John

Fitzgerald Kennedy." Malraux's friends have known for some time of the deep attachment he formed for *la Présidente*, whom he escorted in 1961 to the Jeu de Paume museum and to Malmaison and saw several times after that in the United States. She must have appeared to him a complex creature: a living statue, the star of stars, a person more scarred by history than he will ever be, the very embodiment of sweetness.

Toward the end of his career Malraux's position in French intellectual life was a curiously ambiguous one. Young activists and revolutionaries admired his exploits in China and Spain and the books that grew out of them. They could not bear his apparently unwavering association with De Gaulle, with a party, and with a governmental office. As Minister of Cultural Affairs, Malraux initiated reforms that had little originality. The Maisons de la Culture in the provinces were, even in name, a page out of the Communists' ideological battles of the thirties. Commissioning Chagall to paint the ceiling of the Opéra seemed quite a coup until someone pointed out that Lenin had employed him for the same purpose in Moscow thirty years before.

The promotional campaign that surrounded the Paris publication of *Anti-Memoirs*, including radio and television appearances and a long-playing record, was widely interpreted as a kind of official propaganda effort designed to cover up unrest and use Malraux's prestige to bolster the government. When he intervened in the administration of the Cinemathèque and tried to relieve its director, Langlois, of his responsibilities, Malraux had to back at least halfway down. He summarily fired Jean-Louis Barrault for turning over the Odéon theater to students in May 1968. Malraux himself played no public role during the May Days until they were practically over. Then, on June 21, he appeared on Europe I in an interview that came as a kind of summation: "First of all, there has been a real crisis over the idea of hierarchy. It is not easy to see because theoretically what people put forward against hierarchy is the idea of disorder." He went on to speak of the drama inherent in the fact that Christian culture continues even though Christian faith has disappeared as a sustaining force. "Today, in a way, civilization exists in a vacuum and is going nowhere." As a minister Malraux was not listened to very attentively. As a writer, however, he never lost his audience.

2

Anti-Memoirs opens with ten pages that rise like a bright rocket and then go out before we have glimpsed much of the surrounding terrain. The effect is tantalizing. A country priest gestures in the night and speaks of hearing confessions. We hear many voices, Malraux's above all. He has wise words about death and sincerity, about dying gods and rising cities. "I hate my childhood . . . I do not find myself very interesting . . . how [can one] reduce to a minimum the theatrical side of one's nature." In the last paragraph, Jung, of all people, is climbing down a ladder in New Mexico. The surface provides little continuity. Malraux seems to back systematically away from the very subjects the title promises. But be patient. The journey has not yet begun.

Almost everything, of course, comes back transfigured. These pages form an elliptical preview that distorts and truncates what will later be made whole. The priest does have something portentous to say about age and greatness. Malraux does not really hate his youth or disdain his past. Sincerity is a doubtful ideal, found least of all in memoirs. To kill the playactor in oneself may mean abandoning the game. Jung is as culture-bound as any poor Indian. There is no recapitulation, but by the end of the book we recognize the landscape of Malraux's many-mansioned life. In the course of this opening chapter he tells us that the Berger family, which he chronicles through three generations in *The Walnut Trees of Altenburg*, is in reality a transposition into the Alsatian forests of his own seafaring forebears from Dunkirk. The second chapter of *Anti-Memoirs* consists of a twenty-page condensation of the middle 150 pages of that novel. Such a radical telescoping destroys the story line in order to pick out what are apparently the autobiographical elements. From the start we are suspended between fiction and non-fiction, between the already recorded and the unascertainable.

From this point on, the book might be called "Ports of Call." Each place evokes its memories. Egypt, the first stop, carries him back to his first discovery there thirty years earlier of the "two languages" in art: appearance and truth. Halfway between East and West, Egypt is the desert out of which everything came forth, the culture which discovered the human soul and built the first great tombs. Moreover, Egypt reminds Malraux of his archaeological stunt with the pilot Corlignon. Subsidized by a Paris newspaper, they had tried to locate the ruins of the Queen of Sheba's ancient capital in the desert east

of Aden. That flight produced a stirring account of a near-crash they had in escaping from a local storm, as well as a few blurred snapshots, duly published in the sponsoring paper.

The memories that cluster about India, the next layover, take us further back and bring us further forward in time. Malraux had stopped briefly in Ceylon in 1923 and had visited a series of holy cities in northern India in 1929, including Jaipur, "the most dreamlike place of all." But the mention of a 1958 fence-mending mission to see Nehru for De Gaulle transports the narrative back to Paris. The next thirty pages are devoted to Malraux's meeting with De Gaulle. Apparently each was led to believe the other had asked for the interview. By divulging this fact at the end, Malraux contrives to extract a minimum of comedy out of this epic *malentendu*. By his own account Malraux seems to harangue the politely listening general about the primacy of the nation, the revolutionary spirit, and intellectuals in politics. After this first take comes a series of retakes of De Gaulle. Malraux characterizes him as the exact opposite of Trotsky. (Thereby hangs another tale, not told here, of how Malraux refused to admit in 1934 that he had gone to Royan to meet the exiled Russian. Malraux was very close to the Party then.) The story of another political mission for De Gaulle in 1958 turns into a semi-burlesque thriller. Malraux discovers himself on a platform in Guiana talking only to the first few rows of a vast audience while its outer edges are engaged in a well-organized uprising.

The narrative moves back now to India, where the ship is still docked, and gives an account of Malraux's 1958 conversation with Nehru. "So now you're a minister." Malraux's response is one of the nimblest literary leaps in the book. He recounts an anecdote that implies he is as much a minister as the cat that lived in Mallarmé's apartment was Mallarmé's cat: it's all a matter of pretending, like Sartre's waiter. They talk of many things, at the end of which Nehru says, "Tomorrow we shall learn from the newspapers what we said to each other"—a wistful motto for our times, just as much a theme here as it is in *Bonnie and Clyde*.

The Indian interlude with its multiple appendages is not yet over. A line from Gandhi about freedom being found in prison leads into the trumpet-like line "My prison began in a field." The following section (we are approaching the center of the book) picks up Malraux's "absurd" arrest by the Gestapo in 1944 north of Toulouse and his decision to reveal his real identity at his first interrogation. The

Germans staged a mock execution to unnerve him and from then on everything, including his imprisonment in Toulouse, seems to turn on *malentendus:* Malraux shares a room with a man hideously tortured because the word "tourist" in his file had been read as "terrorist"; Malraux himself barely misses being tortured, and is possibly saved from death, because the Paris authorities sent down his brother Roland's file instead of his.

The subtitle of this long Indian section of the book now changes from "Anti-Memoirs" to "The Temptation of the West," the title of an epistolary novel or essay he published in 1926. The 1958 visit takes him to the holy towns of Benares, where he is mistaken for (so Raja Rao tells him) Vishnu, to Ellora, and finally to Bombay, where he recalls his brief combat service as a tank commander in 1940. These pages are lifted almost verbatim from the end of *The Walnut Trees of Altenburg.* The chapter closes with a romantic yet moving passage about an old peasant woman's smile bringing back all human realities to his crew, who have barely missed death in a trap.

The desultory conversation with Nehru that concludes this section reads like a reworking of ideas from *The Temptation of the West.* The discussion of values and action and culture circles slowly around the concept of transmigration of souls, which resists assimilation into the Western view of the world. But Malraux is forever coming back to it as if it were a far more tempting solution to the conundrums of death and immortality than the Christian game of gambling all eternity on a single life. Nehru himself remains a shadowy figure, guru of all India. He should be the very soul of that nation which is not yet a victim of the Western disease of individualism. But such a country of the mind cannot be concentrated in one character of high relief; we glean its reality from a tempo and the patina of its places. "Remote from us in dream and in time, India belongs to the Ancient Orient of our soul."

The steamship *Cambodia* moves on toward Singapore and is rammed in the narrows. Malraux lingers a few days in that agonized city of refugees. Out of a real past and out of his own fiction emerges the character Clappique. (The narrative has now modulated into the present tense of a journal with frequent excursions into the past.) In *Man's Fate,* Clappique is the clownish talker and shady dealer whose forgetfulness at the crucial juncture leads to Kyo's death. This aging yet still vigorous character reads, mimes, and summarizes to Malraux

the scenario of a film based on the life of Mayrena. He was a legendary adventurer—prince of his own private realm among the Sedangs and toast of Montmartre at the turn of the century. It makes quite a film, complete with witch doctors and elephant hunts, entitled *The Devil's Kingdom (Le Règne du Malin)*. Malraux, by including it, has signed it—a striking anticipation of *Apocalypse Now*.

Leaving the disabled ship, Malraux takes an airplane to Hong Kong and rereads his own novel, *The Royal Way*, about the Moï tribes, whose territory he is now flying over. A few miles further on, Da-Nang lies below him, another legendary place out of the fictions of Mayrena, Clappique, and Malraux himself. But now: ". . . around the port, the American battle fleet lies motionless." Cut: to the last section, called "Man's Fate."

In Hong Kong, posters in the big Communist department store inspire a dramatic retelling of the Long March and the heroic crossing of the Ta Tu River by Mao Tse-tung's troops. Malraux flies to Peking and begins a series of conversations that rise steadily in significance and tension. First, Marshal Chen-yi, one of the founders of the Chinese Communist Party in France, expelled in 1921, now Foreign Minister. In a long discussion of Vietnam, the marshal states that the United States' escalation is Vietnam's Long March. Malraux suggests that the United States has no world strategy at present, imperialist or otherwise, and is simply repeating France's old errors. With Chou En-lai ("He knows as well as I do that in the United States he is thought to be the original of one of the characters in *La Condition humaine*"), the exchange moves far beyond Vietnam to China's sense of destiny, her newly found freedom, and her will to transform herself. Malraux thinks to himself of Sun Yat-sen's sentence about the word "freedom" being new in Chinese and therefore lacking the weight it has in the West.* "It is always men who win in the end," says Chou at the end of the talk.

The official audience, with presentation of credentials to President Liu Shao-chi, provides the occasion, as everyone understands in advance, for the meeting with Mao Tse-tung. Malraux begins by talking about the Museum of the Revolution he has just visited in Yenan. We are now at the true summit, not of world power, but of

* Malraux's secondhand philology is barely adequate: an old word, meaning something like "doing things without interference," has begun to carry the sense of political freedom only since the Revolution.

wisdom and experience. On the walls, not propaganda posters but Manchu scrolls. At least that is the account Malraux gives, reconstructed like all the other conversations from transcripts and recollections, corrected, I feel sure, to register how it should have happened.

> *Malraux:* Gorky said to me one day, in Stalin's presence: Peasants are the same everywhere.
>
> *Mao Tse-tung:* Neither Gorky, a great vagabond poet, nor Stalin . . . knew anything at all about peasants.

Mao Tse-tung means the Chinese peasantry, in whom he puts his faith more than in professional revolutionaries. This is the true father of the country; unlike Chen-yi and Chou, he has never left China. He is concerned about the nationalist-bourgeois opposition and about his following among the young. A few sentences suggest the thinking that may have led to his five-month "disappearance" and subsequent developments—the Cultural Revolution and the Red Guards. But every stage direction implies a great immobility on Mao Tse-tung's part, "a bronze Emperor" with cigarette. The conversation, slowed to half-time by the pauses for translation, seems monumental even when it is trivial. Russian revisionism, French socialism, the possible Indonesian alliance—everything finds a place in the tapestry of world politics held between them quietly and pondered for its true meaning.

Obviously Malraux admires this "Old Man of the Mountain," who keeps repeating that he is "alone with the masses." Is Mao Tse-tung confiding anything to this emissary from another lonely chieftain? Malraux looks at him. "What an extraordinary power of allusion! I know that he is about to intervene anew. Through the young? Through the army? No man will have shaken history so powerfully since Lenin." It takes Mao Tse-tung a long time to walk his guest out to the car. Afterward, what Malraux remembers is the single emphatic gesture Mao Tse-tung made during the entire afternoon's exchange when his French guest, in reference to the United States, said, "We're independent, but we're their allies." Mao Tse-tung's arms rose into the air in surprise, or dismay.

"I return to France 'over the Pole.'" The last pages cut back and forth between a meeting to decide an appropriate monument for a Resistance hero, concentration-camp scenes of degraded humanity

confronting total inhumanity, and the Lascaux cave. It was dis-
covered by two boys and a dog in 1940 out exploring the countryside.
The place was used by the Maquis to store arms. Its prehistoric
paintings must now be protected against fungus. Lascaux is the first
museum, and possibly the last. The death-resisting works it guards
may still perish in spite of us . . . The book ends in mid-air. We
are promised more.

3

Three or four hundred years from now, what myths or legends
will have precipitated out of our century? We may know better than
we usually venture to say. The young liberal king who abdicated an
ancient throne for love and liberty. The great international performer
(a hybrid of Caruso and Nijinsky) who became a victim of his own
astonishing talent and found a sad and lonely end. The laconic
cowboy-mechanic who gambled everything on a single engine, his
capacity to stay alert for thirty-three hours, and an oversize wing
full of ping-pong balls. The gesticulating dictator who led a civilized
nation into savagery with the brazenness of his lies and the hypnotic
qualities of his voice. The new Oriental, sage and activist, a composite
of Gandhi, Nehru, and Mao Tse-tung, who revived a sundered con-
tinent. The youthful President shot just when he was learning how
hard it would be to fulfill the hopes the whole world had begun to
place in his smile and in his words. The early astronaut who cannot
readjust to living on the Planet Earth and comes to a shameful
end . . . The exact repertoire is not important. Here, however, is the
company among whom Malraux sets out to measure his own role.
Do not be misled. The tone is not megalomaniac or even mytho-
maniac; it is curiously self-effacing. But he has chosen his league.

In earlier days, every photograph showed Malraux with a cigarette
—the intellectual as tough guy and mystery man. He carried the
role well, as the illustrated pages of *Malraux par lui-même* (*Malraux
on Himself*) amply demonstrate. Walter Langlois's book *The Indo-
china Adventure* leaves little doubt about the traumatic effect on
Malraux of the Phnom Penh trial in 1924 which sentenced him to
three years in prison (later reduced to one, and never served) and
branded him a criminal for finding and wanting to keep some barely
known and unclassified temple sculpture in Cambodia. The gangster
surface wore off slowly through a long cohabitation with works of art

and through gradual disenchantment with the power struggles of the Communist Party. Between 1936, when he organized an aviation brigade to help the Republicans in Spain, and writing *Wrestling with the Angel* in 1941, a second crisis altered his thinking. It involved the Republican defeat in Spain, the Stalin-Hitler pact, the German invasion, and Malraux's own combat experience as a tank commander. *Wrestling with the Angel* is a title he took seriously. It appears again in the opening pages of *Anti-Memoirs,* followed immediately by the bluntly affirmative question ". . . and what else am I undertaking?" When Jacob fought all night with the angel, he prevailed, earned the name Israel, and bore his battle scar in the hollow of his hip. Malraux has squared off here with the dark angel of his own past, which is all that remains for him of the expiring gods. Everything implies that his struggles may belong to legend. But do they?

Even reinforced by T. E. Lawrence, Saint-Exupéry, and Rimbaud, Malraux will not be given a new name by the angel of history. He has neither of the essential qualities: obsession and aura. Intellectual brilliance is not enough. "And it is not the role which makes the historic personage, but the vocation." The words tumble out after the first meeting with De Gaulle. Malraux's struggle holds us because of the quality he finds or creates in his encounters. He prepares the ground for them in an ominous sentence on the first page of *Anti-Memoirs.* Punctuating his statement by raising his arms in the air, the chaplain of Glières (he is the chorus and will be seen and heard again) declares: ". . . le fond de tout, *c'est qu-il n'y a pas de grandes personnes.*" Malraux underlines. Kilmartin translates: "There is no such thing as grown-up people." Too much is lost. Behind the cliché expression *"grande personne"*—grown-up—stands the bedrock meaning of "great man"—hero. "In the end you can't tell the men from the boys." Or: "When you come right down to it, there are no little people and big people—just people." The ambiguity is essential and far-reaching. There has been a mighty striving in the night, expressed in both the structure and the style of this volume. But its greatness resides in a subtle and ironic avowal that greatness may escape even the great.

4

I have touched on the structural features that bind together this seemingly jerry-built book. The succession of datelines, some of them

double or triple, establish the log-book format; it is fleshed out with flashbacks and time mixes into a kind of four-dimensional journal. The "transitions" make a further revelation. Writing in Bombay in 1965, Malraux recalls at length a 1958 trip to the same city during which he retired to the governor's seaside bungalow to reread a text he had written in 1940 about tank combat. But the different levels of reference are not merely thrown together by casual association; they interlock and frame one another in a second structural pattern— that of a building carefully refashioned out of an earlier structure, with further materials added to complete the new design. The first version of the Berger family story appears in Malraux's first novel, *The Royal Way*, expands into a full-dress version in *The Walnut Trees of Altenburg*, and reappears in *Anti-Memoirs* drastically reduced in size and given both as a fiction (i.e., transposed in a variety of ways) and as a true version of Malraux's youth.

When old stones were reused in an Egyptian temple, the "usurped" inscriptions carried a reference to their previous function and position. The old structure is not forgotten but subsumed in the new one. *Anti-Memoirs* has folded into itself not only fifty pages from *The Walnut Trees* but also an execution scene from *Days of Wrath*, a rich store of images and ideas from his writings on art, and a hundred pages in the middle of the deck lifted from the scenario he was working on in 1945 about the adventurer Mayrena. Everything is tightened and revised in small details as it goes in, yet it remains immediately recognizable. The effect, and probably the purpose, of this self-quotation will come clear in a moment. As structure, it carries an experimental and often disconcerting echo-chamber effect in which characters and scenes return in fragments, reinterpreted and colored anew.

The third structural device is the use of recurring motifs. There are in fact two major motifs, both of which are used like refrains. Stated in full only once, they are invoked at intervals like the choruses of a song. I have already identified the first refrain: the chaplain of Glières. He baptized Jews left and right to save them from the Gestapo, never left the Vercors as Mao Tse-tung never left China, and lifted his arms in the starry night to intone the theme *il n'y a pas de grandes personnes*. Four times in the second half of the book, Malraux, in almost identical sentences, "thinks of the chaplain of Glières"—of his spirituality, his endurance, his sense of humanity before evil and before death. The opening page of *Anti-*

Memoirs is really a film sequence, stated with an extreme economy of images and words. It is then alluded to explicitly but fleetingly when such peasant perseverence seems either furthest from or closest to the trajectory of the narrative.

The other refrain has to do with an elemental city world that is, if anything, even more Malraux's than the open country. He calls it "coming back to earth"—*retour sur la terre*. Vincent Berger experiences it when he returns to Marseille after several years' absence in Turkey and discovers that "first of all Europe meant shop windows." Malraux went through that rediscovery of the familiar after his nearly fatal flight over the Aden desert.

> By the side of the road there was a gate without a fence as in a Chaplin film, with an inscription in huge Second Empire characters: *Ruins of Hippo*. In the town, I passed an enormous red hand which was the glovemakers' sign in those days. The earth was peopled with hands, and perhaps they might have been able to live by themselves, to act by themselves, without men.

Malraux readers will recognize the *farfelu* mood of his early "Surrealist" works, but here the whimsy is not gratuitous. Reenchantment with the ordinary world follows a significant or spiritual adventure. In the preceding sequence Malraux has already associated the wrinkled surface of the earth seen from an airplane with the lines in people's palms: the latter are said to fade away at the moment of death. This disembodied, familiar, and ominous red hand serves as the second refrain. When it recurs later in the book, it recalls us to the magic of the simple things that lie around us at every moment and that we can come home to. *Anti-Memoirs* has the extended, circular, yet essentially domestic shape of the *Odyssey* or a fairy tale.

The fourth unifying factor lies very close to the third, but extends it in a different direction. The lyric passage I quoted at the start about "humble or exalted moments" is picked up a few pages later when Malraux speaks of the nonchronological order of significant memories. They form "an unknown constellation . . . the most significant moments in my life do not live in me, they haunt me and flee from me alternately." Forty years ago in his essay on the psychology of film, he spoke of "privileged moments" that emerge unexpectedly out of the chaos of experience. The various comings back to earth provide a whole series, particularly when the tank crew escapes from its trap. Other "moments" are fairly sustained and

cover as much as several days' time: Nietzsche literally singing the words of his last poem as he is being taken in the train through the St. Gotthard tunnel back to Basel; the meetings with De Gaulle and Nehru and Mao Tse-tung; the sequence of Malraux's arrest by the Gestapo and his final liberation. Malraux's privileged moments fall between what Stendhal calls *moments probants* (he is referring to Molière and implies that true drama presents encounters that test and certify the characters) and Joyce's epiphanies.

In *Anti-Memoirs* when the camera pans off into the landscape, when a conversation ceases in order to register a gesture or a distant sound, when time itself seems to dilate, then we have reached a point of intersection between the opposites Malraux can never forget—what you do and what you are, deeds and secrets. It is a profoundly unsatisfactory division of the act of living. Yet Malraux records scrupulously the occasions when these two elements come into phase and reinforce each other. Without such moments, this voyage of rediscovery would have little to offer beyond the litheness of its language.

5

Everything I have said about the way Malraux has constructed this work, particularly his use of long passages salvaged from previous writings and his focus on privileged moments, suggests comparison with Marcel Proust. Now Proust is one of the greatest figures of literature. The novel form, European society, the French language, and the human sensibility itself have all experienced the tyranny of his feline mind. Malraux has no claim to such stature even though he is a powerful writer in several genres. But the comparison will bear examination. They are both mosaicists. True, Proust's densely involuted, mimetic style and his complex character development have little part in Malraux's universe. But both authors spend a lifetime rewriting crucial scenes and themes until they finally take their place in a single all-encompassing work. All Proust's writing before 1909 is a rehearsal for *Remembrance of Things Past*. To a somewhat lesser degree—after all, he is starting late—Malraux's thirteen previous books begin to look like trial runs for the final contest with destiny in *Anti-Memoirs*. Some of his readers will abandon him here; they will be the losers.

The development toward reappraisal and summation in Malraux

points up the problem that has bothered the French critics: to what genre does *Anti-Memoirs* belong? Classification can be crucial. Malraux himself broaches the question right at the start, cites St. Augustine and Rousseau and T. E. Lawrence, and ends the chapter by stating: "I have called this book *Anti-Memoirs* because it answers a question which memoirs do not pose and does not answer those which they do . . ." He appears to mean that he is concerned not with events exclusively but with a particular relation between them: privileged moments. Furthermore, one significant passage at the start implies that the book is oriented not so much toward memory as toward its opposite, *premonition*. In their work writers anticipate the fate they will go on to act out in life. He points to Nietzsche and Hemingway.

George D. Painter's description of Proust's undertaking may turn out to be close to the mark for Malraux: "not, properly speaking, a fiction, but a creative autobiography . . . Though he invented nothing, he altered everything." The effects of such a literary project on the writing itself may be even more complex in *Anti-Memoirs* than in Proust's novel. In Malraux's palimpsest of fiction and non-fiction, the *je* becomes a chameleon. The *I* is narrator, character in his own narrative, and author of earlier works and deeds—and at other times a fictional narrator and character related to the "original" *I* and in a parallel situation. (We are approaching the territory of *The Counterfeiters*. But Gide's puzzle of authors within authors points by implication, and ironically, either to a divine agent or to the void. Not so Malraux.)

This identity game works out most neatly and paradoxically in the prison sequence in 1944. Malraux tells it tersely and well. It looks to me like the autobiographical and phenomenological heart of the book. Captured by surprise in uniform, Malraux decides to give his true identity as man and writer as well as his *nom de guerre*, Colonel Berger. (He had chosen the name originally for the hero of *The Walnut Trees of Altenburg* because it could be either French or German in origin.) The Gestapo is puzzled by the prisoner's apparent forthrightness and never does accept his unlikely story. Later, the French prisoners in Toulouse free themselves while the German tanks are still leaving. Malraux alone is in uniform. Out of the dangerous confusion in the courtyard someone calls out, "Let Berger take over!" And he does—yet he doesn't. For Malraux never enters the action directly as himself but acts through his surrogate and alter ego,

through the character of himself as Berger, his pseudonymous creation brought to life. Stendhal played this game all his life. Malraux too, it seems, but without the same style and relish. A flesh-and-blood person is called to command liberated prisoners in the guise of one of his own fictional characters whom he usually casts in the role of his father—this is why the book moves so mysteriously through the straits that separate history from dream, and which connect history and dream. Colonel Berger became Minister of Culture in a highly flammable government.

Malraux's novels and especially his works on art are shot through with ill-defined hortatory words that have incurred the wrath of careful art scholars, such as Gombrich. Something is accomplished, I believe, by falling back on a concrete term: "conquest." It provided the title of his first novel. His career and writings turn on that theme. His first "serious" book, *The Temptation of the West*, presents a confrontation of East and West in a context of conflict and domination. The characters in that book vigorously criticize museums as the repositories of dead trophies from the culture wars. In his political speeches of the thirties, Malraux retains the image of conquest, now enacted less against distant cultures than against our own unconscious. The heterodox speech he gave in Moscow to the first Congress of Soviet Writers (1934) was called "Art as Conquest." André Breton found Malraux's solution to the artist's political dilemma so convincing that he quoted a lengthy passage in one of his own speeches collected in *The Political Position of Surrealism*: "Art is not a surrender, it is a conquest. Conquest by what? By feelings and means of expressing them. Conquest of what? Of the unconscious almost always; often of logic itself . . ." The passage ends with the motto "More consciousness," lifted from Marx (early *and* late) and obviously alluding to Freud, who was by then anathema to the Soviets. Garcia, in *Man's Hope*, picks up the same theme in his widely quoted line about "transforming into consciousness the broadest possible range of experience." Möllberg, the ethnologist in *The Walnut Trees of Altenburg*, has written and destroyed a lengthy manuscript entitled *Civilization as Destiny and Conquest*.

If culture, the creative act, and even life itself can best be seen as a conquest, we still have one further step to go in order to understand the particular dilemma Malraux must face. To conquer implies a responsibility to dominate, to occupy, to assimilate or be assimilated. The conqueror in some way undertakes to live in relation to what he

has conquered. But not so Perken and Ferral in the earliest novels. Their haughty and remote attitude toward a sexual partner is transferred in later books to other forms of knowledge and activity.

> The special pleasure one experiences in discovering unknown arts ceases once the discovery is made and does not develop into love. [*The Temptation of the West*]

> To transform society doesn't interest me at all. It's not injustice that puts me off, but something more basic, the impossibility of joining, of giving my loyalty to any form of society at all. [Garine in *The Conquerors* explaining why he is a revolutionary but not a Communist]

> The adventurer is obviously an outlaw; the mistake is to believe he breaks only the written law, or convention. He stands opposed to society to the full extent that it represents a pattern of life. He is opposed less to its conventions than to its very nature. To win is his undoing. Lenin was not an adventurer, nor Napoleon. [Malraux's marginal comments in *Malraux par lui-même*]

The curve can be traced across Malraux's works, whether they be concerned with archaeological prospecting, revolutionary struggle for power, aesthetic discovery and domination by means of museum or illustrated book, or a man's desire for a woman. His vocabulary is saturated with words like "wrest," "crush," "annex," "conquer," "victory," "triumph," "dominate." More widely circulated terms like "metamorphosis" are dignified versions for a title page. Notice that pleasure occurs only in the initial stage of conquest—even though the corpus of writings on art represents Malraux's resolute attempt to live with his empire. But he finally cannot.

> Our feelings seem to have a special charm while they are forming, and the whole pleasure of love lies in its shifting moods . . . In the end nothing is so satisfying as to overcome the resistance of a beautiful woman. And on that score I have the self-feeding ambition of a conqueror who can never have enough victories or limit his desires. [Molière's Don Juan on himself]

In spite of his lifelong attempt to settle accounts with culture and art, in spite of the lucidity that reaches a high degree of intensity in *Anti-Memoirs*, Malraux remains a cultural Don Juan more excited by seducing than by possessing his prey. Is that a harsh judgment?

I think not. Better we know ourselves than hide from ourselves. Furthermore, even Molière did not probe this passion-without-attachment to the full. Moral comprehension comes through the cool voice of Montaigne in his last revisions of the *Essays*.

> I feel weighed down by an error of soul which I dislike because it will not leave me in peace. Though I try to correct it, I cannot get it out of my system.
>
> It comes to this: I underestimate my own possessions and correspondingly attach too much value to things that are strange, far away, or belong to someone else. ["On Presumption"]

Here, according to my reading, lies Montaigne's secular account of original sin, our natural weakness. The inversion of pride distorts as fully as pride itself. Malraux has lived in constant struggle against this incorrigible soul-error.* Every museum filled, every revolution won, every woman led to the bed of slaughter is a Pyrrhic victory unless our natural perverseness of mind can master itself. Here, in the context of our eternally empty conquests, arises the absurdity that prefaces every effort Malraux makes to reach lucidity or profundity. And here in the context of eternal enchantment and disenchantment, one should reread the opening of *Anti-Memoirs*. "*Il n'y a pas de grandes personnes.*"

In *The Temptation of the West*, Malraux develops the idea that "Every civilization molds its own sensibility." The following year he wrote an article in which he refers to a "grid" through which we apprehend the world. For thirty years a loose group of thinkers whom it is convenient to refer to as "Structuralists" has kept repeating to us that language forms and sustains the shape of experience, the pattern of available ideas and feelings within which we live. We cannot see the pattern except by an effort of personal and cultural transcendence, like that of visualizing the Milky Way as our own galaxy. Malraux can be regarded as one of the early Structuralists—*but not of language*. The mental grid he has increasingly devoted himself to mapping consists of *images*—forms, colors, simplifications, and their transformations. His temperament and his talent remain predominantly verbal. But his subject, his deepest fascination, is paint-

* I develop this subject in a chapter of my book *Marcel Proust* (Viking, 1974; Princeton, 1982).

ing and sculpture. Gaëtan Picon, who writes with the authority of long friendship, concludes his portrait of Malraux with a flat statement: "The great admission of *The Voices of Silence* is that the author would have wished to manipulate colors and forms, not write sentences." The same book, *Malraux par lui-même*, reproduces eight of his drawings that display a surprising sensitivity to line and movement. By vocation and profession he manipulates words, yet he is forever telling us that thinking takes place by images in many of the greatest minds. For the past twenty years he has produced books whose profuse illustrations form the armature. It is so because he feels instinctively that a painting or a sculpture attests directly to and arises from an act. A non-verbal work of art detours the mental set inherent in language. Malraux speaks for himself in *The Voices of Silence*:

> The non-artist's vision, wandering when its object is widespread (an "unframed" vision), and becoming tense, yet imprecise when its object is a striking scene, achieves exact focus only when directed towards some *act*. The painter's vision acquires precision in the same way; but, for him, that act is painting.

The novels and *Anti-Memoirs* carry no illustrations. But the pictures lie in the text itself in the form of landscape, focused acts of seeing which express the character's freest thinking. *Anti-Memoirs* is a travel book because Malraux thinks through places—through the landscapes that punctuated the dialogue.

In respect to this radical insight into human consciousness, and in respect to a number of other preoccupations (politics, time, the novel as a vehicle of action, the faltering maturation of a man), there is one wistful figure who bears comparison to Malraux. Allow for at least three generations or sixty years of difference. He is not even a Frenchman: Henry Adams.

Locating Michel Tournier

It's hard to consider the case of Michel Tournier in 1983 without falling back on a conspiracy theory. How else can one explain the fact that this French writer, still in his fifties, whose four novels have won prizes, stirred up rumbling controversy, and gained a loyal audience in Europe and parts of the Orient, remains virtually unknown in the United States? And even in his own country popular success and official recognition appear to disqualify him in many intellectual circles from genuine literary eminence. A recent rumpus in New York and Paris newspapers about the state of contemporary French culture raised the blunt question whether Tournier is the only "novelist of real importance" to appear there in twenty years.*

* It all came to a head when Raymond Sokolov in *The Wall Street Journal* (February 16, 1983) editorialized caustically about Mitterrand's Sorbonne colloquium of international celebrities invited to discuss the uses of creative genius to fight the worldwide recession. Behind the whole classy affair Sokolov detected

The whole overblown dispute probably served more to swell the envy of Tournier's detractors than to gain him new admirers. From both a literary and a social standpoint, his case will bear scrutiny.

In 1967 Tournier at forty-four won the Grand Prix de l'Académie Française for his first novel, *Friday*, based on *Robinson Crusoe*. Three years later he added the Prix Goncourt (by the first unanimous vote since the award began in 1903) for *The Ogre* (*Le Roi des aulnes*). After receiving these honors one is out of the running in France for all lesser prizes. In 1975 *Gemini* (*Les Météores*) intensified the outcry about obscenity, perversion, and unsavory politics provoked by the earlier works. It also inspired some stunning reviews: "apocalyptic genius" (*L'Aurore*); "abundant . . . radiant" (*Le Monde*); "beautiful, subversive" (*Le Point*); "a book of the greatest magnitude" (*Le Canard Enchaîné*). Tournier's latest novel appeared in 1980, *The Four Wise Men* (*Gaspard, Melchior & Balthazar*), a devout yet parodic retelling of the Nativity story. It seems to close a cycle and has won readers that felt uncomfortable with his earlier work.

Tournier has also published a volume of short stories, a remarkable intellectual autobiography, *Le Vent du Paraclet* (*Wind of the Paraclete*), a collection of literary essays, two volumes on photography (his hobby), and several books for young people. Sales have moved comfortably into the millions in France, where schools use some of his books. His novels have been translated into close to twenty languages, and he has gained a strong following in England. All his major novels have been published promptly by Doubleday in this country; only *The Four Wise Men* has had an excellent press.

Nevertheless, at higher cultural levels Tournier is quietly shut out. No book has been written about him anywhere, scholarly or popular, and only a small number of articles have appeared in literary journals.* The most influential reviews devoted to the new criticism ignore him. The annual Colloque de Cerisy, an elite forum

a socialist invasion of high culture and deep-dyed anti-Americanism. "Instead of worrying about 'Dallas,' Jack Lang [Mitterrand's Minister of Culture] should spend his time wondering why France is a nullity in a contemporary, active world culture." There followed a sentence citing Tournier as the only exception in the area of literature. Mistaking Sokolov for the whole of *la presse américaine*, most Paris papers matched his ineptness by responding on the same shrill level of polemic.

* Gilles Deleuze wrote a solidly analytical essay on *Friday* in *Logique de sens* (1969), and the Marseille literary review, *Sud*, devoted a special number to Tournier in 1980. Except for reviews and interviews, that is all.

for invited speakers that has promoted the New Novel and writers like Artaud and Bataille, has never recognized Tournier. American graduate programs in French literature obediently follow the party line. They make a serious fuss over ideologues like Jean Ricardou, Julia Kristeva, and Philippe Sollers and usually act as if they had never heard of Tournier. The carefully edited *Columbia Dictionary of Modern European Literature* (1980) gives full-column entries to the three authors mentioned above and no entry at all to Tournier.

But why would anyone want to conspire against so prominent a writer? Does the resistance to Tournier lie deeper than the inevitable jealousy provoked by a talent that leaped suddenly to fame without the backing of any established literary or political group? One partial answer lies in a series of events on which I can give only a brief report.

In the fall of 1953 a young researcher at the CNRS (National Center for Scientific Research), who had just published a thin volume of literary polemics collected from Camus's newspaper, *Combat,* flew to Manchester to visit a friend and deliver a few lectures. In the plane he read a first novel by an unknown whose detective-story format and stark style coincided so closely with his own ideas about literature that he wrote a probing and favorable review of the novel while still in Manchester. It appeared in *Critique* in early 1954, where only a few months earlier the novelist in question had revealed his literary provenance in a brief review of the recent French translation of Bioy Casares's *The Invention of Morel* (1940). In the 1953–54 season the thirty-year-old French novelist and the critic seven years his senior began an intellectual collaboration that would for a time deflect the course of fiction and criticism. After the appearance of their first books, *The Erasers* and *Writing Degree Zero,* Robbe-Grillet and Barthes tossed ideas and terms back and forth in a series of now famous articles in the *Nouvelle Revue Française, Critique,* and *Les Cahiers du Cinéma.* Almost without need for consultation they set out to eliminate from narrative fiction the interlocking notions of the referent, nature (including human nature), psychology, and the theory of correspondences and analogies ("Baudelairean rhetoric"). Like Leibnitz and Newton discovering the calculus, these two sensibilities came independently upon the purely formal nature of literature in spite of their deep-seated Marxist orientation. For almost a decade they worked with many converts and followers to transform fiction, criticism, and film into anti-

humanistic, neoscientific endeavors based on linguistics and communications theory. A parting of ways came in the sixties.

The "conspiracy" I have just described is, of course, a historical fiction, useful only as a way of tracing how intellectual and literary movements come into being following the encounter of powerful temperaments. However, the ideological goals of this fictive conspiracy—goals concerning nature, language, and society—have assumed a far greater importance than the mixed aesthetic of the much publicized "school" called the New Novel. In the last two paragraphs of *Writing Degree Zero,* Barthes calls for "an absolutely homogenized condition of society" and for "language warfare inseparable from class warfare." In the sixties and seventies, often without understanding its political underpinnings, wide segments of the literary and academic communities in the United States assimilated the Barthes–Robbe-Grillet creed—a new art for art's sake covering an imperfectly defined social revolution.

In the face of this influential set of ideas, any novelist who makes modest claims to represent reality and to maintain a stake in the principles and beliefs according to which his characters act and make decisions is likely to be seen as retrograde and bourgeois. To some degree, then, the neglect of Tournier in the United States and his paradoxical situation in France can be traced to the force of a reigning literary doctrine, even though the general public in both countries has refused to swallow it. The explanation has the merit of exposing neglected literary undercurrents, but it will not suffice. I can think immediately of two trusted friends—an estimable French writer of catholic tastes and an American intellectual gypsy—whose negative reaction to Tournier's ideas, style, and stories is almost visceral. They find his works pretentious and inept. What is Tournier up to that produces so strong a clash of reactions? After all this gnashing of teeth are we dealing simply with a French equivalent of James Michener?

Both by modifying the events and by alternating a third-person omniscient narrative with Crusoe's log, Tournier's first novel, *Friday,* shifts Defoe's story from stolid survival to high-intensity drama. Crusoe falls into a state of wallowing, hallucinating bestiality (*la souille*) before pulling himself together and civilizing his solitude into a caricature of eighteenth-century social order complete with charter, penal code, calendar, water clock, palace, and public in-

scriptions from Franklin's *Almanac*. Friday, when he arrives years later, fits uneasily into this thoroughgoing culture and literally blows it up by inadvertently igniting Robinson's cache of gunpowder. That mammoth explosion triggers an even more devastating earthquake. Afterward, emerging from the rubble, Friday gradually initiates Crusoe into a new existence more responsive to the spiritual poetry of air and sun than to cultivating an earthy garden. Friday stretches a goat's hide into a huge kite and mounts its skull as a wind harp high in a dead cypress. Then the two residents of the island wait for a suitably stormy and moonlit night in order to participate in the ritual. For twenty pages after Crusoe first senses "a hidden unity" in Friday's behavior, Tournier has been preparing the scene.

> The wind blew with increased strength as they drew near the singing tree. Tied on a short string to its topmost branch was the kite, throbbing like a drumskin, now suspended in trembling immobility, now swerving around wildly. Andoar-the-flier hovered over Andoar-the-singer, seeming both to watch over him and to threaten him . . . And over all sounded that powerful, melodious song, music that was truly of the elements, inhuman music that was at once the deep voice of earth, the harmony of the spheres, and the hoarse lament of the dead goat. Huddled together in the shelter of an overhanging boulder, Robinson and Friday lost all sense of themselves in the splendor of this mystery wherein the naked elements combined—earth, tree, and wind celebrated in unison the nocturnal apotheosis of Andoar.

The passage assembles a number of Tournier's most characteristic themes: the physical and symbolic power of the elements (*les météores* in the original, meaning all atmospheric phenomena compounded of air, water, and fire), the different forms of throating or shouting by which human beings attempt to answer the elements, and the precious union or communion achieved under rare conditions of effort and circumstance, and lasting only for a short space. Twenty-eight years after Crusoe's wreck a ship stops for water and finds an Englishman gone native living with an English-speaking native. Crusoe has become so attached to his "solar metamorphosis," in which he has overcome both solitude and insanity, that he decides to stay. Friday, fascinated by the ship, joins the crew and leaves in his place a cabin boy whom Crusoe names Thursday. Tournier transposes Defoe's story into a superb vehicle for both symbolic action and philosophic reflection. The double point of view permits

striking meditations not only on God, religion, and morality as in Defoe, but also on perception, identity, and the temptations of oblivion.

Tournier's fourth novel turns to a story both closer to us and more remote from us than Selkirk's shipwreck off Chile. *The Four Wise Men* accepts the three names and three gifts recorded as far back as the sixth century in a Nativity account attributed to the Venerable Bede. For some reason Tournier makes Gaspard black instead of Balthazar. Considering the freedom of his version, I wonder why Tournier adopted the traditional royal status of the Magi, whereas that ancient Chaldean word designates priestly augurers, occult knowledge, and suspicious status akin to charlatanry. Non-royal magi of dubious origins would have suited one of Tournier's strongest concerns: good twinned closely with evil. Instead, Tournier's novel concentrates the power and fascination of evil in the world-weary, desperately ill, cruel figure of Herod. These two hundred pages of subtly stylized prose sprinkled with humor and concrete detail create a strong awareness of coincidence as the other face of destiny. At the hub of history, timing is all.

Each king, according to his circumstances, pursues in the miraculous comet his personal illusion: Gaspard seeks consolation after the loss of the blond white slave girl who betrayed his love; Balthazar seeks the markings of a supernatural butterfly that will lead him to a higher form of art; Melchior seeks an unknown celestial kingdom to replace the terrestrial one he has lost through palace intrigue. And when the three kings reach the stable in Bethlehem, Tournier, instead of raising the language to majesty or hushing it to piety, has the ass tell the story in a vernacular account that finds its level between the reverence of a stained-glass window and the rudeness of a comic strip. The Angel Gabriel arrives in a column of light to direct the numerous cast. After the birth and swaddling, he has a testy exchange with Silas the hermit about our "hopelessly carnivorous God" who has never stopped demanding animal sacrifices—from Abel, from Abraham, and constantly from the High Temple in Jerusalem, thus turned into a stinking slaughterhouse. Gabriel answers Silas that this little child will be the last sacrificial lamb, replacing all others for all time.

> After this angelic speech there was a thoughtful pause that seemed to make a space around the terrible and magnificent event the angel had announced. Each in his own way and according to his powers

tried to imagine what the new times would be like. But then a terrible jangling of chains and rusty pulleys was heard, accompanied by a burst of grotesque, ungainly, sobbing laughter. That was me, that was the thunderous bray of the ass in the manger. Yes, what would you expect, my patience was at an end. This couldn't go on. We'd been forgotten again; I'd listened attentively to everything that had been said, and I hadn't heard one word about asses.

Everybody laughed—Joseph, Mary, Gabriel, the shepherds, Silas the hermit, the ox, who hadn't understood one thing—and even the Child, who flailed merrily about with His four little limbs in His straw crib.

This time Tournier makes the moment of unison in the cosmos tragicomic, as if only that tone could renew the story in our battered consciences.

The Nativity is central, not final, in this reworking of the Magis' story because Tournier has drawn from related legends and introduces a fourth king, Taor by name, who has set out from India in search of a celestial nourishment (or Turkish delight) more subtle and sustaining than all the delicacies of confectioners and pastry cooks. Taor meets the other kings as they are leaving Bethlehem and arrives there too late to see the Child. In a wonderful scene reminiscent of the wedding feast in *Madame Bovary*, he sets a royal offering of sweets from his elephant caravan before the children of the village assembled in a cedar grove. Thus they are saved from witnessing the Massacre of the Innocents that takes place that very night. Tournier's imagination does not shrink from the stuff of legend. Taor dismisses his royal entourage and takes upon himself a thirty-three-year sentence in the salt mines of Sodom in order to save a laborer for his wife and family. Reduced to a blind skeleton, Taor is released at the end of his time and gropes his way with Lazarus's help to Jerusalem. He reaches the upper room just too late to find Jesus and the apostles, but discovers the bread and wine still undisturbed. "The eternal latecomer" is "the first to receive the Eucharist."

Friday and *The Four Wise Men* are Tournier's most accessible and successful novels. He makes those old bottles hold new wine. Both novels include episodes that explore the limits of plausibility and fantasy. Spurning Defoe's prim silence on the subject, Tournier gives appropriate space to Crusoe's sexuality. After yielding briefly to the temptation to return to the womb of nature by curling up in a mysterious niche deep underground, Crusoe returns to his society of one on the surface. Inspired by observing complex forms of plant

insemination that require the cooperation of insects, he hesitatingly makes love to the moss-softened crotch of a fallen soapbark quillai tree and enjoys several months of "a happy liaison." Then an excruciatingly painful spider sting in the worst place warns him that "the vegetable way" is not the right one. Tournier finds the sturdy blend of poetry and earthiness needed to narrate both that sequence and a more challenging one: a whole chapter describing Crusoe's discovery in a remote dell or coomb of how to make love to the soft, sun-warmed humus of the forest floor, to embrace the body of the island itself. After a year of these happy nuptials Crusoe reads a verse of the *Song of Songs* about the mandrake and notices a new plant growing in the coomb.

> On the day when this thought occurred to him, he ran to the pink coomb and, kneeling beside one of the plants, very gently lifted it out of the ground, digging around the root with his hands. It was true! His lovemaking with Speranza was not sterile. The white, fleshy, curiously forked root bore an undeniable resemblance to the body of a woman-child. Trembling with delight and tenderness, he put the mandrake back, and pressed the earth around it as one puts a child to bed . . . That this closer union represented a further step in the shedding of his human self was something of which he was certainly aware, but he did not measure its extent until he perceived, when he awoke one morning, that his beard, growing in the night, had begun to take root in the earth.

So ends the chapter; we have glanced for a moment into the magic domain of Ovid's *Metamorphoses*.

In such passages the tone must not falter. Tournier meets the challenge and creates a fully rounded instance of what he elsewhere calls "cosmic comedy."[*]

In *The Four Wise Men* color rather than sex provides the lurking humor. Encamped at Hebron, the oldest city in the world, Gaspard and Balthazar visit the local tourist sites—Adam and Eve's tomb ("only Jehovah's ashes are needed to make it complete") and the plowed field from which Jehovah scooped up the dust with which to create Adam. Its dirt, both kings agree, is far from white, closer

[*] In *Le Vent du Paraclet*, Chapter III. He detects the strain in Valéry, Thomas Mann, and Nietzsche. Tournier does not mention his contemporaries Gabriel García Márquez, Italo Calvino, and Thomas Pynchon, whose versions of cosmic comedy spring from a hallucinated, historical encyclopedism not unrelated to his.

to the original meaning of the word "Adam" in Hebrew: ocher red. They conclude that Adam and Eve before the fall must have been black—thus implying the negritude of the Being in whose likeness the original human beings were made. Two hundred pages later we encounter the full consequences of this speculative theology. Taor urgently insists that Gaspard reveal "the miraculous surprise" because of which the Nativity converted him to a life of charitable love.

> ". . . in bending over the Crib to adore the Child, what do I see? A black baby with kinky hair, with a sweet little flat nose, in short, a baby just like the African babies of my country . . . If Adam didn't turn white until after he had sinned, mustn't Jesus in his original state be black like our ancestor?"
> "But what about his parents? Mary and Joseph?"
> "White, I assure you! As white as Melchior and Balthazar!"
> "And what did the other people say when they saw this miracle, a black Child born of white parents?"
> ". . . It was rather dark in that stable. Maybe I was the only one who noticed that Jesus was a black . . ."*

Having expressed my admiration for Tournier's first and fourth novels, I must not neglect his two other substantial works of fiction. In *The Ogre* World War II carries Abel Tiffauges from a Paris garage to three different sites in Germany where, as a somewhat privileged prisoner of war, he approaches closer and closer to the awful heart of Nazism. From the start he knows he is an ogre, "issued from the mists of time," a benevolent, virtually sexless monster dreaming of an earlier androgynous condition in which man, woman, and above all child inhabit one body. This intricately plotted narrative gradually reveals Tiffauges as a modern stock bearing two legendary grafts: St. Christopher, who gave his life to save the infant Jesus by carrying him across a river; and the fearsome death figure of the

* I shall not attempt to evaluate the translations of all four of Tournier's novels. In general he is well served. Ralph Manheim does not err often in his version of *The Four Wise Men*, though even his professionalism cannot consistently match the formality, tinged with familiarity and irony, of Tournier's prose in this book. "Let's face it" is not the right tone for "*Disons-le.*" King David did not "see the light" in Bethlehem; he was born there [*avait vu le jour*]. Taor was seeking not "the trace" of Jesus but his trail. Manheim occasionally accepts the French spelling of place names that should be anglicized. But we should be grateful that one of our best translators has devoted himself to Tournier.

Erlking immortalized in Goethe's poem. Feeling sympathy toward many aspects of German history and life, Tiffauges discovers the full horror of the Nazi system only when he has become half implicated in it. He extricates himself by saving a Jewish boy prisoner and carrying him to safety at the cost of his own life.

The net of religious, political, philosophical, and historical meanings that traverses every page of *The Ogre* has its counterpart system in *Gemini*, the story of an ultimate couple, a pair of identical twins. When Jean leaves their nest-prison, Paul can only follow his other half in a desperate platonic quest that turns into a latter-day version of *Around the World in 80 Days* and ends at the Berlin Wall. With a little detachment *Gemini* begins to sound like a systematically dialectic work generated by the concepts of identity and alterity, of individuality and twinship. But the central story line is almost usurped by the portrait of Uncle Alexander. This flaming homosexual and King of Garbage Men comes so close to taking over the novel that Tournier has to kill him off halfway through. *The Ogre* and *Gemini* are highly ambitious novels of ideas in contemporary settings.

At the end of *Des clefs et des serrures* (*Keys and Locks*), one of his books on photography, Tournier has hidden his own "Necrology of a Writer."

> After prolonged studies in philosophy, he came late to the novel, which he always thought of as a plot construction [*affabulation*], as conventional as possible in appearance, covering an invisible metaphysical infrastructure endowed with a lively power to influence readers. It is in this sense that his work has often been referred to as *mythological*.

Thus Tournier deftly rolls the three parts of his literary self into one: the irrepressible teller of stories about exceptional people in dire circumstances; the trained philosopher (in 1949 he failed the crushingly competitive examinations for the *agrégation* and left the university world for radio and translation) who offers us something approaching a new *paideia*, a reconstituted system of truth and education; and the former student of Bachelard and Lévi-Strauss who, as Duchamp devised "playful physics," has developed a playful mythology that recycles all legends for his own ends. Those ends, which restrain Tournier from formal innovation, also appear to dic-

tate his style. He describes it as "hyperrealist"—"objectivity pushed to the point of hallucination."*

Too often, however, especially in *The Ogre* and *Gemini*, Tournier fails to impose the formal and stylistic discipline he prescribes for himself. The narrative energies overflow the channels of the action, and the style sometimes follows suit. He indulges in too many "untimely interventions by the author," a practice he himself condemns as interfering with the reader's responsibility to assemble the pieces of the story. Tournier is an incorrigible pedagogue and, having decided not to innovate or experiment with the traditional form of the novel and to maintain the advantages of clear language, falls occasionally into excessive didacticism.

But Tournier remains immensely readable despite his lapses. The question we can no longer avoid is just what ends are served by this powerful literary phenomenon of attractive exterior. Just what is this new *paideia*? The most direct and abrupt way of addressing the question may be to take hold of the extreme accusations aimed at Tournier by his French detractors, usually veiled in print, yet often blurted out uncompromisingly in conversation. He is a pervert. He is a Fascist. Or presumably his books, if not the living author, deserve those qualifiers.

Perversion. Tiffauges in *The Ogre* obeys a tender, non-sexual attraction to young children of both sexes that is mistaken in the novel itself for child molesting. Several other dubious inclinations accompany Tiffauges's pedophilia—inchoate coprophilia, vampirism, and fetishism. They combine into the gentle, polymorphous perverse of a modern ogre. *Gemini* will strain most readers' sensibility even more. After an initiation combining sex acts with Christian ritual and fencing exercises, Alexander carries his homosexuality with an arrogant flourish of moral superiority. But homosexuality is a flimsy makeshift compared to the dyadic cell of individual twins, the ultimate incestuous-homosexual unit. Jean and Paul practice "oval love" (*sic*) from a very early age, and their existence for each other as perfect doubles, permitting unnaturally close physical and spiritual relations, both defines and destroys their identity as separate indi-

* Tournier must have found and assimilated Zola's letter to Henri Céard in 1885: "We all lie more or less . . . but I believe that for my part I lie in the direction of truth. I practice hypertrophy of true detail, the leap up to the stars from the springboard of exact observation. With a single stroke of its wings truth rises to the level of symbol."

viduals.* In *The Four Wise Men* the residents of Sodom defend their erotic practices as an effective means of diverting sex away from propagation into stimulation of the entire organism. Yet only Crusoe appears to have achieved a happy love life; for him, "sex difference has been surpassed."

Fascism. "Returned to the state of nature, the goats no longer lived in the anarchy to which domestication reduces them. They formed into hierarchical flocks commanded by the strongest and wisest rams." These lines from *Friday* may be Tournier's most succinct refusal to espouse the ideal of a classless (or homogenized) society. In *The Ogre* Tiffauges accommodates to the Nazi system of which he is a prisoner more than he rebels against it and participates in some ghoulish, SS-sponsored race experiments that fascinate him as strongly as they repel him. Tournier believes that a writer has so privileged a relation to his language and to his country that what he writes, even though traitorous, as in the case of the Nazi collaborator Brasillach, should not be used legally against him.

All these elements are present in Tournier's writings. They do not represent the dominant features of his moral and political thought, nor do they constitute adequate evidence to associate his work with perversion or Fascism. Such scurrilous charges (perversion from the right, Fascism from the left) conspire further to prevent us from reading Tournier without prejudice. Even if we can do so, it is not easy to survey and describe the new dispensation toward which his works seem to converge. For in most ways Tournier takes the world as it comes and preaches few reforms. Sometimes his attitude comes close to the tolerant skepticism alert to all forms of the comic that Jarry named 'Pataphysics. At our best we are capable of a finely tuned demeanor I like to call ironic conformity. In photographs Tournier looks more like a playful bourgeois than like a closet aristocrat or an aging hippie. His novels of ideas search out a new *paideia* the way Einstein performed "thought experiments" in order to feel his way toward relativity theory. The most compact and eloquent expression of Tournier's philosophy can probably be

* The identical twins in Bruce Chatwin's *On the Black Hill* (Viking, 1982) work out their adjustments to one another and to society in a far more restricted community than that of *Gemini*, published seven years earlier. It is hard not to detect traces of Tournier's highly charged narrative in the somber pages of its Welsh-English counterpart. The theme of the flesh-and-blood *Doppelgänger* stirred both of them to undertake an ambitious work.

found in the last chapter of *Le Vent du Paraclet*, where he deplores the disappearance of *Sophia*, the ideal wisdom, a slowly acquired, personal compound of knowledge and experience. Rousseau's "conscience" and Kant's "good will" killed the ancient wisdom by shattering it into science, formal morality, and mere information. And in the same chapter Tournier rejects the collective security of both Catholicism and Marxism and defends the stern rewards of solitude and self-reliance: Crusoe elected to remain on his island.

I dissent from many segments of Tournier's thinking about the world and our conduct within it. But his chosen themes have led him to write impressive novels. Tournier returns us to the universe of Melville, Conrad, and Tolstoy, where, despite a straining toward myth and patches of overwriting, something humanly significant is continually at stake.

Tournier's books may claim one's attention for another reason. Without placards or fanfares, keeping their comedy and their anomaly behind a decorous exterior, his four novels acquiesce in the widely announced disappearance of the avant-garde. Insofar as they adapt existing legends and celebrate earlier forms of wisdom, his works leave behind the preoccupation with originality that has propelled the arts for the last two centuries. Tournier's orientation toward history and traditional areas of philosophical dispute does not of itself grant him classic stature or effectiveness as a novelist. But by sparing himself the need to innovate, he has been able to direct his inventive powers simultaneously toward elaborating a story line and toward marshaling a powerful style that is by turns descriptive, narrative, and expository.

Appropriately, the opposing figure here is once again Roland Barthes. From the preface to *Critical Essays*, where he isolates originality as the essential defining quality of literature, to *The Pleasure of the Text*, where he states that he achieves full sensual satisfaction [*jouissance*] only from "the absolutely new" in literature, Barthes acknowledges his quest for the new thrill. He represents a very widespread sensibility, both in the realm of art and beyond. The contrast between Tournier and Barthes may tell us something about our present position in the rough seas of literature. Both profess Gide and Sartre as two of their most enduring masters. Both revel in interpreting signs, particularly signs raised to the level and scale of myth. But where Barthes demythologizes the patterns and protections of bourgeois thinking, Tournier remythologizes our

world with potential meanings by a constant transformation of the existing repertory of stories and ideas. In one of his last seminars Barthes pronounced a near-maxim that identifies the two successive stages of his own career: "One must choose between being a terrorist and being an egoist." Tournier, always troubled by the trials and rewards of solitude, has moved in his writing toward altruism. *The Four Wise Men* honors its most strenuous form, Christian charity. Biographical facts may point to an even more revealing contrast between these two authors. The vagaries of state examinations excluded Tournier comparatively early from the constraints and expectations of a university career and obliged him to become a writer without institutional encumbrances. All his life Barthes fought against the conventions of the university world in which he achieved stunning successes and yearned for the open spaces of the writer. Not only did he announce in his last years that he planned to write a novel; in his book *Roland Barthes* he lists among his projects "a fiction about an urban Robinson Crusoe"—as if he hoped to go Tournier one better.

As time goes on, we may begin to see Barthes and Tournier as complementary figures of French literature in the second half of the twentieth century. Tournier cannot be shut out much longer. Barthes gradually distanced himself from modernism (a stopgap term), remaining faithful to originality and to the priority of language, and renouncing correspondences and the naturalized meanings of myth. Tournier courts an old maid called Sophie who may be much younger than she looks. Both are proselytizers, sometimes for causes that many readers will find disturbing.

The time has come to answer the question long left hanging. No, Tournier's great success with the French public in the face of deep-seated opposition from some literary quarters has nothing to do with the wooden commonplaces and conventional plots of James Michener. Tournier is a writer of superb gifts and major achievements from whom we shall be hearing more. When asked who was the greatest French poet, André Gide reluctantly answered, "Victor Hugo, alas." If asked today who is the most exciting novelist now writing in French, I would answer with alacrity, "Michel Tournier, paradoxically."

ARTISTS
AND OTHERS

Claude Monet:
Approaching the Abyss

1

"All gardening is landscape painting." The sentence is attributed to
Alexander Pope, the reigning prince of eighteenth-century English
poets. In 1719, at the age of thirty-one, Pope moved fifteen miles
up the Thames from London to a riverfront property called Twicken-
ham and resided there for his remaining twenty-five years. Digging
an elaborate shell-encrusted tunnel under Hampton Court High-
road, which divided his five-acre estate in two, he designed and con-
structed not a formal garden after Versailles but something in the
new style of an English "romantic" garden. This vision of landscape
can be traced variously to Milton's descriptions of the Garden of
Eden in *Paradise Lost* and to essays by Temple, Shaftesbury, and
Addison. Pope himself was one of its principal instigators and theo-
rists. In an irregular yet carefully laid-out design he built walks, vistas,

mounts (or little hills to provide outlooks), clumps, sculpture, dense woods, and a kitchen garden. Imitating Horace, he wrote:

Content with little I can piddle here
On Broccoli and mutton round the year . . .
 [*Satire* II, ii]

All this was no idle pastime; it formed a part of his essential outlook:

To build, to plant, whatever you intend . . .
In all, let Nature never be forgot . . .
He gains all points who pleasingly confounds,
Surprizes, varies, and conceals the Bounds.
Consult the Genius of the Place in all,
That tells the waters or to rise or fall . . .
Now breaks, or now directs, th'intending lines;
Paints as you plant, and, as you work, designs.
 [*An Epistle to Lord Burlington*, 1731]

Pope designed the landscape he desired to live in and then (in addition to making sketches of it himself) indirectly discoursed upon it in poem after poem. He even installed in his grotto-tunnel an optical device dear to artists since the Renaissance, and described it in strikingly prophetic terms to Edward Blount: "When you shut the Doors of this Grotto, it becomes on the instant, from a luminous Room, a *camera obscura*; on the Walls of which all objects of the River, Hills, Woods, and Boats are forming a moving Picture in their visible Radiations." The principal product of Pope's garden at Twickenham was the constant stimulus it gave his imagination by its changing vistas, moods, and seasons. The place had a genius worthy of his.

A decade after Pope's death, a famous friend of his left Geneva to move across the French frontier to a 500-acre estate in Ferney. He, too, immediately began redesigning his chosen environment. Voltaire, aged sixty-six in 1760, transformed a poverty-stricken locality of forty-nine peasants into a flourishing community of some 1,200 citizens engaged in watch, silk, and lace production. The prince of this little kingdom not only had to become "the Tavern-keeper of Europe," receiving a stream of invited and uninvited visitors, but he imposed the very lines of his thinking on the countryside. That thinking was more formal and all-encompassing

than Pope's. While his incredible literary production never flagged, the gay old dog saw to it that there was a constant round of theatrical productions, balls, pageants, banquets, and magic lantern shows. In this rural community, liveried footmen in powdered wigs announced the guests as they entered the salon. Voltaire's biographer John Hearsey describes the complementary side of life at Ferney. "Until 1772 when he reached the age of seventy-eight, there was one field which no one else was allowed to touch, and which Voltaire ploughed and sowed himself." He had, after all, composed the famous sentence at the end of *Candide*, "*Cultivons notre jardin*." Pope and Voltaire gave new resonance to the expression "the Genius of the Place."

Monet moved to Giverny on the Seine at the age of forty-two, to remain there for his next forty-three years. He was not retiring from active work any more than Pope or Voltaire had done. Even more than they, though with far less philosophical and social ideology to direct him, he set about to transform his bare and almost unproductive property—traversed like Pope's by a road, and also by a railroad—into his personal domain, the very pasture of his mind. He gradually abandoned his monthly visit to Paris and his dinners at the Café Riche with other painters. As time went on, his frequent travels to London and Brittany and later Venice ceased. Increasingly, even before his wife's death in 1911, life in Giverny consisted of eating well, sleeping well, painting all day beginning before sunrise, and gardening. The last responsibility grew with the size of the property, with the size of his staff (six full-time gardeners for the last twenty years or so), and with Monet's ambitious plans for diverting streams, building ponds and bridges, and planting flowers in prearranged color combinations. The older Monet got, the higher the prices his paintings commanded on the market, and the more ambitious his landscape plans became, the more nature herself seemed to take over. The flower beds, the ponds, even the house disappeared under a great welling up of vines, foliage, overhead arches, and trellises. Monet seemed content to be overwhelmed by his own creation, and his last paintings become the celebrations and extensions of his plantings.

William Seitz, one of the earliest and best critics of the Monet revival, points out that the garden at Giverny successfully mediated between two opposing tendencies in his art: the desire to paint in front of the motif, *en plein air*; and the desire to create huge decorative paintings—canvases too large to trundle around conveniently

out of doors. In the form of a garden he combined the controlled, compact environment of an atelier with the open, natural spaces of *plein air*, inside and outside reconciled. Even more effectively than Pope and Voltaire, Monet designed his chosen garden spot in the universe as a living and working milieu with a direct operational relation to his creative life as an artist. As the walls grew higher, this vision of himself in the landscape became more personal, more intense, and a little mad.

2

During the forty-three years at Giverny, Monet's painting underwent changes so profound that he seems to have entered a second career. I want to distinguish several aspects of this evolution and the continuity that guided it. To begin with, anyone who surveys Monet's paintings after 1883 is bound to notice the gradual dwindling and final disappearance of the human figure. Two matched paintings of a rowboat illustrate the process dramatically and almost humorously. *The Pink Boat* (1885) contains two seated human figures; the same highly enclosed landscape entitled *The Boat* (1887) shows an empty boat and no traces of the rowers.* People make their last stand as mere specks in the London series done in 1903. This expulsion means something very far-reaching: it constitutes a turning away from significant modern motifs. Abandoning the picnics and cafés and railroad stations and lively street scenes of his earlier years, Monet renounced the whole tradition of *"l'héroisme de la vie moderne"* that came down from Baudelaire through Manet. Unlike Rembrandt, who hovered more and more over the most expressive features of the human form, Monet restricted himself to the forms and colors of nature without people, cleansed of the human presence. At the end he was painting Eden after the Fall, when the garden was growing up to obliterate all traces of earlier occupancy, a wistful paradise which eventually came to have a new relation to mind and to appearance.

* "Monet's Years at Giverny," an exhibition at the Metropolitan Museum of Art in the spring of 1978, contained no painting displaying the figure and therefore included only the latter of these two paintings. At the installation of the same exhibit in the St. Louis Art Museum in the fall, the former painting was added and hung prominently immediately over the entrance. For an alert spectator the St. Louis exhibit began with a deliberate curatorial lapse—or joke.

In work of the same period one also discerns a contraction of space in Monet's compositions. All objects move up close, cutting off the sense of open distance and of vast skies filled with light. Monet's double cataract and incipient blindness in his last years no doubt contributed to some of these changes. But they do not tell us why Monet began, around 1900, to tilt his point of view downward so as to exclude the horizon and often eliminate any recognizable point or passage that the spectator could use for orientation. And finally, by a compensating reaction of major significance for modern art, the canvases tend to become larger and larger as the actual field of vision becomes smaller.

In all these respects Monet was going counter to Impressionist practice. He left behind the world of light-saturated space occupied by beautiful people in nineteenth-century costumes. He left behind the small, rapidly brushed easel paintings which, from the 1870s on, had declared their opposition to the enormous *machines* meticulously built up in studio conditions for the official Salon. The stocky old man whose dark beard had now turned white addressed himself resolutely to a new adventure of his own.

Monet used a revealing vocabulary to describe his undertaking. Many of the Realist and Impressionist painters of the nineteenth century were inclined to talk of their work as a struggle. "The study of the beautiful," wrote Baudelaire in one of his most painterly prose poems, "is a duel in which the artist cries out in fright before being overcome." Caricaturists loved to represent the Impressionist painter as literally dueling with his canvas. But that was not Monet's metaphor. At the end of letter after letter to Durand-Ruel and Bazille and Clemenceau, he habitually employed two down-to-earth words to describe his daily activity: *Je pioche.* (I'm hoeing my row. I'm opening new ground with my mattock. I'm hacking away.) In other words, he unconsciously associated wielding a brush with wielding a gardening tool. That association helped liberate him as a painter.

Monet did not abandon all his loyalties to the original Impressionist ideals. According to his own repeated statements, he continued to put on canvas only what he saw with his own physical eye *en plein air*. But he had constructed so elaborate an observation post, with extended paths, prepared sites, and three studios, that it was hard to know when he was inside and when he was outside. And, as the most astute critics sensed when they saw the Durand-Ruel

exhibit of forty-eight water-lily paintings in 1909, Monet had taken
a further step. He was practicing painting to the second power,
painting within painting. The scenes he looked at around the lily
pond and along the flower beds were *already* painted—that is, cre-
ated by his landscape gardening. In his late works Monet realized
the consequences of applying Pope's law that all gardening is land-
scape painting. After 1895 or so, the subject of Monet's canvases,
their "content," is not so much "nature" as painting itself, the
painting of a master gardener. In 1907 without having visited
Giverny, Marcel Proust instinctively grasped the significance of that
garden: ". . . it is a true artistic creation even more than a model
for pictures, itself a picture executed in nature as it comes to light
under the gaze of a great painter" (review of *Les Eblouissements*
[*Bedazzlements*] by la comtesse de Noailles).

Initially one could say that Monet was investigating a new form
of the picturesque. He painted pictures of a landscape already de-
signed to lend itself to painting. A kind of aesthetic amplification
sets in that can become as overwhelming in certain canvases as the
scream of feedback in a P.A. system. But when Monet succeeded in
adjusting to one another his palette, his scale, and the formal pat-
terns of his disappearing motifs, he left the picturesque far behind.
In the late Japanese Footbridge series, for example, the carefully
arranged elements of domesticated countryside display qualities of
plasticity and formal invention that we associate with Chardin and
Cézanne in their still-life paintings. Paradoxically the gardens at
Giverny led Monet not to landscape painting but to a form of monu-
mental still life.

The huge scale, of course, may throw us off. To understand that
scale we have to consider a different compulsion to which Monet
was responding at the same time.

3

Whatever his reputation as a crusty recluse, Monet did not iso-
late himself totally from the world. He signed a document in de-
fense of Dreyfus, and for two decades battled the bureaucracy to
have the state purchase Monet's *Olympia* for the Louvre. Geffroy,
his biographer, assures us that he continued to read widely in lit-
erature "with sensitive and confident taste." But this partly self-
taught painter, who had found the basis of his style in the 1870s

and established himself as the standard-bearer for the Impressionist school, did not pay much heed to later developments in painting that crowded Impressionism off to one side or back into history. Fauvism, Cubism, Futurism, Expressionism, Dada, Surrealism—all these tendencies arose before Monet's death in 1926 without leaving any noticeable trace on his art. For he had found his line and pursued it according to its own inner logic and dynamics.

But what about other domains of knowledge and investigation? How much distance did Monet put between himself and his era? Was he aware of developments in science?

During the latter half of the nineteenth century and the opening years of the twentieth, the physical sciences accomplished a complete overhaul of our understanding both of the subatomic universe and of the cosmos itself in its furthest reaches. Moving beyond the randomness of Brownian movement noticed in the 1820s, J. J. Thomson established the existence of the electron in 1897. After that, the quantum theory of energy and the concept of wave mechanics were not long to follow. During the years Monet was watching the erupting foliage and the shimmerings on the pond at Giverny, physicists had lost their hold on any simple concept of location in time and space and had replaced it with a notion akin to vibration, something imponderable at the heart of things. At the same time, at the opposite order of magnitude, a comparable revolution had taken place. Extending Faraday's work in electromagnetism, James Clerk Maxwell established the nature and dynamics of the electromagnetic field within which light waves now took their appointed place. Here also one can see in retrospect the inevitability of Einstein's hypotheses of special and general relativity relating light and space to gravity itself through the key concept of *field*. In the closing years of the nineteenth century there was a struggle in progress between scientists who believed that the description of the physical world could best be reduced to mathematical equations and those who held out for some sense of "real" phenomena that could be imagined and preferably diagrammed. Maxwell's seminal *A Treatise on Electricity and Magnetism* (1873) contains a large number of plates showing fields. In the preface he makes this telling statement about how he and Faraday differ from "the professed mathematicians":

> For instance, Faraday, in his mind's eye, saw lines of force traversing all space where the mathematicians saw centers of force attract-

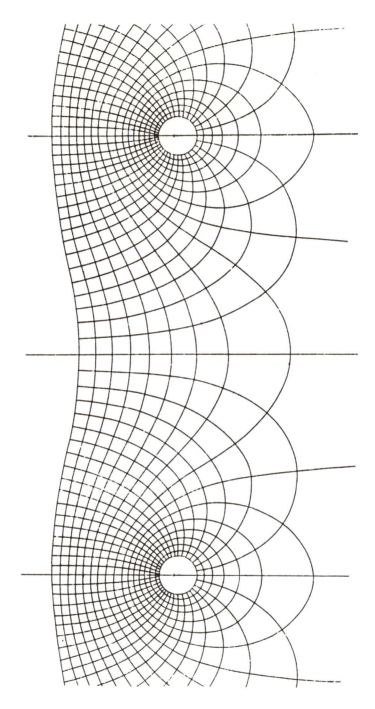

James Clerk Maxwell, Figure XIII, "Lines of Force near a Grating." From *A Treatise on Electricity and Magnetism* (1873). Rotated 90° counter-clockwise, these lines bear a singular resemblance to Monet's Japanese footbridge series

ing at a distance: Faraday saw a medium where they saw nothing but distance; Faraday sought the seat of the phenomena in real actions going on in the medium, they were satisfied that they had found it in a power of action at a distance impressed on the electric fluids.

This vivid statement about kinds of seeing belongs to the historic controversy over the existence of the luminiferous ether. I quote it, however, because it describes the tensions at work within powerful scientific imaginations or sensibilities in the 1870s; that was precisely the moment at which Monet organized his friends to exhibit together as the Société Anonyme (1874), soon to be dubbed the Impressionists. The question as to whether this chronological convergence carries significance should be approached cautiously.

If there is one thing about which every friend and critic agree, it is that Monet had a superior, almost a miraculous eye. Cézanne's famous quip ("Monet was just an eye. But what an eye!") and Clemenceau's enthusiastic book present the Patriarch of Giverny almost as a mindless optical device. Monet's aversion to theorizing about his practice does not justify such a distortion of the case. But the question haunts us: What did Monet see? What did he see, both when he stared at the *motif* and when, eyes closed, his arms hanging limp beside the studio armchair, he meditated on his painting? Do his paintings fully answer the question?

Some information can be gleaned from the writings of contemporary critics and friends who were perplexed by the same question. Furthermore, since Monet usually read what they wrote, their lyric prose may have influenced the development of his sensibility. Here are some of the thoughts Roger Marx attributed to Monet in a real or imaginary interview that appeared as an account of the 1909 "Nymphéas" exhibit in Paris. In the water-lily pond, Marx wrote, Monet had

> discovered, as in a microcosm, the existence of the elements and the instability of the universe in perpetual transformation under our very eyes . . . Monet differs from his predecessors by his hyperesthesia, and also by the oppositions united in his temperament; coldly passionate, he surveys his impulses and deliberates over them; he is as obstinate as he is lyric, as brutal as he is subtle.

Such messages could not help but have some effect on Monet in spite of his craggy temperament. Like any powerful artist, he was endlessly propelled forward by the spectacle of his own performance.

To describe Monet's sensibility Geffroy used a word that helps relate it to the profound shifts in scientific outlook I have been considering. The word is *"phénoménisme"* (not to be confused with "phenomenology"), a post-Kantian philosophical doctrine current during the second half of the nineteenth century. The doctrine asserts that only phenomena exist, only the objects of actual sense experience and not the noumena that Kant postulated beyond them. *Phénoménisme* implies that an adequately refined and attuned sensibility can directly experience the ultimate reality of the universe in appearances themselves. For there is nothing else. Monet never used such ambitious words. Yet he was making similar claims for his art when he referred insistently to painting only "what he saw."*

Friends and critics may have encouraged Monet to cultivate his special powers of vision. But I believe that basically he had trained himself to see in nature values that loosely correspond to the two complementary categories of physical science described earlier: namely, the infinitesimal vibration of particles of matter and the all-pervasive, overarching lines of force that form a unifying field. His painting moved steadily in this double direction; he intuitively worked in close relation to the most advanced scientific thought of his day. His work in Giverny, especially during the last fifteen years, reveals to what degree his eye could, as Wordsworth put it, "see into the heart of things."

To produce some painterly embodiment of vibration and a unified field as Monet increasingly perceived them in his prepared garden motifs required both convincing detail and an imposing scale. He needed to arrest and hold the spectator's attention for an essentially new aesthetic experience. It was at this point that Monet's paintings expanded rapidly to the maximum dimensions possible for stretched canvas and then spilled over onto several canvases to form an enveloping environment. The dramatic change in scale of his late work seems to spring from his hyperesthesia, from his preternatural vision into universes physicists were trying to map. He

* Monet's mind and sensibility stand diametrically opposed to the complacently alienated, demythologized, self-referential universe of "post-modernism," in which no nature exists to afford the luxury of appearances or even of phenomena. For Monet, art deals not with fictions but with brute realities as they impinge on our senses, and with our desire to register that experience in artificial yet human works.

saw the field vibrating and he painted it—painted it huge enough
to force the rest of us to see it also.

4

It is very difficult to trace a development in Monet's work through
distinct stages. He can repeat himself for long intervals, revert to
an earlier style, or leap ahead unexpectedly. Still, I discern four
levels or manners in Monet's painting which emerge chronologically.
To differentiate among them will help us understand where his eye
eventually led him.

In his late teens, while he was still working as a caricaturist for
hire, Monet could depict the thing out there, the object at a dis-
tance where our eyes see it by an intricate series of adjustments and
illusions. Often that distance becomes a kind of interfering medium
of fuzziness; both Baudelaire (*Salon de 1846*) and Delacroix em-
phasized the spectator's need for adequate distance from a painting
in order to judge it properly as form apart from representation. For
Monet, distance, real or atmospheric, melts the tones and changes
even the solidest object into a flicker of itself. At this first level of
sensibility (still operative in the early Giverny years), the garden is
still essentially and recognizably a garden, flecked and blurred by
air and light but not mistaken for anything else, not dissolved into
pattern or flux. Clemenceau, who had every reason to know from
long friendship, observed that Monet never needed to step back from
a canvas in progress in order to grasp its overall effect or check how
it matched the motif. The painter could create the necessary distance
at will, in his mind. The visual world kept its familiar shapes and
positions when he wanted it to.

Later, Monet tended to deemphasize representational and pic-
torial form even more in order to render the fluid vibratory sub-
stance that he seemed to see, literally to sense, in everything around
him. I have already quoted Pope on the "visible radiations" seen
from his grotto and Maxwell on how Faraday saw "lines of force
traversing all space." Leonardo da Vinci spoke along strikingly similar
lines: "The air is filled with tiny straight lines radiating from every-
thing, crossing and interweaving without ever coinciding; and they
represent the true *form* or reason of each object" (Codice A2171).

This is what I mean by field; it is what Monet meant, I believe,
when he said to Lilla Cabot Perry: ". . . forget what objects you have

before you—a tree, a house, a field, or whatever," and referred to painting the "naïve impression." Monet as well as his critics have tended to describe these moments of insight in terms of catching the fleeting effects of light and color. My own response to the later paintings urges a slightly different reading. Monet approached the painting of *matter itself*, matter so thoroughly penetrated by his eye as to appear as field, as lines of force, dissolved into energy in a way comparable to Einstein's scientific insight that matter is convertible into energy.

It was the *series*, I believe, that helped Monet make the transition in his own practice from the transitory effects of light he assumed he was painting to the more essential nature of things he was actually rendering as vibration, as field. The paintings in series display Monet's powers of total absorption, of meditation on his own creative activity. The impasto surface of his canvases keeps telling us that he was depicting the kinetic content of the scene, its heat, its beat. This audacious specialization of vision obviously had a lot to do with aging and incipient blindness, and even the muscle tone of a vigorous old man. We tend to see that vision as a kind of veil thrown over the motif, a colored glass through which he peered resolutely for the last fifteen years. Yet we would do better to interpret it as the advanced stages of a process of training Laforgue had described twenty years earlier writing on Impressionism. The young poet spoke of the ideal modern artist, who "by dint of living and seeking frankly and primitively . . . has succeeded in remaking for himself a natural eye . . . or a refined eye, for this organ, before moving ahead, must first become primitive again by ridding itself of tactile illusions." Laforgue understood that direct or "primitive" vision is not given; it is an accomplishment requiring long discipline. Without knowing for sure what was going on in Monet's sensibility, I find myself responding to certain paintings of this period with the conviction that he was almost *hearing* the landscape. I wonder if the time hasn't come to speak of Monet's *ear*. He listened to the field, where figure and ground tend to fuse and only vibration remains. This form of synesthesia seems almost normal, common sense.

Since hearing normally encompasses a full 360 degrees, we now begin to understand why Monet formed and carried out his final project of painting in the round, a fully encompassing environment or field that enlarges vision to match the unlimited field of hearing.

What began as separate works forming a series (e.g., *Haystacks*, 1889–91; *Rouen Cathedral*, 1892–93) consolidated into a single mammoth composition that forms a circuit, a cyclorama. Monet's circuit paintings confront us with both a dazzlingly painted periphery implying a virtual center, and a hookup of elements that carry a steady current of appearances and feelings. The successiveness of the series yields to the simultaneity of the circuit. What the Cubists sought to collapse into overlays of multiple perspectives Monet spread out in panoply around the entire horizon. He catapulted himself into nature and submitted to it in order to depict it from inside —virtually to restage it for a spectator standing inside the circuit paintings in the Orangerie in Paris or in the Museum of Modern Art in New York.

For many, a late Monet looks as alien as an infrared photograph of their own back yard. Nevertheless, Monet's unswerving purpose to paint exactly what he saw, and nothing else, was the principle that had propelled him to this second "vibration in the field" style. As I have tried to show, he overshot his mark, primarily out of sheer visionary energy, partly by lending half an ear to the claims of enthusiastic critics and friends.

John Singer Sargent provides insight into Monet's third manner; he probably said to Monet himself what he wrote to a friend and repeated many times to others in his campaign in favor of Impressionism. " 'Impressionism' was the name given to a certain form of observation when Monet, not content with using his eyes to see what things were or what they looked like as everyone else had done before him, turned his attention to noting what took place *on his own retina* (as an oculist would test his own vision)."* To paint what impinges on the retina, "in here," constitutes a very different task from depicting the vibrating field "out there." Either out of orneriness or out of genius—probably both—Monet was able to demonstrate a further meaning of "impression": the physiological-chemical traces registered on the retina by light. All our experience of focusing, noticing, and paying attention conspires to make this unprocessed "first" impression inaccessible. How then did Monet reach it?

One of the most compelling descriptions of what Monet was

* From a letter to D. S. MacColl dated 1911 or 1912, in Evan Charters, *John Sargent* (Scribner's, 1927), p. 123.

undertaking comes from the pen of a scientifically trained philosopher who published his first work in 1889 as *The Immediate Givens of Consciousness*. Henri Bergson made few direct references to painting, yet he used what will sound to us like a painter's vocabulary in criticizing ordinary modes of perception. "Impression" had a specific meaning for him: "We keep substituting for the qualitative impression our consciousness receives the quantitative interpretation our intelligence gives of it."

Bergson went on to suggest that we can catch the immediate impression only by "abstaining" from certain habits of mind. Laforgue was on the same track. The opposition here seems to operate between *le regard*, an active looking that interprets the world according to categories we already have in mind, and *l'impression*, a relaxed communion with things, achieved only through a willed abdication from certain modes of thought and expectation. This third level of vision, as Monet developed it, can be associated neither with the garden out there nor with the field that throbs and trembles within or beyond what we see out there. It belongs to the retina as sensor, in here, in us. Such vision is so intense as to resemble a form of audition or even touch, linking us closely to the physical world of our own body.

Impressions, however, whether we think of them as residing in the field out there or as occurring on the retina receiving optical stimuli, do not last. They are no more than passages, fleeting disturbances. By recording them for preservation, the traditional Western artist gives priority over all other stages of vision to the two-dimensional surface of the canvas on which he is working. By training, habit, and vocation the artist strains to establish a correlation between that picture plane and the impression he sees or has seen. Yet as the artist builds and mixes and balances and measures effects, that plane interferes more and more with the motif. Impression now comes to mean something the artist is creating, imprinting on the canvas. At this point in the creative process, the painting surface assumes the role of a *screen*, a visual event in its own right blocking out the garden, or the field, or the retinal image it is presumably intended to register. Paint on canvas begins to generate its own dynamics and live its own life apart from appearances.

In Monet's case, when he came to this juncture after the construction of his third mammoth studio at Giverny, the dimensions of his canvases first doubled and finally more than quadrupled, to the point

of his having to give up his folding stools (at age seventy-five) and paint standing in front of multipanel compositions that ultimately formed a full circuit around him. Even though he often had his workmen carry these huge sails out to the water garden, when set up they virtually cut him off from the scene he proposed to paint. Instead of saying, "*Je pioche*," as he could of his earlier works, he could now have claimed with accuracy, "*Je patauge*"—I'm floundering, I'm up to my knees in problems. He often felt this way about the last water-lily series, yet he went on. As he worked away on these immense canvases, brandishing with loud scratching noises the new bristle brushes Sargent had suggested to him, Monet built up a surface that seems to be more and more fluid, elusive, personal. The impasto belongs not only to the painted surface but even more to the movements that applied it; Monet stood already, as we now know, within the portals of action painting. For years he worked less than three feet away from the surface of vast paintings that were in effect screens shutting him off from the visible world of places and objects. Even when nearly walled up inside his own visionary universe behind these great canvases, he never lost touch with the original visible garden "out there," his anchor in palpable reality. Like the Cubists, who carried out their collective formal experiment during Monet's last twenty years, he refused to take the final step into abstract art. But the temptation was increasingly there around him in the form of huge panels screening him from the motif and offering themselves as a sovereign plane of visual composition independent of the two modes he had mastered: the vibrating field of the natural landscape as he had prepared it at Giverny and the inchoate retinal impression cleansed of the conventions of image. That beleaguered situation strained Monet to his limits as a painter and gave his last works an unparalleled excitement, a fierce starkness beneath the welter of strokes. One can virtually hear Monet's struggle to keep the real world of natural appearances from melting away in a flood of dynamic gestures imprinted on a two-dimensional surface.*

* My references to Monet's later Giverny paintings differ considerably from the "decorative vision of peace and quiet" proposed by Charles S. Moffett and Grace Seiberling. Even though Monet apparently referred in interviews to his "decorative aim" and to "peaceful meditation" in front of his compositions, I believe that the struggle to defend and record appearances can always be felt urgently in the dimensions, textures, and precarious "realism" of his late canvases. To my

5

Stated succinctly, the four manners through which Monet's art intermittently developed and defined itself encompass the major areas of modern Western art since Turner and Delacroix.

1. *The garden*: appearances on a conventional human scale seen "out there" as the real world of nature.
2. *The vibrating field*: both tiny and infinitely great forces behind or beyond appearances, discernible by a hyperaesthetic sensibility as the constituent elements of the universe.
3. *The retinal impression*: what a painter may gradually become aware of taking place in his own eye as a physiological phenomenon prior to seeing, looking, recognizing—a stripping away of the culturally influenced categories of vision.

eye and ear, they are rarely restful. (See Charles S. Moffett, *Monet's Water Lilies*, Metropolitan Museum of Art, 1978; and Grace Seiberling, "The Evolution of Impressionism," in *Paintings by Claude Monet*, Art Institute of Chicago, 1975.)

I must also confront an argument put forward by Paul Valéry. In his *Degas Danse Dessin* (1936) one comes upon two sobering pages called "Reflection on Landscape Painting and Several Other Matters." He points out that landscape used to serve as the expressive backdrop for scenes of human action and has achieved independent standing as a painterly subject only in modern times. The elimination of the human figure from landscape has led, Valéry believes, to the illusion of facility in rendering natural forms (producing Sunday painters) and— far more important—to a reduction in its content and value. "The development of landscape painting seems indeed to coincide with a marked diminution in the intellectual side of art." Landscape painting, Valéry affirms, does not offer "the act of a complete man," as presumably would be the case in painting figures placed in expressive relation to a natural setting. As we might expect, he mentions Poussin and Claude.

The popular image of the Impressionist painter seems to confirm this criticism. He is seen as recording his fleeting perceptions with a minimum of interference from the mind; he becomes pure eye. But this view is far from adequate to describe Monet in his subjects treated in series and in the late paintings I have been discussing. In those pure landscapes a strong human presence makes itself felt and stands as a surrogate for the human figure. Monet's sensibility and his "intellect" do not subordinate themselves to color and light effects. The fascination of his work at Giverny resides in the insistence with which a recognizable, individual sensibility affirms itself in choice of motif, in scale, in treatment of color and brushwork. What we see in these garden subjects is a mind thinking, thinking about painting, obsessed by the infinite resources of painting as he was still discovering them. Glaringly in Monet's case Valéry is wrong. These "landscapes" are neither facile nor intellectually shallow. Not merely "an eye," but a complete man labors here; there can be no mistaking in whose presence we stand.

4. *The screen*: a painter's absorption in the optical surfaces he is constructing (often very large) to the verge of their blocking him off from the three previous forms of perception.

During the last ten years in Giverny, when his palette, scale, and brushwork all underwent a forceful change, I believe Monet reached a *modus vivendi* in which he projected the portrayal of exterior appearances (number 1 above) back on exterior nature in the form of his constantly expanding gardens and ponds and stands of trees. Giverny became a huge framed environment or composition representing— itself. "All gardening is landscape painting." The care and planning Monet devoted to his gardens freed him to concentrate increasingly in his painting on the vibrating field and the retinal image—items 2 and 3 above. The genius of the place he had made abetted his own genius. This late development in Monet's work parallels that of Cézanne's last years (1895–1906), during which he studied a few highly familiar sites around Aix-en-Provence. Aix provided his garden. Both artists settled deeper than ever into the role—established by Courbet—of the artist as stubborn peasant, scorning public taste, dismissing criticism and theory, cultivating his garden.

I believe Monet did not anticipate the full effect on himself of his own last water-lily and wisteria compositions; they swept him away by their scale and by the importunacy with which they substituted their colored surface for every other aspect of painting, including vibrating field and retinal impression. Their scale grew until they closed the visual circuit around him. In order to describe these final compositions I shall appropriate a distinction Michael Fried set up between "non-representational" and "non-figurative" painting in discussing the work of Jackson Pollock (*Three American Painters*). As I see it, Monet remained representational while becoming non-figurative. Partially because of the certifying authority of their titles, we recognize the representational power of compositions as extreme as *The Path through the Irises* (1918–25), *Water Lilies—Reflections of the Willow* (1918–25), and *Water Lilies, triptych* (1916–23). The original scenes survive the radical transformations of the painting process only as ghostly emanations of themselves. These intense appearances, "a buzzing, blooming confusion," in William James's phrase, are probably what Monet came to see. Their link to the visible world is still secure. Yet their accumulation of strokes and gestures and sheer texture composes an overall surface on which we cannot

confidently distinguish line from color, water from air, figure from ground, inside from outside, before from behind. Those vast swirling fields have become non-figurative, rendering the vibrating field and raw retinal data rather than the conventional forms and figures (straight line, circle, angle, grid, etc.) of learned perception. At this crucial juncture in European easel painting, Kandinsky and Mondrian and Malevich were becoming non-representational while remaining emphatically figurative. Monet, on the other hand, remained stubbornly representational and at the same time abandoned conventional shapes and sizes for expanding optical fields. The token survival in his titles of a few identifiable garden sites seems to have given him the confidence to animate the entire area of the larger-than-life canvas screens he was working on. In the circuit compositions he painted himself not into a corner but into the center of the natural universe.

"*Je pioche.*" We now know what he meant. Monet was tending flower beds in the middle of the French countryside, and at the same time with his painting tools he was planting beds of paint, saturated surfaces that came closer and closer to being self-signifying without ever going all the way. In both cases he was single-mindedly cultivating appearances, phenomena, not eternal forms.

It is difficult to avoid one logical consequence of this way of looking at Monet. The accomplishments of his last years in Giverny can be seen as highly unsettling to the platonic tradition of the nature of reality that is deeply ingrained in our culture. Heraclitus' flux, Plato's parable of the cave, Christian doctrine about the vanity of material life, and proverbs in every language tell us that the world of appearance is evanescent and deceptive. One must penetrate behind this transitory spectacle in order to reach a universe of forms, ideas, enduring entities, the grand design. The Impressionists themselves tacitly accepted this attitude in their pronouncements about catching only fleeting effects of light and atmosphere. For thirty years Monet led the way in this exploration of an ever wispier and more tenuous world of surface effects; presumably they arise from an underlying continuity and solidity of forms. Then, around the turn of the century (e.g., *Morning on the Seine—Giverny*) and in the early water-lily series (1903–7), Monet seems to reverse his direction, to live through a shift of vision comparable to the reorientation we experience when an optical illusion flips over into its reverse arrangement. In Monet's very last paintings the world of ap-

pearances—both the still recognizable garden motifs and the non-figurative traces of his gesturing brush—has metamorphosed from the transitory into permanence. Those vivid impressions of the visible world constitute our only sure refuge; for, if one dares look, *the flux lies behind*. The security of appearances screens us from the fluctuating field Maxwell tried to diagram, from the elementary particles that will not hold still, and from the dizzying dance of it all on our own retinas. The world is in constant flux, yes, not on its surface but behind, in its depths. Here is the abyss. Monet attested to its power over him by the galvanic strength with which he clung to "what he saw," to nature. He sustained himself in the face of the abyss by cultivating his garden—the real garden of flower beds and paths and ponds and bridges at Giverny, as well as the thick layers of paint he built up like compost in his last works. His painting became truly phenomenal, for he found his salvation in phenomena themselves, in the appearances his work teaches us to perceive as real, lasting, and endlessly exciting.

Apollinaire's Great Wheel

Out of the fabled, pre–World War I decade that launched the most dazzling feats of modernist art, one would expect to be able to identify the few works that best represent its contradictory aspirations and accomplishments. For better or for worse, a critical consensus appears to have been reached already on two works in which belligerent primitivism becomes nearly indistinguishable from bold experiment. Picasso's *Les Demoiselles d'Avignon* (1907) and Stravinsky's *The Rite of Spring* (1913) have stood up under a tremendous weight of interpretation and evaluation identifying them as the pivotal creations of the era. Is there any literary equivalent?

I believe the answer must be no, nothing combining their considerable scale with their synthesizing and innovative power. In those prewar years Eliot was writing in French, Pound was translating from all over, Yeats was still floundering, and Joyce had not yet begun *Ulysses*. Proust perhaps? Response to his work was de-

layed, however, until the twenties. No single literary work had the immediate and lasting impact of Stravinsky's thudding music at the Châtelet, and of Picasso's lineup of skewed facial masks—even though the painting was visible only in Picasso's studio till 1921. However, I want to suggest that there is a literary work, though much smaller in scale than *Les Demoiselles* or *Rite*, the audacity and extremity of whose style bears comparison to theirs. Instead of examining it immediately, let me recall some of the cultural crosscurrents that led up to the season of 1913–14—the last before the slaughter.

This was the crucial decade in which the countryside emptied itself into the cities. The automobile, electricity, radio communication, and film no longer looked like toys, for they were already transforming daily life. Aviation was close behind. Atomic physics, relativity theory, modern genetics, and psychoanalysis had just been born. As if in compensation, a powerful strain of primitivism had erupted in the arts. Works from Africa and Oceania, from folk traditions, and by children and the insane, seemed to point to the best escape routes from the conventions of Naturalism, Symbolism, and Impressionism. Artists responded enthusiastically to the confusions and opportunities of the era. At times, the resounding opening of the twentieth century looks like its premature culmination. In an era when travel was still possible without a passport, these developments washed through the great cities of the West, from New York to Moscow. Paris remained the most vital cultural center and had three hundred vertical meters of naked girders in the Eiffel Tower to prove it.

For all its dash and challenge, however, this exciting *Zeitgeist* could not have existed without individual artists of vision and talent to shape it, respond to it, and give it expression. No one is likely to forget Diaghilev's conquest and occupation of Paris following 1907. After presenting Russian art and opera, he had the astuteness to perceive that dance was the perfect vehicle for the special blend of primitivism and avant-gardism that became his trademark. Paris had tired of the high aestheticism and decadence of the nineties and gave a spirited welcome to the gaudy yet sensitive artistic collaborations that produced *The Firebird* (1910), *Petrushka* (1911), and *The Rite of Spring* (1913).

Meanwhile, the most notorious literary figure in Europe was a second-rate Italian writer, unstoppable agitator, and self-promoter,

F. T. Marinetti. He organized Futurism in Milan like an international holding company, launched it in Paris with a manifesto in 1909 and a big exhibition in 1912, and carried it to London and Berlin and Moscow by using effective publicity techniques. For his frontal attack on all traditions Marinetti commandeered every resource: manifestoes, posters, street performances, scandalous public statements, and the press. For the head Futurist, literature and the arts converted quickly into a political campaign.

Far more quietly, the Russian painter Wassily Kandinsky, based in Munich, asked painters and writers from all parts of Europe to contribute to *Der Blaue Reiter*. The German words for "The Blue Rider" provided the title for two eclectic exhibits and for a remarkable album of the arts in 1912. Kandinsky obtained works from Picasso and Matisse and the Douanier Rousseau in Paris, from Arp in Switzerland, from both the Jack of Diamonds and the Donkey's Tail groups in Moscow, from Schönberg in Vienna, and from many German artists soon to be labeled as Expressionists.

In Moscow the public antics and strident declarations of the Cubo-Futurists had reached such a pitch that it is difficult to locate any focal point. One of the most embattled moments occurred when the aggressive and prolific painter Mikhail Larionov organized the Target exhibition in March 1913. That show of works by Larionov and Goncharova launched Rayonism, a style that shouldered aside all contemporary Western movements and practiced fully abstract painting in a presumably Russian mode. In some Rayonist poems the sentences radiate in all directions. Then in the spring of 1914 Larionov and Goncharova happily picked up stakes and accompanied Diaghilev to Paris as designers for the Ballets Russes.

Throughout the prewar decade a heavy traffic of ideas and artistic practices circulated among European cities. Illustrated reviews like Herwarth Walden's *Der Sturm*, published in Berlin, kept people informed and created an atmosphere of international excitement and competition. In Paris the official salon had long since lost its leadership to the juryless Salon des Indépendants and to the Salon d'Automne. It was on the eve of the "Great War" that the Banquet Years reached their furthest point of dynamism and celebration.

The writer who emerged miraculously at the top of the Paris heap in 1913 was an unnaturalized Italian of Polish descent and French education, an intermittently modernist poet, art critic, and occasional literary hack. He was best known to the newspaper-reading

public for his brief arrest in 1911 on suspicion of having stolen the *Mona Lisa* from under the noses of the guards in the Louvre. (He was innocent.) A half century later the poet-critic Henri Meschonnic has called Guillaume Apollinaire "the Moses of modern poetry." Today, he has a street named after him in the St.-Germain-des-Prés quarter and a monument by Picasso to go with it.

In 1913 Apollinaire was thirty-three years old and working at the peak of his powers after a fifteen-year evolution of styles and loyalties. He edited his own spirited review of poetry and the arts, *Les Soirées de Paris*, in which he promoted the most advanced artists in his erratic style of prophecy and spoof. He was the regular art critic for the daily *Paris Journal*. He had published a number of lyric poems in the tradition of Villon, Nerval, and Verlaine. By 1908 he was writing also in supple free verse, often interspersed with traditional stanzas, yet tending increasingly toward the visionary manner of Whitman and Rimbaud. Out of this expansion of his talents came some highly modernist experiments. He composed "peripatetic poems" recording his walks across Paris and his real or imaginary travels across all Europe. He put together "conversation poems" in a fragmentary style closely related to Cubist collage. In 1912 a mixture of audacity and exasperation over printer's errors drove Apollinaire to delete all punctuation from the proofs of his first volume of poems, called *Alcools* (*Spirits*; perhaps *Fire Water*). That gesture assimilated even his most traditional work into the outward appearance of modernism. The rhymed, free-verse, manifesto-like poem, "Zone," which opens *Alcools*, contains the extremes of Apollinaire's poetic universe. Nostalgia for the rituals of traditional religion shifts almost effortlessly into enthusiasm for airplanes, street life, railroad stations. Apollinaire assembled all of life inside the circular structure of this expansive poem, including his strong attraction to primitive art. Within three dizzy months in the spring of 1913 he published *Alcools*, a collection of art criticism called *The Cubist Painters*, and an eye-popping Futurist manifesto whose strident typography "blessed" modern aspects of life like speed, skyscrapers, and purism, and "blasted" all dead artists including Whitman, Poe, and Baudelaire.

After this burst of activity early in 1913, where could he go next? More than anything else Apollinaire's art reviews reveal the degree to which he felt pushed on all sides, almost outflanked. The Futurists, Italian and Russian, were making more noise than anyone else. A number of young poets in Paris were proclaiming Orphism, Drama-

tism, and Simultanism as their personal property. Henri-Martin Barzun and Jules Romains tried out simultaneous recitation of several different poetic texts. Blaise Cendrars, an earthy globe-trotting poet, had returned to Paris and collaborated with Sonia Delaunay on the "first Simultanist poem." They produced a six-foot vertical scroll that combined abstract painting, printed poetry, and a paste-in map. Apollinaire was even aware of the Imagists in London and of Pound's interest in Chinese ideograms. To maintain his lead position in this great European *concurrence* ("running together" in the double sense of competition and collaboration), he would have to outdo himself.

In June 1914 Apollinaire printed in *Les Soirées de Paris* a work called "Lettre-Océan": "Ocean-Letter." Some years ago in my introduction to *Selected Writings of Guillaume Apollinaire* I treated it in cavalier fashion: "From this poem one does receive a certain impression of the distribution of the world in space, of distances which at the same time separate and link together remote places. But the lines are unreadable; thus sprinkled about the page, it is not a poem." I now believe this poem deserves a place beside *Les Demoiselles d'Avignon* and *The Rite of Spring.** (See pages 246–47.)

In the double-page spread of "Lettre-Océan" we see several things in uncertain order:† a double spoke-and-wheel pattern or clock face formed of words; a partial frame, external and internal, of bold-face type; and at the top, an irregular block of what looks like straight prose message. The eye receives two simultaneous sets of cues: one set tells us to draw away in order to assemble the visual shapes; the

* In recent years a large number of scholars—French, English, American, Swedish, and Italian—have dug around the roots of this remarkable and revealing work. I mention three items to which I am indebted and which contain all other pertinent references: D. Delbreil, F. Dininman, and A. Windsor, "Lettre-Océan," in *Que Vlo-Ve?* no. 22 (juillet–octobre 1979); Guillaume Apollinaire, *Calligrammes*, translated by Anne Hyde Greet, edited by Anne Hyde Greet and S. I. Lockerbie (Berkeley: University of California Press, 1980); and "Lecture et interprétation des Calligrammes," special number of *Que Vlo-Ve?* no. 29–30 (juillet–octobre 1981), particularly the article by Georges Longrée.

† The poem must be perceived as a single visual unit combining several disparate parts, the way Apollinaire printed it on two facing pages of *Les Soirées* with almost no central gutter to separate right from left. Most modern editions, in order to enlarge the fine print, divide the poem in two vertically and print the two halves on successive spreads rotated ninety degrees. This format deprives "Lettre-Océan" of its visual dynamics and makes a travesty of many compositional and verbal effects.

other set tells us to move close enough to read the fine print. This contradictory first impression tends to produce exasperation in an unprepared viewer. He may well pause no longer than to classify the work as a childish game or a ridiculous literary experiment. But partly because of the ambiguous reactions it produces, the work will reward close scrutiny, both verbal and visual. The problem of course is where to start reading or talking about a shaped poem, for each of us may approach it differently if left alone. "Lettre-Océan" imposes no point of entry and offers no consistent order of reading. It even undermines conventions of figure and ground, surface and depth, frame and canvas that traditional easel painting in the West has made second nature for most of us. If it is a poem, it is also a puzzle.

Before examining "Lettre-Océan" in detail, we should know the pedigree of this "calligram." As a lover of curiosities Apollinaire was probably familiar with shaped poems like George Herbert's "Easter Wings," and surely with Panard's amusing eighteenth-century version of "La Dive Bouteille" ("The Divine Bottle"). He was even more concerned with avant-garde experiments of his own period that crossed poetry and painting and favored typographical manipulation, circular forms, and an aesthetic based on simultaneity. The French Cubists, whom he was one of the first to defend, had included letters and printed texts in their paintings, functioning both as visual elements and as verbal signs. By 1913 the Italian Futurists, with whom Apollinaire corresponded regularly, had pushed typographical experiments further than the Cubists. The poster was their chosen form, and they reveled in explosive arrangements that proclaimed the total liberation of words from syntax, from discursive meaning, from any constraints at all. Usually their typographical innovations were concentrated in their manifestoes. In the spring of 1914 Apollinaire received Marinetti's long Futurist book, *Zang Tumb Tumb*, an onomatopoetic and statistical description of a military campaign. On one of its most graphic pages Marinetti outlines the shape of a captive observation balloon. The circular form, the mooring masts with "TSF" (wireless telegraphy) at the top, and the central inscription, "Altitude 400 meters"—all these details will turn up in Apollinaire's calligram.

Also early in 1914, the Futurist painter Carrà pasted up a handsome collage that makes Marinetti's antics look raucous. *Free Word Painting: Patriotic Celebration*, as Carrà called it, contains several

LETTRE-OCÉAN

Je traverse la ville nez en avant et je la coupe en **2**

J'étais au bord du Rhin quand tu partis pour le Mexique
Ta voix me parvient malgré l'énorme distance
Gens de mauvaise mine sur le quai à la Vera Cruz

Les voyageurs de *l'Espagne* devant faire
le voyage de Coatzacoalcos pour s'embarquer
je t'envoie cette carte aujourd'hui au lieu

Juan Aldama

Correos
Mexico
4 centavos

YPIRANGA

**REPUBLICA MEXICANA
TARJETA POSTAL**

11 45
29 5
14
Rue des Batignolles

de profiter du courrier de Vera Cruz qui n'est pas sû
Tout est calme ici et nous sommes dans l'attent
des événements.

U. S. Postage
2 cents 2

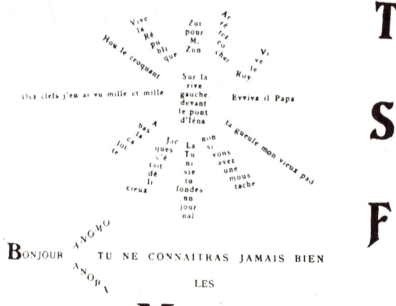

T
S
F

Vive la République
Zut pour M. Zun
Arrêtez cochez
Hou le croquant
Vive le Roy
Des clefs j'en ai vu mille et mille
Sur la rive gauche devant le pont d'Iéna
Evviva il Papa
A bas la calotte
ta gueule mon vieux pad
Jacques c'était dé li cieux
La Tunisie tu fondes un journal
non si vous avez une moustache

BONJOUR ANOMO ANORA TU NE CONNAITRAS JAMAIS BIEN
LES

Mayas

Te souviens-tu du tremblement de terre entre 1885 et 1890
on coucha plus d'un mois sous la tente

BONJOUR MON FRÈRE ALBERT à Mexico

Jeunes filles à Chapultepec

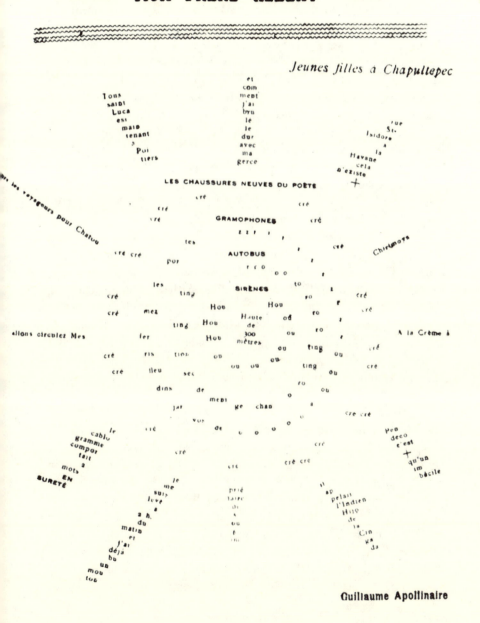

Guillaume Apollinaire

more elements Apollinaire used in addition to the circular form—
the noise of sirens, references to the Pope, song fragments. Because
of the dates it is difficult to determine who borrowed from whom.

In May 1914, Larionov and Goncharova arrived in Paris with
Diaghilev and his troupe, bringing with them near-abstract works
full of painted words and radiating lines according to the theories
of Rayonism put forth in Moscow. Goncharova's sets for the ballet
Coq d'or at the opera were so widely discussed that Apollinaire
complained in one of his newspaper articles that she was receiving
more attention and more commissions than major artists like Matisse
and Picasso. However, when the Paul Guillaime gallery opened its
big Larionov-Goncharova show on June 17, 1914, attended by Dia-
ghilev and his principal dancers from Pavlova to Nijinsky, by Cocteau
and Cendrars, and by a big contingent of Paris artists and critics,
the catalogue carried a preface by Apollinaire. He had met and
become friendly with the Russian couple. At the vernissage he
proudly explained their works to the chic invited guests. The Rus-
sian avant-garde painters drawn toward abstract art increasingly con-
sidered Apollinaire their mouthpiece and champion.

However, the artist who attracted and influenced Apollinaire most
strongly in 1913–14 was the French painter Robert Delaunay, whom
he had known for several years and in whose studio he stayed for six
weeks at the end of 1912. Around 1913, with Apollinaire cheering
him on, Delaunay was developing theories of simultaneous color
contrast based on Chevreul, and illustrated them with a series of
abstract paintings he called *formes circulares*. After the "Central
Laboratory" of Cubism in the Bateau-Lavoir between 1905 and
1910, Delaunay's busy studio became a major way station in Apol-
linaire's career.

I am inclined to think that another major source for "Lettre-
Océan" lies in an unexpected quarter. Toward the end of his life
the Symbolist poet Stéphane Mallarmé decided to etch his thought
into meticulous typographical designs. Though it first appeared in
1897, *Un coup de dés* (A *Throw of the Dice*) was printed in the
special oversize format intended by Mallarmé only in 1914. The
man responsible for this NRF edition, André Gide, gave a lecture
on Mallarmé in November 1913 which Apollinaire must have heard
or read. Gide quoted a letter from Mallarmé describing his inten-
tions. In such a poem the word "constellation," for example, "will,
according to exact laws within the limits of a printed text, fatally

take on the appearance of a constellation." Mallarmé is very precise: words can usually mimic their meaning.* But this is heresy! Here is the patron saint of Symbolism attaching poetry not to music but to painting! Mallarmé's letter to Gide, published in April 1914 (*La Vie des lettres*), may well have meant more to Apollinaire than the text of *Un Coup de dés*.

In the 1913–14 season Apollinaire assimilated all these typographical experiments and circular forms into a poetic universe that constantly renewed its equilibrium between personal lyricism and the futuristic modernism of science and technology. Fortunately we have a fragmentary record of how he composed "Lettre-Océan." The first state of the manuscript shows him laying out the elements in a sandwich format, with linear script top and bottom enclosing two circular figures. Much of the text is already in its final form. The significant word *"foule"* (crowd) will disappear from later versions of the left-hand figure. In a later state of the manuscript he has developed a more careful arrangement of the lower section, with the capitals TSF now placed in the center. At no point do we have to rotate the text in order to "read" it. In the final printed version Apollinaire shifts things around so as to increase the contrast between linear elements and circular elements.

Where, then, shall we start reading? All the words written prominently in capitals have something to do with communication, with messages. TSF means *télégraphie sans fil* or wireless—radio communication in general. The term *"Lettre-Océan,"* used as the title, means not only an ordinary letter going by ship but also, in 1914, a recently introduced service of ship-to-ship or ship-to-shore wireless message. The format of the poem beckons us to approach it as a form of correspondence between two parties immediately identified by *Hello Brother Albert* and the signature at the bottom. This obvious motif carries us first into the upper section of the composition—the linear parts that have approximately the shape of Oklahoma. The various pieces of writing below the lowest set of wavy lines carry their own label in Spanish: POSTCARD. All the parts are there: two stamps, Mexican and United States; Paris postmark showing time and place of arrival; the name of an actual German steamship, *Ypiranca*; the picture on the back of some girls in Chapultepec, a site sacred to

* Mallarmé's Cratylism was also auditory. He complained almost petulantly about the inappropriate nocturnal hollowness of the French word *"jour"* and of the complementary brightness and airiness of *"nuit."*

Apollinaire, "Lettre-Ocean" (1914), manuscript versions, first state (left),
second state (right). Reproduced in P.-A. Jannini, *La Fortuna di Apolli-
naire in Halia* (1959), from documents in the Alberto Savinio Archive,
Rome

the sun worship of the Mayas; and the message from Apollinaire's brother. He had been in Mexico for some months and had to send this card via the United States because the U.S. Marines had occupied Vera Cruz during that highly unstable revolutionary period. Possibly taken from a postcard Apollinaire had actually received from Albert, the text reads:

> Since passengers on the [French steamer] *The Spain* had to make the trip to Coatzacoalcos to disembark, I'm sending this card today instead of using the Vera Cruz mail, which is not to be trusted. Everything is quiet here and we're waiting for developments.

The postcard is given a typographical concreteness that corresponds to the labels or clippings pasted into Cubist paintings of this period.* Above the postcard Apollinaire replies in unpunctuated poetry that runs over to the right:

> *I was staying on the Rhine when you left for Mexico*
> *Your voice reaches me in spite of the enormous distance*
> *Suspicious-looking people on the docks at Vera Cruz*
> *Do you remember the earthquake between 1885 and 1890*
> *We lived in a tent for over a month*
> GOOD DAY MY BROTHER ALBERT
> in Mexico City

At the bottom left the message is repeated and combined with a jocular line about Albert never becoming acquainted with the Mayas, the real residents of that region. Two details imply that the space in question is the flat surface of the earth. The wavy lines, mimicking a common style of postal cancellation, also symbolize ocean waves, the medium of transport for the postcard. And the triangular shape at the top left reinforces a flatland organization of space. It reads: "I / cross the city / nose first / and cut it in 2"— virtually a rebus. All these surface-mail motifs, answered by a poetic text tossed on the waves, create a strong sentiment of distance and time. In this down-to-earth world all events are contingent, separated

* In 1915 at the front, Apollinaire reproduced on gelatin handwritten copies of *Case d'armons* (*Futchel Slot*), a thin volume of war poems, one of which was printed on a real army postcard slipped through a slit in one of the pages. Apollinaire's correspondence shows us that he came to treat the postcard almost as a literary genre.

from us, long in coming, difficult to communicate. Time flows through the upper part of this composition as wistfully and as graphically as it flows under the Mirabeau Bridge in Apollinaire's most famous poem.

Vienne la nuit sonne l'heure
Les jours s'en vont je demeure

May night come and the hours ring
The days go by I remain

The lower section of "*Lettre-Océan*" tells another story, describes another universe, even though we gain entry to it through the same passageway of capitalized words proclaiming communication, correspondence. The central words of the two circular figures identify the scene. To the left: "On the left bank in front of the Iéna Bridge." To the right: "300 meters high." In 1914 any Parisian, and most Europeans, would unhesitatingly furnish the correct answer. The Eiffel Tower meant not only the tallest structure in the world but also the recently installed wireless mast that sent messages instantaneously to stations and ships all over the world: TSF. The tower also stood for the synchronization of time in the world. Ever since an International Congress on Time, in Paris in 1912, the Eiffel Tower had been transmitting an official hourly signal by which all clocks worldwide were to be set in reference to Greenwich mean time. It all went into the poem. Through the implied altitude rising far above ordinary lives, through instant communication with everything everywhere, through seeming command over the very passage of time, Apollinaire's circular motif removes us from the flux and raises us to a still place of universal perception.

But I am moving much too fast over ground which Apollinaire covers ever so slowly and humanly. Let us start with the larger right-hand figure. The Eiffel Tower seen from above is given multiple legs, not just four. And those twelve legs or convergent lines are formed out of fragmentary sentences snatched from the immediate environment and the poet's mind: " 'board passengers for Chatou." "and the way I had to ride the rails with my chick." "Toussaint Luca is in Poitiers now." The lower right-hand corner renews the transoceanic motif by including two Latin American obscenities that have lost none of their power. "*Pendeco* [*sic* for *pendejo*] is worse

than jerk." "He called that Indian *Hijo de la Cingada* [*sic* for *Chingada*]." (The fifteen central pages of Octavio Paz's *Labyrinth of Solitude* examine *Hijos de la Chingada*, approximately "Offspring of Rape," as the ultimate cultural expression both of the colonial exploitation of Latin America and of that continent's defiance of its lot. How did Apollinaire spot the phrase from Paris in 1914?)

Then, in concentric circles, four onomatopoetic constructions. Outside, "*cré, cré*" all the way around, labeled "The Poet's New Shoes," presumably as he approaches the tower. Next, gramophones, making vowel sounds that end in a bit from a popular song: "Close the gates of your flowering gardens." Then the sounds of a bus, with the conductor ringing his bell *ting, ting,* and announcing "*changement de section.*" Last, sirens mounted on the tower going *hou, hou.* They warn us of danger, including the danger of female charms. For personal reasons Apollinaire was going through a very anti-romantic, anti-sentimental period. Out of these commonplace parts of Paris life there rises, steeply and miraculously, the 300-meter column, merely a point in this representation and held in direct contact with the world below.

The left-hand figure repeats the same conversation-poem pattern of impinging bits of speech. It might be possible to classify the lopped utterances into categories: political ("*Vive la République.*" "*Vive le roy.*" " 'Ray for the Pope." "Down with priests"); mock-sexual ("not if you have a mustache," "Jacques that was delicious"); and purely casual ("stop here driver"). This secondary figure located "On the left bank in front of the Iéna Bridge" may represent the radial field of the poet's consciousness next to the more powerful field of the Eiffel Tower with its radio mast. Yet there is another possibility. From 1898 to 1921 a 100-meter, brightly lit Ferris wheel with forty gondolas turned near the foot of the Eiffel Tower and added the excitement of motion to the wonder of height. Visually the two shapes were closely associated in most Parisians' minds. In one of his 1913 paintings Apollinaire's friend Delaunay shows the Ferris wheel as tall as the tower. At the conclusion of a poem written during this period to accompany Delaunay's Eiffel Tower paintings, Apollinaire writes, "*La Tour à la Roue / S'adresse*": The Tower addresses the Wheel. Now we have an arrangement in which the Ferris wheel on the left along with the letters TSF are seen as vertical from the point of view of a spectator on the ground, whereas the tower on the right is seen from above in a bird's eye view. This juxta-

position of two points of view belongs once again to the Cubist vision, or more precisely, to Cubist composition by multiple perspective.

In his 1918 lecture on poetry Apollinaire affirmed a point of view closely related to height. "The poet has at his disposition the entire world, its sounds and its sights." Apollinaire asks us to place ourselves with him at the top of the tower, at the center of the field. That circular pattern of wheels and spokes carries immediate associations. Apollinaire's other poems of this period (e.g., "*Liens*," or "Links") refer to rails, cables, sounds, light rays, all of which link the world together in a vast circular network. Looking at this right-hand figure, our own imagination tends to keep on working even without clues. A pebble in a pond. A spider's web spun across vast distances. A mandala-calendar, illustrations of which Apollinaire had probably examined in his investigations of ancient Mexican art. A clock face, here superimposed on the square pattern of the Eiffel Tower's base. But unlike one of Apollinaire's other calligrams, this dial has no hands. The clock shows no specific time but all times emanating from the Tower that announces the hours to the world. And we have only begun to explore the figure. To many of us this shape suggests a sunburst—the light motif that Apollinaire was constantly aware of in his own chosen name. The poem radiates outward toward infinite space. In the end one is justified in reading these circular and divergent shapes as a map of the universe itself arranged around the centered consciousness of the poet who identifies himself with the altitude and communicating power of the Eiffel Tower. The double diagram made of words represents an egocentric cosmology—*I*, king of all that is not-*I*, emperor of everything I can see—crouched like a spider at the center of my domain.

But what is to say that these circles do not lead inward? To some beholders centripetal associations may be even stronger, even though they are not quite so neat. Apollinaire himself suggested such a double orientation when he discussed possibilities for expanded theater design and production. In the opening scene of *The Teats of Tiresias*, the director calls for "a circular theater with two stages / One at the center, the other forming / A ring around the spectators . . ." Many people see the circular shapes of "*Lettre-Océan*" converging on a tunnel-like vanishing point or descending into a deep well of inwardness. The same arrangement of lines can carry one not only out into cosmological space but into the opposite abyss, the complementary dimension of the infinitesimal. That

dimension of infinite regress stands for the endlessness of mental space, the coils of thought out of which something we call the self is precariously born. This time we reach not a map of the universe but a counterpart map of the mind, of impinging experiences related to one another by attention, memory, and nested levels of consciousness in the psyche.

Now is it really possible to assemble the scraps of language that make up this poem and raise them to as ambitious a level of significance as I am suggesting? It requires a period of relaxed yet attentive looking. Much of the effect arises from the fact that the concrete and radial shapes of two lower figures do not have a single direction, but two: outward and inward. That ambiguity allows Apollinaire to distribute tiny messages on the page in such a way as to surpass the contingent, time-bound, space-bound situation in which he places himself and his brother in the upper, linear section of the poem. Like Bergson he was resisting a deep-seated tendency of human consciousness: "Just as we separate in space, we fix in time." Apollinaire diagrams his dream of ubiquity. He yearned to match the miraculous claim of Fantomas, criminal hero of the popular mystery series of that period: "*Je suis partout*"—I am everywhere. The circle here represents no blind sealed monad. It evokes an ultimate mythological geometry of correspondences and universal analogy.*

Here then is a poem that represents a postcard, the Eiffel Tower, a Ferris wheel, a theater in the round, a sunburst–clock face, a cosmology, and a map of the mind. How shall we deal with such an extraliterary enterprise that in great part does not say what it means but shows what it means? The way we usually assimilate an unfamiliar phenomenon is to find a name for it, to classify it. For such word pictures Mallarmé tried out the term "constellation." Marinetti proposed "auto-illustration"—verbal works shaped into their own figurative content. The American poet Harold Monro coined the term "verbal photography" for the Futurist poster poems he encountered in London in 1914. Our fashionable term today is "verbal icon"—a sign, in this case a set of signs, that displays certain material or formal aspects of what is signified. Yet none of these is satisfactory. The kind of mimesis Apollinaire tries out here leans in two directions: toward the childish desire to mimic and thus attain some-

* See the Leonardo da Vinci passage dear to Valéry that I quote on page 87.

thing other than oneself; and toward the magic impulse to control something by possessing its effigy. Apollinaire himself was hard put to find words to describe his project. "Figurative poem" and "Lyric ideogram" soon gave way to "calligram." In his last public lecture, "The New Spirit and the Poets," he discusses the ease with which men invent a single word to designate such complex entities as "a crowd, a nation, the universe." Poetry, he says, has not yet matched this inventiveness. The following sentence surely refers to himself: "Poets are now filling that gap, and their synthetic poems are creating new entities which have a plastic value as carefully composed as that of collective terms."

What Apollinaire was reaching for will be a little clearer if we take account of what he found exciting about reading a newspaper: "Open up a newspaper. Immediately ten, twenty different events jump out at you. The two big headlines printed daily on the front page of *Paris Midi*, isn't that Simultanist poetry?"

Statements like these confirm my reading of *"Lettre-Océan."* On the simplest level the poem-image represents several ordinary objects—postcard, waves, Eiffel Tower, Ferris wheel. Later calligrams will revert almost entirely to such figurative content. But this synoptic poem, the first calligram, strives to present a principle that is also a state of mind: *simultaneity*. Those scraps of verbal experience arranged in spokes diagram a total all-at-onceness. Apollinaire knew that the Futurist painters had galloped across this terrain and claimed it as their own. His review of their 1912 Paris exhibit opened with a line quoted from the catalogue: "The simultaneity of states of mind in the work of art: that is the intoxicating aim of our art." But Apollinaire was working not with paints but with words. In the manifesto-like article that accompanied *"Lettre-Océan"* on its first publication in *Les Soirées de Paris*, he describes how a few of his works before 1914 had "accustomed the mind to conceive a poem simultaneously like a scene from life." But they still had to be read sequentially, diachronically. The new Simultanist poems, he claims, "accustom the eye to read the whole of a poem in one glance, as a conductor looks at his score, as anyone takes in the typographical layout of a poster." Filled with dizzying thoughts of simultaneity as an artistic and metaphysical principle, Apollinaire attempted to depict in a circular array of commonplace phrases the unnamable, the indescribable. The "new entity" aimed at in *"Lettre-Océan"* is collective consciousness, a picture of the attunement of everything

to everything in a total present, a snapshot of time. The opening pages of *The Cubist Painters* connect Simultanism to the fourth dimension, which "reveals the intensity of space eternalizing itself in all directions in a moment of time."* From the point of view of the individual consciousness *"Lettre-Océan"* also represents the mind raised to the level of omniscience, ubiquity, self-transcedence in the complete instant: a form of self-divinization.

In *"Lettre-Océan,"* then, the heroism of modern life announced by Baudelaire in 1846 is hubristically affirmed in one of the most extreme experiments of modernism. The painter-poet climbs to the summit of his own universal experience and traces magic symbols on a piece of paper to re-create for the eye an instant or cross-section of collective consciousness. At the same time, the poetic intent expressed by the headlines and the circles is imperialist—the expanding ego striving to conquer the universe and surpass the collective rather than submit to it.

"Lettre-Océan" occupies a still unsettled place in the history of literary and plastic expression in the twentieth century. Hugely ambitious, it also emits a kind of playfulness that we associate with poems by Lewis Carroll or A. A. Milne or E. E. Cummings. My extended discussion is intended to demonstrate that this picture-poem deserves a prominent position in literary and artistic canon. By its blatant mixing of innovative plastic forms with a primitive treatment of language, *"Lettre-Océan"* ranges itself alongside *Les Demoiselles d'Avignon* and *The Rite of Spring* as a major exhibit and achievement of modernism.

This high opinion of Apollinaire's radically Simultanist work does not dispel the problem of *readability* raised in my original comments. How can one recite the complex array of words that form this composition, perform them in such a way as to give them the auditory status and appeal essential to poetry? Except for certain segments, this "poem" accommodates no linear, sequential reading. Here lies the challenge of the work, its apparent sacrifice of auditory to visual, of temporal to spatial. One cannot utter all the visual elements of the poem simultaneously in one blast of sound as the format seems to suggest; they would cancel one another out the way bright hues, when mixed, dissolve into a meaningless, disappointing brown. The

* Compare these words to the quotation from A. N. Whitehead on page 148.

point at issue here is crucial if one has strong convictions, as I do, about the central importance of reading poetry aloud, of sounding it out expressively in order to give it its full life.

Apollinaire is the poet and *"Lettre-Océan"* is the poem that establish most dramatically the turn of post-Symbolist poetry away from music as model and ideal for art. Even the major figures of the so-called Symbolist movement, in spite of Pater's and Mallarmé's famous dicta, showed an ambiguous attitude toward music.* And the Symbolist era also precipitated what Mallarmé identified as the true "verse crisis," namely, the possibility of free verse. From about 1885 on, free-verse works by Laforgue and others and the discovery of Whitman, Rimbaud, and Lautréamont carried French poetry away from music toward the rhythms and diction of common speech and permitted unconventional arrangements of lines on the page. Apollinaire's elimination of all punctuation placed even more emphasis on typographical patterns, and it was in effect a logical step for him to give his lines geometric, mimetic, and schematic shapes based on plastic composition. In a shift of emphasis far more complex than this summary can acknowledge, French poetry at the turn of the century oriented itself increasingly toward the layout of contemporary painting. The calligrams, of which *"Lettre-Océan"* was the first, represent the culmination of this shift. Have they lost touch with the auditory, with music? I no longer think so. For I believe I can demonstrate that this startling "poem" remains even-handed in its presentation of visual and auditory, of spatial and temporal.

Notice that the typographical disposition of elements here depicts a world mapped out in acoustical space. Fragmentary phrases float in the air in precise relation to a central consciousness. Messages go forth in visible waves. At the bottom left the poet's voice is ragging Brother Albert through what looks like a megaphone, a striking analogy for the whole enterprise. The poem is shouting at us in a comic-strip version of vocal amplification. Notice also that the poem is studded with sound effects—onomatopoetic (*hou, cré*), verbal-conversational, and symbolic (headlines). At first glance it looks

* "All art constantly strives toward the condition of music," writes Pater in *The Renaissance* (1873). "Poetry must take back its rightful property from music," writes Mallarmé in "Crise de vers" ("Verse Crisis") (1896). Astringent scholarship on the relation of poetry and music can be found in an article by Henry Peyre, "Poets against Music in the Age of Symbolism," in *Symbolism and Modern Literature*, edited by Marcel Tetel (Durham, N.C.: Duke University Press, 1978).

like a geometrical drawing; one soon discovers that it cries out for active reading, oral interpretation. But how?

In Book IV of *Pantagruel* Rabelais describes a landscape of frozen words that hang in the air; they have to melt in order to emit sound. He exemplifies in ice the spatial or synchronic pole of language in order to reject it in favor of the temporal or performed *parole*—active speech. As they melt, the words release noises that would be at home in *"Lettre-Océan"*: *"hn, frr, bou, brededac, on-on."* How do we melt Apollinaire's frozen words? The common-sense answer has been given technical terminology by modern psychology of perception. Our global vision first grasps the Gestalt, the shape of the whole. But this immediate perception has to be completed and corrected by *scanning*. To read *"Lettre-Océan"* one must scan it in search of vectors and relations leading to a possible order of events. Apollinaire liked to use the term *"poème-événement,"* or event-poem. This may be the closest he came to writing one. Using a few sound effects and five readers in varied groupings, I have rehearsed and performed a reading of the poem in an arrangement based on a montage or counterpoint of three basic lines. First, headlines and sound effects (*"Bonjour,"* sirens, waves, squeaky shoes, radio signals, etc.) supply the opening and close and a dynamic background to set the scene and give a rhythmic impetus to the whole. Second, the sustained sequential texts at the top are read by two individualized voices for the poet (*"J'étais au bord du Rhin . . ."* five lines of print) and for Brother Albert's postcard (*"Les voyageurs de l'Espagne . . ."* six lines). Third, alternating with the second line, the fragmentary bits of speech forming the two circular fields are performed at varied levels so as to give an effect shifting between centrifugal and centripetal. Throughout the oral performance the printed version of the poem is displayed on a screen, interspersed with details of the poem to make the words legible and with related images—Eiffel Tower, Ferris wheel, both sides of contemporary postcards, photograph of Apollinaire and his brother, etc.

Such an illustrated reading running from the title and opening *"Bonjour"* to the final signature could last anywhere from five to fifteen minutes, depending on the extent of elaboration and repetition called for in the script. The audience should encounter passages of perfectly articulated clarity and others of verbal and visual confusion and near-noise.

It was during the process of preparing the reading, of hunting for

ways to render the poem's multiple effects, that I discovered what I now consider its essential beat or life. The playfulness I have mentioned arises not only out of the bits of street lingo thrown together seemingly at random but also out of the evident contrast between the linear patterns and utterances at the top that flow in time and the circular shapes of arrested movement below that signify ubiquity and universality in a stillness out of time. Neither visually nor orally can they be synthesized without violating the structure. They stand for two distinct articulations of meaning: sound—temporal; image—Simultanist. It is as if Apollinaire accepted the challenge latent in Lessing's "New Laokoon." Furthermore, any sustained effort to interpret the poem strikes up against the fact that its immediate visual aspect precedes and may usurp its verbal message. Recognizable images short-circuit the arbitrary conventions of language and thrust us directly without words toward waves and circles as modes of thought. Apollinaire has allowed his written text to embrace the Cratylist temptation, to form an icon in which the signifier reproduces salient features of the signified. This is a form of primitivism in language, a deliberate lapse into ideogram or picture language. Phonetic language is more efficient and advanced. Both playfully and in a spirit of serious experiment, in order to maintain his leadership in the arts at a moment of fierce competition, Apollinaire juggled two modes of meaning at once, verbal and visual. In combination these codes convey complementary messages—nostalgia and separation in contingent time, and individual consciousness surpassing collective consciousness in arrested time. They coexist yet cannot fuse.

"Lettre-Océan" obliges us to attempt an exceptionally complex perceptual act. We must respond to conflicting visual and verbal cues. Furthermore, the iconic visual cues refer insistently to a real visible world of postcards and tall towers and the like, whereas the verbal cues remain in a more disembodied world of thoughts and conventional signs. We are poorly prepared for such a juggling act.

Yet it is here that I believe one becomes aware of the poem's essential beat. Finding that we are hard put to process such an overload, we discover in the poem's overall deployment, as well as in a few visual details, the means to register its complexity. Ultimately, as a whole and in its parts, the poem depicts *vibration*—alternation between two different codes, waves of all sorts, a flickering shift (like an enlarged optical illusion) between the contingent situation

of separated brothers and the supremacy of the beholding conscious-ness. Vibration, then, implies the way in which we can take in the work: not a steady stare but a relaxed scanning. Like a radio tower the poem emits a pulse that alerts the reader on how to receive and respond to its unfamiliar signals.

"The dispersion and the reconstitution of the *self*. That's the whole story." In his *Journal* Baudelaire makes this gnomic reference to a vibratory movement of consciousness itself. The opening lines of his unfinished essay, "Philosophic Art," gloss the idea: "What is pure art in the modern sense? It is to create a suggestive magic containing at the same time object and subject, the world exterior to the artist and the artist himself." "*Lettre-Océan*," a circular-linear display of verbal fragments, depicts this reciprocating movement in a verbal-optical illusion. Far from being unperformable, this hybrid work reveals its characteristic systole and diastole most convincingly in performance. By that means the reader-listener is invited to join the dance, to climb on the great Ferris wheel, and to cross the threshold of poetry as performance in images and sounds.

Apollinaire's commonplace literary device of a friendly corre-spondence between two brothers separated by an ocean descends unabashedly to the level of illustrated greeting-card art without jettisoning its ambitious freight of meanings about the shape of consciousness and the rhythm of perception. Apollinaire enjoys standing tall at the center of the poetic universe he creates, as any of us can enjoy singing in a chorus, both making music and hearing music being made all around us, feeling ourselves as both performer and listener. Secure in its eccentric format, "*Lettre-Océan*" says twice, straight out, top and bottom, in simple salutation: BONJOUR. That everyday greeting glistens at us from the page, reverberates around us in the air, incorporating all other messages, trivial and profound. BONJOUR. Have, as we say familiarly among us, a good day.

The Devil's Dance: Stravinsky's Corporal Imagination

Cleveland
October 5, 1981

Professor Lydia Glaser
Department of Music
George Washington University
Washington, D.C.

Dear Professor Glaser:

I am an aging part-time graduate student at the Cleveland
Institute of art, or (I prefer this version) a young independent
scholar-critic working in the arts. I make my living by other means.

For years I have been circling around Stravinsky, and this
summer I found your essay "Seeing and Hearing Stravinsky" in the
collection *Stravinsky Revisited*. May I send you a thirty-page article
of my own, which has grown out of a course in twentieth-century

performance arts? Your comments would be of great help to me, and I hope to submit the article for publication. I believe the subject will interest you.

Sincerely yours,

Pat Cartnell

Department of Music
George Washington University
Washington, D.C.
October 15, 1981

Dear Mr. Cartnell:

Please excuse me if I should write "Ms. Cartnell." The name Pat is ambiguous, and your letter gives no clues to help me.

I am also not clear what a course in twentieth-century performance arts might cover and what you have written about. Nevertheless, I'll try to make some comment on your article if you send it. It may be a little while before I can read it.

Sincerely yours,

Lydia Glaser

Cleveland
November 10, 1981

Dear Professor Glaser:

I'm male, Patrick. Sorry. I rarely write to strangers.

Your letter gave me pause. You sound very busy and a little dubious about reading thirty pages on an undivulged subject. I decided to drop the whole idea. Then last night I reread your article and got excited enough to change my mind again. But instead of asking you to read my article, I'll summarize my ideas as concisely as I can in this letter. And this time, as you see, I'm typing.

It's a curious situation. Since you are the principal scholar whose work I refer to and build on, you should have no trouble understanding what I want to say. At the same time, you are probably the last person I should write to, because in a way I'm attacking you. I have no competence as a trained musician or

musicologist. But I have spent a large pie-shaped piece of my free
time in the past seven or eight years listening to Stravinsky
recordings plus all local concerts, and by now I've read a good part
of what has been written by or about him. Still, I'm an amateur.
For some reason Stravinsky's work and Stravinsky's presence as an
almost monstrous mind draw me more forcefully than any other
artist—painter or writer—of this century. I'm trying to find out
why. After all, I'm supposed to be in the visual arts. It's Saturday
morning here in Cleveland and the rest of the day belongs to
you—that is, to this letter.

I admire your article because you find something all Stravinsky
scholars know perfectly well but have neglected, and you make it
obvious. The quotes cannot be dismissed. It is "not enough to hear
music . . . it must also be seen." I had forgotten the "fleeting
vision" and all the visual imagery that Stravinsky tells us inspired
the composition of *Rite of Spring*. It's wonderful the way you
demonstrate how S. participated actively with Nijinsky to work out
the original choreography for the *Rite* along with the music. What
you say about S.'s insisting on placing the musicians on stage for
L'Histoire du soldat and *Les Noces* could be developed a lot more.
That's the aspect that caught my attention in connection with
performance arts. How could you leave out the wonderful quote
from the *Autobiography*? "I wanted all my instrumental apparatus
to be visible side by side with the actors or dancers, making it, so
to speak, a participant in the whole theatrical action."
And there's the "Eye Music" passage from *Themes and Episodes*
that you must know. "To see Balanchine's choreography of the
Movements is to hear the music with one's eyes; and this visual
hearing has been a greater revelation to me, I think, than to anyone
else." I even have two more examples for you—the
importance of two-dimensional Japanese prints for the conception
of the *Japanese Lyrics* of 1912, and S. noting choreographic ideas
in the manuscript score while composing *Agon*. The visual
inspiration was often there, and you make us sit up and take notice
of it.

Of course, someone could question what the role of the visual
was—is—in vocal works like *Pribaoutki, Renard, Symphony of
Psalms, Cantata*. And there's something constricting, incomplete,
in any attempt to concentrate the appeal of stage works on the
visual. The visual image distances and locates our experience in

space outside us, whereas the auditory distributes it throughout space and carries it deep into our listening mind. Do I make myself clear? Still, Stravinsky must have had an alert eye, maybe a compulsive eye. Now I'm going to try to go beyond you, thanks in great part to what you've shown me.

One of my sources is *Stravinsky, in Pictures and Documents*, a wonderful, undigested mishmash of information on the man and his music. I finally had to buy a copy. After this free-form performance, I'll wager Craft never tries a sit-down biography. He doesn't have to. But I'm getting off the subject.

I'll begin *ad hominem*. Look at the descriptions of S. playing the piano, not in concert, but in rehearsal or in private. The written record goes back at least to *Firebird*. In her little memoir on Stravinsky, Karsavina recalls how he played her part for her over and over before rehearsals: "His body seemed to vibrate with his own rhythm; punctuating staccatos with his head, he made the pattern of his music forcibly clear to me, more so than the counting of bars would have done. Rhythm lived in, at times took possession of his body." He played a two-hand reduction of *Rite* for Diaghilev and Monteux in 1912, a session that Monteux later described: "Before he got very far, I was convinced he was raving mad . . . The very walls resounded as Stravinsky pounded away, occasionally stamping his feet and jumping up and down . . ." (*SPD*, p. 87). He played with equal vehemence at early rehearsals, according to Marie Rambert (*SPD*, p. 90): "Hearing the way his music was being played, [Stravinsky] blazed up, pushed aside the fat German pianist . . . and proceeded to play twice as fast as we had been doing and twice as fast as we could possibly dance. He stamped his feet on the floor and banged his fist on the piano and sang and shouted." In 1914 Diaghilev took the composer to a meeting in Milan of Futurist and Bruitist musicians. According to the sculptor Cangiullo, S. felt far from left out: He "leaped from the divan like an exploding bedspring, with a whistle of overjoyed excitement. At the same time, a Rustler rustled . . . The frenetic composer hurled himself on the piano in an attempt to find that . . . sound" (*SPD*, p. 657). Elliott Carter's version of S.'s "electricity-filled piano playing" in the thirties catches the same effects barely tempered by twenty years. Carter speaks of "the very telling quality of attack he gave to piano notes," of "intensity" and "extraordinary dynamism" even in the soft passages (*SPD*, p. 215). There must be scores of such descriptions.

Stravinsky was a man of enormous physical energy. Do you
know the 1924 photograph of him (*SPD*, p. 298) doing his daily
set of Swedish-German gymnastics? A musical psychoarchaeologist
could reconstruct all his music from that one image. He was always
in training, acutely aware of his physical condition. It may be the
natural attitude toward life of a midget who had become a
conductor and a star. Ansermet says somewhere that S.'s morning
calisthenics could become highly competitive and relates how
the tiny composer tried to wrestle him to the floor when they went
on tour together. Ansermet was a big man.

I find it much harder to locate believable accounts of S.'s physical
behavior while conducting. Apparently in public performance his
movements were fairly restrained and concentrated. Some
observers considered him mechanical. Toscanini was shocked to
hear him counting aloud (White, p. 518). But the best firsthand
accounts of his rehearsals—by Paul Rosenfeld (*SPD*, p. 255),
a Vienna journalist (*SPD*, p. 302), Emile Vuillermoz (*SPD*,
p. 310), and a Belgian critic in 1924 (*SPD*, p. 325)—all emphasize
the nervous imperious dynamism of his movements. It's incredible.
They all use exactly the same verb for him: *dance*. Rosenfeld's
famous article-interview is still one of the best: "He commenced
singing the words in Russian, even danced a little in his pink sweater
up on the conductor's stand . . . His arms at all times mimed the
rhythmic starts and jerks, till one could actually perceive where
his music came from" (*SPD*, p. 255). That says it all. S. once
ridiculed an overly demonstrative conductor by comparing the
performance to "a belly dance seen from behind" (*SPD*, p. 382).
In his own case I have a hunch he tried to make the physical
postures of conducting recapitulate and even extend the process
of composition. Here's a 1930 interview: "I have the impression
that only in conducting his own works does a composer feel
the fullest blossoming of his temperament. To realize the
composition that one has conceived gives an incomparable
pleasure" (*SPD*, p. 629). Those are not the words of a man who
conducted only for the fee and the glory. I believe his statement—
above all for his own case.

Sorry. This summary of my article is coming out all quotes. They're
the best part. You must see what I'm driving at. I find it even more
obvious than your demonstration about the visual. S. composed
with his whole body, not just with his enormous ears and his sharp
eyes. (He even said ear and eye get in each other's way. Remember?

—*SPD*, p. 347). This son of a famous opera singer loved amateur theatricals before he loved the piano. In 1924 he improved on Ramuz's description of him from "born conductor" to "born performer" (*interprète né*) (Letter 1051). I think it's essential to understand that S.'s music emanates from a whole dancing body, his own. Look at the dancing bear in *Petrushka*. In one performance I saw the bear lead the whole ensemble. A metaphor for Stravinsky conducting.

Now, I haven't really parted company with you. You just didn't go far enough with your visual thesis. The corporal is right there in the same passages you quote, but you have to read on. In the *Autobiography* you quote the section where S. speaks about the "vision" and the "picture" that seemed to provide the theme of *Rite*. A few pages later he refers to deciding with Roerich on the "visual embodiment" of the episodes. You underline *visual*; I underline *body*. He's correcting himself. And here's your other key quotation: "I have always had a horror of listening to music with my eyes shut, with nothing for them to do" (*Auto.*, p. 72). But you stopped too soon! In the very next sentence he corrects himself again: "The sight of the gestures and movements of the various parts of the body producing the music is fundamentally necessary if it is to be grasped in its fullness" (*Auto.*, p. 72). Body again, and always, no? In the *Poetics*, where he talks about "seeing" music, he makes it clear that he is referring to the physical performance, the gestures of dancers and instrumentalists.

It's frustrating to discover that S. has said it all. He talked too much and too well for our own good. There's nothing left to do but collate. He wrote my conclusion, and you must know the passage as well as I do. A month after the *Petrushka* première, in mid-composition of *Rite*, he already foresaw his whole career and described it in a letter to Rimsky-Korsakov's son. I consider this S.'s only true manifesto. Every word counts. "I believe that if some Michelangelo were alive today—so it occurred to me, looking at the frescoes in the Sistine Chapel—the only thing that his genius would admit and recognize is choreography ... Not until I had worked in choreography did I realize this, as well as the necessity and value of what I am doing."

Amen.

Sincerely yours,

Patrick Cartnell

Washington
November 20, 1981

Dear Mr. Cartnell:

Thank you for sending a lively six-page letter instead of a thirty-page article. I read it straight through standing by the mailboxes and have just read it again, carefully. Your knowledge of Stravinsky impresses me very much. I hope you can continue your work and your concern with performance, the role of the body, and their relation to music. There is a sentence near the beginning of his *Poetics* in which Stravinsky defines music as ordered sound that comes from "the integral man." Isn't that what you're saying?

You begin your letter by asking for my comments. The evidence you collect makes a very strong case for the physical and corporal side of his inspiration. Possibly it was stronger than the visual side. I never saw or met the composer, but I feel sure you're right about his intense physical presence. People have described him as everything from a leprechaun to a champion cyclist.

But something in all this makes me very uneasy. I'm at fault as much as you and I may be partly to blame. Both of us rely almost entirely on written sources by and about Stravinsky, and pay little attention to the music itself. We mention a few titles, but neither of us analyzes any musical examples. I talk about Stravinsky's collaborations with great visual artists like Benois and Bakst and Goncharova and Picasso and Larionov. You have hunted through *Stravinsky, in Pictures and Documents* and other books with infinite patience and found lots of quotes. But it all seems speculative, bookish, the thoughts of someone who came to the music through the life and writings. Do you know Stravinsky's music as well as you know the books?

You were right to think that I might be your best and your worst reader. Your article is probably worth publishing, if simply because it collects most of the extrinsic evidence on the physicality of Stravinsky's music. That's helpful, but also superficial and inadequate. The intrinsic evidence would mean much more. Can you show that Stravinsky's work is consistently more corporal, of the whole body, than Debussy's or Prokofiev's? Schoenberg's or Bartók's? I'll go a long way with you, but there's one aspect of Stravinsky's music that remains essentially visual for me. That is his tendency to compose without transitions, by abrupt juxtapositions and interruptions. Stravinsky himself refers to "cutting off the fugue with a pair of scissors" (Nabokov in Corle, p. 146). In my

article I discuss this abruptness in relation to Cubism and
Primitivism in France just before World War I. Within careful
limits it makes sense to refer to *Rite* and *L'Histoire du soldat*
and *Les Noces* and even many late compositions as "Cubist."
Motifs are jammed together and overlaid in a fashion I find
visual, and the driving pulse of most of the music emphasizes the
effect.

Perhaps you will want to answer some of my criticisms. I might
as well say that yours is the only challenging response I have had
to my article. Most people said nice things and went about their
business. My work doesn't threaten anyone, I guess. Thank
you again, in any case, for writing. I'm afraid I've offered you very
little useful comment.

Sincerely yours,

Lydia Glaser

Cleveland
December 2, 1981

Dear Ms. Glaser:

The bookish nature of the letter I wrote you cannot be blamed
on the evil influence of your article. I'm a dilettante who can barely
read music and therefore I didn't dare attempt any musical
discussions. But the way I first grasped the corporal nature of
Stravinsky's music was by listening to it over and over again. The
reading came afterward, in order to *transformer ma volupté en
connaissance*. (In art history we have to know our Baudelaire. I
suppose you must know this quote from his essay on Wagner.)
So now I'll have to start all over again from the beginning and
convince you that I'm *hearing* something in S. that's really there in
the played notes.

I'll pick a piece I know well, *L'Histoire du soldat*. Let's forget
what people have said about it—S. himself, Ramuz, Ansermet,
and everyone else—even though the original itinerant theater
conception is marvelous, and the way it grew. The first three
measures say everything. A brisk cornet call to launch us on a
regular walking pulse that will keep coming back. The phrasing
and the instrumentation in those measures sound both military
and circusy—like fairgrounds music. It involves a very odd sideslip

into the key of G. How would you analyze it? I can't. I hear it as
a physical summons to a performance, to start walking, to find some
spring and verve in our bodies. Nothing visual here, rather two
insistent and coherent lines directed more toward provoking
bodily movement than toward establishing a tonal center. There's
a section in Adorno's book where he works himself up to assassinate
"the schizoid dispersion of aesthetic functions" and the
"hebephrenia" of *L'Histoire du soldat*. What does all that mean?
But Adorno still had a sensibility behind his crass prejudices and
talks about "passages in which the 'melody' is bypassed, in order
that it might appear in the actual leading voice—in bodily
movement on the stage." That's far from stupid. S.
composes music here to galvanize everyone into action.

Or take the music that forms a complete contrast in the same
piece, the two chorales near the end. To my ear it's the most
successful counterpoint S. ever wrote, with fermatas held until
you think it's all finished and it hasn't. The slowly wheeling
harmonies won't allow the tension to drop. They create the feeling
of plenitude, of life completely realized, of an almost superhuman
condition. To me it's a sustained instrumental gesture, yes, a
chorale for all our voices rejoicing with arms outstretched and
necks straining. Personal associations? Perhaps. But I don't think
so. You cannot hear the Great Chorale without experiencing a vast
expansion of physical space—visual perhaps, but above all corporal.
Of course he breaks it off with the devil's dance.

And there's the crux. Do you know about the ending? It's in
Ramuz's letters. An actor and a dancer alternated in the devil's
role. In rehearsal neither one could begin to produce the wild jerky
energetic movements S. and Ramuz wanted for the last Triumphal
March. Solution? Stravinsky would do it himself! Stravinsky on
stage as devil dancing to his own music! Ramuz agreed
enthusiastically, asked others to encourage the composer, and
wrote to S. urgently: "Dance that *last scene yourself*; you'll live
it rhythmically and you'll save everything." Before conducting
offered him an appropriate (and lucrative) outlet, S. showed
signs of a Molière syndrome, the desire to write and direct
performances in which he would himself perform himself. That
little tidbit about S. almost dancing the devil's role in *L'Histoire du
soldat* sums up his entire corporal genius.

Can you hear the *Octet* without sensing that S. was thinking
not so much in terms of sounds as in terms of bodily movement

suggested by, reached through those sounds? I haven't seen
Jerome Robbins's choreography; I'm told it's wonderfully inventive
and witty. After a while, almost everything S. wrote affects me that
way—I don't mean foot-tapping or some kind of routine body
language, such as ballet can become at its worst. S. composed to
reveal the expressive resources of the body. Take the opening of
Symphonies for Wind Instruments. A friend of mine calls it
"eerie lyric." Yes. But I begin to hear it as another summons, like
L'Histoire, to action—the torso twisted, legs slowly tensing and
releasing, a contortion, but not painful. The end of *Les Noces*
takes the opposite position. Those slow-flowing measures of counted
silence punctuated by chimed beats spaced out to the limits of
our capacity for time perception—Stravinsky wrote an extended,
shimmering, precise, perpetual-motion device that leads us out
finally onto a plateau of pure silence. He would call it "ontological
time." The piece must be heard almost backward, I think, as one
prolonged, convoluted cadence announced at 58 or at least by
80 and going on and on like a hundredfold amen. The insistent
physicality of the music carries us to an ultimate repose, quietness
and silence as forms of expression, calm after the storm.

I just reread what I've written. I shouldn't send it. Why do you
put up with my rantings? Possibly I know the answer. I got a
surprise when I looked you up in *Who's Who* and didn't find you.
I had to go to the *Directory of American Scholars,* latest edition,
to find out that you're younger than I am! I first imagined you
as a white-haired senior scholar with the authority and appearance
of Nadia Boulanger. In the *Directory* there's no photograph beside
your short entry to fill the newly created void.

Cordially,

Patrick Cartnell

Washington
December 11, 1981

Dear Mr. Cartnell:

White hair, you thought! Sorry to disappoint you. I'm not
flattered, but I did laugh. I'm an assistant professor. Now you
know the truth. Are you angling for a photograph?

This will be short. I have several impossibly busy weeks ahead of me. I want to answer you before the sky falls in. Three points:

1. You're right, of course. Stravinsky was a dance musician with a choreographic imagination. But not exclusively. You know about his near-*ménage à trois* in the twenties and thirties. Musically he kept a *ménage à trente-six*, or maybe *à 1001*. Take *L'Histoire*. It's almost all dances, some of his most inventive. But what holds it together? The chorale, not for the reasons you suggest, however. All the driving ragtime and tango and marching frame the near-immobility of the Great Chorale, which in turn frames and guards the secret place, the tabernacle of the composition that keeps its holy emblem. Have you heard the Oubradous recording with French actors reading the script? At 3 in the Chorale after that incredibly open and beautiful voice leading (it's really not counterpoint), the six instruments hold a fermata on a D chord with the seventh doubled, and Jean Marchat's unhurried, worldly-wise voice says the words. They have to be in French.

> *Il ne faut pas ajouter à ce qu'on a ce qu'on avait.*
> *On ne peut pas être à la fois qui on est et qui on était.*
> *Il faut savoir choisir.*
> *On n'a pas le droit de tout avoir. C'est défendu.*
> *Un bonheur c'est tout le bonheur, deux, c'est comme*
> * s'ils n'existaient plus.*

> You cannot add to what you now have what you once had.
> You cannot be both what you are and what you were.
> You must know how to choose.
> No one has the right to have everything. That's forbidden.
> One happiness is all happiness. Two—that cancels everything out.

As I see it, hear it, Stravinsky wrote *L'Histoire* to house those words. They deserve it. He felt them deeply, personally. The Great Chorale corresponds to the pure time sequence at the end of *Les Noces*.

Still, neither of us can generalize from these examples. S. had no one overriding preoccupation. The quotations get confusing. "What survives every change of system is melody." At other times his chief concern does seem to be note-against-note counterpoint. A critic would not be wrong to claim that no twentieth-century composer has been so single-mindedly devoted to extending the rhythmic resources of our musical language. Or that S. composed most consistently and brilliantly on syllables, words reduced to

nonsense noises in five languages. You say the body and choreography. Yes—and more.

2. There's something else that troubles me about your case. The only works you refer to belong to the period before 1940, before the *Rake,* before S. began trying out serial techniques. I don't believe you could do so well looking for the corporal aspects of the *Cantata,* or even of the specifically dance pieces like *Movements* and *The Flood.* In other words, isn't your hypothesis an indirect way of attaching a higher value to his pre-serial works? This means slighting some of his greatest music. Your idea about the importance of the physical is enlightening but partial.

3. I think that the corporal aspect of S.'s pre-serial music that you find so appealing has to do with his stretching and distorting the pulse, and doing it in such a way as to emphasize its underlying presence. It's no accident that your favorite *L'Histoire* ends with battering percussion, the pitch bled out, and the pulse all powerful. It seems, if I follow your argument, that you are equating lack of strong rhythmic feel with cerebral music. How does that follow?

One of the reasons I'm so busy for the rest of the month is that I'm organizing a conference here for next year to honor Stravinsky's centenary. Most of the old-timers and vested scholars and official companions have been very sweet to me and say they'll come. It's really a miracle. I also want to bring in some new blood. Would you do a brief presentation on S. and performance for one of the panels? I suppose I should know more about you before inviting you. Well, now that I've done it, please send me a *curriculum vitae.* I don't need a photograph. After this conference I will have white hair.

<div style="text-align:right">Yours,</div>

<div style="text-align:right">Lydia Glaser</div>

<div style="text-align:right">Cleveland
January 4, 1982</div>

Dear Lydia Glaser:

You have my full permission to retract the invitation to your conference before I accept it. The enclosed *curriculum vitae,* drawn up for your sole benefit, will inform you that I have no advanced

degrees, have dabbled in painting, scenery design, and art history, and remain unattached at age thirty-five. It will not tell you that I'm an airline steward and work alternate weeks. Not a bad living. In other words, no credentials, no publications, no connections— except this exchange of letters with you. The article on Stravinsky I originally wrote you about is really a project, the figment of a dallying imagination. It is coming into being through these letters. Conclusion: part impostor.

A few final remarks. ("Final" for reasons I'll explain in a moment.) Yesterday I reread by "chance" Craft's journal notes for March 31, 1948 (*SPD*, p. 399). He contrasts a physically disheveled Auden little interested in his meal with the slightly dandified S. savoring his Chateaubriand and his glass of Château Margaux. Then this sentence: "While with Auden the senses seemed to be of negligible importance, with Stravinsky the affective faculties were virtual instruments of thought." May I rest my case? The contrast is too neat, probably. But it's another version of what I've been trying to say about the physicality, the corporal side of S.'s music. For me his pre-serial compositions—this will sound pretentious and literary, but here goes—his pre-serial compositions accomplish a reassociation of sensibility, favor the thinking body, the choreographic imagination, have the order and sense of limits that allow reason and feeling to fuse. T. S. Eliot kept talking about this fusion, and our lack of it today. He deplored our "dissociation of sensibility." In poetry, Eliot said, we have come to want all feeling and suggestiveness, and no conceptual thought. Hasn't the opposite happened in music? It's becoming more cerebral than corporal. Is that a prejudiced opinion? I know that there are neoprimitive composers around like Crumb and Berio. But even a popular composer like Glass, with all his endless repetitions and variations, strikes me as basically cerebral. He's working out a concept of music, an extended set of intellectual patterns, not giving us the discoveries of a wonderfully sensitive ear or body. Perhaps the quality of S.'s music that unifies the intellectual and the sensuous exists also in his later compositions and I just don't hear it. I don't dislike those works, I just find them wanting or remote. Will you take me in hand?

Tomorrow I go off for a two-week vacation that will, if my plans work out, take me as far as India and Ceylon. It's my reward for working steadily through the holidays. As a steward with some

seniority, I have great travel privileges. On the way back via Egypt,
Paris, and Dulles, may I take you out to dinner on Thursday,
January 21? Well, this letter won't reach you before I leave. I'll
send it anyway and call you tonight for an answer. At least I'll hear
the sound of your voice. A musician's photograph.

<div align="right">A bientôt?</div>

<div align="right">Patrick</div>

P.S. Do you like to dance?

The human imagination has produced nothing that
is not true.

—Nerval, *Aurélia*

René Magritte
Meets the (Irish) Bull

Secret agent in dark overcoat and derby, René Magritte presents
credentials as a wallpaper painter, speculative semanticist, and
frame-up artist. His project has truly pataphysical dimensions. He
takes the entire Western tradition of optical likeness, perfected
through centuries of cumulative research, and applies it scrupulously
to subvert the usual paths of thought. Every separate item in his
paintings looks reassuringly like something we know. No painting
as a whole looks like anything we ever saw or conceived before
Magritte concocted it.

The cherubic Belgian who produces these cool enigmas appears
in photographs painting with palette and easel in a corner of the
dining room of his suburban house in Brussels. His dress, his style,
everything visible seems to conform to a secure tradition of the

Netherlands painter in a bourgeois setting. He tells us himself that one of the rewards of painting is that it bestows a particularly pleasurable form of ownership: you can possess anything you can paint. The spell of painting fell upon him very young.

> In my childhood I used to play with a little girl in the old crumbling cemetery of an out-of-the-way provincial town where I always spent my vacations. We would open the iron grates and go down into the underground passageways. Climbing back up to the light one day I happened upon a painter from the capital; amid those scattered dead leaves and broken stone columns, he seemed to me to be up to something magical. ["Lifeline"]

During World War I, which he was too young to take part in, Magritte studied at the Academy in Brussels. Then came the inevitable flirtation with abstraction derived from Cubism and Futurism. The crucial revelation around 1925 sounds like a metaphysical crisis of perception.

> I grew able to look at a landscape as though it were but a curtain hanging in front of me. I had become skeptical of the dimension in depth of a countryside scene, of the remoteness of the line of the horizon. ["Lifeline"]

The magic of the first encounter with painting now revealed an underside of profound doubt. What exists out there? The appearance of things can turn into a curtain hiding from us their true state. Conventionalized into a movable prop or flat, the curtain recurs like a refrain in Magritte's paintings. It hides and reveals according to how you look at it. "Each thing we see," Magritte said in a radio interview, "hides something else we want to see." The curtain, in fact, furnishes the subject of one of the most striking of his late paintings. In front of and almost blocking out a window formally draped in velvet stand four large overlapping panels. Each shows a fragment of a recognizable scene: the dark green foliage of a forest, the stone façade with windows of an ordinary building, bright red flames, and, in the foreground, a clear blue sky with clouds. One recognizes that each panel is shaped in the form of a single freestanding curtain. The splendid play of color, texture, and depth among the panels develops into a kind of lyric feast and earns every letter of its sensuous title, *Tastes and Colors* (from the

proverb "Tastes and colors are not worth discussing"). Then, suddenly, the surface splendor surrenders to three mauve-colored dead spots in the composition just where the curtains are pulled back slightly. And one is drawn fatally into whatever mystery these brilliant curtains open onto or into, three virtual holes in the canvas and in the universe itself. Magritte's revelation of landscape as a partially drawn curtain implies a great skepticism about recognizing and labeling anything at all.

The same autobiographical note, "Lifeline," describes the third stage of Magritte's encounter with the higher powers of painting. After the magic, after the doubts, there came

> an intolerable interval of terror I went through in a working-class Brussels beer hall: I found the door moldings endowed with a mysterious life and I remained a long time in contact with their reality. A feeling bordering upon terror was the point of departure for a will to action upon the real, for a transformation of life itself.

He reacted to this trauma by settling down to a forty-year career of unrelenting work based on a paradox. His traditional, figurative style of painting helped keep the terrors at bay and, at the same time, permitted him to depict convincingly his most uncanny transformations of the elementary arrangements of things. As a result, his best works generate a strong current alternating between apprehension and amusement.

When we perceive something and at the same time become aware of our act of perception, two things can happen: we can experience mental vertigo facing the infinite regress of thought, or we can produce an utterance, a word to designate the thing and halt the feedback of reflection. Years ago, Magritte painted a scrupulously naturalistic picture to exact scale of a piece of Brie cheese, framed it, and exhibited it under a glass cover with the title: *This is a piece of cheese.* Magritte understood that the word lends us security, gives us a crutch. He can, therefore, yank it out at will from under our unsuspecting minds. Before Wittgenstein earned his reputation as the great sophist of language, before modern semantics had come into its own, Magritte was practicing his own lay analysis of language in the pages of *La Révolution surrealiste.* He called his illustrated essay "Words and Images" (1929). The car-

toons animate the slippery relations between objects, images, words —and by implication, the mind which entertains them. For instance:

An object is not so stuck on its name that you can't find it another.

An object leads one to believe there is something behind it.

Everything leads one to believe that there is little relation between an object and what represents it.

Hold on tight. We walk on the edge of the precipice. As Mallarmé knew, to name anything is to obliterate it, even more effectively than by looking straight at it. Thus the tags, the names we attach to things, may save us from the vertigo of reflexive perception, but they lead us into other dangers. Magritte's own titles, the labels he dreams up (with the help of friends, he insists, after he has finished his paintings), do not tell us directly what the painting is about. An entirely different principle now comes into play that revalorizes language in a series of sly word paintings—everyday objects assigned names that are in error by dictionary convention. Occasionally a correct label sneaks in and causes a kind of semantic stall or tilt. In the famous composition *Wind and Song*, a painted pipe is labeled *This is not a pipe*. Traditional rhetoric has a neat trick called preterition: you say what you are not going to say, thus saying it. There is an exasperating device called negative invocation: someone instructs you, "Do not think of a large body of water." Michel Foucault wrote eighty pages of philosophical speculation on the conundrum of the pipe.

But while Magritte was scrambling the semantic dictionary, he was assembling another one with his left hand. We barely noticed. Only in a few cases did he divulge its existence. *The Promenades of Euclid*, which belongs to the painting-within-a-painting sequence, also records a kind of resemblance we are systematically trained to overlook because of depth perception. From a high window a pointed turret nearby "looks like" a broad boulevard next to it if we can juggle vanishing-point perspective and flat canvas. But why bother? Because they rhyme—visually.*

We begin to see how much in Magritte's painting turns on rhyme. Visual rhyme to start with. Levitating boulders rhyme with

* This visual rhyme was first noticed by a poet, Apollinaire, whose poem "Windows," inspired by a Delaunay painting, contains the line "Streets are towers."

LES MOTS ET LES IMAGES

Un objet ne tient pas tellement à son nom qu'on ne puisse lui en trouver un autre qui lui convienne mieux :

Il y a des objets qui se passent de nom :

Un mot ne sert parfois qu'à se désigner soi-même :

Un objet rencontre son image, un objet rencontre son nom. Il arrive que l'image et le nom de cet objet se rencontrent :

Parfois le nom d'un objet tient lieu d'une image :

Un mot peut prendre la place d'un objet dans la réalité :

Une image peut prendre la place d'un mot dans une proposition :

Un objet fait supposer qu'il y en a d'autres derrière lui :

Tout tend à faire penser qu'il y a peu de relation entre un objet et ce qui le représente :

Les mots qui servent à désigner deux objets différents ne montrent pas ce qui peut séparer ces objets l'un de l'autre :

Dans un tableau, les mots sont de la même substance que les images :

On voit autrement les images et les mots dans un tableau :

From *La Révolution Surréaliste*, December 1929. © ADAGP, Paris, 1984

clouds, and grisly anatomical toes rhyme with the toes of boots (*The Red Model*). Here is the place to fit the obsessive Surrealist masterpiece Magritte calls *Rape*; it violates the steadiness of our vision. In this rhyming dictionary of images, face rhymes with female torso.

Furthermore, the term "rhyme" suggests more than resemblance, because it invokes a domain we tend to exclude from painting: *sound*. The elementary act of framing, of paying attention, evokes the spoken word. Look. What do you call this? Think of a . . . We cannot avoid such responses. In 1962 Magritte painted a boulder on a beach and, hovering over it, a cloud identical in size and shape. The title: *The Origins of Language*. Paul Nougé, an artist and old friend of Magritte's, has written one of the most perceptive commentaries of his work. Nougé reports what we have suspected all along: the *word* serves as a source of Magritte's poetic invention. Nougé refers explicitly to "the secret of rhyme."

Take the revealing series of eight drawings that trace the visual-verbal genesis of *A Bit of the Soul of Bandits* (1960). The final painting shows a violin standing erect on a wing collar. If you read these desultory doodlings in French, here's what you find: *violon, vipère, veste, vase, vigne*. And in half of them Magritte toys with ideas he finally discarded: he rhymes violin, which in French has a *queue* (tailpiece; also prick) with *queue* (pigtail) as well as with *noeud* (knot) and *noeud papillon* (bow tie). He sustains a running short-circuit of puns between sound and image.

And the fun has only begun. Look up *violon* in a French dictionary: here's the page in the 1950 Larousse; it may have been at Magritte's elbow. The name of every labeled part is highly suggestive: *crosse* (scroll; butt), *chevilles* (pegs; ankles), *sillet* (nut), *touche* (fingerboard), *chevalet* (bridge; easel; rack), *âme* (sound post; soul; bore), *table* (sounding board), *bouton* (tailpin; nipple), *ouies* (sound-holes; gills), *éclisses* (ribs). And you must not miss the third meaning for *violon*: "A kind of prison adjacent to a guard room or police station." It adds up to a multiple painted pun in French, a potpourri of words and images. It is very contrived—and very handsome as finally executed in flawless oils. The title, I would insist, is an essential element of the composition.

At its best, Magritte's painting arises out of two reciprocating acts basic to human consciousness or "thinking"; they are also prone to violent distortions. First, he frames: he removes common objects

VIOLETTE (*lèt'*) n. f. (lat. *viola*). Genre de plantes des régions tempérées, à fleurs violettes très odorantes : *la violette est l'emblème de la modestie. Bois de violette*, nom ancien du palissandre.

VIOLEUR, EUSE (*leûz'*) n. *Fam.* Celui, celle qui viole.

VIOLIER (*lié*) n. m. Un des noms de la giroflée.

VIOLINE n. f. Alcali extrait des fleurs de la violette colorante. Adj. D'une couleur violet pourpre.

VIOLISTE (*list'*) n. m. Joueur de viole.

Violettes.

VIOLON n. m. (ital. *violone*). Instrument de musique à quatre cordes en boyau de mouton, accordées de quinte en quinte, qu'on frotte avec un archet : *Stradivarius a construit d'admirables violons.* Celui qui en joue. *Payer les violons*, les frais. Espèce de prison contiguë à un corps de garde ou à un poste de police. — Le *violon* a été enfanté par la viole; son étendue est de trois octaves et une sixte. Il est formé de deux tables réunies par des éclisses; celle de dessous et les éclisses sont en hêtre; celle de dessus en sapin ou en cèdre. Les parties du violon sont : la *crosse* ou *volute* (A); les *chevilles* (B), qui servent à tendre les cordes; le *sillet* (C); la *touche* (D), où l'on touche les cordes; le *chevalet* (E), qui supporte les cordes et que soutient l'*âme*, entre les deux *tables* (H); la *queue* (F); le *bouton* (G); les *ouïes* (I); les *éclisses* (J); le *manche* (K); la première corde, *mi* (1); la deuxième corde, *la* (2); la troisième corde, *ré* (3); la quatrième corde, *sol* (4).

Violon.

VIOLONCELLE (*sèl'*) n. m. (ital. *violoncello*). Instrument à quatre cordes, comme le violon, mais beaucoup plus grand. Artiste qui joue de cet instrument. (On dit aussi dans ce sens VIOLONCELLISTE.) — Le *violoncelle* sert de basse; ses quatre cordes sont accordées de quinte en quinte en montant à partir du *do* grave. Son étendue dépasse trois octaves. (V. la planche MUSIQUE.)

VIOLONCELLISTE (*list'*) n. m. Musicien qui joue du violoncelle. (On dit aussi VIOLONCELLE.)

VIOLONEUR ou VIOLONEUX (*neû*) n. m. Mauvais joueur de violon; ménétrier de campagne.

VIOLONISTE n. Personne qui joue du violon.

VIORNE n. f. (lat. *viburnum*), Arbrisseau de nos pays, de la famille des caprifoliacées.

VIPÈRE n. f. (lat. *vipera*). Genre de reptiles ophidiens venimeux. *Vipère fer de lance*, trigonocéphale. *Fig.* Personne très méchante. *Langue de vipère*, personne très médisante. — La *vipère*, qui se distingue de la couleuvre surtout par sa tête nettement triangulaire, affectionne les

Vipères : 1. Aspic; 2. Dite « péliade »; 3. Tête de vipérine; 4. Tête d'aspic; 5. Tête d'aspic montrant la glande à venin.

terrains pierreux et ensoleillés. Sa morsure, surtout par les temps chauds de l'été, est dangereuse, et peut être mortelle chez les enfants et même chez l'homme.

(left) Page from *Dictionnaire Larousse* (1950)
(right) Magritte, drawings for *Un peu de l'âme des bandits* (1960). Collection of Harry Torczyner, Lake Mohegan, N.Y. © ADAGP, Paris, 1984

from their usual settings, not to subdue them, but to set them free. Then, consulting his dictionary—a rhyming dictionary, remember— he names them afresh, explicitly by enigmatic titles, or implicitly by visual punning and rhyming. Magritte's subject, what he painted for forty years, accumulates like a new and unsettling atmosphere around the objects he paints and the colors he confers on them and the clarity with which he consecrates that mystery. His subject is a state of mind, an intellectual uneasiness such as we feel when a remotely familiar but unrecognized person confronts us: "Do you remember me? I'm sure you don't know who I am . . ." The challenge is the more disturbing when it comes from a strongly attractive person or painting, like *Personal Values* (1952). Your whole body participates in the act of looking through that bottle-green wineglass at a mirror reflecting a sky visible through the transparent walls—or painted on them. What is the difference? My first reaction in front of this handsome yard of painted cloth, with its third dimension set at infinity, is to mutter Hopkins's line: "Glory be to God for dappled things." After a longer look, this assemblage of floating, outsized objects strikes me as both comforting and unsettling. It is as if Magritte had painted one of those cozy little elevator-cabins in space that Einstein dreamed up for his "thought experiments" in relativity. It contains only the most practical objects of everyday life. Every one of these objects lends itself to an *explication de texte* that may lead anywhere. On top of the *armoire* (armorial and clothes press) lies a *pinceau* (shaving brush, paintbrush, pencil of light) which alliterates with the *peigne* nearby. *Peigne* shares the brush's double function as toilet article and painter's tool—comb and multiple brush for imitating wood grain. *Pinceau* rhymes with *pain de savon*, thus turning soap into bread to go with the absent wine in the green glass—*verre vert*. The floor's tidy geometric perspective and the cumulus clouds in a blue sky—this is part of Magritte's signature and can be traced to de Chirico. We know already about the window and the double set of curtains around it, and the fact that the only undefined area in the painting lies exactly there in the shape created where the curtain is pulled back. In color, in meaning, in depth, that patch generates and jeopardizes the whole composition. Overhead, the molding begins to crack and crawl, as it did in the Brussels beer hall. A match instead of a fireplace. A bed, but not really to tell us anything about dreams and love. A bed because it belongs with the other objects and like every one of them announces the absence-presence of the

person who dwells among them and whose values they are: a room of one's own; food and drink; personal appearance; reflection; an uneasy calm. *Personal Values* proposes a set of perplexing and droll thought experiments whose implications reach far beyond the painted appearances of things.

Magritte was clearly a literary painter. He resorted to words and sounds to devise visual motifs and usually chose titles with literary associations. That aspect of his work is illuminated in comments by two quite different writers. In a 1949 lecture in Montevideo (of which only a few notes survive), Borges listed what he considered to be the four basic devices of fantastic art:

1. The work-within-the-work (deliberately underlining the artificiality of a work of art).
2. The contamination of reality by dream or unreality (the destruction of objectivity).
3. The voyage in time (dissolution of temporality and, by extension, of causality).
4. The double (the negation of the principle of identity).

Not only are these ready-made categories with which to approach Borges's own tantalizing work, but they apply to the swelling segment of modern art and literature that invokes the fantastic. Magritte lives here, at the intersection of these four principles. Often he employs all four at once. In effect, they constitute a single principle: *infringement.* Each one amounts to a short-circuit, or a slow leak, across fundamental boundaries in human thought and behavior. Each of the four proposes a monstrous grafting: artificial onto real, sleep onto waking, elsewhere onto here-now, not-I onto I. The result is profound uneasiness. The monstrous, unstable form may die; its survival would entail a new arrangement of everything else. Among the majestically painted, curtain-shaped flats in *Tastes and Colors*, discussed at the start, the eye pauses finally over the three mauve-colored areas just where the curtains are pulled back as well as overhead. The veil of appearances gleams before us, yet its secret folds reveal . . . vacancy, nothingness, a dead vision of unbeing. The corresponding spot in *Personal Values*, a veritable "vanishing point" protected by mirror, window frame, and curtains, wears the same disquieting color. I find these two paintings as ominous as they

are beautiful. A carefully delineated patch of indistinct form and color is enough to contaminate the rest with the principle of infringement. The boundaries will not hold.

The technique Magritte uses in *Blanc Seing* (untranslatable: *Free Hand* or *Blank Check*) is a little more whimsical and brings the ontological doubts out into the open. One might explain this composition as a mosaic formed of two pictures of the same scene at different moments—a version of time travel. It could be a dream woven around the words "threading one's way through the trees." Even more pertinent is the old riddle about whether Niagara Falls makes any noise when there's nobody there to hear it. At first glance, just at the moment one registers its spatial anomalies, the painting has the effect of a visual pun, a trick to unsettle seeing and being. Magritte's fantastic scene troubles us much more than the more radical yet logical manipulations of Cubism. Is there anything left of the painting after you have spotted the idea of motionless horse and rider appearing and disappearing among the trees of an utterly stereotyped forest scene? My answer is yes. The fantastic, if we accept it as a makeshift term for the state of mind invoked by *Blanc Seing* and in *Tastes and Colors*, bestows a freedom of vision both to see and not to see, to oscillate between the outer eye which registers and the inner eye which beholds. As boldly as Velázquez's *Las Meninas*, these two paintings acknowledge our act of seeing them by displaying an inner movement, a potential shift like an optical illusion. They seem to look back at *us*. (*The Fake Mirror* depicts precisely this motif.)

Coleridge will help us even more than Borges to understand the special mental cast of Magritte's work. Coleridge wrote a long footnote for Chapter 4 of *Biographia Literaria* in which he describes a mental condition opposed to habit and compares it to the experience of an (Irish) bull.

> The bull namely consists in the bringing together two [*sic*] incompatible thoughts, with the *sensation*, but without the *sense*, of their connection. The psychological condition, or that which constitutes the possibility of this state, being such disproportionate vividness of two distant thoughts, as extinguishes or obscures the consciousness of the intermediate images or conceptions.

Coleridge supplies an example about changelings: "I was a fine child but they changed me." Artemis Ward had a Civil War bull:

"It would have been money in Jefferson Davis's pocket if he had never been born." The best bulls never go out of circulation. "At your age Mozart was dead." "No one goes to that restaurant any more. It's too crowded." An unformulated *sensation* or hunch connects the ill-assorted terms of these bulls; our *sense* or intelligence is not given enough time to catch up and correct the hidden error. The vivid but disruptive mental state provoked by a bull induces a simultaneous thwarting and acceleration of thought.

Out of this flickering state of mind Magritte made a visual-verbal fine art. The bull affirms an anomaly beyond retraction and exposes us to unexpected perspectives and reverberations. The categories, the modalities of ordinary perception and response come asunder. *Bull* applies to every Magritte painting I have discussed. His traditional painterly rendering of appearances imposes on us the *sensation* of connection among the things he paints. They appear to belong together. At the same time their obvious incompatibility, not gratuitous but somehow chosen, rigged, confounds our *sense* of order and reality. Magritte systematically depicts a vivid disproportion of thought without mediating terms, a dislocation that Coleridge termed a *bull*. It is a disciplined and mysteriously comic form of nonsense, known also to Lewis Carroll.

Stillness hangs like a spell over Magritte's compositions. Yet when we detect what they contain and convey of the incompatible and of infringement, we understand that they are ready to spring at any moment directly to the seat of our innermost thought processes.

Marcel Duchamp

Marcel Duchamp appointed himself the court jester of twentieth-century art. We have had many eccentrics, fanatics, and experimenters, but only one astute wag who understood that he could mix enigma and spoof in approximately equal proportions and be tolerated as a contraband artist. He shuttled constantly between Paris and New York; his act had two parts. Until he died in 1968 Duchamp devoted his fifty-year career to saying a prolonged, ritualized goodbye to painting—ostensibly in order to play chess. Yet he never succeeded in getting out the door. Compared to this old music-hall routine, the other part of Duchamp's act looks very sober. He described it in an interview with James Johnson Sweeney: "I was interested in ideas—not in merely visual products. I wanted to put painting once again at the service of the mind."

The consequences of Duchamp's influential defection from retinal painting to ideas and intellectual content have been varied. Genuine

talents like Magritte and Steinberg have known how to benefit from his example without following it. Pop art and particularly conceptual art have explored limited segments of Duchamp's wide domain. Neither has extended very far the essential element with which Duchamp protected himself against charges of pretentiousness: an all-pervasive sense of humor and self-irony. The life work of this chess-playing *bricoleur* adds up to an unruffled and edifying hoax. The two registered masterpieces that "hang" in the Philadelphia Museum of Art are really elaborate pretexts for preliminary drawings and written statements by the artist, and for commentary from participating critics. Everyone has been taken in, with foreknowledge and gusto.

I see Duchamp as a combination of Tolkien and Rube Goldberg: Tolkien because Duchamp spent years concocting a legendary elfland of stripping brides, liveried bachelors, cultivated dust, and ironic causality; Rube Goldberg (whose cartoons Duchamp published in 1921 in *New York Dada*) because Duchamp contrives to spoof his own preposterous engineering projects, of which he offers us detailed drawings signed and sealed as art. Yet this incorrigible prankster was no opportunistic charlatan. In 1916, jobless and virtually penniless, though far from friendless, in New York City, he turned down a yearly retainer of $10,000 from Knoedler's.

One of the best ways to find Duchamp's trail is to read *Marcel Duchamp: Appearances Stripped Bare* (1979) by the Mexican poet and diplomat, Octavio Paz. This short, vigorous book shuns the psychoanalytic speculations that weaken many of the twenty-odd existing studies and probes deeply into Duchamp's relations to Eastern and Western culture. Even Duchamp cannot escape history.

"The Castle of Purity," the first essay, opens with a consideration of Duchamp's origins and his radical yet calm responses to the modern Midas myth: "Everything that man has handled has the fatal tendency to secrete meaning." The following sixty-page description and interpretation of the *Great Glass*, or *The Bride Stripped Bare by Her Bachelors, Even* (1915–23), treats the two partially painted clear panes (and the copious written "instructions" that almost engulf them) as belonging to the ancient Western tradition of theological art conveying idea and myth. In our era, however, the only powerful idea at hand according to Paz is the antimyth of criticism; Duchamp employs it ironically. Therefore, the meaning of the *Bride* resides in complex allusions to absence (or multiplicity)

of meaning. Next to this intellectual complexity, Duchamp's ready-mades seem simpleminded. In the original cases of *Bicycle Wheel* and *Bottle Rack* Duchamp transformed an ordinary object into art either by mounting it or by signing it. Paz sees ready-mades as a strategy for avoiding a "double trap": fetishism of the work of art and idolatry of the artist. I believe he is right about the anti-art intent of these aesthetic gestures; yet in practice Duchamp's works are prized by museums and collectors, and his name appears prominently in writings on the history of art and artists. The real trap lodges in Duchamp's annoying question (not mentioned by Paz), "Can one produce works that are not works of art?" He tried; we wouldn't allow it.

Paz's second essay, "Water Writes Always in Plural," concentrates on the major assemblage Duchamp was secretly hatching in his last years. It is now cleverly displayed—or hidden—in the Philadelphia Museum of Art. An uninitiated visitor could miss the empty side room with antique wooden doors and two unmarked peepholes. *Given: 1. The Waterfall, 2. The Illuminating Gas* appears to solve the enigma of the *Bride* by showing to the Peeping Tom spectator a naked woman sprawled provocatively in a mock-up landscape. In a stunning exegetic performance Paz connects *Given* to the myth of Diana and Actaeon (virgin and witness), to mathematical optics of perspective and anamorphosis, to modern theories of relativity and the fourth dimension, and to the traditions of courtly love and Bruno's neo-Platonism. This tour de force sometimes pushes the limits of credibility; a mind as limber as Paz's could probably extract meaning from a randomly selected number in the telephone directory. But overall Paz's demonstration holds up. Duchamp ceases to be merely the "anaesthetician" of modern art and shows some of the markings of a historical and philosophical artist astray in the twentieth century.

Paz leaves a few of his ideas in a wobbly condition. For instance, the dismissal of retinal painting in favor of an art of the mind is not adequately reconciled with the importance of sheer *looking* in Duchamp—the glance, viewing through the picture or object, vision as creation. Historically the eye has been the principal organ not only of sensual pleasure but also of knowledge, of religious devotion in the Christian tradition, and of ordering nature in diagrams, perspective drawing, celestial charts, and the like. Duchamp's eye remained highly sensitive till the end.

My principal demurral concerns Paz's treatment of the impeccably staged, straightfaced joking that presides over all Duchamp's production. Surely *Given* is the ultimate bluff against art and its whole superstructure, an obscene diorama pawned off on a reputable museum because of the reputation of the "artist" and the brilliant literary apparatus lending it prestige. At some point Duchamp must have made a wager with himself that he could bring it off—and he did. Paz keeps referring to humor, spoof, and play as elements in Duchamp's work, and quotes the expression "hilarious picture." But Paz can rarely detach himself enough from the task of criticism to laugh outright and point to *la blague* as the central axis of Duchamp's ethos—more important even than love or language. Still, Paz does give proper credit to Alfred Jarry, creator of *Ubu Roi* and the science of 'Pataphysics; Jarry's sense of reality as a cosmic joke of serious proportions never abandoned Duchamp.

That heritage helps explain why Duchamp remains both our court jester and a great cautionary figure of our culture, warning us with jokes and quiet scandals of the menacing encroachments of criticism, science, and even art.

Meyer Schapiro's
Master Classes

1

In April 1957 the two principal speakers before the American Federation of Arts meeting in Houston were Marcel Duchamp, proto-Dada and practicing non-artist, then seventy years old, and Meyer Schapiro, a Columbia University art historian best known for his articles on Early Christian, Romanesque, and nineteenth-century French art. In an almost symmetrical reversal of roles, Duchamp read a sober (and probably ironic) assessment of the spectator's considerable role in "the creative act" and cited Eliot's "Tradition and the Individual Talent." Schapiro delivered an eloquent hortatory defense of contemporary Abstract Impressionist painting emphasizing its spontaneity, randomness, automatism, and the self-sufficiency of its pure forms and colors.

Both talks appeared that summer in *Art News*. Duchamp's was republished the following year in a collection of his writings; Scha-

piro's, entitled "The Liberating Quality of Avant-Garde Art," was not reprinted for over twenty years. Nevertheless it achieved an immediate and vigorous underground existence through photocopies and quotations and became one of the most widely read interpretations of abstract painting. For almost forty years Schapiro's scruples about book publication obliged us to read his writings on modern art in *samizdat* form. The volume that finally appeared in 1979, *Modern Art: 19th and 20th Centuries,* carries fourteen essays, some written as early as 1937. They have contributed heavily to our attitudes toward contemporary painting (sculpture is barely mentioned), and merit careful attention. In six of the articles—among them the Houston talk—scholarly considerations are in great part preempted by highly controversial questions about the nature and direction of contemporary art. This book really falls into two counterbalanced halves: a hundred pages at the start on major figures of nineteenth-century painting (Courbet, Van Gogh, Cézanne) and a slightly longer section at the end on the development and nature of abstract art. In between the editor has sandwiched three short pieces on Seurat, Picasso, and Chagall. Rather than recapitulate the arguments of so many articles, I shall address myself principally to the general cast of Schapiro's treatment of modern paintings and touch on certain historical, philosophical, and aesthetic principles that guide his thinking as it moves between the two sections.

Schapiro writes an evenly paced prose that leans toward the florid yet never abandons a carefully conducted argument. He avoids dramatic effects and startling leaps; he finishes many of the essays by just coming to a stop, as if time or material ran out. But nothing seems missing. The intellectual excitement of attending his lectures is partially muted in this printed version; what one hears is the steady stride of a powerful mind surveying the scene. That mind is endowed eminently with three faculties: an eye alert to detail, form, color, and image; a capacious and available memory for paintings in every era of Western art; and a powerful capacity to discover relations between art, society, history, science, and ordinary experience. In the early essay on abstract art, one can practically hear the polemical rhythms of Marx's *The Eighteenth Brumaire.* Increasingly through the years, Schapiro makes it clear that he believes that painting, more than any other art, has become a special record of human sensibility and the principal source of invention in the domains of the perceptual, the aesthetic, and the formal. In comparison to the painter,

". . . the writer is still absorbed by the representation of a world in which extra-artistic meanings have a considerable part." This sophisticated intelligence yearns for the purest and most elemental forms of art.

2

Schapiro belongs to a small company of critics writing on modern art who were first distinguished as scholars of medieval and Renaissance art. Their command of earlier work appears to augment their authority on contemporary art. Of this company, Kenneth Clark, E. H. Gombrich, and Edgar Wind withhold full endorsement from modern artists who sever themselves from the representation of nature and often from any social or institutional role for art (except economic). *Civilisation, Art and Illusion,* and *Art and Anarchy* end as gently admonitory books telling us, among other things, that contemporary painting expresses the chaos and sickness of our time far better than it opens any promising path into the future.

It is more difficult to locate the group with whom Schapiro keeps company. The great medieval scholar Henri Focillon wrote sympathetically about twentieth-century painting. *The Life of Forms in Art* (1934) contains passages (e.g., "The chief characteristic of the mind is to be constantly describing *itself*") that imply a deep insight into the processes of abstract art. However, Focillon's lyric statements about an autonomous world of pure forms lie at a great distance from much of Schapiro's writing, which traces painting to the artist's life and to social conditions. Adrian Stokes, the English critic who died in 1972 and wrote about practically all phases of art, never articulated a sustained response to abstract painting. Only Pierre Francastel seems close to Schapiro, in spite of the slenderness of his work on art after Cubism. *Peinture et société* (1965: not translated into English) undertakes the task that Schapiro's *Modern Art* accomplishes in a series of powerful lunges.

What Francastel and Schapiro have in common is a deep sense of the continuity of abstract art with earlier art, in spite of the almost universal invocation of terms like "turning point," "revolution," and "revision of values" to describe what has happened to art in the twentieth century. When Roger Fry and others sponsored the First Post-Impressionist Exhibition in London in 1910, if not the most typical at least the most symptomatic reaction came from Virginia

Woolf: ". . . on or about December 1910 human character changed."
Schapiro's mission in writing about modern art is to combat that
kind of euphoria (or, conversely, catastrophism) in our thinking. He
argues for an art-historical continuity between earlier and contem-
porary art, and for two other continuities as well—psychological and
sociological.

I can best document Schapiro's refusal to accept that there was a
quantum jump in the history of modern art by quoting a fairly long
passage from his 1937 essay "The Nature of Abstract Art."*

> All renderings of objects, no matter how exact they seem, even pho-
> tographs, proceed from values, methods, and viewpoints which
> somehow shape the image and often determine its contents. On
> the other hand, there is no "pure art," unconditioned by experi-
> ence; all fantasy and formal construction, even the random scrib-
> bling of the hand, are shaped by experience and by nonaesthetic
> concerns.
>
> This is clear enough from the example of the Impressionists
> mentioned above. They could be seen as both photographic and
> fantastic, according to the viewpoint of the observer. Even their
> motifs of nature were denounced as meaningless beside the evident
> content of romantic and classicist art.
>
> In regarding representation as a facsimile of nature, the ab-
> stract artist has taken over the error of vulgar nineteenth-century
> criticism, which judged painting by an extremely narrow criterion
> of reality, inapplicable even to the realistic painting which it ac-
> cepted. If an older taste said, how exactly like the object, how
> beautiful!—the modern abstractionist says, how exactly like the
> object, how ugly! The two are not completely opposed, however,
> in their premises, and will appear to be related if compared with the
> taste of religious arts with a supernatural content. Both realism and
> abstraction affirm the sovereignty of the artist's mind, the first, in
> the capacity to re-create the world minutely in a narrow, intimate
> field by series of abstract calculations of perspective and gradation
> of color, the other in the capacity to impose new forms on nature,
> to manipulate the abstracted elements of line and color freely, or
> to create shapes corresponding to subtle states of mind. But as little
> as a work is guaranteed aesthetically by its resemblance to nature,
> so little is it guaranteed by its abstractness or "purity." Nature and
> abstract forms are both materials for art, and the choice of one or
> the other flows from historically changing interests.

* In his prefatory note Schapiro states that he now regards certain arguments in
this early text as inadequate or mistaken. I shall risk the assumption that he
stands by this passage.

Schapiro's argument is not arcane. After passing over the great watershed of Impressionism, modern art changed its loyalty among the available materials and espoused a different kind of abstraction devoted to forms and colors rather than to images represented in geometrical space. The artist's mind remains sovereign (at least in this passage); the chain of aesthetic response has not been broken, only shifted. Fifteen years later in a superb article on the Armory Show, Schapiro supplies the historical documentation to support his reaffirmed thesis that abstract art is not merely decorative or arbitrary; though private, it has genuinely human content.*

"The Liberating Quality of Avant-Garde Art" (1957) poses something of a problem for my argument.† Here Schapiro seems to revert to a theory of discontinuity and he refers on the second page to "a unique revolutionary change" in the character of twentieth-century art. He even goes so far as to attribute to contemporary art a "special task" of mastering free forms, while leaving the representation of reality to "other means"—e.g., photography and its offspring. This position approaches heresy if compared with the full trajectory of Schapiro's thought. I attribute the polemical, tendentious tone of the speech given in Houston to the circumstances in which it was given, to Schapiro's awareness of the exciting position in which American Abstract Expressionist painters found themselves in 1957, and probably to certain ideological shifts in his thinking. It is as if suddenly Schapiro forgot his overall strategy of continuity in art for the shock tactics of touting abstraction as a new breakthrough.

The article on Mondrian, published for the first time in *Modern Art* and presented as the product of reflections and lectures covering forty years, reaffirms the briefly dropped strategy. Schapiro writes as if he were setting his house in order again: "I wish in this essay to explore closely several of [Mondrian's] abstract works in order to bring into clearer sight the character of those 'pure relations' and to

* In this essay, and in one or two other places, Schapiro refers to Cubism as "abstract" and "imageless." I cannot concur. Though Braque and Picasso took a giant step in this direction, one of the most significant art-historical facts about Cubism is that it refused to eliminate the real world, the image. Compared to Malevich's Suprematism or to Delaunay's Orphism, Cubist paintings overflow with identifiable—though contorted—representations of tables, pipes, musical instruments, and people, and sometimes authentic paper objects glued in. Confident of its radical recasting of the perceptible world, Cubism precisely did *not* leap into abstraction, where others dared to tread.

† In the published book Schapiro's original title is restored: "Recent Abstract Painting." The perfectly appropriate title given to the lecture for publication in *Art News* has its advantages, for many readers will identify it by this label.

show their continuity with structures of representation in preceding art." He produces the word "continuity" again a few pages later in reference to elements of design and field in Degas and Mondrian. Except in the Houston lecture, then, Schapiro generally tries to demonstrate that representational and abstract art are sailing on the same lake. If one or the other disappears around a point or a bend, the connection nevertheless remains demonstrable, navigable, and significant. A passage in his important essay on "Style" reinforces this approach to the point of paradox.

> The experience of the art of the last fifty years suggests further that the degree of naturalism in art is not a sure indication of the technological or intellectual level of a culture. This does not mean that style is independent of that level but that other concepts than those of the naturalistic and the geometrical must be applied in considering such relationships. The essential opposition is not of the natural and the geometric but of certain modes of composition of natural and geometric motives. From this point of view, modern "abstract" art in its taste for open, asymmetrical, random, tangled, and incomplete forms is much closer to the compositional principles of realistic or Impressionist painting and sculpture than to any primitive art with geometrical elements.*

It takes a perceptive mind to grasp that style and composition will tell us more about the genealogy of art than subject matter or its apparent absence.

The other two continuities Schapiro is intent on establishing can also be derived from my first long quotation. Its second sentence refers to "experience" and "nonaesthetic concerns" that shape the final work of art. The essay on Cézanne warns us not to separate the apparently innocent objects of still life, in this case apples, from the personal life and experience of the artist; for Cézanne mastered and redirected erotic obsessions only gradually and with great difficulty. The essay on Van Gogh speaks of catharsis, of painting as a "lightning conductor," and of the artist's personal failure as the key to his artistic success.†

* In *Anthropology Today*, edited by A. L. Kroeber (University of Chicago Press, 1952), frequently reprinted.

† It remains a stunning essay after thirty years. However, in the painting Schapiro analyzes, *Crows over the Wheat Field* (1890), I still cannot see "black crows which advance from the horizon toward the foreground." To my eye those dark patches have a markedly ambiguous direction, and usually they seem to move away toward the horizon. Part of the conflict Schapiro finds in the painting may belong to his own imagination.

These powerful relations between the artist's life and his work—not a literal transference but a subtle transformation which the critic can discern—provide a basis for the stylistic, art-historical continuity between figurative and abstract art that Schapiro believes in. For, just as clearly as realism, he argues, non-objective painting maintains its connection with the artist's inner experience and, in its fashion, expresses that experience. Only the vocabulary is different.

To make clear that distinction is the burden of Schapiro's short piece "On the Humanity of Abstract Painting." Those six pages plead with us to see how "the subjective becomes tangible" even in the barest and coldest of abstract painting, and declare that our approach to it should be to "a problem of practical criticism and not of theory, of general laws of art." I read the latter sentence as a summons to critics to reconcile the quality of an artist's living experience with his art. The essays on Cézanne, Van Gogh, and Picasso accomplish that task beautifully for earlier styles of painting. But the long article on Mondrian, outside of fleeting references to theosophical doctrine and New York skyscrapers, says almost nothing about the artist; it devotes its energies to analyzing the forms in Mondrian's grid-and-ground compositions and showing their connection with earlier forms in Degas, Bonnard, and Monet. In a case where we sorely need evidence of humanity we do not find it—or at least Schapiro does not produce it.

Schapiro's third continuity links art to the surrounding society and culture. The last sentence in the first long quotation states that the choice of natural or abstract forms "flows from historically changing interests." Those interests reside in the cultural environment and impinge on "the sovereignty of the artist's mind." A partially overlapping set of essays study this reciprocal relation between art and society. Schapiro's historical article on Courbet traces his use of popular imagery and children's art as forms of naïveté that were welcome developments within realism. But Schapiro is equally concerned with Courbet's responses to the political crosscurrents of the era, whence his conclusion attributing the painting *The Burial at Ornans* (1849–50) to extra-aesthetic forces: "Thus the consciousness of the community, awakened by the revolution of 1848, appears for the first time in a monumental painting, in all its richness of allusion, already retrospective and inert."

In the long text on the 1913 Armory Show, Schapiro explores quite a different interconnection between painting and the environment.

In the closing decades of the nineteenth century and the opening decades of the twentieth, the separation of the most creative art from public and institutional life led to professional solidarity among artists and a sense of "creative morale." The new conditions of art that helped produce abstraction can, he argues, be seen as a "rejection of the environment." Artists turned inward or began manipulating the medium itself. Schapiro's essays on abstract art maintain a steady awareness of the complex social background of the new painting.

In Schapiro's hands none of these three continuities sets up a determinism—historical, psychological, or social. His long-standing sympathy for Marxism reveals itself not in any rigid historical pattern but rather in a wonderfully tuned sense of dialectical opposites mediating between these extra-artistic forces. Their action leaves open a generous role for the artist's consciousness, temperament, creativeness, and aesthetic response—even for chance. This vision of art imposes no exclusions and gives a feeling of richness and understanding to everything Schapiro writes.

I believe, however, that the first of his continuities, denying any radical break between representational and abstract art, is more an article of faith with Schapiro than a demonstrable fact. When the most expensive and critically acclaimed paintings in our culture renounced the imitation of three-dimensional nature "out there," a shift took place whose aesthetic and social causes and consequences we have not yet assimilated. Seventy years after Kandinsky's conversion to abstraction and about thirty years after Jackson Pollock's first one-man show, students and teachers and artists are growing up with a modified vision. They are willing to look at and respond to pure forms.

Yet they face enormous problems. Whereas for five hundred years Western painting was able to refer to an area of common practice, almost an established code (linear perspective, rendering, chiaroscuro), abstract art has no such collection of conventions to work with or from. Even traditional principles of design are often recognized by being flouted. The gradual development of a common language or style is not a goal recognized by most abstract painters—except the imitators—in spite of anecdotes about the comradeship of the Russian Futurists or the patrons of the Cedar Tavern. Since Cubism at least, most major artists, like Greta Garbo, want to be alone. Most spectators feel the challenge of this shift

very deeply. Schapiro's demonstrations of historical continuity diminish but do not eliminate the gap between two modes of painting, one representing the visible world, the other discovering forms of inchoate meaning.

We still do not know whether abstract art will finally "take"—whether it will flourish alongside realist art (a condition devoutly to be desired if one believes in artistic free enterprise), eliminate the opposition, or wither away. I am apprehensive myself of abandoning the depiction of the everyday world of objects and people to the "other media." Photography, film, TV, and whatever lies beyond will always have a very different texture and aura from an image that has been created directly by the human hand.

3

Schapiro's thesis of continuity has the virtue of the long view. By adopting his gradualist perspective, we will have less tendency to cast ourselves as historical heroes leading Western culture around a big bend called modernity. However, I would like to examine some debatable aspects of Schapiro's outlook toward modern and modernist art. If abstract painting represents merely the exploitation of a possibility always latent within earlier painting—creating forms as opposed to representing nature—then one wonders why Schapiro attaches such major significance to the shift. For if his essays about modern art have one theme in common, it is the proclamation that the liberating virtues of abstract painting lead to self-realization.

> What seemed to be a hopeless relativism in this eternal treadmill of stylistic invention . . . was surmounted, however, in the modernist's vision of the art of the last few centuries, and even of older art, as a process pointing to a goal: the progressive emancipation of the individual from authority, and the increasing depth of self-knowledge and creativeness through art. ["The Armory Show"]

> The modern artist . . . is attracted to those possibilities of form which include a considerable randomness, variability and disorder . . . That randomness corresponds in turn to a feeling of freedom, an unconstrained activity at every point . . .
> No other art today exhibits to that degree in the final result the presence of the individual, his spontaneity and the concreteness of his procedure.
> This art is deeply rooted, I believe, in the self and its relation to the surrounding world . . .

Painting by its impressive example of inner freedom and inventiveness and by its fidelity to artistic goals, which include the mastery of the formless and accidental, helps to maintain the critical spirit and the ideals of creativeness, sincerity and self-reliance, which are indispensable to the life of our culture. ["The Liberating Quality of Avant-Garde Art"]

This widely respected historian of art, steeped in the traditions of Byzantine, Christian, and Judaic cultures, sometimes writes about Abstract Expressionism in the style of Herbert Marcuse heralding a culture of liberation. Schapiro employed the hortatory tone as early as the thirties, even before he became well acquainted with artists like Barnett Newman and Willem de Kooning. The gist of his message, repeated like a litany in all the essays about modern art, seems to be that abstraction, in proper hands, liberates the self from both nature and culture and lifts it into a higher realm of existence. Very early he amalgamated aspects of Marxism with ideas like Purism and Minimalism discussed in the thirties among New York painters.

I find two problems in these high claims for abstract art as therapeutic. First, who is liberated? The question does not receive a direct answer. From most passages one infers that only the great creative artist can be sure of reaching freedom. Little is said about the sensitive art lover who might follow the artist vicariously across the great watershed of abstraction. Perhaps the discerning critic will pass muster. Schapiro nowhere considers the part these magnificent emancipating powers might have in education, or in visual media like television and film. Second, to what realm is the modernist artist liberated? The last sentence quoted above from the manifesto-like "The Liberating Quality of Avant-Garde Art" does stake a claim to "the critical spirit" and to an undefined form of culture. Both, however, are almost smuggled at the last minute into this lyrical celebration of freedom. Liberation for Schapiro remains liberation *from* something; he does not say into what better state of life we shall step. "Selfhood," once achieved, would presumably distribute its own rewards. Only occasionally do we hear reservations to the effect that "modernity is problematic and includes conflicting irreconcilable elements."

I remain skeptical about Schapiro's now widely accepted hypothesis of the therapeutic value of abstract art, partially because one famous case seems to argue the other way: Van Gogh. The evidence,

much of which Schapiro assembles in his short essay on the painter in *Modern Art*, points toward an attitude on Van Gogh's part that let him find reassurance in an intense realism, in the perceived object, and not when he lost the object under the importuning of free-floating forms. In any case, it is worth taking notice when an art historian and critic as powerful and as widely informed as Schapiro makes claims for Abstract Expressionist art that rival and often surpass those of Apollinaire on Orphism, Kandinsky on "the spiritual," Malevich on "absolute values," and Mondrian on "the universal." He made them first in 1937 in the *Marxist Quarterly* article, before Clement Greenberg and Harold Rosenberg had developed their own different but related positions on abstract art.

In spite of these claims—or perhaps because of them—it is difficult to say whether Schapiro is more at home in dealing with the representational art of Cézanne, Courbet, and Van Gogh, or with Abstract Expressionism of the past fifty years.* He opens his 1947 article "On the Aesthetic Attitude in Romanesque Art" by refuting the allegation that modern art is "mere ornament"—and then has to call himself to order: "What concerns us here, however, is not the defense of modern art." Yet increasingly Schapiro has accepted responsibility for that defense, and we must examine more closely just what he finds there. "The Liberating Quality of Avant-Garde Art" remains a key.

> That sentiment of freedom and possibility, accompanied by a new faith in the self-sufficiency of forms and colors, became deeply rooted in our culture in the last fifty years. And since the basic change had come about through the rejection of the image function of painting and sculpture, the attitudes and feelings which are bound up with the acceptance or rejection of the environment entered into the attitude of the painter to the so-called abstract or near-abstract styles, affecting also the character of the new forms. His view of the external world, his affirmation of the self or certain parts of the self, against devalued social norms—these contributed to his confidence in the necessity of the new art.

It is wonderful to watch a master at work on the prevailing myth. Earlier artists and critics imagined the evolution toward nonrepre-

* To judge by his choice of subjects, he is either indifferent to contemporary art that represents natural objects, or impatient with it. His two 1937 reviews on Surrealism that appeared in *The Nation* take Surrealist art to task precisely for containing, among other things, images.

sentative painting as a process akin to taking vows of poverty and chastity.* Schapiro beholds a dream of untold opulence. Every word counts in this carefully phrased passage. "Freedom" I have already commented on. "Faith in self-sufficiency" seems to have a clear meaning: these marks on the flat surface are held to refer to nothing outside themselves, they image no content. The problem is whether the main clause of the second sentence slips something back in. The feelings the artist has about (in this case) rejecting his (natural and social) environment "affect the character" of the new forms. My rewording is designed to reveal how Schapiro has left his sentence "negative pregnant," as our founding fathers would have said. The very absence of content expresses an attitude toward that rejected content. Thus the art we call abstract carries with it everywhere a kind of phantom meaning: the artist's alienated attitude toward the world he lives in. Yet to my sensibility much abstract art (Arp and often Rothko, for example) radiates benignity and peacefulness.

We are probably confronting here an ancient phenomenon. "Nature abhors a vacuum" easily yields "Human nature abhors a semantic vacuum." Critics, particularly, and some artists cannot tolerate meaninglessness for long. At the same time that he was eliminating natural appearances from his art, Kandinsky was searching out a new content: the spiritual. Schapiro makes various tentative gestures toward identifying more than just a negative or phantom content in modern abstract art. He refers to expressing "moods," frequently to the artist's unconscious, and once to "communion" and "religious life." But he usually shies away from the spiritual, the metaphysical, and the archetypal. In the article on Mondrian, an exercise in the "practical criticism" he himself calls for, Schapiro tries out the undeveloped notions of the "virtual object" and "truth to vision." They make us aware again of the degree to which he wants us to see abstraction as continuous with representation. Schapiro ultimately describes Mondrian's revolutionary abstract art as unable to venture far from its host animal, the very body of Western mimetic art. In several respects, therefore, abstract art appears to fall short of "the self-sufficiency of forms and colors."

* Constable: "When I sit down to make a sketch from nature, the first thing I try to do is to forget that I have ever seen a picture." Courbet: "The museums should be closed for twenty years, so that today's painters may begin to see with their own eyes." Monet: "When you go out to paint, try to forget what objects you have before you, a tree, a house, a field, or whatever."

Schapiro's uneasy awareness of this dilemma comes out not only in his work elsewhere on the semiotics of art* but in his use of the word "physiognomic" in this volume. He used it first, I believe, in a 1932 review of a book on ornament. There he paired it with its opposite, "constructive," and gave it the sense of expressive in contrast to the merely formal—expressive primarily of human inventiveness. The term returns in the fifties, linked now not to Romanesque sculpture but to abstract art.

> Yet one may speak of certain relations of the geometric units in Mondrian's paintings as "abstracted" or transposed from the previous art of representation, without assuming that the units themselves are reductions of complex natural forms to simple regular ones. These elements are indeed new, as concrete markings of pigments on the tangible canvas surface with distinctive qualities—straightness, smoothness, firmness—which may be called physiognomic and are grasped as such, rather than as illustrative presentations of the ideal concepts of mathematical or metaphysical thought, although we may use the terms of geometry in talking about them. ["Mondrian"]

Physiogomy refers to the ancient art (repackaged by the eighteenth-century Swiss mystic Johann Lavater) of reading outward features or appearances as an index of inner character. It assumes a pervasive correspondence or unity in the cosmos. The above passage goes on to suggest that knowledge, freedom, and selfhood are as discernible in abstract art as in the art of representation. What has happened to the autonomy of these forms? Physiognomy, one suddenly realizes, is also the subject of the wonderful text on Cézanne's apple-breast shapes, where Schapiro discerns "an implied human presence" and a "heraldry of a new way of life." An even more revealing pronouncement turns up in the Van Gogh essay: "Personality is itself an object"—the object that, at the deepest level, Van Gogh was attempting to paint. All art, for Schapiro, depicts the character, the temperament of the artist at work. "The subjective becomes tangible," he writes in "The Humanity of Abstract Art." I would be happier if he tried to make his case for abstract art by staying longer with the visual, with self-sufficient forms, rather than by tracking them so often to the

* See "Some Problems in the Semiotics of Visual Art," in *Semiotica*, No. 3 (1969).

elusive domain of the subjective. But the suction of the semantic vacuum may be most powerful in powerful minds.

In this volume sprinkled with unexpected juxtapositions, one of the most revealing is that of Bonnard's *View from Window* (1895) with Mondrian's *Composition* (1936–42). Bonnard presents a pattern of basically rectilinear forms half concealed in the appearances of window frame, casement, buildings, roofs, pipes, chimneys, and windows facing back from the wall opposite. The scene could be interpreted to represent all Paris, the form and charm of a modern city beholding itself at close quarters across a courtyard; and one could also subsume the clear formal elements of the composition in a few strong bands traversing a flat surface. Mondrian presents similar bands all by themselves, impeccably painted to imply a larger imaginary grid embedding them.

Many people would agree, I think, that next to Bonnard's lithograph the Mondrian painting seems naked. He paints an armature of girders and columns related in appearance to the steel frame we see for a time in the construction of tall buildings before the cladding is added. Mondrian worked his way through a series of representational styles before reaching this geometrical manner for which he is known. He gradually and systematically simplified the complexities of his visual experience until he could distill a chaste diagram of the world of appearances. Consequently, the compositions of his last twenty-five years have the effect of a visual short circuit: they give us an answer before we have solved or even grasped the aesthetic problem. Because he arrests the universe at this level of schematic simplicity, the only mystery in Mondrian is one of bareness, of "certain relationships of form." In the case of *Composition*, as Schapiro points out, he retouched the 1935 original by adding two horizontal bars and two patches of color; but the final effect remains that of a skeleton, the bare bones of design.

Of these two works I find the Bonnard more satisfying because of the old principle of *"la difficulté vaincue"*: a gratification achieved through our own efforts can mean more to us than a gratification directly conveyed and received. The principle applies as much to the life of the mind and art as to physical desire and love. To reclothe abstract painting (as I would maintain most viewers do) by projecting our associations onto it holds great appeal, but is finally less rewarding (and more isolating because highly subjective) than

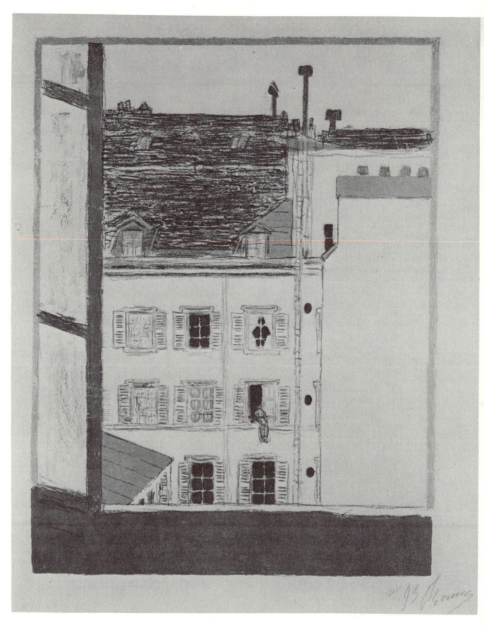

Bonnard, View *from Window* (1895, lithograph, 22″ x 12″). The Metropolitan Museum of Art, Harris Brisbane Dick Fund, 1932

(right) Mondrian, *Composition* (1936–42, 42½″ x 23″), Collection of Mr. and Mrs. Burton Tremaine, Meriden, Connecticut

disrobing representations of the natural world to find an underlying beauty of form. Mondrian is our Piranesi—in reverse.

I would agree with Schapiro that there is a profound reciprocity and even a continuity between these two aesthetic activities. Do freedom and selfhood and modernity lie more with one than with the other? I seriously doubt it and am troubled by the earlier sections of this book in which Schapiro argues with zeal for the superiority of abstract art. The rest of his writings here and elsewhere suggest a steadier vision.

Of course one can only admire Schapiro's willingness to write as a partisan about the art of his own time. He is the only university figure who stands beside Clement Greenberg and the late Harold Rosenberg as a force on the American art scene of the past forty years. Writing in magazines, they campaigned mightily in favor of a new indigenous art soon to be known as Abstract Impressionism or the New York School. The Columbia professor wrote about the new art with a passion and dedication equal to theirs, but without having to enter the fray as often as they did. The solidity of his scholarship on early periods of art and his understanding of the exciting complexities of nineteenth-century painting give his voice a particular weight and richness compared to theirs. He has tamed and harnessed art history, psychoanalysis, and Marxist social criticism to his purpose of demonstrating the continuing significance of art in the modern world. Only Meyer Schapiro, in an article on Courbet, could turn gracefully to a two-page examination of Baudelaire's paradoxical attitude toward the child's sensibility and then, in a footnote, mention Taine's article on the acquisition of language by children—an article whose translation in *Mind* (1877) inspired Darwin to turn his attention to child development.

There is no bottom to this book. It incorporates both a picture gallery and a library in presenting the achievements of a magisterial mind.

TWO
POLEMICAL ASIDES

How to Rescue Literature

Literature has two advantages over wine. A good book ages forever; and you can read it as often as you wish without diminishing its substance. The devoted reader is like a wine lover whose dream has come true. His stock will never spoil or be consumed. He can sample, enjoy, and share his cellar without fear of depleting his reserve; it will grow as he grows. He need never go thirsty.

For many people literary *criticism,* to continue the analogy with wine, continues to mean the unconfined medium of personal responses, informal and formal talk, reviews, and scholarship in which works of art circulate and finally locate themselves. For others, however, criticism has taken bold steps in the past thirty years. It now encompasses activities that have little relation to tasting or enjoying anything. Symbolic systems and quantified scientific analysis have become fairly common approaches to literary works. Furthermore, literary criticism has virtually abandoned a set of practices that was

once considered essential to the full appreciation of literature. In order to examine this state of affairs, I shall have to touch first on a few preliminary matters.

1

Baudelaire and Blackmur produced two wonderfully tonic statements about criticism: "Criticism should be partial, passionate, and political, that is to say written from an exclusive point of view, but the point of view that opens the most horizons" (*Salon de 1846*). Baudelaire's own criticism usually meets his standards; his writings on art and literature themselves belong to literature. Blackmur begins "A Critic's Job of Work" with a fine slyness: "Criticism, I take it, is the formal discourse of an amateur."* An amateur is both a nonprofessional and a person who loves something very much. I could not improve on Blackmur's emphasis.

It is worth insisting, moreover, on how large and varied the domain of criticism has become today. The journalistic reviewer addresses himself to the general public, usually on the subject of recent works. A recognized writer like Edmund Wilson used the wide-ranging form of the literary essay. Teachers choose works to present to their classes for discussion, interpretation, and evaluation. Scholars, whether they lean toward biography, history, or interpretation, contribute to the stock of tools and materials with which all critics must work. Literary theorists and philosophers try to give it all a shape and a name and often attach literature to adjacent fields, as if to provide a safe dock in the perilous seas of critical dispute. Because it is by far the most widely practiced, the most influential, and the least acknowledged as a branch of criticism, I shall write principally about teaching, and refer to other branches as they support or disrupt it.

Literature in the Professor's Den

In a university I recently visited, I regularly passed two classes which I found myself observing with fascination through the open doors. In the first, five or six students sat around a table listening to the elderly professor read to them in Spanish from a beautifully bound book propped in front of him. What I heard of his voice was ex-

* *Language as Gesture* (New York, 1952), p. 372.

pressive and very clear. His histrionic gestures and shifts in emphasis played constantly between the comic and the passionate. At frequent intervals a student would read from his own text—haltingly, yet catching some of the professor's feeling and even a few of his gestures. My host informed me that some faculty members considered Professor M.'s teaching the scandal of the Spanish department; in his Cervantes seminar he simply read *Don Quixote* aloud, with running commentary on the language, historical background, and cross-references in the novel, and with little systematic interpretation. Yet a few graduate students always stated that they had learned a great deal from Professor M. and expressed great loyalty to him. The question was moot; he would retire next year.

Farther down the corridor an intense young man in a corduroy jacket and no tie had always, by the time I passed, covered the blackboard with carefully lettered diagrams, assorted symbols, and equations. He stood gesticulating with the chalk at the large class, all of whom were taking notes with a concentrated expression. According to my host, Assistant Professor N. had a strong following among the graduate students in English and had attracted some good undergraduates. He had published two stunning articles combining communications theory and speech-act theory in an analysis of comic strips. He was a candidate for early promotion and had received offers from two universities to participate in special interdisciplinary programs.

Both these classroom critics faced the same problem: How does one fill the forty hours of class or lecture time we call a "course"? In the past the accepted activities in the teaching of literature seemed limited in number and free of serious challenge. The life and times of the author, a close reading "on many levels," and an accompanying history of ideas combined personal response with the Great Tradition and usually led to some form of appreciation and evaluation. "Appreciation" grew out of an attempt to relate a work as interpreted to other literary works and to the dynamics and tensions of our lived experience.

I. A. Richards fluttered the pedagogical chicken coops a bit, back in the twenties. It took the wider ideological challenges of the sixties to leave a lasting mark on classroom behavior. Professor M. has reverted almost to the Middle Ages, when students often spent their time copying a precious manuscript read aloud by the teacher. Professor N. would probably feel a certain malaise about a Great Tradi-

tion and about attempting any form of appreciation, a word now consigned to music departments. His methods of interpretation and analysis give him an apparent mastery of literary works (he would say "texts") that has turned the activities of English and foreign literature departments on their heads.

An early pastiche version of what is happening today can be found in Oscar Wilde's entertaining dialogue "The Critic as Artist." Gilbert, by far the more eloquent speaker, acclaims the critic's role.

> Criticism, being the purest form of personal impression, is in a way more creative than creation, as it has least reference to any standard external to itself . . .

Gilbert's aggressive posing has gradually been systematized and institutionalized to the point where literature may be looked upon in the most respected circles as a pretext for criticism, as a convenient armature for theory. I sense that in some graduate literature programs around the country today more extensive and more careful reading is expected of students in literary theory and methodology than in works of literature—let alone in literary history. It is not just that literature has been submerged in doctrinal thinking. A literal usurpation has begun which would depose literature and grant sovereign authority to one or more of several competing disciplines. It is impossible to describe these pretenders in any detail, but a partial roll may help.

Various forms of Structuralism appropriate literature to a set of myths that rule us through a strong binary logic. "We do not claim," writes Lévi-Strauss, "to show how men think in myths, but how myths think themselves in men, and without their knowledge . . . Myths think themselves among themselves."* The slippery doctrine of *écriture* (writing? scripture?) has delivered literature into the hands of linguistics and set out to eliminate the author in favor of language itself. Barthes stated it categorically in the sixties: "Language is not the predicate of a subject . . . it is the subject."† (By "subject" he meant not topic but the seat or agent of thought and consciousness.) It is the phenomenon, the possibility, of having significance, of being a sign, that lies at the heart of semiology (or

* *Le Cru et le cuit* (Paris, 1964), p. 20.
† *Critique et vérité* (Paris, 1966), p. 70.

semiotics), a discipline founded on the supremacy of a universal theory of signs.

Communication and information theory has staked a major claim to the territory of literature since Roman Jakobson's "Linguistics and Poetics" speech in 1958.* So far as I can discern in the writings of J. L. Austin and J. R. Searle (both philosophers) and their followers, speech-act theory originally took no interest in literature except marginally as "etiolated" or stagnant speech. This mode of analysis recently grafted onto criticism has the effect of converting literary studies into a form of sociolinguistic philosophy. Reader-response theory tends to look around and beyond the text to the reactions it elicits. Promising as a basically experimental approach, it often becomes enmeshed in interview statistics, transactional psychology, and curious notions about communities of readers. These recent theories have defined and refined their methods while both Marxist and Freudian criticism remain very active.

All these approaches can widen our horizons in ways Baudelaire would have approved, and challenge us to reexamine the relations between criticism and its host, literature. What we should beware of is the temptation to subordinate literature to the claims of any extra-literary discipline to superior authority or knowledge. (In a moment I shall discuss the claims of linguistics.) Literature is not autonomous and unrelated to our daily lives; on the contrary, we all to some degree live by and through it. But it does not belong to any domain outside the domain of art, and we are shirking our responsibilities if we look the other way while self-styled "literary" critics deliver literature into the hands of one or another branch of the social sciences.

We would do well to remember something of the past. It has taken approximately two hundred years to free literature from the authority of established religion, royal patronage, and bourgeois values. The heroes of that struggle—Swift and Diderot and Goethe, Flaubert and Dostoevsky, Joyce and Proust—were above all independent writers who submitted their work to no authority beyond the conflicting traditions of literature itself and the demands of their own sensibilities. Do we now, out of loss of confidence in literature or out of doubts about how to spend class time in a difficult

* "Concluding Statement: Linguistics and Poetics," in *Style in Language*, edited by Thomas A. Sebeok (Cambridge, Mass., 1960), pp. 350–77.

season, want to surrender literature—or criticism—to a new set of masters?

A disturbing aspect of these raids on literature and criticism by outlying disciplines is their common aspiration to the objectivity and certainty of science at the very moment when the tendentious and teleological nature of much scientific activity is coming to light."* Not the existence of this ambition but its spread should trouble us. In the introduction to *Course in General Linguistics*, Saussure, a consistently exciting and clearheaded thinker on language, called for the creation of "a science which will study the life of signs in the midst of social life" and named it semiology. In a beautifully self-fulfilling prophecy, comparable to the gaps in Mendeleev's periodic table anticipating the discovery of new elements, Saussure wrote that "its place is determined in advance."† A number of influential literary critics, including Northrop Frye and Roland Barthes, have taken the same tack. In the opening pages of Frye's *Anatomy of Criticism* we read:

> It may also be a scientific element in criticism which distinguishes it from literary parasitism on the one hand, and the superimposed critical attitude on the other . . . Everyone who has seriously studied literature knows that the mental process involved is as coherent and progressive as the study of science . . . If criticism is a science it is clearly a social science.

Do we wish to adopt this stringent approach to enter a field that, for many readers, still encompasses individual consciousness, free will, accountability, and human values? Should we as critics postulate the perfect uniformity and coherence of literature and deal with it systematically in terms of laws and equations, models and statistics, and nonlinguistic symbolic systems? Such projects should indeed be tried out and the results evaluated; we have reason to take alarm when they begin to undermine the study and teaching of literature as one of the humanities.

* A few key references on the subject are Karl Popper, *The Logic of Scientific Discovery* (New York, 1959) and *Conjectures and Refutations: The Growth of Scientific Knowledge* (New York, 1962); F. A. Hayek, *The Counter-Revolution of Science* (New York, 1952); and Lewis S. Feuer, "Teleological Principles in Science," *Inquiry*, 21 (1978), pp. 377–407.

† Edited by Tullio de Mauro (Paris, 1976), p. 33.

I would trace yet another important aspect of this scientism to Saussure. For it is he who, by fiat, in his introduction, banishes individual or personal speech from the house of linguistic study.

> The study of language contains two parts: one, the essential part, takes *langue* for its object, which is essentially social and independent of the individual . . . the other, the secondary part, takes individual speech (*parole*) for its object . . .
> Such is the first bifurcation one comes upon as soon as one sets out to form a theory of language. One must choose between the roads, both of which one cannot follow at the same time.*

Since Saussure omits any consideration of individual speech (except to call it "diachronic") † this bifurcation amounts to a beheading. When combined with the thought of Marx or Freud, of Lévi-Strauss or Lacan (as is often the case), this position incinerates the whole humanistic tradition of persons and scatters the ashes across a landscape composed of language, myth, the unconscious, and other collective entities. To dismiss *parole* means to dismiss individual acts of communication, including literary works. True, the willful crotchets of individual acts of communication do not submit readily to scientific study, linguistic or otherwise; stylistic analysis has succeeded in dealing far more adequately with individual cases. Nevertheless, linguistics as a science seems to have invaded literary criticism, brandishing its claim to be the central human social science that holds the key to all the others. The claim will not stand up; the price of neglecting persons and their acts is too high.

We all behold the obvious results of this growing scientism among literary critics: aggressive and often turgid new terminologies; the displacement of discussions of literary works by discussions of theory and method—even in the classroom; and the growing demand of critics (without Wilde's wit) to stand as the full peers of "creative" writers. We have not reckoned fully yet with feedback effects whereby writers may be composing linguistically generated, nonpersonal, systematically ambiguous works in order to provide critics with the fodder they seek. For, increasingly, particularly in the United States and France, writers are critics and are also professors

* Op. cit., pp. 37–38.
† Ibid., p. 138.

of literature. This plurality of offices can lead to an intellectual conflict of interest unforeseen by Baudelaire when he insisted that "all great poets naturally and fatally become critics."

What Then Can We Do?

In the face of these efforts to use literary works as the subject matter for a science that anatomizes literature, what can we do to keep literature whole, especially as it is taught, and to encourage an integral process of reading? For it is as if each province of criticism today wanted to limit itself to only one element in the communication-theory model I referred to earlier. Structuralism works away on the message or text sealed off from author and reader and recircuits it into myth and language. Semiotics "breaks" or "cracks" the literary work like a code to produce not so much a set of interrelated meanings attributable to author or audience as a protracted commentary on the infinite possibilities of meaning. Speech-act theory concentrates on a segment of intentional performance linking speaker to message ("illocutionary act" is a particularly infelicitous term for it) and shuns literature as parasitical. Reader-response theory finds its pertinent evidence in the addressee. Much criticism today is characterized above all by its myopia.

The rest of us would do well to keep our heads, eschew intellectual fashions, avoid cleaving to one method as suitable to all circumstances, and attempt to approach a work of literature without rigid preconceptions, without a grid of theory. And in the domain of teaching literature which concerns us here, I would also favor certain kinds of exercises—busy work even—that have fallen totally out of favor: word-for-word copying, dictation, reading aloud, summarizing (précis writing), memorizing, and translation. All of these activities enforce close attention to what a piece of writing is actually doing without requiring an elaborate theory of literature to begin with. Reciting aloud, in particular, impresses me as both a fruitful form of reading and a sturdy antidote to some of the abuses I have been discussing. Another anecdote will make the point.

A visiting professor from France widely respected for his command of semiological approaches gave a lecture recently on Apollinaire's poem "Le Pont Mirabeau." At the start he handed out copies of the two successive versions of the poem Apollinaire published, which differ markedly in format and punctuation. After giving the audience time to read the two texts, the lecturer began a highly

perceptive analysis, with diagrams and symbols, of the poem's verse structure, rhyme, sound pattern, and syntax. A number of neglected relations emerged. In his conclusion he detected in filigree behind the consonants the name of the woman (Marie Laurencin) whose love the poem celebrates. Then he stopped. That was all.

In what it said the talk was brilliant. Its omissions distressed me. First, the lecturer failed to mention a third version: Apollinaire's own recording of the poem in a strikingly mannered and haunting voice —a version that, without being definitive, would throw into question some of the lecturer's insistence on the nonlinear qualities of the text. (He was indeed acquainted with this recording.) Second, even though much of his talk addressed itself to auditory aspects of the poem, he never tested any of his hypotheses by reading the poem aloud—not a stanza, not a single line. Those in the audience had to create these sounds and the complex emotional effects for themselves in their inner ears—and in a foreign language. "Le Pont Mirabeau" was left in pieces on the blackboard.

At this point I shall let Henry James and Valéry speak for me.

It is scarcely necessary to note that the highest test of any literary form conceived in the light of "poetry"—to apply that term in its largest literary sense—hangs back unpardonably from its office when it fails to lend itself to *vivâ-voce* treatment . . . The essential property of such a form as that is to give out its finest and most numerous secrets, and to give them out most gratefully, under the closest pressure—which is of course the pressure of the attention articulately *sounded*.*

Poetry on paper has no existence at all. In that condition it is no different from a machine in the closet, a stuffed animal on a shelf . . . It comes to life only in two situations—in the state of composition in a mind that ruminates and constructs it, and in the state of recitation [*diction*].†

I do not propose here to enter the ancient debate over the priority of the visual or the auditory in our perception of the world and the formation of our sensorium. John Hollander, Walter J. Ong, Marshall

* Henry James, Preface to *The Golden Bowl*, in *The Art of the Novel* (New York, 1934), pp. 346–47.
† Paul Valéry, *Cahiers II*, Bibliothèque de la Pléiade (Paris, 1974), p. 1141.

McLuhan, Rudolph Arnheim, and Jean Piaget have published im-
portant works on the subject.* Rather I wish to suggest that the
critical activity of teaching literature should include as one of its
essential goals the *oral* interpretation of literary texts. The analytical
dismantling of a work or passage would then lead up to a perfor-
mance serving as verification and demonstration, a means of actually
experiencing the forms and features previously discussed at the re-
move of critical interpretation. If the author's biography or the
work's narrative structure do not help us to hear the voice and tone
of the whole, the articulation of its parts, and the pacing of its lan-
guage, then they are largely irrelevant to the study of that work—
though they may interest us for other reasons. At least for literary
criticism as it is practiced in the classroom and lecture hall, the acid
test is not the intellectual brilliance of the teacher's argument but
the demonstrability of the interpretation when he (or someone else)
actually reads aloud a sizable passage. I would not maintain that
every literary effect will be clear in an oral interpretation. But the
continuous challenge of recitation keeps us alert to gesture and tone
of voice, and to the burden of argument and figurative language
which they weave together.

The fact that modern linguistics as shaped by Saussure restricts
itself to competence (*langue*) and neglects performance (*parole*)
should not influence our reading of the special class of texts called
literature. For instance, the widely read volume *Style in Language*,
the proceedings of a conference called in 1958 to bring together
linguists and literary critics, devotes more than half its discussions
to auditory aspects of literature. Oral performance, however, is fa-
vorably considered only once, in relation to early American folk
narratives and Lincoln's artistry as a performer of them. In at least
six places oral interpretation is rejected as not capable of conveying
"the poem itself." "Wimsatt and Beardsley insist that the poem
itself is not to be identified with any performance of it or with any
subclass of performances."† And in a discussion of metrics Jakobson
quotes as "a sage memento" a similar statement: "A performance is
an event, but the poem itself, if there is any poem, must be some kind

* John Hollander, *Vision and Resonance* (Oxford, 1975); Walter J. Ong, *The
Presence of the Word* (New Haven, 1967); Marshall McLuhan, *The Gutenberg
Galaxy* (Toronto, 1962); Rudolph Arnheim, *Visual Thinking* (Berkeley, 1969);
Jean Piaget, *The Language and Thought of the Child* (New York, 1955).

† *Style in Language*, p. 188.

of enduring object."* Furthermore, it is surprising that speech-act theory and reader-response theory should have entered the arena of literary study without encouraging experimental performances of the complex expressive actions that constitute communicative speech. The conspiracy against the spoken work seems to be deep-seated and powerful.

2

Five major considerations lead me to speak out in favor of voicing literary works as a means of interpreting or appreciating them.

1. Oral interpretation restores the freshness and urgency of older works, and puts them in a collective setting which improves on the intimist convention of the author murmuring directly into the reader's ear. Performance requires the creation of another projected voice, that of "the text itself," not for all time, but for this time. And in the delicate process of locating that voice, criticism can re-insert itself into the physical act of reading rather than having to trot along always after or before the fact, as commentary. One metaphor occasionally used to suggest the difference between reading silently and reading aloud is that of looking at a map compared to walking over the actual terrain. Only a few critics have spoken their minds as forcefully on the subject as C. S. Lewis:

> They have no ears. They read exclusively by eye. The most horrible cacophonies and the most perfect specimens of rhythm and vocalic melody are to them exactly equal. It is by this that we discover some highly educated people to be unliterary.†

2. The practical attention to the physical words enforced by reading aloud protects a work from being usurped by the ambitious categories of much contemporary criticism. For example, when a work is read aloud the speaker implied or projected by speech-act and communication theories no longer remains a phantom, a putative offstage role never available for examination. He enters and speaks his text for us to hear and respond to. Reading aloud also obliges us to register literary works first in linear human time, with its subtle

* Ibid., p. 366.
† Quoted in Robert Beloof, *The Performing Voice in Literature* (Boston, 1966), p. 107.

aspects of evanescence and renewability, before the text can be converted into a synchronic structure out of time and subsumable under a diagram. The presence in live performance, however informal, of all three elements of the communication transaction (addresser, message, addressee) discourages premature concentration on one of these as the object of criticism. Oral interpretation can at least delay the abduction of the text by method, theory, or system.

3. An emphasis on oral interpretation in literary criticism would restore our sense of the power of the speaking voice. Western phonetic languages (and to a comparable degree Eastern logographic languages) have articulated the sounds of human speech. And because of the way it is produced and received, vocal speech can convey thoughts and feelings not available to vision. Our need for vocal communication, wrote St. Augustine, "is occasioned by the deep of the world, and by the blindness of the flesh, which cannot see thoughts; so that there is need to speak aloud into the ears."* Sound rather than vision appears to be the most effective and sensitive transmitter of human thought and feeling and therefore capable of uniting us in the experience of the present. Writing records this experience without reproducing it.

The most deep-seated reason for the privileged status of speech in our lives probably springs from its close relation to fundamental biological rhythms. In *The Biological Foundations of Language* Eric Lenneberg explains, "It has long been known that the universal rhythmicity of the vertebrate brain . . . is the motor for a vast variety of rhythmic movements."† He refers to breathing, heartbeat, walking, and speech. The physicality of speech and its reliance on the presence of two parties at least marginally in communication with each other keeps it in touch with the whole of our being, mind and body, reason and feeling. Most of the relevant quotations are widely known.

> I lay it down as an educational axiom that in teaching you will come to grief as soon as you forget that your pupils have bodies. Above all the art of reading should be cultivated.‡

* Quoted in Hollander, op. cit., p. 250.
† New York, 1967, p. 119.
‡ Alfred North Whitehead, *The Aims of Education* (1929; reprinted, New York, 1967), pp. 50, 58.

Recitation has been defended as the true test of the quality of a poetic work by Frost, Eliot, and Gerard Manley Hopkins.

> Sentences are not different enough to hold the attention unless they are dramatic. No ingenuity of varying the structure will do. All that can save them is the speaking tone of voice somehow entangled in the words and fastened to the page for the ear of the imagination. That is all that can save poetry from sing-song, all that can save prose from itself.*

> What I call the "auditory imagination" is the feeling for syllable and rhythm, penetrating far below the conscious levels of thought and feeling, invigorating every word; sinking to the most primitive and forgotten, returning to the origin and bringing something back, seeking the beginning and the end. It works through meanings, certainly, or not without meanings, in the ordinary sense, and fuses the old and obliterated and the trite, the current, and the new and surprising, the most ancient and the most civilized mentality.†

> . . . above all, remember what applies to all my verse, that it is, as a living art should be, made for performance and that its performance is not reading with the eye but loud, leisurely, poetical (not rhetorical) recitation, with long rests, long swells on rhyme, and other marked syllables and so on.‡

The gradual dissociation after Socrates of thought from speech and the ultimate displacement of oratory and dialectic by the privacy of print§ have not prevented literature from remaining deeply oral—even prose fiction. Flaubert shouted his sentences to himself in his *gueuloir* in Croisset. Tolstoy read his chapters aloud to his family as he wrote them. The innovations of modernism, such as free verse from Whitman to Cummings, stream of consciousness in Joyce, verbal inventions from Gertrude Stein to Barthelme, and even Proust's long-distance periods, are all largely oral. How can we read, let alone *teach*, any of them without assaying their auditory nature?

* Robert Frost, "Preface" to "A Way Out," in *Selected Prose*, edited by Hyde Cox and E. C. Latham (New York, 1966), pp. 13–14.

† T. S. Eliot, "Matthew Arnold," in *The Use of Poetry and the Use of Criticism* (Cambridge, Mass., 1933), p. 111.

‡ *The Letters of Gerard Manley Hopkins to Robert Bridges*, edited by C. C. Abbott (Oxford, 1970), p. 246.

§ See William K. Wimsatt and Cleanth Brooks, *Literary Criticism: A Short History* (New York, 1964), Chapter 4; Walter J. Ong, "Transformations of the Word," in *The Presence of the Word*.

That certain authors, like Dreiser or Hegel, sound clumsy when read aloud provides an accurate commentary on their deafness to language. They survive by other means.

4. The oral approach to literature can help establish among the young the opportunity to improve voices for expressive and pleasing speech. A large part of religious training and military discipline is based on the ancient belief that by learning and performing the outward physical signs of emotions and moral attitudes we will come to experience those emotions and attitudes inwardly. Training the voice in control and expressiveness very probably enlarges the scope of mental states available to us—particularly in a culture where the tonalities of speech have fallen badly into neglect and abuse.

"The quality of life," to which we now pay close attention, depends greatly upon the tonality and dynamics of the voices with which we communicate with one another. Those vital sounds influence our moods more subtly than the weather and music. My own experience in a fairly large university course in world literature has taught me that the lecture-discussion method of presenting literary work leaves a far more vivid and lasting impression on students when it is directed toward some form of interpretative reading. Certain authors, indeed—and by no means only poets and dramatists—cry out for oral performance and remain difficult of access without it: Milton, Diderot, Goethe, Wordsworth, Whitman, Emily Dickinson, Flaubert, Chekhov, Eliot, Proust.

More important than my own testimony is the fact that a professional discipline of oral interpretation already exists in this country at several colleges and universities, sometimes organized into an independent department or program, sometimes taught in the drama or speech department. Many of these students go into college or high school teaching. The gulf of ignorance and neglect that separates these programs from the traditional study of literature in English and other literature departments is, to my mind, scandalous to the point of looking like a conspiracy to suppress the opposition. But no, the standoff is probably attributable to the monopoly of the written word and to the deep-seated reluctance of most literature teachers to read aloud, to interpret orally.

5. The arguments that oppose the ideas I have been voicing belong to a tradition as old as the invention of printing. "The pen is the tongue of the soul," wrote Cervantes. A sentence lifted out of Emily Dickinson's letters has been mistakenly construed as demon-

strating her opposition to reading aloud: "A Pen has so many in-
flections and a Voice but one."* Such apparent declarations of faith
in silent reading are rarely assembled and systematically examined.†
The clearest presentation of the arguments I have discovered is con-
tained in Suzanne Langer's *Feeling and Form*: Unlike music, which
arises from our perception of "the passage of time made audible by
purely sonorous elements," poetry "is not a fabric of *tönend bewegte
Formen*," and therefore lends itself to silent reading. She grants that
some poetry "profits by, or even demands, actual speech," but argues
that

> much poetry and nearly all prose should be read somewhat faster
> than the normal rate of speech. Fast speaking does not meet this
> demand, because it becomes precipitous. Silent reading actually is
> faster, but does not appear so, because it is not hurried at the quicker
> tempo, whereas physical enunciation is. The images want to pass
> more swiftly than the spoken word. And furthermore, in prose fic-
> tion as well as in a good many poems, the voice of a speaker tends
> to intrude on the created world, turning formal lyric address such
> as: *I tell you, hopeless grief is passionless . . .* into genuine speech,
> addressed by the poet's proxy—the speaker—to another real person,
> the listener. A novel that centers chiefly in the creation of virtual
> personalities almost always suffers, when read aloud, by the periph-
> eral presence of the reader.‡

Now what Langer is getting at, I believe, is closely related to a
debate in film criticism about the relative virtues of a novel and a
film version of it. Since words only signify and suggest, and do not
in any way embody a world, a written text projects a virtual or im-
plied space which the reader's imagination must actively fill out of
its own experiences and associations. By contrast, in performance or

* Quoted in Stanley Burnshaw, *The Seamless Web* (New York, 1970), p. 247.
The full context of the quotation reveals that Emily Dickinson was wary of the
slippage of script and was affirming the precise nuances of direct speech. In this
letter of August 1876 she is answering a letter from T. W. Higginson: "Dear
friend: I almost inferred from your accent you might come to Amherst. I would
like to make no mistake in a presumption so precious—but a Pen has so many
inflections and a Voice but one, will you think it obtuse if I ask if I quite
understand you?" *Letters*, edited by T. H. Johnson (Cambridge, Mass., 1958),
Volume II, p. 559.

† For a lightly sketched historical exploration, see Elias Rivers, "Literature as
the Disembodiment of Speech," in *What Is Literature?* edited by Paul Hernadi
(Indianapolis, 1978).

‡ New York, 1953, p. 278.

in a film, this space is filled in by the speaker's or director's imagination. The ambiguities and mysteries in the printed text are channeled into a limited range of rhetorical and dramatic effects. St.-John Perse took this position in opposing any oral recitation of his works and favoring a mental reading. But Langer's observations do not, as I see it, necessarily establish the superiority of silent reading. Rather they seem to suggest that silent and oral readings can be seen as complementary. Furthermore, she is dead wrong about rate. Most good prose and poetry, particularly when they contain images, should be read more slowly than the normal rate of speech. Precisely this shift of pace enables reader and listener to experience the subtleties of the passage.

The burden of my argument here is not to suppress silent reading but to advocate the need for both. I am trying to repair the present imbalance and give oral reading its deserved place. These two modes of approach to a work feed each other; the classroom offers a particularly good opportunity to combine them. An oral interpretation may well extend our understanding of a work beyond the range of our own experience and imagination more convincingly than a commentary could do. This is precisely because reading aloud is a public act, open to examination, shared by many observers who can then discuss the "reading" as they cannot so readily discuss their several private and silent readings.

I would not suggest that reading aloud produces a definitive or authoritative version of "the work itself." The purpose of reading aloud is basically heuristic. In trying out several different oral versions a group can explore the meanings released by a passage more effectively than if it is discussed in an incompletely shared set of private readings. A similar assumption lay behind the once universal exercise of translating classic texts—not to produce a perfect version but to show students the subtleties of language and literary discourse through translation.

Following the virtual reversal of the classical ideal of "clarity" in literature that has occurred in the nineteenth and twentieth centuries, many contemporary critics take an intellectual delight in discovering the greatest possible number of meanings in a work. Seven types of ambiguity led to polysemy, which led in turn to valuing quantity of meaning over quality, and then to the practice of tricking out the printed word in hyphens, parentheses, slashes, double

columns, foldouts, and nonlinear format, in order to redouble the overlay and iridescence of meanings. (Some of these devices amount to directions for oral performance.)

Yet if literature is to be valued as a shared enterprise we must find a common ground of meaning and a limit on the splash and overflow of divergent interpretations. Even information theory sets a ceiling to the number of "bits" the human mind can process; every channel has a capacity.* Oral interpretation can serve as a kind of test or verification that will suggest just how much of a work can be transmitted by speech to a community of listeners. It is true, as Emily Dickinson's one-liner states with beautiful economy, that an oral presentation may require the reader to choose between, say, an ironic and a naïve tone of voice, whereas a silent reading would allow those two moods to flicker in the mind. In a reading by a competent performer, however, the vividness of the meanings conveyed will more than compensate for those set aside.

If not all critics, at least most teachers are potential performers, and all of us can develop our skills in that direction according to our gifts and opportunities. The tradition of reading aloud in the family circle barely survives today in the face of competition from stereo recordings, television, movies, transistor radios, and engineered sound amplification. The formidable group of nineteenth-century British authors who, without loudspeakers, turned professional readers and lecturers for lucrative American tours (Thackeray, Dickens, Matthew Arnold, Oscar Wilde, Conan Doyle, and many more; plus our own champions: Emerson and Mark Twain) served to encourage domestic readings in a pre-media era. In our contemporary electronic paradise, what is to become of our faculty of speech and its potential to foster feelings and community? The pervasive force of television confronts us with what is only a phantom oral culture: it offers no presence (the visual side is often redundant and dispensable), no participation, no exchange, no sense of collectivity—a depressingly one-directional enterprise.†

* See the remarkable exploratory article by George Miller, "The Magical Number Seven, Plus or Minus Two: Some Limits on Our Capacity for Processing Information," The Psychological Review, 63 (1956), 2, pp. 81–97.

† After finishing this essay I discovered a pertinent article by Walter J. Ong, "Literacy and Orality in Our Times" (Profession 79 [New York, 1979], pp. 1–7). Ong traces the gradual displacement of "primary orality" by "literacy." I would argue that the writers' statements I have quoted here suggest that the most

Those of us who deal with language and literature can do far more than we are now doing to keep the spoken word alive and responsive to its expressive resources. We need constantly to reconsider our theories of literature and our methods of approaching it. But the vast exercise of criticism that goes on in the form of teaching literature in school and college will serve its purpose handsomely if it turns a substantial part of its attention to the trials and rewards of oral interpretation. The best literary works will grow with each reading. Perhaps old Professor M. should be kept on a year or two to teach *Don Quixote.**

powerful works of modern literature flourish in a frontier zone claimed and colonized *both* by primary orality (characterized by "rhapsodizing," recourse to proverbs, composition by sound patterns, and playing with language) and by literacy or writing (relying on linear action and argument, analysis, abstraction, and classification). I hope it is evident that I seek above all some means of keeping this fruitful conflict vigorous and unresolved, in readers as well as in writers.

* I wish to thank Frank Galati (Northwestern University) and my colleague Arthur C. Greene for their instruction in the art of oral interpretation. A. James Arnold, Nathan A. Scott, Jr., and Roland Simon gave me trenchant criticism of an early draft of this essay.

The Poverty of Modernism

On that Christmas night, the U.S. customs inspectors at the Canadian border did not delay the southbound *Montrealer*. The growling, snow-streaked train arrived just before ten, in Richmond, Vermont, and took on about thirty skiers from Stowe. As they clustered around the steps to climb aboard, their collective breath filled the cold night with so much vapor that it looked like the return of the steam era.

In the club car among the Scandinavian sweaters and down parkas, one passenger looked out of place. He sat alone with a drink and a book, wearing a dark green turtleneck under his corduroy jacket. Graying hair seemed to heighten the alertness of his small face. He might have been forty-five. The influx of passengers carrying bulky luggage made him look up with a frown. Then he concentrated on his book again. A young man with a full blond beard passed him,

looked around, paused, and turned back. He was already smiling as he put down his ski boots and backpack.

"Mr. Carlson! Edgar!"

Their handshake was genuinely cordial. Twenty minutes later they had reconnoitered the two years since Chuck had left the University of Pennsylvania with an M.A. in English. Edgar Carlson's suggestion that he go on for a Ph.D. in comparative literature had not held Chuck. He was now working as junior editor for a Boston publishing house and also selling the trade list to New England bookstores and jobbers. After a few days of skiing with a friend, he was on his way to New York on book business. Edgar Carlson was chairman of the comparative literature program at Penn. This year for the first time, he told Chuck, he and his wife and three teenage children were spending Christmas at their little summer place near Burlington. Edgar talked for a while about keeping a wood stove going and getting the driveway plowed.

In the lull after the first exchange of information, Edgar ordered another round of drinks. Chuck looked with curiosity at the man whom, for over a year, he had admired and resisted in equal proportions, the person he probably would have tried to emulate. His "mentor" appeared wearier than Chuck remembered him, but the smile was still warm around the hazel eyes.

Edgar Carlson felt both pleased and saddened to run across the student who had caused his most lingering disappointment. He hoped he could have a talk with Chuck, yet didn't want to press things. In one of the rare postcards they had exchanged, Edgar had asked Chuck to call him by his first name.

Chuck spoke first. "Edgar—it doesn't sound right yet—what takes you away from the family nest on Christmas night?"

"M.L.A. Remember? Our annual convention."

"Oh yes. It's one of the reasons I quit. Why teach if you can't stay home for the Christmas holidays? Why do you go this year when you could stay in Vermont? You have candidates to interview for an opening?"

"Not really. You're right about M.L.A. My wife could kill me. One of the pipes froze last night, and she'll have to deal with the plumber. But a year ago I was invited to give a paper at a general session. I figured I shouldn't turn it down. The subject is right up my alley."

"Wyndham Lewis?"

Edgar laughed. "Not quite. Modernism. I'll have twenty min-
utes. It's a good panel. They're importing some big names from
France and England."

Chuck declined the cigarette Edgar offered him and looked
around the car. Among all those gesticulating people in ski clothes,
he couldn't keep Edgar in focus. "Why don't you tell me what
you're going to say in your paper? That way I can find out what
you've been thinking about for two years."

"Well, if I give you my spiel, you'll have to agree to be a stern
critic. Remember what a hard time you gave me when I began to talk
about codes and textuality in my seminar?"

Chuck smiled and nodded. Edgar seemed to hesitate and played
with his cigarette. Then he straightened up in his chair and
began.

"The tack I take is to say that we can't talk about modernism in
the arts without going back at least to 1750—the English novel,
Rousseau and Diderot, early German Romanticism, the rise of sci-
ence. And that in the 1980s we're approaching a new *fin de siècle*
complete with revived decadence, catastrophism as a way of life, and
a systematic refurbishing of art for art's sake. In Europe and the
Americas, that is. We're building a higher ivory tower, critics and
artists together. The real world, if it exists, can go hang."

The train lurched so hard that they both reached for their glasses.
Chuck seemed to be musing. "Isn't someone going to object that
you're trying to make the twentieth century into a replay of the
nineteenth?"

"Don't jump too fast. But that's partially right. What I argue is
that our new *fin de siècle* carries two distinguishing marks. No one
could miss them. First of all, we are trying to abdicate individuality,
personality, identity, and everything related to them. We settle all
their claims in favor of a supposedly prior entity: language. The new
champions—Saussure and Wittgenstein, Sapir and Whorf, Lévi-
Strauss and Barthes—have a simple message: Language made us. I call
it neocreationism. For these people, language didn't evolve out of a
long struggle between individual human beings and the realities of
life. It's just there, the sole given, occupying the whole landscape. It
takes the monumental form of myth. It flows through a few select
minds and comes out in the form of mysterious, autonomous, self-
generating *écriture*, otherwise known as *text*, endowed with *textualité*.
It breaks out everywhere and anywhere in the form of cultural codes

waiting to be interpreted. *Eigentlich spricht die Sprache*—Heidegger said it all. When you reach the top of the extended ivory tower, there's no one up there, no people, just the booming echo-chamber voice of language talking to itself. I quote Joyce and Calvino."

Chuck had nodded a couple of times. "Even before I quit Penn, I noticed that the trendy graduate student in English or French never says poem or novel, work or book anymore. Everything is text, text, text. It sounds like a password, or a chant."

"Don't interrupt yet, Chuck. Now that you've got me started, you're going to have to stay still to hear my second point about the new *fin de siècle*. We really don't like surrendering everything to language. So in order to get back our individuality and some sense of choice in living our lives, we have had to find a new hero. Or rehabilitate an old one. Not the warrior; not the saint; not the scientist. Today our model is the actor. Almost anyone could write this section. From Oscar Wilde to Pirandello to Existentialism to the Theater of the Absurd, personal identity and authentic living have become increasingly a matter of role-playing, of self-creation in situations. Sartre's *pour-soi*, for example, is a purely theatrical notion, and also a parody of it. His famous café waiter acts his role in order to assume his status, in order to become himself. 'The truth of masks' goes back at least to Stendhal and Baudelaire, to Kierkegaard and Nietzsche. Or read John Barth. Every character is a charlatan and revels in it. And look what's happening now in sociology and anthropology and psychotherapy. They're awash in theories of performance and social enactment and game playing. So there's my second point. First we drain the best of ourselves away into the collective dynamics of language, and then we try to put it back by playing roles and projecting self-images. A queer game. Of course I'm talking about intellectuals trying to locate or resist the latest trends. Like me . . . Probably no one else in this car would follow a word of this rant. What about you, Chuck?"

"Oh, I follow you. I haven't stopped being an intellectual just because I ski." Chuck made a few vague gestures. "Do you say all that in your paper?"

"Of course not." Edgar caught the waiter's eye and ordered another round. "I feel lousy about leaving my family before the Christmas turkey's cold. I've had four drinks. I don't like what I've written in the modernism paper. I meet a former student who left

the fold two years ago but seems ready to listen still. So you've just heard a juiced-up, club-car version. To tell the truth, I like it better than the original, which is pretty tame."

The car was quieter now. But the two of them had moved closer, as if the noise had increased. Chuck waited, sensing that it was his turn, yet uncertain how much to say. When he spoke, the words came softly.

"You must have been saving up for a long time, Edgar. You're bursting with polemics. Something's gnawing at you. Your ideas may sound a little strange at M.L.A. And I don't understand where you stand yourself. Are you with them or against them? Who's the *we* you keep using?"

Edgar lit another cigarette and watched the smoke he made. Everything around them was pulled from side to side in an endless series of jerks, and the two of them swayed in unison with the other passengers. "You're incorrigible, Chuck. You hear me almost too well. How can I take a stand when I'm swimming in deep waters like everyone else? That's what the *we* means. All I can do is decide what direction to swim in. Unlike most of the others I still think there is a bottom somewhere, and I haven't given up looking for it. To explain that I'll have to tell you about the part of the paper I haven't written."

Chuck laughed. "Is that why we met tonight? So I could be your audience?"

Edgar nodded and went on. The drinks had made him intense. "Funny thing is, I remember this part better than the rest. I see a set of twentieth-century texts—works—lined up, like points on a curve." His hands sketched it out. "Strindberg described his own *A Dream Play* by saying, 'Anything is apt to happen, anything seems possible and probable.' That was 1902. In 1925 Gide has the narrator of *The Counterfeiters* warn us that he's going to mix everything into the pot—real, imaginary, fantastic—with no holds barred. There's even a chapter about an angel walking the streets of Paris! Twenty years later Borges, in an apocryphal lecture in Montevideo, proposed that fantastic fiction (meaning his own) relies on four devices: the work within the work, the contamination of reality by dream, time travel, and the double. Each one of these devices serves in some way to undermine our sense of the reality and identity of anything. When Robbe-Grillet wrote the introduction to his scenario of *Last Year at Marienbad* in 1961, he no longer bothered to treat

fantasy as a separate genre. It's all one. I can quote you the key sentence by heart: 'The total film of our mental activity admits, one after another, at the same time, and without distinction, real fragments relayed by sight and hearing along with remote fragments from the past and future, or even the totally phantasmagorical.' *Without distinction*—that's the crux of it. It means there's no way to tell the real from the imagined.

"They're all saying the same thing. It goes on and on. Having assimilated Borges and Robbe-Grillet and God knows who else, Gabriel García Márquez created the masterpiece in the genre. In *One Hundred Years of Solitude* everything begins in reality and ends in fantasy. You can watch it happen. The natural gives birth to the supernatural, the surreal—with no detectable shift in style or tone. Believe or disbelieve the events at your own risk. It's like an unstoppable roller coaster—but we're not supposed to get dizzy! Just let it all flow by.

"Do you see the curve now? Language has assumed the throne. It asserts its sovereignty in a universe of signs that owes no loyalty of correspondence or plausibility to a prior *reality*. For there is no reality, no natural world against which to measure the inventions of language. We are free to play with words and ideas and situations as we will—with strict rules or no rules. Result: a genre that I call the metaphysical picaresque. It's everywhere. Soon it will drive out all other forms, like bamboo in the lawn. And you can see what it adds up to. Each one of these works of the metaphysical picaresque devises its own particular reenactment of *Don Quixote*—but with one major difference: Sancho Panza has been eliminated—gagged or kidnapped or killed outright. Without his voice of sanity and reality, all modes of existence can claim equal status. And they do—*without distinction*. We seem to want that. *One Hundred Years of Solitude* pleases everyone just by the way it keeps on overflowing the pot and outdistancing reality. The more a work makes us lose our orientation, our sense of constraints, the more we praise it. The metaphysical picaresque. There. Now, you've heard it. My palaver is over."

Edgar leaned back but he didn't subside. He looked at Chuck with a mixture of defiance and sheepishness. The train was drifting through the darkness, neither fast nor slow, neither accelerating nor braking. The waiter announced that the bar would close after the stop at White River Junction. Chuck looked at his watch: past midnight. He began to talk as the scanty lights of White River floated

across the huge windows, and they both rocked forward slightly as the brakes tightened.

"If that's what you didn't write, let me try to tell you *why*. You know, we got some of that in your seminar on narrative. You were fighting with yourself for a whole semester, and you even used the term 'metaphysical picaresque' once. Then dropped it. I think you've stopped short of the final step. That's why you haven't written it out. But you must have seen where you were headed. Remember when you made us go back and read the tenth book of the *Republic* and Aristotle's *On Interpretation*? You spent half the next class talking about 'modalities.' You said that Plato's vertical scheme of ideas at the top of diminishing levels of imitation was absorbed into Aristotle's horizontal scheme of modalities. Four of them: the impossible, the possible, the contingent, the necessary. You said it has taken us three thousand years to learn that true wisdom consists in discriminating adequately among these modalities and in living accordingly. The philosophers and thinkers of every age have rearranged the modalities a little and sometimes changed their names. The latest major revision is Freud's. He reduced them to two: the reality principle and the pleasure principle. A little like Plato's two horses in the *Phaedrus*.

"Up to here it's your thinking. This is where the connection comes. You must have made it. The modalities have to be prior to language. To put language first runs the risk of destroying the modalities."

As Edgar listened, his eyes shone. With his open right hand he made the self-effacing gesture that invites another person to go first through a doorway. Chuck paused, smiling at the invitation, and then went on.

"The metaphysical picaresque sets three thousand years of hard-earned philosophical thought on its head and jettisons the modalities as irrelevant. Anything goes. Playtime of the arbitrary and the autonomous. There are no fundamental distinctions. Dream has contaminated all domains. We cannot locate anyone for sure, least of all ourselves, because a double lurks in every corner. The work of art doesn't refer to a recognizable reality but gives way under our feet to an infinite regress of embedded works and interior reflections. A bottomless abyss of art. You quoted Strindberg: 'Anything is possible and probable.' No modalities for him. And Robbe-Grillet was talking about using all the modalities 'without distinction.' Same

difference. They abandon the long struggle to separate appearance and reality, fact and fiction. Someone else will do that—the philosophers maybe, or the reader, if he survives.

"But"—Chuck's forefinger rose as high as the top of his head in his most forceful gesture yet, and he continued—"we shouldn't be taken in. All those metaphysical picaros are dependent on the rest of us bourgeois philistines to keep reality and the modalities in place. That way they can play with them, deface them. The language creationists and the writers climbing the ivory tower aren't a real opposition ready to take power after a struggle and occupy all literature. Their 'adversary intention' has careful limits. They want to sustain the bad-boy status and the appearance of daring and danger. In order to do so, they need an antagonist strong enough to make them look like the underdog. It's a recognized form of parasitism. Maybe symbiosis if you look closely. Since we value deviation and discrepancy, some norm must exist. Otherwise how could we identify a deviation? It's elementary. The modernist picaros need their host-adversary in order to feed on it and scoff at it; the host needs lots of kicks and pricks to stay alert. Maybe it's a healthy situation.

"The trouble is, no one will stay in position." Chuck had found his voice now. The train was swaying heavily as it gathered speed out of White River, and a last round of drinks stood untouched in front of them. Chuck went on, "You talked about a higher ivory tower, where the modalities no longer hold, where there's no telling the difference between the phantasmagorical, the contingent, the real, the necessary. Okay. That's your new *fin de siècle*. But when pressed, these new decadents reverse themselves. They won't stay put. I remember that Robbe-Grillet passage you quote about mixing all types of fragment without distinction. But he goes on and claims in defense of *Marienbad* that this total film is also the most faithful, the 'truest' account available of our ordinary affective life. Those are almost his words. It's not a higher ivory tower anymore. It's a deeper slice of life. Gide makes the same claim somewhere about *The Counterfeiters*, I think. From fantasy unleashed to improved realism. They confound themselves. Of course, it may be their secret weapon, their double whammy. They will win both ways if we don't watch them closely."

Edgar shook his head slowly. A crooked smile creased one side of his face all the way back to the ear. "You should never have left us, Chuck. Just look at what you can do. You run circles around me

using my own ideas. Maybe you should stand in for me tomorrow.
It's uncanny. I started following up that parasite argument, too, but
I came out in a different clearing. There was a line I just hated not
using: 'All well-brought-up modernists are conservationist in dealing
with the physical environment and stripminers in dealing with the
intellectual environment.' I'll have to keep it in the freezer.

"But listen, Chuck. Some happy fate must have brought us to-
gether. You may not believe it, but I had forgotten all about the
business of the modalities. It sounded pretentious when I tried to
lay it out in class. If I remember right, I got no response at all, no
excited note taking or questions. I guess I suppressed it. Now you turn
up like a messenger of the gods in disguise and supply me with the
missing link in my own argument about language creationism and
the confusions of the metaphysical picaresque. Modalities . . . of
course . . . still . . ."

For a time Edgar was perfectly quiet in his chair, except for
his eyes. They moved restlessly across the blackness of the window
that hid the landscape, probing its seeming depths, ignoring the flat-
tened reflections of the car on the surface. Chuck waited and let
Edgar pick up the thread of his own thought.

"Still, I can't hold too steadfastly to the modalities and refuse
to admit works that blur the borders. I'd be violating my own tastes
and instincts, which is where we have to start. Cross-contamination
may sometimes be necessary. If I take the modality argument all
the way, what becomes of *Gargantua*? or *In Praise of Folly*? or *Faust*?
or *Ubu Roi*? I can't sacrifice them to a principle. They are a prin-
ciple in themselves. Even Corneille knew you have to break the
rules: '*Les grands sujets vont toujours au delà du vraisemblable.*' I
think that's why I haven't been able to write this part. I still couldn't,
even with the modalities added. I'd be locking myself into a theory—
a theory I believe but cannot systematically apply."

"I think you could handle that." Chuck's voice sounded both de-
tached and insistent. "That's not why you can't write this part. It's
because you accepted an impossible subject."

"What do you mean?"

"Modernism," Chuck said. "It goes nowhere. It's a dud. Look
what it makes you do, or keeps you from doing. Look what it makes
me try to do."

For the first time Edgar looked a little nettled. "You're supposed
to say, Look at the heights it's carried you to."

Chuck didn't yield. "You asked me to play the critic. Don't call me off. I can just see the program of your panel. 'Modernism and the Strategies of Desire.' 'Tolstoy, or the Closet Modernist.' 'The Modern, Modernism, Post-Modernism, Modernismo, Modernization, Modernité, Merdonité—a Trial Taxonomy.' Something like that? Look, Edgar, it's all make-work, an exercise in nomenclature with no grounding in compelling events or works. Modernism is not a meaningful category of literary history or art history. It's a feather bed for critics and professors, an endlessly renewable pretext for scholars to hold conferences, devise special numbers, and gloss one another's works into powder. You talk about the metaphysical picaresque. Where will Sancho Panza be during tomorrow's M.L.A. panel? Bound and gagged in the coatroom."

For some time Edgar had been inching forward to the edge of his chair, and he held his hands in front of him, waiting to make a gesture. He broke in before Chuck had finished. "Modernism is not a period, like the Victorian Era. It's not a proper school or movement, like Surrealism. It has no geographic character or associations, like *Der Blaue Reiter*. It serves no heuristic purpose, like the Enlightenment or Romanticism. It suggests no stylistic practice, like Baroque or Imagism. It's the weakest term we've had since Symbolism, which even Verlaine mocked by spelling it with a *c* and an *a*. But best of all"—Edgar paused long enough to finish his drink and make an abortive move toward standing up—"modernism embodies a disabling contradiction. It has cancer. The only general characteristic of the modern era is the celebration of individual experience, of particular feelings in particular circumstances, not repeatable. Every epiphany is *sui generis*. The term 'modernism' tries to make a category of items that will not fit into a category . . ."

Edgar waved instead of finishing. They were both planing now, half dancing in their seats while the nearly empty car rumbled through the dark. Chuck took his turn happily.

"See, if you can't have a real category, you palm off a negative category on me, a phony. It must be the teacher in you, Edgar. You can't survive without a cubbyhole. That's all we're talking about, isn't it? Cubbyholes? Like the metaphysical picaresque. Listen, I have a series of quotes for you. At least one I got from you. I must have been saving them up for tonight. First Ortega: 'Man has no nature. What he has is history.' Emerson was there waiting for him: 'Properly speaking there is no such thing as history. There is only

biography.' And Gombrich coming in to meet them: 'There is really no such thing as art. There are only artists.' And finally, to stitch it all together, Chuck McDennis: 'There is no such thing as modernism. There are only professors talking about it in order to keep their tenure in the culture.' Try that on your colleagues tomorrow!"

Chuck's voice had remained buoyant, with no edge of bitterness or mockery. But Edgar's grin faded into a quizzical frown. The pause was almost awkward.

"Is that what made you quit, Chuck?"

"I guess so. At the time I didn't know what I was doing. But I couldn't stand the way literary works got lined up and systematized and left behind in most graduate courses—sometimes just ignored in favor of criticism and critical theory. Everything is a strategy. Even you worried me sometimes. I remember one day you referred to a book called *The Armed Vision*. I never read it. I don't know who wrote it or what it's about. But the title came to stand for everything I wanted to fight. I suppose it got mixed up with the antiwar, antimilitary demonstrations at the time. For a while I was going to write you a paper with the title 'The Disarmed Vision.' My manifesto. Oh, I had lots of ammunition . . . Damnit, there's the military metaphor again."

They both laughed briefly. When Edgar spoke, his tone was relaxed. "Aren't you pushing us professors a little hard? We know modernism is a makeshift. But feather bed—that goes too far. We all need handles on things—genres, names, cubbyholes, strategies. Students especially. They get desperate without clear reference points. You know that."

Chuck leaned forward. His young face carried more intensity now than Edgar's. "Don't always try to say as much as you know, Edgar. At least not in that direction, not toward abstraction and classification. You must have some wonderful things in your paper, believe me, but it sounds as if they get lost, buried. All that modernism framework carries you further and further away from individual writers. What did you say about García Márquez? Everything starts in reality and ends in fantasy? That's fine. You can do something with that, something much more important than tucking *One Hundred Years* into a little subcategory of modernism. Show us what he does and how. You're good at that. No big schemes, no systems of signification. You were best in class when you got warmed up and just read aloud with a few running comments. Why did you always apologize

after you did that? Once when you were reading Blake to us I thought you'd had a few too many drinks before the seminar. But it was great."

Edgar grinned before he spoke and raised his glass. "The drinks are tonight. We should be reading Blake. Or Emily Dickinson. I think you fell in love with her, no? . . . Do you ever think of starting again?"

Chuck raised his glass and held it up for a moment in silence. "You remind me of the story you told us yourself, I think, about Emerson visiting Thoreau when Thoreau was in prison for refusing to pay his income tax. I always use it when people ask me why I let my beard grow. Emerson said, 'What are you doing in there, Henry?' And Thoreau answered very gently, 'What are you doing out there, Ralph?' " Then Chuck shook his head and moved his arm as if to block something. "No, that's not right. I think we're in the right places now. You were born to teach and to be troubled by teaching. I'm made, or have made myself, maybe, to stay behind the wood-work and make a scratching noise every so often, like tonight. We couldn't improve on the situation." Chuck finally put down his glass.

"But now listen to this. It's your turn not to believe me. I've been looking for an author to write a book for which I have chosen the title: 'The Unseemly Schemes of a Junior Editor.' But I'm serious. As you probably know, Proudhon attacked Marx in a book with the title *The Philosophy of Poverty—La Philosophie de la misère.* Marx roared back in French with *The Poverty of Philosophy.* André Breton picked up the exchange in a Surrealist-political diatribe he called *The Poverty of Poetry.* Recently E. P. Thompson, the English neo-Marxist, has denounced everyone in sight with *The Poverty of Theory.* So I figure the scene is set and the time has came for a definitive polemic called 'The Poverty of Modernism.' I've been looking for a year. No luck. No serious candidates. But now you've just delivered yourself unwittingly into my hands, haven't you? May I send you a contract next week when I get back to Boston? From what you've said, the book is already half written. I can't understand why I didn't think of you right away. Suppression? Censorship? But why?"

"Maybe because you didn't want to admit to yourself that I could do it only with your help. Well, ask me again after the M.L.A. I'll rewrite my paper tomorrow, using some of this." Edgar raised both his palms. "Something ought to come of it."

The windows in the car looked like a bank of dark, oversize TV

screens. Only an occasional blip of light in the countryside wandered across the empty scopes and disappeared off the opposite edge. It would be twenty minutes before the brakes clenched again for Bellows Falls.

AFTERWORD

None of us can ever retrieve that innocence before
all theory when art knew no need to justify itself.
—Susan Sontag, "Against Interpretation"

In matters of literary experience, as in all other ex-
periences, one is a virgin but once.
—Murray Krieger, "The Vanity of
Criticism and Its Value"

Thomas Reid, writing against Hume in the 1780s,
and J. L. Austin, writing against Ayer in the 1950s,
had a lot of fun at the expense of the idea that we
might peep back behind our judgments to "the ex-
periences on which they are based."
—Richard Rorty in *The New Republic*,
December 6, 1982

The Innocent Eye
and the Armed Vision

Where does one start? The three epigraphs answer with a single
voice: By the time we can talk seriously about literature, it is too
late to find a natural starting point in any direct, spontaneous re-
sponse to the act of reading. All readings are culturally determined;
our innocence slipped away too long ago to remember now. The up-
to-date intellectual version of "You're a virgin only once" (a saying
I have found in no collection of proverbs or folklore) sounds like a
chant: "Everything is always already interpreted." We live all our
lives in the prison house of language, from whose codes and con-
ventions no particle of our experience can escape. Only when you
have picked out for yourself a literary theory and a critical method
can you begin to discourse securely on literature with the other
prisoners. The armed vision is the only vision.

This influential philosophical half-truth has tended to obscure

a valuable attitude in and toward art that I can best evoke by further quotation.

In December 1817 an English poet aged twenty-two dined in London with half a dozen fashionable wits whose company he despised. Later, during a discussion with a friend as they walked back to Hampstead, "several things dovetailed in my mind." The letter he wrote to his two brothers about that discussion contains a celebrated and elliptic definition of

> . . . what quality went to form a Man of Achievement especially in Literature and which Shakespeare possessed so enormously—I mean *Negative Capability*, that is when a man is capable of being in uncertainties, Mysteries, doubts, without any irritable reaching after fact and reason.

Because of John Jeffrey's unreliable copying, a few words here may not be accurate. But Keats's meaning is picked up and reinforced in many other letters where he speaks of "passive and receptive" moods, of "the Chamber of Maiden Thought," and of "complete disinterestedness of mind."

Keats's quietistic approach to setting aside confining categories of thought and stock responses is matched at the other end of the poetic spectrum by the paroxystic "*long, immense et raisonné déréglement de tous les sens*" of Rimbaud, by which the Poet "reaches the unknown." The two *Lettres du voyant* prescribe the whirling-dervish approach to regaining intellectual and spiritual innocence. Another half century later, Rilke advised a young poet to follow a path almost identical with Keats's.

> To let each impression and each germ of a feeling come to completeness quite in itself, quite in the dark, in the inexpressible, the unconscious, beyond the reach of one's own understanding, and await with deep humility and patience the birth-hour of a new clarity: that alone is living the artist's life [*künstlerish Leben*]—in understanding as in work.

It was Ruskin in *The Elements of Drawing* who found the key phrase.

> The perception of solid Form is entirely a matter of experience. We *see* nothing but flat colours; and it is only by a series of experiments that we find out that a stain of black or grey indicates the dark side

of a solid substance, or that a faint hue indicates that the object in which it appears is far away. The whole technical power of painting depends on our recovery of what may be called the *innocence of the eye*; that is to say, of a sort of childish perception of these flat stains of colour, merely as such, without consciousness of what they signify—as a blind man would see them if suddenly gifted with sight.

After quoting this passage, E. H. Gombrich is impelled to protest in *Art and Illusion*, "The innocent eye is a myth." But listen to Jules Laforgue's response to a new vision of the world he found in Impressionist painting in 1883.

Physiological Origin of Impressionism . . . Let us grant that if the pictorial work arises from the mind, the soul, it does so only by means of the eye, which functions basically like the ear in music. The Impressionist is a modernist painter who, endowed with an uncommon sensitivity of eye, forgetting the paintings accumulated through the centuries in museums, forgetting his optical training in art school . . . by means of living and seeing luminous forms frankly and primitively in the open air . . . has succeeded in remaking for himself a natural eye.

Aside from the knotty physiological problems of vision, of how far one can separate mind and body, Ruskin's and Laforgue's and even Rimbaud's innocent eye merits careful attention along with Negative Capability.

Variations on a myth? Yes, of course, as long as that term is construed to mean not damaging falsehood but useful fiction. We have a whole set of such devices that allow us to live beyond our immediate means or experience—the state of nature in philosophy, the corporation in economics and law, infinity in mathematics, salvation in religion. All the artists I have quoted from declare that the state of quietistic (or paroxystic) responsiveness represents an attainable ideal, a mystery that lies within our reach. They believe that there is more in the world around us—and particularly in the world of art—than meets an eye or a mind equipped in advance with ready-made questions, a set of categories, a method, a strategy. We are dealing with the most subtle of all hermeneutics. Candor is a goal, not a given. In spite of words like "primitive" and "childish" in the above quotations, the attitude they describe does not result from a lapse back into inexperience, a newly costumed anti-intellectualism. On

the contrary, the "new" in Rilke and the "remaking" in Laforgue point toward an advance beyond experience, an ulterior innocence derived from and building on our encounter with life, not know-nothingism, but a tolerant wisdom in the face of what we both know and don't know. No one has put the paradox so succinctly as Pascal: "*Il n'y a rien de si conforme à la raison que ce désaveu de la raison.*" ("Nothing is so consistent with reason as this disavowal of reason.") *

Literary study has many directions, and I pursue several of them in the essays of this collection. Here I am suggesting that it is possible, and sometimes advisable and rewarding, to start by looking at individual works with as innocent an eye as one can attain. Complete naïveté is impossible, but one can learn to put aside many categories of thought and provisionally to meet a work of art on its own terms. The armed vision of systematic analysis comes later when we wish to verify or correct our first response. We cannot do without logical processes and clear categories. Psychoanalytic and semiotic and sociological critics can track literary works to exciting areas in the unconscious, in language-like codes, and in social structures. There is a new energy and a new hubris in criticism. Because many critical analyses have the appearance of scientific reports or legal briefs, it has become difficult to raise questions of taste and value.

Can we identify a central purpose of literary study? We read *Madame Bovary*, for example, to learn about nineteenth-century provincial life, to take account of Flaubert's mastery of French prose, to examine the novel form at its peak of perfection, to follow a moving and revealing story of unsatisfied human longings, and, above all, to share all those aspects of the book with other readers as a point of reference for our sense of reality and moral values. In order to place and illuminate Flaubert's novel, we may explore complex lines of stylistic influence, propose laws of narrative effect and perspective, and codify the structure of his descriptions. But the heart of our reading of Flaubert resides not in the generalities about lit-

* A startling number of key concepts in modern criticism and philosophy display a close relation to Negative Capability and ulterior innocence: Husserl's *epoché*, or bracketing; Shklovsky's *ostranenie*, or defamiliarization; Brecht's *Verfremdungeffekt*, or distancing; and Heidegger's *Gelassenheit*, or releasement. Each term designates a subtle mental operation that seeks to achieve freshness and particularity of attention. It is probable that all these notions should be traced back to Bergson's early writings on "a more direct vision of reality" than what we attain in our usual re-cognition of it. Of course, phrases like Coleridge's "film of familiarity" have been in place for much longer.

erary form to which his work gives rise but in the uniqueness of that individual creation, its particularity, which is not in any sense surpassed by or subsumed into theories of genre or style or meaning.* From the literary-humanistic point of view, the value and significance of *Madame Bovary* lies in the work itself, in the contrasting characters of Emma and Charles, in Flaubert's deeply equivocal attitude toward the possibility of expressing anything significant at all in language, and in much more that is inextricably embedded in the novel. I would maintain against strong intellectual currents flowing in other directions that the central purpose of literary study continues to be the reading and discussion of the masterpieces of literature. In doing so, one also participates in the gradual revision of that canon of works. Ideally, the reading begins simply, without elaborate critical apparatus, and moves toward a fully informed understanding. The innocent eye precedes the armed vision.

At its best the study of history and of literature confronts us with the fruitful conflict of two great truths—the puniness of human life and the marvel of human life. A deep knowledge of molecular biology or of anthropological archaeology may also oblige us to contemplate those truths, but differently, nomothetically. History and literature as basic humanistic disciplines convey their lessons idiographically, through individual cases—persons or works. "Science is of the general," wrote the literary historian Gustave Lanson, "but one must add: knowledge is of the particular." In contrast, an intelligent proponent of contemporary literary theory, Jonathan Culler, defines a literary work this way: "It is a tenuous intertextual construct, and the critical task is to disperse it, to move through it toward an understanding of the systems and semiotic processes which make it possible" ("Beyond Interpretation" in *The Pursuit of Signs*). Culler's project is essentially abstract and scientific—and of course perfectly

* My distinction parallels Windelband's 1894 division of thinking into the *nomothetic* method, which explores nature in order to establish universal laws, and the *idiographic* method, which examines and compares individual cases in order to discover their uniqueness. All fields of learning rely on both methods; in general, the sciences give priority to the nomothetic, the humanities to the idiographic. The "case method" of teaching, practiced today in many law and business schools, was originally promoted as "scientific" because it was more empirical than the exposition of rules and principles in lectures. The emphasis on clinical medicine in medical schools seeks to keep a balance between idiographic and nomothetic. My approach to literature and the arts favors the idiographic direction.

legitimate. Its purpose is to lead us away from literary works toward presumably higher systems and processes. The reasons for my uneasiness over this trend in literary studies is beautifully expressed by an author usually considered a social scientist, the anthropologist Edward Sapir.

> In spite of the oft asserted impersonality of culture, a humble truth remains that vast reaches of culture, far from being "carried" by a community or group . . . are discoverable only as the peculiar property of certain individuals, who cannot but give these cultural goods the impress of their own personality. ("The Emergence of the Concept of Personality in a Study of Cultures," *Journal of Social Psychology* 5 [1934])

To "certain individuals" I would add "certain individual works." Those works concern us not so much because they may display cultural uniformities but because they embody strong or subtle personalities we wish to keep near us. It is the rough faith in the particular, in the individual, that draws many of us to literature and the arts.

In recent years, advanced critical theory has brought forth a new term to tantalize us: textuality. It means that the language of literature refers to and represents no real world outside language itself. There are only language and the social conventions that sustain it. A "text" refers only to itself and to other texts. If, by the remotest of chances, there is something behind or beyond language, texts neither correspond to it nor report on it. Reality remains uncertain and unspeakable. Texts are all.

This radical epistemological skepticism comes from two sources. It has a long philosophical ancestry going back at least to solipsism in Berkeley and Hume—and to Dr. Johnson kicking a stone to disprove it. And it comes forth anew, under quite different circumstances, from twentieth-century linguistics.* Textuality, a kind of refried

* From Aristotle (*De interpretatione*, I) down to Ogden and Richards's *The Meaning of Meaning* (1923), philosophers of language have described the basic signifying function of language in terms of the relations between three elements: word, thought, and thing. A word "means" or refers to a thing by mediation through an idea in a triangular process, thus:

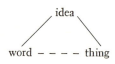

solipsism, has been swallowed avidly or obediently by a number of critics. But it fails to reckon adequately either with the common sense of reality, which induces most of us to rely on language to correspond to what we do and think every day, or with the enormous accomplishments of science, which takes the real phenomena of nature for granted as the object of its investigations. Werner Heisenberg would have no truck with textuality. He defends "natural language," by which he means ordinary conventional language that points to something outside itself.

> We know that any understanding [of the physical world] must be based finally upon the natural language because it is only there that we can be certain to touch reality, and hence we must be skeptical about any skepticism with regard to this natural language and its essential concepts. [*Physics and Philosophy*]

Of course no one can prove, logically or philosophically, either that the real world exists or that it does not exist. On this question we simply act according to the assumptions we make, by faith or by default. Anyone who acted consistently on the premises of textuality would be quietly put away. The absorbing fictions of Kafka, Borges, Beckett, and Calvino can be seen as belonging to a mode of litera-

Then came Saussure, a brilliant linguist with a mind chained to binary distinctions. His *Cours de linguistique* (1915) dismisses traditional semantics in favor of a scheme based on only two elements: signifiers (words) and signifieds (ideas). In Saussure's binary diagram of "value" (p. 34), A represents thoughts and B words. Thus Saussure collapses the universe. His scheme eliminates any reference to the features and entities of a "real world" to which language might correspond and affirms essentially collective mental processes.

This generally unnoticed or at least unchallenged maneuver seeks to simplify linguistics by separating it from the outside world and to limit the fundamental orientation of intellectual pursuits to linguistic-idealist phenomena. It is as if posthumously Saussure's work has established by fiat since 1950 what epistemological skepticism still has not achieved in philosophy: the suppression of reality. Meaning is all in the mind, founded by cultural convention, untainted by any relation to the world or by any truth function. Saussure's revolutionary amputation has had a major influence in fields where his ideas have been assimilated—language theory, anthropology after Lévi-Strauss, Lacanian psychoanalysis, Foucault's interpretation of culture, post-Structuralist criticism, postmodernist fiction. This upheaval in contemporary intellectual history has by no means received the attention it deserves. It remains nearly invisible; yet its implications are enormous and verge on the political. If language need not correspond to any reality of nature or of history and is merely a manipulation of conventions, we have come to the threshold of Orwell's newspeak and doublethink in *1984*—language prone to domination by a party.

ture that does not describe reality, that spins fantasies out of the resources of a language system with a long history of encoded structures, texts suspended in the feedback circuit of textuality. But this analysis overlooks the powerful guiding presence in all their works of "the superior joke" of caricature. Much of their power arises from deflected and distorted representations of reality. Special categories will not hold the works of such authors. Epistemological skepticism and textuality are the newest and snappiest technologies available for literary study, but they have not driven out the old hand tools like the correspondence theory of reality: art represents and reveals life by an endlessly varied set of conventions.

Indeed, textuality can be understood as the second generation of art for art's sake, a nineteenth-century doctrine that diminished and domesticated art by severing it from life. Plato dismissing the poets from his Republic showed a greater respect for the power of art to sway our thinking and behavior than Gautier or Wilde placing art above life or Auden grumbling that "poetry never changed anything." A refurbished version of the autonomy of art in our era of experiment and excess in every domain will not help us decide what to encourage and what to denounce. Critics who debate the qualities and merits of individual works attract me more strongly than those who debate theories and processes.

Meanwhile, is there no way to recognize and reconcile the two undeniable extremes of art: its urgent, realistic depiction of human life and its retreat to a self-reflexive realm of language, forms, and ideas? Can infection ever lie down with autonomy? I can answer only with a parable. Many years ago when I lived in Texas I was struck by a type of side road fairly common along the highways of that state. Called "loop roads" and assigned a state number, these routes ran a few miles into the countryside, sometimes to a homestead or small community, and returned to the highway at the same point or a little farther on, thus forming a loop. They were neither dead ends nor connecting roads to another highway. By taking one of these loop roads you could explore the landscape, change your direction, break your journey, and perhaps discover an impressive outlook or landmark, knowing that you would return to your original path after the detour. For many years my favorite loop jogged west from U.S. Highway 81 (between Austin and San Antonio) and circled across low hills to the tiny, surprisingly green and pleasant settlement of Buda. I sensed even then that this loop would later furnish a compact analogy for something I could not yet identify.

A work of art or literature removes us temporarily from the regular path of our life and diverts us into a partly imaginary domain where we can encounter thoughts and feelings that would not have occurred to us on the highway. These side experiences differ from our daily lives. In literature they are made up of words—disembodied, intense, complex, wonderfully malleable, and convincing. These differences permit a literary work to probe disturbingly deep into potential relations among character, action, thought, and the natural world. We accept the differences and expect them to observe or exceed certain conventions of plausibility and exaggeration, usefulness and fantasy. At the same time we know that this detour of art will deliver us back before long into the track of our life, which may be changed or influenced in some manner by the side trip.

This loop analogy presents a work of art as a form of delay or relay along the path of living. Its processes are only temporarily autonomous; they turn off from and return to the realities of human existence. The frontal lobes of the human brain have extended our capacity for delayed response, for foresight based on hindsight. Here precisely lie the faculties developed and refined by artists and writers who are constantly rehearsing real and imaginary events in order somehow to get them right—in timing and tone. This process of pausing to reflect, of rehearsing (both before and after the fact) the consequences of our actions, inspired prehistoric cave drawings, as it inspired Duchamp's elaborate mental mechanism *The Great Glass*, with its accompanying books and boxes. He called it "a delay in glass." Art is free to try all the genres and modes it can imagine; some of them travel a long way from reality. Its responsibility is to return us to reality better prepared to continue our journey.

One of the daunting sentences that haunts our intellectual firmament is the Blake quotation that probably encouraged Yeats to compose *A Vision*: "I must create a System or be enslaved by another Man's." Blake expended vast reservoirs of poetic energy to concoct his system of angels and devils in symbolic spaces—with precarious results when compared with his simpler works. Yeats did likewise. But Blake's advice is dangerously misleading. Better something even sterner: "I must think carefully and critically enough about systems to escape other people's and not to be enslaved by my own." In most ordinary activities we rely heavily on habit and system, ours and other people's, and properly so. The world would come apart without those braces. But the experience of art is in part defined by the

fact that it asks to be an exception to this practice. Ideally, as the human embryo recapitulates all the stages of evolution before becoming recognizably human, each encounter with a work of art can recapitulate the stages of wonder, exploration, and discovery by which we have come to value that realm.

Baudelaire answers Blake as directly and vehemently as if he had read him that very morning.

> I have tried more than once, like all my friends, to shut myself up in a system in order to have a convenient position to preach from. But a system is a kind of damnation which forces us into a perpetual recantation . . . My system was always of high explanatory power, flexible, useful, simple, and elegant—or at least it appeared so to me . . . Endlessly condemned to a new conversion, I made a great decision . . . To escape from the horror of these philosophical apostasies, I contented myself with feeling: I began once again to take refuge in an impeccable naïveté. ["Critical Method," from *Exposition universelle de 1885*]

Yes, we have all lost our innocence long since. The important thing is to be able to find it again, and not by going back. We need not despair, for in a few domains an ulterior innocence awaits us. The most exhilarating quality of art in its truest forms is to enable one to come to it again and again and to find oneself a virgin every time.

ACKNOWLEDGMENTS

Four essays are published here for the first time: "The Demon of Originality," "The Prince, the Actor, and I," "Apollinaire's Great Wheel," and "The Innocent Eye and the Armed Vision."

The others have appeared, usually in a different version, as follows:

"Having Congress." *Partisan Review*, No. 3, 1984.

"The D-S Expedition." *The New York Review of Books*, May 18 and June 1, 1972.

"The Tortoise and the Hare." In *The Origins of Modern Consciousness*, edited by John Weiss, Wayne State University Press, 1964.

"The Alphabet and the Junkyard." In *Fragments: Incompletion and Discontinuity*, edited by Lawrence D. Kritzman, New York Literary Forum, 1981.

"What Is 'Pataphysics?" *Evergreen Review*, No. 13, 1960.

"Balzac and the Open Novel." "Afterword" in Honoré de Balzac, *Eugénie Grandet*, translated by Henry Reed, New American Library, 1964.

"Vibratory Organism." *The Georgia Review,* Summer 1977.

"Artaud Possessed." *The New York Review of Books,* November 11, 1976.

"Malraux the Conqueror." *The New York Review of Books,* October 24, 1968.

"Locating Michel Tournier." *The New York Review of Books,* April 28, 1983.

"Claude Monet." *Artforum,* March 1982.

"The Devil's Dance." *The New Republic,* December 26, 1983.

"René Magritte." *Artforum,* September 1966.

"Marcel Duchamp." *The New York Times Book Review,* February 11, 1979.

"Meyer Schapiro's Master Classes." *The New York Review of Books,* April 19, 1979.

"How to Rescue Literature." *The New York Review of Books,* April 17, 1980.

"The Poverty of Modernism." *The New Republic,* March 14, 1983.

I wish to thank Paul Schmidt for his help in choosing the essays for this collection.

INDEX